Selfies as a Mode of Social Media and Work Space Research

Shalin Hai-Jew
Kansas State University, USA

A volume in the Advances in Media, Entertainment, and the Arts (AMEA) Book Series

Published in the United States of America by
　　　IGI Global
　　　Information Science Reference (an imprint of IGI Global)
　　　701 E. Chocolate Avenue
　　　Hershey PA, USA 17033
　　　Tel: 717-533-8845
　　　Fax: 717-533-8661
　　　E-mail: cust@igi-global.com
　　　Web site: http://www.igi-global.com

Library of Congress Cataloging-in-Publication Data

Names: Hai-Jew, Shalin, editor.
Title: Selfies as a mode of social media and work space research / Shalin
　　Hai-Jew, editor.
Description: Hershey, PA : Information Science Reference, [2018]
Identifiers: LCCN 2017016123| ISBN 9781522533733 (hardcover) | ISBN
　　9781522533740 (ebook)
Subjects: LCSH: Online social networks. | Social media--Research. | Digital
　　images--Social aspects. | Self-portraits--Social aspects.
Classification: LCC HM742 .S448 2018 | DDC 302.30285--dc23 LC record available at https://
lccn.loc.gov/2017016123

This book is published in the IGI Global book series Advances in Media, Entertainment, and the Arts (AMEA) (ISSN: 2475-6814; eISSN: 2475-6830)

British Cataloguing in Publication Data
A Cataloguing in Publication record for this book is available from the British Library.

All work contributed to this book is new, previously-unpublished material.
The views expressed in this book are those of the authors, but not necessarily of the publisher.

For electronic access to this publication, please contact: eresources@igi-global.com.

Advances in Media, Entertainment, and the Arts (AMEA) Book Series

ISSN:2475-6814
EISSN:2475-6830

Editor-in-Chief: Giuseppe Amoruso, Politecnico di Milano, Italy

MISSION

Throughout time, technical and artistic cultures have integrated creative expression and innovation into industrial and craft processes. Art, entertainment and the media have provided means for societal self-expression and for economic and technical growth through creative processes.

The **Advances in Media, Entertainment, and the Arts (AMEA)** book series aims to explore current academic research in the field of artistic and design methodologies, applied arts, music, film, television, and news industries, as well as popular culture. Encompassing titles which focus on the latest research surrounding different design areas, services and strategies for communication and social innovation, cultural heritage, digital and print media, journalism, data visualization, gaming, design representation, television and film, as well as both the fine applied and performing arts, the AMEA book series is ideally suited for researchers, students, cultural theorists, and media professionals.

COVERAGE

- Blogging & Journalism
- Geometry & Design
- New Media Art
- Digital Heritage
- Design of Interiors
- Digital Media
- Cultural Heritage
- Environmental Design
- Design Tools
- Print Media

IGI Global is currently accepting manuscripts for publication within this series. To submit a proposal for a volume in this series, please contact our Acquisition Editors at Acquisitions@igi-global.com or visit: http://www.igi-global.com/publish/.

Titles in this Series

For a list of additional titles in this series, please visit:
https://www.igi-global.com/book-series/advances-media-entertainment-arts/102257

Digital Innovations in Architectural Heritage Conservation Emerging Research and Opprtunities
Stefano Brusaporci (University of L'Aquila, Italy)
Engineering Science Reference • ©2017 • 152pp • H/C (ISBN: 9781522524342) • US $115.00

Music as a Platform for Political Comunication
Uche Onyebadi (Texas Christian University, USA)
Information Science Reference • ©2017 • 309pp • H/C (ISBN: 9781522519867) • US $195.00

Media Law, Ethics, and Policy in the Digital Age
Nhamo A. Mhiripiri (Midlands State University, Zimbabwe & St. Augustine University, Tanzania) and Tendai Chari (University of Venda, South Africa)
Information Science Reference • ©2017 • 330pp • H/C (ISBN: 9781522520955) • US $195.00

Handbook of Research on the Facilitation of Civic Engagement through Community Art
Leigh Nanney Hersey (University of Louisiana Monroe, USA) and Bryna Bobick (University of Memphis, USA)
Information Science Reference • ©2017 • 672pp • H/C (ISBN: 9781522517276) • US $275.00

Convergence of Contemporary Art, Visual Culture, and Global Civic Engagement
Ryan Shin (University of Arizona, USA)
Information Science Reference • ©2017 • 390pp • H/C (ISBN: 9781522516651) • US $195.00

Cultural Influences on Architecture
Gülşah Koç (Yıldız Technical University, Turkey) Marie-Therese Claes (Louvain School of Management, Belgium) and Bryan Christiansen (PryMarke, LLC, USA)
Information Science Reference • ©2017 • 352pp • H/C (ISBN: 9781522517443) • US $180.00

For an enitre list of titles in this series, please visit:
https://www.igi-global.com/book-series/advances-media-entertainment-arts/102257

701 East Chocolate Avenue, Hershey, PA 17033, USA
Tel: 717-533-8845 x100 • Fax: 717-533-8661
E-Mail: cust@igi-global.com • www.igi-global.com

This is for R. Max.

Table of Contents

Preface ... xii

Acknowledgment .. xviii

Section 1
Human Motivations Behind Selfies

Chapter 1
Shameless Selfie-Promotion: Narcissism and Its Association With Selfie-
Posting Behavior .. 1
Eric B. Weiser, Curry College, USA

Chapter 2
Spontaneous Taking and Posting Selfie: Reclaiming the Lost Trust 28
Ikbal Maulana, Indonesian Institute of Sciences, Indonesia

Chapter 3
Motivations and Positive Effects of Taking, Viewing, and Posting Different
Types of Selfies on Social Media: A Cross-National Comparison 51
Fiouna Ruonan Zhang, Bowling Green State University, USA
Nicky Chang Bi, Bowling Green State University, USA
Louisa Ha, Bowling Green State University, USA

Section 2
Socio-Cultural Aspects of Selfie-Taking and Selfie-Sharing

Chapter 4
Selfies: New Visual Culture of New Digital Society .. 75
Ayşe Aslı Sezgin, Osmaniye Korkut Ata University, Turkey

Chapter 5
Self-Objectification vs. African Conservative Features in the Selfies of Black
African Women: A Study of Nigerian Social Media Users...............................103
 Endong Floribert Patrick Calvain, University of Calabar, Nigeria

Chapter 6
Work-Based Self-Portrayals: Signaling Reciprocity on Social Media to
Reassure Distant Work-Based Project Collaborators...131
 Shalin Hai-Jew, Kansas State University, USA

Section 3
Formalizing the Analysis of Selfies

Chapter 7
Creating an Instrument for the Manual Coding and Exploration of Group
Selfies on the Social Web..173
 Shalin Hai-Jew, Kansas State University, USA

Chapter 8
Senses of "Selfie" Around the World From Web Search Patterns Over
Extended Time..249
 Shalin Hai-Jew, Kansas State University, USA

Compilation of References ...296

About the Contributors ...322

Index...325

Detailed Table of Contents

Preface .. xii

Acknowledgment ... xviii

Section 1
Human Motivations Behind Selfies

Chapter 1
Shameless Selfie-Promotion: Narcissism and Its Association With Selfie-
Posting Behavior ... 1
 Eric B. Weiser, Curry College, USA

Taking selfies and sharing them on social media is a popular activity in the age of the smartphone. Why do people take selfies and post them for others to see? This chapter reviews the empirical literature on the association between narcissism and selfie-posting behavior. Narcissism is a multidimensional personality trait characterized by grandiose views of oneself, a sense of superiority and concomitant feelings of entitlement, and a lack of empathy toward others. Included in the chapter is a discussion of important conceptual and methodological considerations in the study of narcissism, as well as a qualitative review of studies examining the association between narcissism and selfie-posting behavior and what these investigations have revealed. Finally, theoretical models explaining the association between narcissism and selfie- posting behavior are presented.

Chapter 2
Spontaneous Taking and Posting Selfie: Reclaiming the Lost Trust 28
 Ikbal Maulana, Indonesian Institute of Sciences, Indonesia

On social media where people are struggling to attract others' attentions, posting selfies is the most convenient way to communicate their individuality. They do not need anyone's assistance to take their picture, and they can take it anytime and post it immediately on social media. Bodily appearance has always been an influence in

how an individual is perceived and treated by her social environment. Fortunately, on social media this appearance has transformed into information, which, therefore, can be manipulated by computers or even smartphones. With the help of digital image processing software fulfilling the beauty standard of any virtual community is no longer a concern. However, this chapter argues that this technology destroys the realism of a photograph, makes its reliability almost like that of a statement, which depends on its human source not on itself. This creates the problem of trust, and many users seek to overcome it by spontaneous taking and posting a casual and inelegant selfie.

Chapter 3
Motivations and Positive Effects of Taking, Viewing, and Posting Different
Types of Selfies on Social Media: A Cross-National Comparison......................51
 Fiouna Ruonan Zhang, Bowling Green State University, USA
 Nicky Chang Bi, Bowling Green State University, USA
 Louisa Ha, Bowling Green State University, USA

In this study, we explored the motivations and the effects of selfie taking, posting, and viewing. To understand the selfie phenomenon, we conducted in-depth interviews with 16 American and Chinese students. The findings suggest that the selfie phenomenon among American students is not necessarily related to narcissism and low self-esteem, as argued in many previous literatures. Contrarily, selfie usage among Chinese students is more associated with narcissism (self-indulgence in recreational selfie-taking) and impression management (selfie-editing to improve online self-image). In the general, selfie taking, viewing, and posting behaviors could be conceptualized as more than just a display of narcissism, but also as a new way of communication, life-recording, online impression management, and relationship management. Cultural differences between American and Chinese students' use of selfies are also discussed.

Section 2
Socio-Cultural Aspects of Selfie-Taking and Selfie-Sharing

Chapter 4
Selfies: New Visual Culture of New Digital Society ..75
 Ayşe Aslı Sezgin, Osmaniye Korkut Ata University, Turkey

In this study, digital culture emerging with new communication technologies after oral culture and the written culture will be examined in a critical perspective with the example of selfie. As expressed previously, many studies conducted with the same content has focused on the individual psychological effects of selfies. But study will be focusing on the social effects of selfies which are considered as a new visual culture of the new digital society in this study. The new cultural environment in

Turkey created by the selfies in which the impacts of globalization can be observed is being discussed in this study and it will try to evaluate the sociological dimensions of selfies shared publicly by the most widely followed users in Instagram which is among the social media network based on visualization while highlighting the disappeared properties of oral and written culture

Chapter 5

Self-Objectification vs. African Conservative Features in the Selfies of Black African Women: A Study of Nigerian Social Media Users 103
Endong Floribert Patrick Calvain, University of Calabar, Nigeria

Though popularly construed as a universal phenomenon, selfie taking is gendered and culturally determined. This could be evidenced by the fact that the two socio-cultural forces of conservatism and traditionalism continue to tremendously shape African women's style of taking and sharing selfies on social media. Based on a content analysis of 200 selfies generated and shared by Nigerian women on Facebook and Instagram, this chapter illustrates this reality. It argues that Nigerian women are generally more conservative than liberal in their use of selfies for self-presentation, self-imaging and self-expression in public spaces. Over 59% of their selfies have conservative features. However, despite the prevalence of conservative myths and gender related stereotypes in the Nigerian society, the phenomenon of nude or objectified selfies remains a clearly notable sub-culture among Nigerian women. Over 41% of Nigerian women's selfies contain such objectification features as suggestive postures; suggestive micro-expressions and fair/excessive nudity among others.

Chapter 6

Work-Based Self-Portrayals: Signaling Reciprocity on Social Media to Reassure Distant Work-Based Project Collaborators ... 131
Shalin Hai-Jew, Kansas State University, USA

One degree out from an image "selfie" are text-based self-generated user profiles (self-portrayals) on social media platforms; these are self-depictions of the individual as he or she represents to the world. This work-based self-representation must be sufficiently convincing of professionalism and ethics to encourage other professionals to collaborate on shared work projects through co-creation, support, attention, or other work. While project-based track records may carry the force of fact, there are often more subtle messages that have high impact on distant collaborations. One such important dimension is "indirect reciprocity," or whether the target individual treats collaborators with respect and care and returns altruistic acts with their own acts of altruism. This work describes some analyses of professional profiles on social media platforms (email, social networking, and microblogging) for indicators of indirect reciprocity.

Section 3
Formalizing the Analysis of Selfies

Chapter 7

Creating an Instrument for the Manual Coding and Exploration of Group

Selfies on the Social Web...173

Shalin Hai-Jew, Kansas State University, USA

A subgroup of the images shared as part of the "selfie" phenomenon is group selfies (aka "groupies" and "we-fies" or "us-ies") or self-portraits of groups (three or more individuals of focal interest) that are shared on social media. These images have informational value that has thus far been only thinly explored. In this work, an instrument—Categorization and Exploration of Group Selfies Instrument (CEGSI), pronounced "segsy"—was constructed of three parts: (1) Group Selfie Content and Context, (2) Group Selfie Image Creation, and (3) Group Selfie Messaging. It was tested against two image sets: group selfies and dronies, which were scraped from Google Images. This chapter describes the work, the analytical findings, and the resulting instrument for the manual coding of group selfies, and other insights.

Chapter 8

Senses of "Selfie" Around the World From Web Search Patterns Over

Extended Time ..249

Shalin Hai-Jew, Kansas State University, USA

When social phenomena and practices go viral, like "selfies," they instantiate in different locations around the world in different ways based on cultural differences, technological affordances, and other factors. When people go to search for "selfie" on Google Search, they are thinking different things as well. On Google Correlate, it is possible to identify the top correlating search terms that pattern-match the time patterns for the seeding search term. Based in this big data, these search term correlates (associated over extended time) provide a sense of the "group mind" around a particular topic.

Compilation of References .. 296

About the Contributors .. 322

Index..325

Preface

When engaging with selfies, as an individual, these seem to be best consumed singly and with a little time. One looks at the individual or the pair or the group, and there is something of personality, context, activity, and meaning to the image. There are people just being. Others are in the midst of rigorous actions. Others are evoking a mood, maybe a sense of contemplation. In consuming selfies, we are giving each other room to express and room in social space and the public square. There is a communal personhood of selfies. For those of us in the midst of the hypersocial exchanges, there will be likes and commenting and engagement. For others, there are different types of engagement, a step or two out, maybe through research (which is yet another active and intense kind of response). In looking at selfies, we are understanding ourselves better because we can see where we align with others' interests and where we differ; in our more enlightened moments, we even understand why we are similar and different regarding the various dimensions of being human.

In the research context, we tend to engage not with one selfie but larger collections of them. The first impressions: sensory overload! The purpose is not for the pleasure of another's self-expression but a pursuit of information and knowledge, with a mix of both subjective and objective engagement. The senses of the images are not the personal vitality of the other per se but more of the selfies as digital residua from individual contexts. What may have been an impromptu image capture becomes part of a larger pattern, what may have been an incidental element in the image begins to look like a prop, and the individual becomes part of a crowd, behaving in mutually reinforcing and emulative (and memetic) ways. There is a grand meld of the private and the public, evocative of the "rear window" sensibility except in the thousands. In this sensory overload, we see the familiar and the unfamiliar, and we seek both, and we seek understandings from it all.

A NOTE ABOUT THE ORIGINAL INSPIRATIONS

The original inspiration for "Selfies as a Mode of Social Media and Work Space Research" were a few simple questions:

- What informational value do selfies contain? If selfies are datafied, what would people discover and learn?
- In work contexts, how do selfies instantiate?

Back in late 2015, when the initial call for chapter proposals went out, it seemed like a good idea to formally take stock of a runaway social phenomenon. Now, a few years further into this, many of the images still look the same: humanity in numerous self-portraits—individuals, duos, small groups, and large groups. There are people with their significant others, friends, family, colleagues, and pets, in various combinations. There are the smiles (in the various types), the duck face poses, the triumphal grins, the serious expressions, and others. There are the hand and other bodily gestures—with various interpretations. The settings are recognizable and somewhat thematic: comfortable home locales, work-place offices, conference centers, and parking lots. Then, too, there are the more exciting locations: world-famous tourist landmarks, hiking trails and bridges on mountains, boats, cruise ships, and other spaces. The activities depicted are varied but also may be understood within certain common and less common practices, in tourism, in dining, in sport, in work, in rest, and the other habits of people's daily lives. Some of the images were clearly taken on-the-fly, and others clearly required effortful setup both prior to the image capture and with image post-production afterwards. Even though the images may seem fairly easy to interpret early on, some more lingering over the artifacts of the selfie phenomenon suggests that there is more to the images than one may assume. Different viewers will likely interpret each image differently, especially with the images decontextualized from their original contexts and separated from the selfie photographers.

Beyond the images themselves, there is the popular consumption of these images from various social media platforms. There are public figures, from entertainment, from religions, from politics, communicating with their respective audiences, in both a narrowcast targeted way and in broadcast ways. The maintenance of parasocial relationships requires some effortful sharing.

In the past few years, it has become clear that the technologies for selfies have advanced. Beyond the appearance of selfie sticks, there are the uses of different types of cameras (like GoPros) and cameras mounted on drones (for "dronies"), which may be programmed to follow an individual in motion or even cars in motion.

In the Beginning Was the Self

For an individual, in a very simplistic sense, everything begins with the self. While "selfies" are an obvious way of communicating several dimensions of the self, so, too, are less obvious types of sharing—such as the publicizing of self-created profiles on social media platforms.

In 2013, "selfies" was selected as the Word of the Year in the Oxford English Dictionary. Then, on March 2, 2014, Ellen DeGeneres and her friends shared the famous Ellen selfie (now, a meme) from the #oscars, an image which has spawned many other shares, many of them group ones. Since then, the "selfie" has become even more of a "thing," spreading over all the continents and across many countries in the world. How selfies have instantiated may differ, but many of the human impetuses underlying the sharing of self-portraits is universally human. For all the popularity, though, the term "selfie" or various variants of related terms have not yet made it into books in a broadscale way (Figure 1).

A more timely and apropos approach may be to do a search for "selfie" on Google Search, which returns a cool 919 million results (in 0.82 seconds, no less). This suggests not only that selfies are deeply integrated into people's lives, but there are often status updates of people in their various life activities.

This book is comprised of three sections:

Section 1: Human Motivations Behind Selfies
Section 2: Socio-Cultural Aspects of Selfie-Taking and Selfie-Sharing

Figure 1. Self and variations of "selfies" in the Google Books Ngram viewer

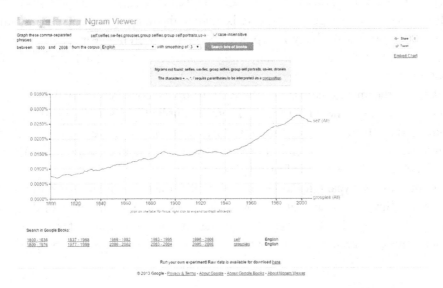

Section 3: Formalizing the Analysis of Selfies

Section 1 deals with the human motivations behind selfies—their creation and their consumption. Chapter 1, "Shameless Selfie-Promotion: Narcissism and Its Association With Selfie-Posting Behavior," by Dr. Eric B. Weiser, explores the intricate ties between the complex psychological construct of narcissism and selfie-taking and selfie-sharing behaviors.

"Spontaneous Taking and Posting (of) Selfie(s): Reclaiming the Lost Trust" (Ch. 2), by Dr. Ikbal Maulana, suggests that selfies may be manipulated information, and that to capture lost trust, selfie takers should be more spontaneous and less controlled in their self-image-capture and sharing. His assertion is that the overlays of filters and effortful image-taking are harmful to the practice, if selfies are to be viewed as accurately informative.

The third chapter in Section 1 is "Motivations and Positive Effects of Taking, Viewing, and Posting Different Types of Selfies on Social Media: A Cross-National Comparison," by Fiouna Ruonan Zhang, Nicky Chang Bi, and Dr. Louisa Shu Ying Ha. This work involves interviews with a small group of college students from the U.S. and the People's Republic of China respectively to understand differences in the usage of selfies. These authors suggest that cultural differences may explain some of the different approaches.

The second section of this book, "Socio-Cultural Aspects of Selfie-Taking and Selfie-Sharing" is comprised of three chapters. These works shed light on the dynamics of selfies—both their creation and their consumption, in various parts of the world.

Dr. Ayşe Aslı Sezgin's "Selfies: New Visual Culture of New Digital Society" (Ch. 4) places the selfie phenomenon in a modern socio-cultural context in Turkey. She examines how people are portrayed in selfies in this country and suggests unpredictable interaction effects between the local and the global.

Dr. Floribert Patrick Calvain Endong's "Self-Objectification vs. African Conservative Features in the Selfies of Black African Women: A Study of Nigerian Social Media Users" (Ch. 5) asserts the cultural gendering of the practice of selfie-taking. He asserts that both conservatism and traditionalism affect how African women from Nigeria self-portray in selfies.

Chapter 6, "Work-Based Self-Portrayals: Signaling Indirect Reciprocity on Social Media to Reassure Distant Work-Based Project Collaborators" assumes an instrumental purpose to professional "selfie" profiles by depicting individuals as good partners for virtual collaborations. Dr. Shalin Hai-Jew uses social media profile descriptions to explore whether "indirect reciprocity" messages are included in the public self-portrayals (through social media profiles) and "direct reciprocity" in private self-portrayals (through email).

Section 3, "Formalizing the Analysis of Selfies" contains two chapters. This section asks how to "datafy" and "informatize" selfie imagery.

"Creating an Instrument for the Manual Coding and Exploration of Group Selfies on the Social Web" (Ch. 7) combines *a priori* coding and bottom-up emergent coding of group selfie image sets to create a more standard approach to analyzing group selfie imagery. Dr. Hai-Jew's chapter is one of the first, if not the first, to address group selfies as a main subject of study.

Finally, the last chapter is "Senses of 'Selfie' Around the World From Web Search Patterns Over Extended Time" (Ch. 8). This work involves the use of Google Correlate to map the search terms that most correlate with a "selfie" search from 2003 – present (extended time). This data was captured over 50 countries and across a number of languages to provide a sense of how different locales and cultures approach the "selfie" phenomenon, in terms of web search activity.

The Initial Call for Chapter Proposals

There is a benefit to reviewing the initial call for chapter proposals as I wrap up the preface to this book. In the initial call, potential authors were asked to address a wide range of potential topics. They were asked to…

- Define "selfies";
- Consider models for the study of selfies;
- Explore applied uses of selfies in various ways (as self-expression; self-actualization; socializing, self-presentation, and social performance; dating; job hunting; marketing; sales, and mixed interests);
- Consider applications of selfies for identity verification (security);
- Discuss the "art of the selfie" (its aesthetics and artful expressions in the selfie *oeuvre*; socialization through self-representation; creation of spectacle; and risk-taking and selfies);
- Explore the rhetoric of selfies (selfies as metaphor, analogy, symbol);
- Research individual selfies, group selfies, organizational selfies (and their respective uses);
- Analyze selfie technologies (mobile devices, selfie sticks, selfie drones, and others) and related social media platforms;
- Describe methods for coding selfies;
- Conduct studies in selfies (or selfies in…personality and psychological analysis; socio-cultural insights; symbolic reasoning; geographical regions; media studies; communications; digital humanities);

- Explore selfie digital portraiture, the relationship of the self and other(s) in selfies, and the relationship between the self and the larger depicted context;
- Study selfies in messaging campaigns, advertising campaigns, marketing campaigns, and branding;
- Consider selfies "by instrumentation" (such as by #dronies or selfie robots); and
- Mull the future of selfies (in the near-, mid- and long-terms).

There is still a lot out there about selfies that has not yet been explored. "Selfies as a Mode of Social Media and Work Space Research" offers eight original works addressing the global selfie phenomenon, but these offer an initial foray into the topic, leaving much still out there to be explored.

Acknowledgment

Selfies as a Mode of Social Media and Work Space Research would not exist without the hard work and thoughtful insights of the respective authors. I am deeply grateful to them for their contributions. Thanks to Jordan Tepper, Assistant Development Editor at IGI Global, Christina Henning, Michael Brehm and the many others at IGI Global who have made this book possible. All were professional and patient, even as initial deadlines were missed! Without their support and flexibility, this book would only be something conceptualized but not actualized.

Section 1
Human Motivations Behind Selfies

Chapter 1
Shameless Selfie-Promotion:
Narcissism and Its Association With Selfie-Posting Behavior

Eric B. Weiser
Curry College, USA

ABSTRACT

Taking selfies and sharing them on social media is a popular activity in the age of the smartphone. Why do people take selfies and post them for others to see? This chapter reviews the empirical literature on the association between narcissism and selfie-posting behavior. Narcissism is a multidimensional personality trait characterized by grandiose views of oneself, a sense of superiority and concomitant feelings of entitlement, and a lack of empathy toward others. Included in the chapter is a discussion of important conceptual and methodological considerations in the study of narcissism, as well as a qualitative review of studies examining the association between narcissism and selfie-posting behavior and what these investigations have revealed. Finally, theoretical models explaining the association between narcissism and selfie- posting behavior are presented.

INTRODUCTION

Are we so in love with ourselves that we have to take a "selfie" for every activity that we do and then post it for everyone to see? Who cares? Are you that insecure or are you just that arrogant? This will be the most photographed generation in history and all for the sake of vanity. It's really sad. – Central Iowa man (2016)

DOI: 10.4018/978-1-5225-3373-3.ch001

The smartphone has become the gateway to the online world. Over three quarters (77%) of U.S. adults now own a smartphone, more than double the level of 2011; these devices are ubiquitous among young adults, with 92% of 18- to 29-year-olds owning one (Pew Research Center, 2017). The increased penetration of smartphones has given rise to a new genre of self- expression: "selfies," or amateur self-photographs taken with these devices and often shared with others through social media websites. We are now living in a world awash in selfies; they are popping up everywhere, whether it be sporting events, graduations, or funerals. We have selfie sticks to take better pictures of ourselves and "no-selfie zones" to prevent putting ourselves in danger. We enhance our selfies to increase the volumes of "likes" and comments they elicit on social media; for instance, photo-editing applications enable us to add charm to our selfies, improve our appearance, and edit them into works of art in the styles of Picasso, Chagall, and Kandinsky. We scrutinize ourselves in our selfies mercilessly and relentlessly, prompting some writers blame "selfie culture" for the dramatic rise in Botox treatment among millennial women in recent years (Blanchette, 2017). We add pop culture to our selfies by photo-shopping ourselves into selfies with celebrities. A true selfie with a celebrity, especially when transmitted instantly to friends and followers thru Instagram or Snapchat, carries enormous social currency; indeed, country music superstar Taylor Swift claimed that that the autograph is now "obsolete" and said that she hasn't been asked for one "since the invention of the iPhone with the front- facing camera" (Swift, 2014, para. 11). Without a doubt, selfies have become irrevocably ensconced in early 21st century culture and pervade every corridor of social media; Instagram, for example, hosts hundreds of millions of photographs hashtagged with either #selfie or #me.

The prevalence of selfies in social media raises intriguing questions concerning why people post them and what they represent. In some respects, the selfie can be viewed as a technology byproduct, a side effect arising from the confluence of mobile operating systems, social media, and online photo-sharing platforms. However, the selfie is best viewed a social phenomenon serving as a means of individual and creative self-expression; as such, selfies convey important information about oneself and – given their pervasiveness – one's culture. But what information do they convey? Indeed, why do people take selfies and post them to social media, and why do some do it more frequently than others? What are the social and psychological motives that drive this behavior? What is it, exactly, that sharing selfies accomplishes?

This chapter addresses one specific factor linked to selfie-posting behavior, namely, narcissism. The term *narcissism* is familiar to most people; formally and informally, we use the word "narcissist" in reference to the individual who seems to think he or she is special and comes across as conceited, vain, and entitled. Personal photos, when shared privately with friends and loved ones, enhance intimacy and social connectedness; when shared publicly, they signal the desire for relationships, as well

as attention, affirmation, or approval from others. Selfies, however, conspicuously exude a "look-at-me" quality; when shared publicly on social media where they can reach a wide audience, they trigger perceptions of self-enhancement, self-promotion, and attention-seeking, all of which are narcissistic-like characteristics. The quote above, which underscores the belief that selfies emanate a miasma of self-absorbed vanity, highlights the intuitive notion that an association exists between narcissism and selfies and cogently captures the essence of this chapter. More specifically, this chapter qualitatively reviews the empirical literature on the relationship between narcissism and selfie-posting behavior. Discussed within this chapter are important conceptual and methodological issues in this area, pertinent empirical findings and what we have learned from them, and important theoretical models explaining the association between narcissism and selfies.

NARCISSISM: ITS CONCEPTUALIZATION AND MEASUREMENT

Narcissism

Social and personality psychologists view narcissism as a dimensional personality trait that is normally distributed in the population and ranges from very low to very high (Miller & Campbell, 2008; South, Eaton, & Krueger, 2011). Conceptually, narcissism as a social-personality construct – that is, trait or "subclinical" narcissism, in contrast to narcissistic personality disorder (NPD[1]; American Psychological Association, 2013) – is characterized by grandiose views of oneself, particularly with respect to agentic features (e.g., intelligence, power, creativity) and physical attractiveness (Campbell, Rudich, & Sedikides, 2002; Twenge, Konrath, Foster, Campbell, & Bushman, 2008), as well as arrogance, egocentrism, an unmerited sense of entitlement, and a constant need for attention and veneration from others (Brown, Budzek, & Tamborski, 2009; Morf & Rhodewalt, 2001). Simply put, a narcissistic individual thinks – and demands others acknowledge – that he or she is special; is smarter, better-looking, and more important than others; and that he or she deserves to be treated accordingly. Narcissism, however, is not simply high self-esteem; although narcissistic individuals do tend to possess high self-esteem, they "are missing the piece about caring for others" (Twenge & Campbell, 2009, p. 24). They lack empathy and have little interest in forming warm, caring interpersonal relationships (Campbell & Foster, 2007; Hepper, Hart, & Sedikides, 2014); the relationships they do have are routinely burdened by their selfishness, entitlement, exploitation, and indifference (Campbell, Reeder, Sedikides, & Elliot, 2000). Narcissistic individuals are adept at making positive initial impressions on others with their charisma and confidence (Back, Schmukle, & Egloff, 2010), and

perhaps because their self-promotion is mistaken for self-disclosure. Over time, however, their self-enhancement and lack of warmth lead to negative interpersonal reactions (Paulhus, 1998). In short, narcissists are in love with themselves to an extent that others eventually find overbearing, aversive, and socially obnoxious. The causes of narcissism have not been studied extensively and are not well understood. Psychodynamic explanations pinpoint dysfunctional child-parent attachments, suggesting that it develops as a consequence of parental rejection, devaluation, or indifference (Kernberg, 1975; Kohut, 1971). Alternatively, others have implicated excessive parental adoration and indulgence as contributing elements (Millon, 1981).

Two variants, or "types," of narcissism have been delineated and studied: grandiose and vulnerable (Miller, Price, Gentile, Lynam, & Campbell, 2012; Pincus & Roche, 2011). *Grandiose narcissism* (sometimes called "overt narcissism") is characterized by outward manifestations of narcissism; that is, the grandiose narcissist openly seeks admiration and is overtly self-aggrandizing, attention-seeking, and entitled. *Vulnerable narcissism* (sometimes called "covert narcissism"), which has been less studied, is characterized principally by self-inhibition, hypersensitivity, and negative affect; that is, the vulnerable narcissist is reserved and withdrawn interpersonally while harboring a defensive and fragile grandiosity (Dickinson & Pincus, 2003; Miller et al., 2011). In simpler terms, the grandiose narcissist is an "in-your-face" kind of narcissist who makes no effort to hide his or her narcissistic objectives from others (i.e., he or she is more "overt"), whereas the vulnerable narcissist is an "insecure" type of narcissist who is more modest in self-presentation, yet anxiously self-preoccupied (i.e., he or she keeps his or her narcissistic needs more "covert") (Rhodewalt & Peterson, 2009). Despite these differences, grandiose and vulnerable narcissists share a tendency toward self-aggrandizement, and both crave attention and admiration; with respect to the latter, however, vulnerable narcissists are too inhibited and insecure to demand it as explicitly as grandiose narcissists do (Pincus et al., 2009). There are measures of both grandiose and vulnerable narcissism; however, most social-personality research has focused on grandiose narcissism (Brown et al., 2009).

The Measurement of Narcissism

The Narcissistic Personality Inventory (NPI; Raskin & Terry, 1988) is the primary instrument social and personality psychologists use to measure individual differences in trait narcissism. Various forms of the NPI exist, but the 40-item "forced choice" version (hereafter referred to as the NPI-40) is the one used most frequently. The NPI-40 is a self-report measure in which each item requires respondents to choose one of two statements that is most self-descriptive; one statement reflects narcissistic sentiments, and the other does not (e.g., "I am an extraordinary person," vs. "I am

much like everybody else"). For each item, the narcissistic statement is scored 1 and the non-narcissistic statement is scored 0. Following completion, respondents' scores are summed (total scores can range from 0 to 40), with higher scores reflecting greater narcissism. The NPI-40 has generally been accepted as a valid measure of narcissism and been translated into multiple languages for research involving non-English- speaking samples (Tamborski & Brown, 2011).[2]

It is necessary to clarify two matters regarding the NPI-40 and the measurement of narcissism. First, narcissism is a complex, multidimensional construct, and, in fact, the NPI-40 seems to assess several of its facets; however, the number and nature of these facets has long been a subject of debate (Brown et al., 2009). Factor analytic studies of the NPI-40 have revealed varying factor structures, with as few as two (Corry, Merritt, Mrug, & Pamp, 2008) and as many as seven (Raskin & Terry, 1988) dimensions having been reported. Traditionally, narcissism research involving the NPI-40 has been guided by Raskin and Terry's (1988) seven-component interpretation as a basis for examining the dimensions of narcissism. These dimensions are labeled Authority (feelings of dominance and leadership), Exhibitionism (showing off), Exploitativeness (taking advantage of others), Entitlement (insistence on getting what one wants), Self-Sufficiency (independence and self-confidence), Vanity (regarding oneself as physically attractive), and Superiority (believing that one is better than others). However, an especially rigorous analysis by Ackerman et al. (2011) demonstrated that the NPI-40 assesses three empirically robust facets of narcissism: Leadership/Authority (L/A), Grandiose Exhibitionism (GE), and Entitlement/Exploitativeness (E/E). These dimensions, which are described in Table 1, hold across multiple data sets and exhibit significant associations with theoretically relevant criterion variables (Ackerman, 2011). Recently, Gentile and others (2013) developed a short, 13-item self-report measure of narcissism (i.e., the NPI-13), which yields a total score and subscale scores for L/A, GE, and E/E.

Second, the NPI-40 appears to capture mostly the grandiose variant of narcissism, and thus is not ideal for assessing the vulnerable dimension (Rhodewalt & Peterson, 2009; Wright, Lukowitsky, Pincus, & Conroy, 2010). Other measures have been developed that assess characteristics related to vulnerable narcissism; these measures include the Hypersensitive Narcissism Scale (HSNS; Hendin & Cheek, 1997) and the Pathological Narcissism Inventory (PNI; Pincus et al., 2009). The HSNS is a 10-item self-report scale measuring the neurotic hypersensitivity, insecurity, and covert grandiosity and entitlement inherent to vulnerable narcissism. The PNI is a 52-item self-report measure of the more maladaptive, "psychologically unhealthy," and pathological aspects of both grandiose and vulnerable narcissism (in contrast to the NPI-40, which assesses both adaptive and maladaptive features of narcissism; Ackerman, 2011). The PNI yields scores on seven dimensions of pathological narcissism: four span problems with narcissistic grandiosity and

Table 1. Three Dimensions of Narcissism, as Assessed by the Narcissistic Personality Inventory (NPI-40)[a]

Facet	Description
Leadership/Authority (L/A)	• Reflects self-perceived leadership, dominance, and capacity for social agency. • Individuals who score high on LA are motivated to lead and to seek power and authority over others
Grandiose Exhibitionism (GE)	• Reflects self-absorption, vanity, superiority, and exhibitionistic propensities • Individuals who score high on GE are in love with themselves and are especially prone toward attention seeking, showing off, and self-promotion
Entitlement/ Exploitativeness (E/E)	• Reflects entitlement, a sense one deserves respect, and an exploitative interpersonal orientation • Individuals who score high on EE possess unmerited or unreasonable expectations of special treatment; they believe they are entitled to whatever they wish and are willing to manipulate and take advantage of others

Note. Adapted from "What Does the Narcissistic Personality Inventory Really Measure?" by Ackerman, Witt, Donnellan, 2011, p. 72.

[a]These facets are also captured by 13-item Narcissistic Personality Inventory (NPI-13;Gentile et al., 2013).

include Exploitativeness (EXP; willingness to manipulate others to achieve one's goals), Grandiose Fantasy (GF; compensatory fantasies of success and superiority), Entitlement Rage (ER; anger when entitled expectations are not met), and Self-Sacrificing Self-Enhancement (SSSE; engagement in purportedly altruistic acts to support an inflated self-image); whereas three span problems with narcissistic vulnerability and include Contingent Self-Esteem (CSE; fluctuating self-esteem that is contingent on others' appraisals), Hiding the Self (HS; unwillingness to show others one's faults and needs), and Devaluing (DEV; detachment from others to avoid shame stemming from interpersonal disappointments). The PNI additionally yields scores for narcissistic grandiosity and narcissistic vulnerability, as well as a total score measuring one's overall level of pathological narcissism. The PNI was developed principally as a tool to support the assessment of NPD, but it was validated using a mostly nonclinical sample; it is noteworthy here because it is one of few existing measures assessing the vulnerable aspects of narcissism.

THE ASSOCIATION BETWEEN NARCISSISM AND SELFIE-POSTING BEHAVIOR

Research in three areas provides both a solid and logical foundation on which to hypothesize that narcissism and selfie-posting behavior are associated. First, the

growth and popularity of social media has facilitated the rise in self-publishing and the sharing of personal information and images; concurrently, it has also facilitated opportunities to self-promote and seek attention. Given that people systematically select and spend time in social situations that dispose them to behave in ways reflective of their personalities (Snyder & Ickes, 1985), research examining predictors of social media use and activity has focused on trait narcissism, the presumption being that social media represents an ideal milieu for achieving narcissistic objectives of self- enhancement, gaining others' attention, and displaying large numbers of shallow relationships (e.g., Facebook "friends;" Buffardi & Campbell, 2008). Indeed, narcissists' tendencies toward self-promotion and self-enhancement are often transferred onto social media, as revealed by investigations reporting positive associations between narcissism and the frequency of using social media (e.g., Panek, Nardis, & Konrath, 2013; Ryan & Xenos, 2011), as well as patterns of narcissistic-like self-promoting behaviors, such the frequency of status updates and the use of language and photographs to draw attention to oneself (e.g., Carpenter, 2012; DeWall, Buffardi, Bonser, & Campbell, 2011; Mehdizadeh, 2010). Second, narcissistic individuals are preoccupied with their physical appearance, which they actively alter in ways to boost others' perceptions of their attractiveness and status. For example, Vazire, Naumann, Rentfrow, & Gosling (2008) found that narcissistic individuals are more likely than less narcissistic individuals to have a neat, organized appearance that seems to require extensive preparation, and to wear expensive and stylish clothing; these authors further reported narcissistic females (relative to less narcissistic females) are more likely to wear makeup, have plucked eyebrows, and show cleavage, whereas narcissistic males (relative to less narcissistic males) are less likely to wear eyeglasses. Third, and as noted earlier, narcissistic individuals perceive themselves to be more physically attractive than do less narcissistic individuals (Bleske-Rechek, Remiker, & Baker, 2008), and, in fact, meta-analytic evidence shows a small but reliable narcissism-attractiveness association (Holtzman & Strube, 2010); perhaps unsurprisingly, narcissistic individuals spend more time looking in the mirror at themselves that do less narcissistic individuals (Robins & John, 1997). Moreover, those who post selfies typically report doing so because they believe they look good in their photos and want others to view them as such (Wickel, 2015). Therefore, it can be deduced that narcissistic individuals might regard uploading selfies to social media as a viable means through which they can use their attractiveness to gain attention and admiration from others, and, thus, that such individuals are more likely to post selfies on social media – and to do so with greater frequency – than are less narcissistic individuals.

REVIEW OF STUDIES

To date, 15 studies (14 cross-sectional designs and one cross-lagged panel analysis) described in 13 published papers have examined the association between narcissism, its facets, and selfie- positing behavior. Of these studies, 13 assessed selfie-posting activity, whereas three (including one of the 13 mentioned previously) investigated the association between narcissism and *intentions* to post selfies. These studies were identified via a literature review using PsychINFO and Google Scholar by pairing the keyword "narcissism" with the following additional keywords: "selfies," "Facebook," "Instagram," "social media, "social networking," "social networking sites," and "social media." The relevant characteristics and findings pertaining to each of these studies are displayed in Table 2.

Most of the samples used in these investigations consisted of young adults, some of whom were undergraduates and others community residents; many in these samples were engaged in online activity, in that they were active users of social media or recruited from Amazon's Mechanical Turk (MTurk; Mason & Suri, 2012). In most of the studies, selfie-posting behavior was quantified in the form of either self-reported number of selfies posted within a circumscribed time period (e.g., one week) or responses to ordinal categories representing differences in selfie- posting frequency (e.g., "once per week," "a few times per week," "once per day," etc.). Three of the studies (i.e., Bergman, Fearrington, Davenport, & Bergman, 2011; Carpenter, 2012; McKinney, Kelly, & Duran, 2012) did not use the word "selfie" explicitly, but rather a synonymic variation; for example, Carpenter (2012) asked participants, "How often do you post photographs of yourself on Facebook?" However, these investigations explored narcissism and its more general link to social media use and behavior. Also, data for these studies were collected prior to when the term "selfie" eventually became part of the everyday vernacular ("selfie" did not become "Word of the Year" until 2013).

The majority of the studies measured grandiose narcissism, using either the NPI-40 or one of its variants (e.g., NPI-13, SD3). The associations between overall narcissism and selfie-posting frequency were more consistent in studies using the NPI-13 (McCain et al., 2016; Moon, Lee, Lee, Choi, & Sung, 2016; Sung, Lee, Kim, & Choi, 2016) than in those using the NPI-40. Of the studies using total NPI-40 scores, three reported significant associations (Bergman et al., 2011; Sorokowski et al., 2015; Weiser, 2015), whereas two did not (Barry, Doucette, Loflin, Rivera-Hudson, & Herrington, 2017; McKinney et al., 2012). Additionally, two studies measuring narcissism as part of the Dark Triad reported positive associations between narcissism and selfie- posting frequency (Fox & Rooney, 2015; McCain et al., 2016). Only one study provided longitudinal data. Using a two-wave design, this study found that time 1 narcissism predicted time 2 selfie-posing frequency (i.e.,

Table 2. Summaries of studies exploring the association between narcissism and selfie-posting behavior

Study[a]	Participants	Narcissism Measures	Key Findings[b]
Bergman et al. (2011)	361 U.S. undergraduates, ages 18-33; 54% were males	NPI-40	Narcissism positively related to participants' posting pictures on social media "that featured only themselves" $(r = .14)$
Carpenter (2012)	294 participants, ages 18-65; 74.1% were college students, 68% were females	GE and EE subscales of NPI-40	GE subscale scores positively related to self-promoting Facebook behaviors (including posting "photographs of yourself;" $\beta = .28$)
McKinney et al. (2012)	223 U.S. undergraduates, average age 19.77; 62% were females	NPI-40	Narcissism weakly correlated with the frequency of "posting photos of oneself" on Facebook and Twitter $(r = .12, \text{n.s.})$
Fox & Rooney (2015)	800 U.S. males, ages 18-40	Four-item narcissism subscale from Dirty Dozen	Narcissism predicted number of selfies posted on SNS in previous week $(\beta = .09)$
Sorokowski et al. (2015)	Study 1: 748 individuals, ages 17-47, recruited from various campuses across Poland; 53% were males Study 2: 548 Facebook users, ages 14-47; 60% were females	NPI-40 – Polish Adaptation Version	Study 1: For women, narcissism associated with frequency of posting own selfies $(r = .14)$ over last 30 days; for men, narcissism associated with frequency of posting own selfies $(r = .15)$, selfies with partner $(r = .11)$ and group selfies $(r = .22)$ over last 30 days Study 2: For women, narcissism unrelated to number of photos posted as selfies in participants' Facebook pages; for men, narcissism associated with number of photos posted as own selfies $(r = .14)$ and group selfies $(r = .21)$ in participants' Facebook pages
Weiser (2015)	1,204 U.S. residents recruited from Amazon MTurk, ages 16-74; 65% were females	NPI-40	Overall narcissism predicted selfie-posting frequency $(\beta = .21)$, as well as L/A $(\beta = .12)$ and GE $(\beta = .13)$ dimensions; E/E predicted selfie-posting frequency among men $(\beta = .08)$, but not women
Halpern et al. (2016)	314 Chilean residents who completed two surveys one year apart (cross-lagged panel design); ages 18-65+; 51% were females	Ten item from the NPI-40 reflecting the Authority, Exhibitionism, Exploitativeness, and Vanity dimensions	Narcissism scores at time 1 predicted frequency of selfie-posting at time 2 $(\beta = .10)$, and selfie-posting frequency at time 1 predicted narcissism scores at time 2 $(\beta = .07)$. Correlations between time 1 and time 2 narcissism and selfie-posting frequency were $r = .12$ and $r = .19$, respectively
Kim et al. (2016)	85 Instagram users, ages 20-32; 89% were females	NPI-13	Narcissism exerted positive influence on intention to post selfies on SNSs $(\beta = .32)$
Lee & Sung (2016)	315 Korean SNS users who had ever posted selfies on SNSs, ages 19-39; 70% were females	NPI-13	Positive and significant relationships observed between narcissism and attitudes toward selfie-posting behavior $(r = .31)$, as well as intention to post selfies in the future $(r = .32)$

continued on following page

Table 2. Continued

Study[a]	Participants	Narcissism Measures	Key Findings[b]
McCain et al. (2016)	Study 1: 348 U.S. residents recruited from Amazon MTurk, average age 31.85; 49% were females Study 2: 491 U.S. undergraduates, average age 18.87; 79% were females	NPI-13; HSNS; Nine-item narcissism subscale from SD3	Study 1: NPI-13 narcissism associated with reported number of selfies posted to Instagram per day ($r = .13$) and with frequency of posting selfies to Instagram ($r = .26$), Twitter ($r = .26$), and other sites ($r = .14$); SD3 narcissism associated with reported number of selfies posted to Instagram per day ($r = .15$) and frequency of posting selfies to Facebook ($r = .14$), Instagram ($r = .17$), and Twitter ($r = .23$) Study 2: NPI-13 narcissism associated with frequency of posting selfies to Twitter ($r = .15$); SD3 narcissism associated with reported number of selfies posted to Instagram per day ($r = .13$) and frequency of posting selfies to Instagram ($r = .10$), Twitter ($r = .18$), and other sites ($r = .10$); HSNS narcissism associated with frequency of posting selfies to Facebook ($r = .10$) and Instagram ($r = .13$)
Moon et al. (2016)	Korean sample of 212 Instagram users, ages 20-39; 52% were females	NPI-13	Narcissism associated with frequency of selfie posting ($r = .30$) and proportion of selfies in Instagram account ($r = .17$); GE predicted frequency of selfie posting ($\beta = .55$) and proportion of selfies in Instagram account ($\beta = .35$); L/A negatively predicted frequency of selfie-posting ($\beta = -.40$) and proportion of selfies in Instagram account ($\beta = -.35$)
Sung et al. (2016)	315 Korean SNS users who had ever posted selfies on SNSs, ages 19-39; 70% were females	NPI-13	Narcissism significant predictor of selfie-posting frequency ($\beta = .13$) and intention to post selfies ($\beta = .15$)
Barry et al. (2017)	128 U.S. undergraduates (Instagram users), ages 18-43; 85% were females	NPI-40; PNI	Overall NPI-40 and PNI narcissism unrelated to selfie-posting frequency and proportion of total Instagram posts that were selfies; NPI-40 narcissism positively associated with selfie collages ($r = .19$); vulnerable narcissism (PNI) positively associated with higher proportion of posts that were "physical appearance" selfies ($r = .18$), grandiose narcissism (PNI) negatively associated with "affiliation" selfies ($r = -.220$; significant relations observed between several NPI-40 and PNI subscales and specific types of selfies

Note. E/E = Entitlement/Exploitativeness; GE = Grandiose Exhibitionism; HSNS = Hypersensitive Narcissism Scale (Hendin & Cheek, 1997); L/A = Leadership/Authority; NPI-40 = 40-item Narcissistic Personality Inventory (Raskin & Terry, 1988); NPI-13 = 13-item Narcissistic Personality Inventory (Gentile et al., 2013); PNI = Pathological Narcissism Inventory (Pincus et al., 2009); SD3 = Short Dark Triad (Jones & Paulhus, 2014); SNS = social networking site.

[a]The surname of only the first author is provided for studies with three or more authors.

[b]All findings described here were statistically significant unless otherwise noted.

people with higher narcissism scores at time 1 reported posting a greater number of selfies one year later). Notably, this study also found that time 1 selfie-posting frequency predicted time 2 narcissism scores. The authors suggested that these findings support a "self-reinforcement effect:" an increase in selfie production over time consequently raises levels of narcissism (Halpern, Valenzuela, & Katz, 2016). A notable limitation of this study, however, was that only 10 items from the NPI-40 were used to operationalize narcissism.

A number of investigations reported associations between different narcissism facets and selfie-posting behavior. Some of these studies used the three subscales identified by Ackerman et al. (2011), whereas others used the seven subscales, or some variation thereof, identified by Raskin and Terry (1988). Weiser (2015), for example, found that the L/A and GE facets predicted the frequency of posting selfies; this study also reported that the more adaptive L/A facet was a stronger predictor of selfie-posting among women than men, whereas the maladaptive E/E facet predicted selfie-posting frequency among men, but not women. In addition, Carpenter (2012) found that scores on the GE subscale predicted the frequency with which participants posted photos of themselves on Facebook. Moon et al. (2016) reported that GE predicted the frequency of posting selfies, as well as the proportion of photos in participants' Instagram accounts that were selfies; however, L/A emerged as a negative predictor of both these variables. In two studies with a pooled sample of 1296 participants, Sorokowski et al. (2015) examined the associations between scores on the four subscales of the Polish adaptation of the NPI-40[3] and the frequency of posting different kinds of selfies (i.e., "own selfies," "selfies with a partner," "group selfies"). In Study 1, participants indicated the number of these kinds of selfies they posted within the last 30 days; in Study 2, research assistants counted the number of selfies posted to participants' Facebook pages and categorized them accordingly. Among men, scores on each of the subscales were correlated with posting one or more kinds of selfies in both studies; among women, Admiration Demand was the only subscale associated with selfie-posting behavior ("own selfies" in Study 1 and own selfies and "selfies with a partner" in Study 2). In a study of 128 undergraduate Instagram users who consented to have their accounts observed for 30 days, Barry et al. (2017) found that NPI-40 Vanity and Superiority were positively associated with the number of posted selfie "collages" (i.e., single post combing two or more selfies), whereas Authority was negatively correlated with the number of posted "event/activity" selfies.

Only three of the studies investigated the association between vulnerable narcissism and selfie-posting behavior. In one, Barry et al. (2017) found that, overall, both the grandiose and vulnerable dimensions of the PNI were unrelated to the frequency of posting selfies and the proportion of total Instagram posts that were selfies. However, these investigators also found that vulnerable narcissism was associated with a higher proportion of posts that were "physical appearance" selfies, and that grandiose narcissism was negatively associated with the proportion of "affiliation" selfies. Further analysis revealed significant associations between PNI grandiosity and vulnerability subscales and selfie categories. "Physical appearance" selfies were positively correlated with the SSSE dimension of PNI grandiosity and the HS and DEV dimensions of PNI vulnerability. On the other hand, "affiliation" selfies were negatively correlated with the SSSE and EXP dimensions of PNI grandiosity. Posting selfies overall and selfie "collages" were negatively correlated with the CSE dimension of PNI vulnerability. In two large samples, McCain et al. (2016) reported somewhat mixed findings: although vulnerable narcissism (as measured by the HSNS) was not associated with self-reported number of selfies posted to Instagram per day (Study 1), it was nevertheless positively associated with the frequency of posting selfies to Facebook and Instagram (Study 2).

Finally, a few studies examined narcissism and its relationship to attitudes and intentions regarding posting selfies. These studies drew on the Theory of Planned Behavior (Ajzen, 2005), which emphasizes the links between attitudes, behavioral intentions, and behavior. One study reported that narcissism is associated with more positive attitudes toward selfie-posting behavior (Lee & Sung, 2016), and three found that narcissism is associated with greater intentions to post selfies in the future (Kim, Lee, Sung, & Choi, 2016; Lee & Sung, 2016; Sung et al., 2016).

DISCUSSION

Collectively, the investigations reviewed here demonstrate that an association exists between narcissism and selfie-posting activity. Of the 13 studies that directly examined either self-reported or observable selfie-posting behavior (e.g., frequency of posting selfies, number of selfies, proportion of social media photos that were selfies), 12 reported significant and positive associations between total narcissism and/or one or more of its subscales and selfie-posting activity. This association was consistent, despite some differences across studies in how narcissism was measured. Sample sizes were generally adequate across investigations, and, in many instances, attempts were made to control for relevant covariates. Most of the studies examined grandiose narcissism; vulnerable narcissism and its relationship to selfies has yet to be explored in depth. The two investigations involving vulnerable narcissism

indicate – albeit preliminarily – that its association with selfie-posting activity is weaker than that of grandiose narcissism, although some dimensions of vulnerable narcissism may be connected to posting specific kinds of selfies (e.g., those that highlight one's physical appearance; Barry et al., 2017).

Additionally, a number of these studies looked at the relationship between various facets of narcissism and selfie-posting behavior. A consistent theme in these studies was that GE and related subscales (e.g., Vanity, Superiority) predicted various forms of selfie-posting behavior, suggesting, perhaps, that this activity constitutes an exhibitionistic display of self-importance.

Notably, the effect sizes reported in these investigations were consistently small to moderate; although the statistical relationships were significant in many cases, examination of the correlations and standardized regression coefficients in these studies suggests that narcissism explains a small amount of the variance in selfie-posting activity. In a recent meta-analysis that included studies exploring the relationship between narcissism and number of selfies uploaded to social media, McCain and Campbell (2016) reported a mean effect size of $r = .14$ across eight studies using measures of grandiose narcissism and a mean effect size of $r = .05$ across three using measures of vulnerable narcissism. Thus, it appears that grandiose narcissism has a small, but reliable, association with selfie-posting behavior; vulnerable narcissism, at least to this point, is at best weakly related selfie-posting behavior. The lack of studies examining vulnerable narcissism and its relationship to selfie-posting activity is a matter that, hopefully, investigators will address, as further work in this are needs to be performed.

THEORETICAL MODELS EXPLAINING THE ASSOCIATION BETWEEN NARCISSIM AND SELFIE-POSTING BEHAVIOR

Why is grandiose narcissism associated with selfie-posting behavior? Three compelling theoretical frameworks pertinent to the study of narcissism are especially useful in explaining this relationship: the personality framework, the motivational/ self-regulatory framework, and the sociocultural framework. Each framework would predict that narcissistic individuals are more prone to posting selfies than are individuals possessing lower levels of narcissism.

The Personality Framework

The personality framework suggests that the trait dimensions associated with narcissism may be important in understanding its connection with selfie-posting activity. From this framework, then, personality traits provide an explanation for

this behavior. In terms of the Five Factor Model (FFM) of personality (Costa & McCrae, 2009), evidence has firmly established that grandiose narcissism consists of high Extraversion and low Agreeableness (Trzesniewski, Donnellan, & Robins, 2008; Miller et al., 2011); in fact, Paulus (2001) characterized the narcissist as a "disagreeable extravert" (p. 228). Of these two traits, extraversion seems particularly important. Extraversion refers to one's level of sociability, as well as the tendency to seek external stimulation and the company of others. The fundamental element of Extraversion is a tendency to behave in ways that attract or hold social attention and to enjoy those behaviors (Ashton, Lee, & Paunonen, 2002). Hence, grandiose narcissists' tendencies to share selfies may reflect their high levels of Extraversion; indeed, Extraversion has been found to predict the frequency of online selfie posting for both men and women (Sorokowska et al., 2016). As well, the disagreeable nature of narcissists is reflected in their sense of entitlement, arrogance, lack of empathy, and disinterest in others. From the perspective of the FFM, selfie-posting on the part of grandiose narcissists might be characterized as an antagonistic form of attention seeking, an effort on the part of these individuals to gain and impress an audience whom they care little about (and may even disdain). To the grandiose narcissist, selfies may be a message that one wishes to be heard but does not want to listen. Alternatively, vulnerable narcissism is comprised of high Neuroticism and low Agreeableness (Miller & Maples, 2011); as such, it is reasonable to infer that vulnerable narcissists would experience anxiety and discomfort with selfies – which they in fact do (McCain et al., 2016) – and, hence, an unwillingness to take or share such photos.

The Motivational/Self-Regulatory Framework

Generally speaking, the motivational/self-regulatory framework focuses on the strategies narcissistic individuals use to buttress their inflated self-views. This framework is especially helpful in understanding how social media in general, and posting selfies in particular, serve narcissistic individuals' needs for attention, admiration, and self-enhancement. A relevant theory within this framework is the dynamic self-regulatory processing model of narcissism (Morf, Torchetti, & Schürch, 2011; Morf & Rhodewalt, 2001). Similar to traditional conceptualizations of narcissism (e.g., Kohut, 1971), this model views narcissistic individuals as possessing fragile, yet overinflated, views of themselves. However, a key idea of the model is that these paradoxical self-views prompt narcissistic individuals to actively engage in a set of self-regulatory processes comprised of both interpersonal and intrapersonal strategies designed to bolster, maintain, and reinforce their unrealistically grandiose self-evaluations. Intrapersonal strategies refer to self-enhancing cognitive, affective, and motivational processes and include such things as overestimating one's

attractiveness and intelligence (Gabriel, Critelli, & Ee, 1994), viewing oneself and one's accomplishments as superior to those of others (John & Robbins, 1994), and making self-serving attributions for favorable outcomes one experiences but had no actual part in effectuating (Rhodewalt & Morf, 1998). Interpersonal strategies refer to social behaviors intended to self-enhance and bolster the narcissist's inflated self-views; these behaviors characteristically take the form bragging, showing off, putting others down, making self-aggrandizing statements during conversation, and behaving in ways to draw attention to oneself (Buss & Chiodo, 1991); seeking social relationships and contexts that provide explicit opportunities for self-enhancement and self-promotion (Campbell, 1999; Wallace & Baumeister, 2002); and taking credit from a partner for a successful joint endeavor (Campbell, Reeder, Sedikides, & Elliot, 2000). Narcissistic individuals have also been known to resort to more sinister means to maintain their inflated self-views, such as reacting aggressively toward others who evaluate them unfavorably (Bushman et al., 2009) or resorting to unethical and deceitful behavior in academic and workplace settings (Blickle, Schlegel, Fassbender, & Klein, 2006; Brunell, Staats, Barden, & Hupp, 2011).

In a nutshell, the germane assumptions of this model – that narcissistic individuals are captive to the goal of maintaining grandiose views of themselves and are adept at capitalizing on social contexts affording such opportunities – provides a sound theoretical framework for explaining the association between narcissism and selfie posting. The model suggests that social media provides a context conducive to the narcissist's goal of self-enhancement and gaining attention, and that uploading selfies, like other self-promotional behaviors on social media (e.g., posting status updates on Facebook; Carpenter, 2012) constitutes an interpersonal self-regulatory maneuver designed to elicit positive feedback and, hence, preserve a grandiose view of self. That grandiose narcissists report positive emotions while taking selfies (McCain et al. 2016) is consistent with the notion that selfie-posting serves an important self-regulatory function for such individuals.

The Sociocultural Framework

Finally, the sociocultural framework views the association between narcissism and selfies as a byproduct of cultural changes over time. More specifically, there is evidence that the United States and many other cultures have been growing more individualistic; the rise in individualism has resulted in a demonstrable shift toward greater self-focus, pointing to a concomitant increase in narcissism and narcissistic-like drives (e.g., uniqueness, self-esteem, fame) that are played out at both the individual level and societal level, with each influencing the other (Twenge, 2011; Twenge & Campbell, 2009). Perhaps the strongest case in support of this assertion comes from research demonstrating that narcissism among young adults has increased over the

last several decades (Twenge, Campbell, & Gentile, 2012; Twenge & Foster, 2010); occasionally, the media has attributed this increase to the popularity of social media (e.g., Chamorro-Premuzic, 2014; Diller, 2015). However, the increase in cultural narcissism predates the advent of social media. As well, the relationship between narcissism and social media use may be reciprocal: narcissism drives social media use, and social media use boosts narcissism, although evidence for the latter is less clear (Twenge, 2013). Nevertheless, it is plausible to speculate that social media has, to some degree, exacerbated cultural narcissism by serving as a context that both encourages and reinforces grandiose and exhibitionistic self-displays (e.g., selfies) deemed normative by a self- absorbed culture. This may be particularly true for younger adults who, in the face of a challenging economic climate providing fewer opportunities for establishing traditional foundations for fueling one's ego (e.g., careers, families, new homes), may choose to migrate more of their lives online to meet their self-esteem needs (Campbell & Twenge, 2015). From this framework, selfies may be viewed as a culturally-sanctioned and technologically "convenient" manifestation of narcissism, a form of self-promulgation shaped by an increasingly self-focused culture whose technology is continuously and rapidly evolving, yet offering fewer traditional opportunities to feel good about oneself.

CONCLUDING REMARKS

This chapter argues that narcissism and selfie-posting behavior are associated, and empirical evidence supports this contention. This, of course, is not to say that all people who post selfies on social media are narcissists, nor that selfies are inherently "bad." Clearly, there are other motives besides narcissistic self-regulation that underlie selfie posting. At the most basic level, we are all social beings who possess a fundamental need to establish and maintain close, stable attachments with other people (Baumeister & Leary, 1995); thus, sharing selfies may serve as a means to connect with others, perhaps thereby explaining why women, relative to men, post more selfies to social media ("Our Main Findings," n.d.; Sorokowski et al., 2015) and use social media at higher rates (Pew Research Center, 2016). Nevertheless, we must appreciate that personality and trait-related motives powerfully shape what we do and how we act, and we must acknowledge that our behavior, including that which is displayed through electronic or digital means, reveals the signature of who we are and what we are. Although there are likely many parts to the psychological engine that drives selfie-posting behavior, it is clear that narcissism is what sparks

that engine. Future research can provide further insight into the association between narcissism and selfie-posting behavior through rigorous examination of the direction of connection between these variables, as well as by uncovering the specific social and psychological motives governing selfie activity among narcissistic individuals.

REFERENCES

Ackerman, R. A., Witt, E. A., Donnellan, M. B., Trzesniewski, K. H., Robins, R. W., & Kashy, D. A. (2011). What does the Narcissistic Personality Inventory really measure? *Assessment*, *18*(1), 67–87. doi:10.1177/1073191110382845 PMID:20876550

Ajzen, I. (2005). *Attitudes, personality, and behavior* (2nd ed.). New York: Open University Press.

American Psychiatric Association (APA). (2013). *Diagnostic and Statistical Manual of Mental Disorders* (5th ed.). Washington, DC: Author.

Ashton, M. C., Lee, K., & Paunonen, S. V. (2002). What is the central feature of extraversion? Social attention versus reward sensitivity. *Journal of Personality and Social Psychology*, *83*(1), 245–252. doi:10.1037/0022-3514.83.1.245 PMID:12088129

Back, M. D., Schmukle, S. C., & Egloff, B. (2010). Why are narcissists so charming at first sight? Decoding the narcissism–popularity link at zero acquaintance. *Journal of Personality and Social Psychology*, *98*(1), 132–145. doi:10.1037/a0016338 PMID:20053038

Barry, C. T., Doucette, H., Loflin, D. C., Rivera-Hudson, N., & Herrington, L. L. (2017). Let me take a selfie: Associations between self-photography, narcissism, and self-esteem. *Psychology of Popular Media Culture*, *6*(1), 48–60. doi:10.1037/ppm0000089

Baumeister, R. F., & Leary, M. R. (1995). The need to belong: Desire for interpersonal attachments as a fundamental human motivation. *Journal of Personality and Social Psychology*, *117*, 497–529. PMID:7777651

Bergman, S. M., Fearrington, M. E., Davenport, S. W., & Bergman, J. Z. (2011). Millennials, narcissism, and social networking: What narcissists do on social networks and why. *Personality and Individual Differences*, *50*(5), 706–711. doi:10.1016/j.paid.2010.12.022

Blanchette, A. (2017, January 28). Botox is booming among millennials – some as young as 18. *The Star Tribune*. Retrieved from http://www.startribune.com

Bleske-Rechek, A., Remiker, M. W., & Baker, J. P. (2008). Narcissistic men and women think they are so hot – but they are not. *Personality and Individual Differences*, *45*(5), 420–424. doi:10.1016/j.paid.2008.05.018

Blickle, G., Schlegel, A., Fassbender, P., & Klein, U. (2006). Some personality correlates of business white-collar crime. *Applied Psychology*, *55*(2), 220–233. doi:10.1111/j.1464-0597.2006.00226.x

Brown, R. P., Budzek, K., & Tamborski, M. (2009). On the meaning and measure of narcissism. *Personality and Social Psychology Bulletin*, *35*(7), 951–964. doi:10.1177/0146167209335461 PMID:19487486

Brunell, A. B., Staats, S., Barden, J., & Hupp, J. M. (2011). Narcissism and academic dishonesty: The exhibitionism dimension and the lack of guilt. *Personality and Individual Differences*, *50*(3), 323–328. doi:10.1016/j.paid.2010.10.006

Buffardi, L. E., & Campbell, W. K. (2008). Narcissism and social networking web sites. *Personality and Social Psychology Bulletin*, *34*(10), 1303–1314. doi:10.1177/0146167208320061 PMID:18599659

Bushman, B., Baumeister, R. F., Thomaes, S., Ryu, E., Begeer, S., & West, S. G. (2009). Looking again, and harder, for a link between low self-esteem and aggression. *Journal of Personality*, *77*(2), 427–466. doi:10.1111/j.1467-6494.2008.00553.x PMID:19192074

Buss, D. M., & Chiodo, L. M. (1991). Narcissistic acts in everyday life. *Journal of Personality*, *59*(2), 179–215. doi:10.1111/j.1467-6494.1991.tb00773.x PMID:1880699

Campbell, W. K. (1999). Narcissism and romantic attraction. *Journal of Personality and Social Psychology*, *77*(6), 1254–1270. doi:10.1037/0022-3514.77.6.1254

Campbell, W. K., & Foster, J. D. (2007). The narcissistic self: Background, an extended agency model, and ongoing controversies. In C. Sedikides & S. J. Spencer (Eds.), *The self* (pp. 115–138). New York: Psychology Press.

Campbell, W. K., Reeder, G. D., Sedikides, C., & Elliot, A. J. (2000). Narcissism and comparative self-enhancement strategies. *Journal of Research in Personality*, *34*(3), 329–347. doi:10.1006/jrpe.2000.2282

Campbell, W. K., Rudich, E., & Sedikides, C. (2002). Narcissism, self-esteem, and the positivity of self-views. Two portraits of self-love. *Personality and Social Psychology Bulletin*, *28*(3), 358–368. doi:10.1177/0146167202286007

Campbell, W. K., & Twenge, J. M. (2015). Narcissism, emerging media, and society. In L. D. Rosen, N. A. Cheever, & L. M. Carrier (Eds.), *The Wiley handbook of psychology, technology, and society* (pp. 358–370). Hoboken, NJ: John Wiley and Sons.

Carpenter, C. J. (2012). Narcissism on Facebook: Self-promotional and anti-social behavior. *Personality and Individual Differences*, *52*(4), 482–486. doi:10.1016/j.paid.2011.11.011

Central Iowa Man. (2016, May 30). Re: Your two cents worth: Monday, May 30 [Online forum comment]. Retrieved from http://www.desmoinesregister.com/story/opinion/readers/2016/05/ 30/cents-worth-monday-may/85054968/

Chamorro-Premuzic, T. (2014). Sharing the (self) love: The rise of the selfie and digital narcissism. Retrieved from https://www.theguardian.com/media-network/media-network-blog/2014/mar/13/selfie-social-media-love-digital-narcassism

Corry, N., Merritt, R. D., Mrug, S., & Pamp, B. (2008). The factor structure of the Narcissistic Personality Inventory. *Journal of Personality Assessment*, *90*(6), 593–600. doi:10.1080/00223890802388590 PMID:18925501

Costa, P. T., & McCrae, R. R. (2009). The five-factor model and the NEO inventories. In J. N. Butcher (Ed.), *Oxford handbook of personality assessment*. New York: Oxford University Press. doi:10.1093/oxfordhb/9780195366877.013.0016

DeWall, C. N., Buffardi, L. E., Bonser, I., & Campbell, W. K. (2011). Narcissism and implicit attention seeking: Evidence from linguistic analyses of social networking and online presentation. *Personality and Individual Differences*, *51*(1), 57–62. doi:10.1016/j.paid.2011.03.011

Dickinson, K. A., & Pincus, A. L. (2003). Interpersonal analysis of grandiose and vulnerable narcissism. *Journal of Personality Disorders*, *17*(3), 188–207. doi:10.1521/pedi.17.3.188.22146 PMID:12839099

Diller, V. (2015). Social media: A narcissist's virtual playground. Retrieved from http://www.huffingtonpost.com/vivian-diller-phd/social-media-a-narcissist_b_6916010.html

Fox, J., & Rooney, M. C. (2015). The Dark Triad and trait self-objectification as predictors of men's use and self-presentation behaviors on social networking sites. *Personality and Individual Differences, 76*, 161–165. doi:10.1016/j.paid.2014.12.017

Gabriel, M. T., Critelli, J. W., & Ee, J. S. (1994). Narcissistic illusions in self-evaluations of intelligence and attractiveness. *Journal of Personality, 62*(1), 143–155. doi:10.1111/j.1467-6494.1994.tb00798.x

Gentile, B., Miller, J. D., Hoffman, B. J., Reidy, D. E., Zeichner, A., & Campbell, W. K. (2013). A test of two brief measures of grandiose narcissism: The narcissistic personality inventory–13 and the narcissistic personality inventory–16. *Psychological Assessment, 25*(4), 1120–1136. doi:10.1037/a0033192 PMID:23815119

Halpern, D., Valenzuela, S., & Katz, J. E. (2016). Selfie-ists or Narci-selfiers? A cross lagged panel analysis of selfie-taking and narcissism. *Personality and Individual Differences, 97*, 98–101. doi:10.1016/j.paid.2016.03.019

Hendin, H. M., & Cheek, J. M. (1997). Assessing hypersensitive narcissism: A reexamination of Murrays narcissism scale. *Journal of Research in Personality, 31*(4), 588–599. doi:10.1006/jrpe.1997.2204

Hepper, E. G., Hart, C. M., & Sedikides, C. (2014). Moving Narcissus: Can narcissists be empathic? *Personality and Social Psychology Bulletin, 40*(9), 1079–1091. doi:10.1177/0146167214535812 PMID:24878930

Holtzman, N. S., & Strube, M. J. (2010). Narcissism and attractiveness. *Journal of Research in Personality, 44*(1), 133–136. doi:10.1016/j.jrp.2009.10.004

John, O. P., & Robins, R. W. (1994). Accuracy and bias in self-perception: Individual differences in self-enhancement and the role of narcissism. *Journal of Personality and Social Psychology, 66*(1), 206–219. doi:10.1037/0022-3514.66.1.206 PMID:8126650

Jonason, P. K., & Webster, G. D. (2010). The Dirty Dozen: A concise measure of the Dark Triad. *Psychological Assessment, 22*(2), 420–432. doi:10.1037/a0019265 PMID:20528068

Jones, D. N., & Paulhus, D. L. (2014). Introducing the short Dark Triad (SD3): A brief measure of dark personality traits. *Assessment, 21*(1), 28–41. doi:10.1177/1073191113514105 PMID:24322012

Kernberg, O. H. (1975). *Borderline conditions and pathological narcissism*. New York: Jason Aronson.

Kim, E., Lee, J. A., Sung, Y., & Choi, S. M. (2016). Predicting selfie-posting behavior on social networking sites: An extension of theory of planned behavior. *Computers in Human Behavior*, *62*, 116–123. doi:10.1016/j.chb.2016.03.078

Kohut, H. (1971). *The analysis of the self.* New York: International Universities Press.

Lee, J. A., & Sung, Y. (2016). Hide-and-seek: Narcissism and selfie-related behavior. *Cyberpsychology, Behavior, and Social Networking*, *19*(5), 347–351. doi:10.1089/cyber.2015.0486 PMID:27028460

Mason, W., & Suri, S. (2012). Conducting behavioral research on Amazons Mechanical Turk. *Behavior Research Methods*, *44*(1), 1–23. doi:10.3758/s13428-011-0124-6 PMID:21717266

McCain, J. L., Borg, Z. G., Rothenberg, A. H., Churillo, K. M., Weiler, P., & Campbell, W. K. (2016). Personality and selfies: Narcissism and the Dark Triad. *Computers in Human Behavior*, *64*, 126–133. doi:10.1016/j.chb.2016.06.050

McCain, J. L., & Campbell, W. K. (2016). *Narcissism and social media use: A meta-analytic review. Psychology of Popular Media Culture. Advance online publication.* Retrieved from; doi:10.1037/ppm0000137

McKinney, B. C., Kelly, L., & Duran, R. L. (2012). Narcissism or openness? College students use of Facebook and Twitter. *Communication Research Reports*, *29*(2), 108–118. doi:10.1080/08824096.2012.666919

Mehdizadeh, S. (2010). Self-presentation 2.0; Narcissism and self-esteem on Facebook. *Cyberpsychology, Behavior, and Social Networking*, *13*(4), 357–364. doi:10.1089/cyber.2009.0257 PMID:20712493

Mehdizadeh, S. (2010). Self-presentation 2.0; Narcissism and self-esteem on Facebook. *Cyberpsychology, Behavior, and Social Networking*, *13*(4), 357–364. doi:10.1089/cyber.2009.0257 PMID:20712493

Miller, J. D., & Campbell, W. K. (2008). Comparing clinical and social-personality conceptualizations of narcissism. *Journal of Personality*, *76*(3), 449–476. doi:10.1111/j.1467-6494.2008.00492.x PMID:18399956

Miller, J. D., Hoffman, B. J., Gaughan, E. T., Gentile, B., Maples, J., & Campbell, W. K. (2011). Grandiose and vulnerable narcissism: A nomological network analysis. *Journal of Personality*, *79*(5), 1013–1042. doi:10.1111/j.1467-6494.2010.00711.x PMID:21204843

Miller, J. D., & Maples, J. (2011). Trait personality models of narcissistic personality disorder, grandiose narcissism, and vulnerable narcissism. In W. K. Campbell & J. D. Miller (Eds.), *The handbook of narcissism and narcissistic personality disorder* (pp. 56–70). Hoboken, NJ: John Wiley and Sons. doi:10.1002/9781118093108.ch7

Miller, J. D., Price, J., Gentile, B., Lynam, D. R., & Campbell, W. K. (2012). Grandiose and vulnerable narcissism from the perspective of the interpersonal circumplex. *Personality and Individual Differences, 53*(4), 507–512. doi:10.1016/j. paid.2012.04.026

Millon, T. (1981). *Disorders of personality*. New York: Wiley.

Moon, J. H., Lee, E., Lee, J. A., Choi, T. R., & Sung, Y. (2016). The role of narcissism in self-promotion on Instagram. *Personality and Individual Differences, 101*, 22–25. doi:10.1016/j.paid.2016.05.042

Morf, C. C., & Rhodewalt, F. (2001). Unraveling the paradoxes of narcissism: A dynamic self regulatory processing model. *Psychological Inquiry, 12*(4), 177–196. doi:10.1207/S15327965PLI1204_1

Morf, C. C., Torchetti, L., & Schürch, E. (2011). Narcissism from the perspective of the dynamic self-regulatory processing model. In W. K. Campbell & J. D. Miller (Eds.), *The handbook of narcissism and narcissistic personality disorder* (pp. 56–70). Hoboken, NJ: John Wiley and Sons. doi:10.1002/9781118093108.ch6

Our Main Findings. (n. d.). *Selfiecity.net*. Retrieved from http://selfiecity.net/#findings

Panek, E. T., Nardis, Y., & Konrath, S. (2013). Mirror or megaphone? How relationships between narcissism and social networking site use differ on Facebook and Twitter. *Computers in Human Behavior, 29*(5), 2004–2012. doi:10.1016/j. chb.2013.04.012

Paulhus, D. L. (1998). Interpersonal and intrapsychic adaptiveness of trait self-enhancement. *Journal of Personality and Social Psychology, 74*(5), 197–208. doi:10.1037/0022-3514.74.5.1197 PMID:9599439

Paulhus, D. L. (2001). Normal narcissism: Two minimalist accounts. *Psychological Inquiry, 12*, 228–230.

Paulhus, D. L., & Williams, K. M. (2002). The Dark Triad of personality: Narcissism, Machiavellianism, and psychopathy. *Journal of Research in Personality, 36*(6), 556–563. doi:10.1016/S0092-6566(02)00505-6

Pew Research Center. (2016). *Social media update*. Retrieved from http://www. pewinternet.org/2016/11/11/social-media-update-2016/

Pew Research Center. (2017). *Record shares of Americans now own smartphones, have home broadband*. Retrieved from http://www.pewresearch.org/fact-tank/2017/01/12/evolution-of-technology/

Pincus, A. L., Ansell, E. B., Pimentel, C. A., Cain, N. M., Wright, A. G. C., & Levy, K. N. (2009). Initial construction and validation of the pathological narcissism inventory. *Psychological Assessment, 21*(3), 365–379. doi:10.1037/a0016530 PMID:19719348

Pincus, A. L., & Roche, M. J. (2011). Narcissistic grandiosity and narcissistic vulnerability. In W. K. Campbell & J. D. Miller (Eds.), *The handbook of narcissism and narcissistic personality disorder* (pp. 31–40). Hoboken, NJ: John Wiley and Sons.

Raskin, R., & Terry, H. (1988). A principal components analysis of the narcissistic personality inventory and further evidence of its construct validity. *Journal of Personality and Social Psychology, 54*(5), 890–902. doi:10.1037/0022-3514.54.5.890 PMID:3379585

Rhodewalt, F., & Morf, C. C. (1998). On self-aggrandizement and anger: A temporal analysis of narcissism and affective reactions to success and failure. *Journal of Personality and Social Psychology, 74*(3), 672–685. doi:10.1037/0022-3514.74.3.672 PMID:9523411

Rhodewalt, F., & Peterson, B. (2009). Narcissism. In M. R. Leary & R. H. Hoyle (Eds.), *Handbook of individual differences in social behavior* (pp. 547–560). New York: Guilford.

Robins, R. W., & Johns, O. P. (1997). Effects of visual perspective and narcissism on self-perception: Is seeing believing? *Psychological Science, 8*(1), 37–42. doi:10.1111/j.1467-9280.1997.tb00541.x

Ryan, T., & Xenos, S. (2011). Who uses Facebook? An investigation into the relationship between the Big Five, shyness, narcissism, loneliness, and Facebook usage. *Computers in Human Behavior, 27*(5), 1658–1664. doi:10.1016/j.chb.2011.02.004

Snyder, M., & Ickes, W. (1985). Personality and social behavior. In E. Aronson & G. Lindzey (Eds.), *Handbook of social psychology* (3rd ed., Vol. 2, pp. 883–947). New York: Random House.

Sorokowska, A., Oleszkiewicz, A., Frackowiak, T., Pisanski, K., Chmiel, A., & Sorokowski, P. (2016). Selfies and personality: Who posts self-portrait photographs? *Personality and Individual Differences, 90*, 119–123. doi:10.1016/j.paid.2015.10.037

Sorokowski, P., Sorokowska, A., Oleszkiewicz, A., Frackowiak, T., Huk, A., & Pisanski, K. (2015). Selfie posting behaviors are associated with narcissism among men. *Personality and Individual Differences*, *85*, 123–127. doi:10.1016/j.paid.2015.05.004

South, S. C., Eaton, N. R., & Krueger, R. F. (2011). Narcissism in official psychiatric classification systems. In W. K. Campbell & J. D. Miller (Eds.), *The handbook of narcissism and narcissistic personality disorder* (pp. 22–30). Hoboken, NJ: John Wiley and Sons.

Sung, Y., Lee, J. A., Kim, E., & Choi, S. M. (2016). Why we post selfies: Understanding motivations for posting pictures of oneself. *Personality and Individual Differences*, *97*, 260–265. doi:10.1016/j.paid.2016.03.032

Swift, T. (2014, July 7). For Taylor Swift, the future of music is a love story. *The Wall Street Journal*. Retrieved from http://www.wjs.com

Tamborski, M., & Brown, R. P. (2011). The measurement of trait narcissism in social-personality research. In W. K. Campbell & J. D. Miller (Eds.), *The handbook of narcissism and narcissistic personality disorder* (pp. 133–140). Hoboken, NJ: John Wiley and Sons. doi:10.1002/9781118093108.ch11

Trzesniewski, K. H., Donnellan, M. B., & Robins, R. W. (2008). Is Generation Me really more narcissistic than previous generations? *Journal of Personality*, *76*(4), 903–918. doi:10.1111/j.1467-6494.2008.00508.x

Twenge, J. M. (2011). Narcissism and culture. In W. K. Campbell & J. D. Miller (Eds.), *The handbook of narcissism and narcissistic personality disorder* (pp. 202–209). Hoboken, NJ: John Wiley and Sons.

Twenge, J. M. (2013). Social media is a narcissism enabler. Retrieved from: http://www.nytimes.com/roomfordebate/2013/09/23/facebook-and-narcissism/social-media-is-a-narcissism-enabler

Twenge, J. M., & Campbell, W. K. (2009). *The Narcissism Epidemic: Living in the Age of Entitlement*. New York: Free Press.

Twenge, J. M., Campbell, W. K., & Gentile, B. (2012). Generational increases in agentic self-evaluations among American college students. *Self and Identity*, *11*(4), 409–427. doi:10.1080/15298868.2011.576820

Twenge, J. M., & Foster, J. D. (2010). Birth cohort increases in narcissistic personality traits among American college students, 19822009. *Social Psychological & Personality Science*, *1*(1), 99–106. doi:10.1177/1948550609355719

Twenge, J. M., Konrath, S., Foster, J. D., Campbell, W. K., & Bushman, B. J. (2008). Egos inflating over time: A cross-temporal meta-analysis of the Narcissistic Personality Inventory. *Journal of Personality*, 76(4), 875–901. doi:10.1111/j.1467-6494.2008.00507.x PMID:18507710

Vazire, S., Naumann, L. P., Rentfrow, P. J., & Gosling, S. D. (2008). Portrait of a narcissist: Manifestations of narcissism in physical appearance. *Journal of Research in Personality*, 42(6), 1439–1447. doi:10.1016/j.jrp.2008.06.007

Wallace, H. M., & Baumeister, R. F. (2002). The performance of narcissists rises and falls with perceived opportunity for glory. *Journal of Personality and Social Psychology*, 82(5), 819–834. doi:10.1037/0022-3514.82.5.819 PMID:12003480

Weiser, E. B. (2015). #Me: Narcissism and its facets as predictors of selfie-posting frequency. *Personality and Individual Differences*, 86, 477–481. doi:10.1016/j.paid.2015.07.007

Wickel, T. M. (2015). Narcissism and social networking sites: The act of taking selfies. *Elon Journal of Undergraduate Education, 6*. Retrieved from http://www.inquiriesjournal.com/ articles/1138/2/narcissism-and-social-networking-sites-the-act-of-taking-selfies

Wright, A. G. C., Lukowitsky, M. R., Pincus, A. L., & Conroy, D. E. (2010). The higher order factor structure and gender invariance of the Pathological Narcissism Inventory. *Assessment*, 17(4), 467–483. doi:10.1177/1073191110373227 PMID:20634422

KEY TERMS AND DEFINITIONS

Dynamic Self-Regulatory Processing Model of Narcissism: A model of narcissistic self-regulation proposed by Morf and Rhodewalt (2001); the model contends that narcissistic individuals actively and perpetually engage in both intrapsychic and interpersonal efforts intended to bolster and maintain a grandiose, but fragile, view of self.

Entitlement/Exploitativeness (E/E): One of the three facets of narcissism assessed by the 40-item Narcissistic Personality Inventory, as identified by Ackerman et al. (2011); this facet is regarded as the most maladaptive of the three and reflects the possession of an unmerited sense of entitlement and special treatment, as well as a tendency to exploit others in the service of attaining narcissistic objects.

Grandiose Exhibitionism (GE): One of the three facets of narcissism assessed by the 40-item Narcissistic Personality Inventory (NPI-40), as identified by Ackerman et al. (2011); primarily reflects self-absorption, vanity, a sense of superiority over others, and a tendency to engage in exhibitionist displays to gain attention.

Grandiose Narcissism: One of two general and broad variants of narcissism; characterized by outward displays of grandiosity, entitlement, and attention-seeking.

Leadership/Authority (L/A): One of the three facets of narcissism assessed by the 40-item Narcissistic Personality Inventory, as identified by Ackerman et al. (2011); considered to be adaptive in some contexts, this dimension primarily reflects self-perceptions of leadership, dominance, and social potency.

Narcissism: A personality trait characterized by grandiosity, a sense of superiority over others and attendant feelings of entitlement, a constant need for attention and admiration, and a lack of empathy toward and willing to exploit others.

Narcissistic Personality Inventory (NPI): A self-report measure of trait narcissism, frequently used in narcissism research to quantify individual differences in this trait; although variants of the NPI exist, the 40-item forced-choice version (NPI-40) is the one used most frequently in social-personality psychology.

Vulnerable Narcissism: One of two general and broad variants of narcissism; characterized by the tendency to be inhibited and reserved interpersonally while harboring a fragile and sensitive grandiosity.

ENDNOTES

[1] NPD is the psychiatric variant of narcissism; it is observed in clinical settings and among clinical populations and is associated with significant impairments in work, relationships, and one's general ability to function normally. NPD is an extreme, pathological form of narcissism, one regarded as a psychiatric disorder that is diagnosed by mental health professionals. This variant of narcissism is not considered here; instead, trait narcissism is the focus.

[2] Researchers exploring trait narcissism have occasionally used other measures of this construct. These measures include a nine-item subscale devoted to narcissism from the Short Dark Triad (SD3; Jones & Paulhus, 2014), a 27-item measure of the "Dark Triad" (i.e., a triad of socially toxic personality traits: narcissism, Machiavellianism, and psychopathy; Paulhus & Williams, 2002); and a four-item subscale devoted to narcissism from the Dirty Dozen (Jonason & Webster, 2010), a 12-item measure of the Dark Triad traits. Items for both scales were derived from the NPI-40; however, instead of the forced choice format, Likert-style rating scales are used in both.

3 The Polish adaptation of the NPI-40 demonstrates a different factor structure than does the English version. Specifically, the Polish version consists of four components: Self-sufficiency, Vanity, Admiration Demand, and Leadership. The first two components are similar to those identified by Raskin and Terry (1988). In the Polish adaptation, Admiration Demand reflects a need to be noticed, admired, and complimented by others, whereas Leadership reflects a conviction that one has influence over others (Sorokowski et al., 2015).

Chapter 2
Spontaneous Taking and Posting Selfie:
Reclaiming the Lost Trust

Ikbal Maulana
Indonesian Institute of Sciences, Indonesia

ABSTRACT

On social media where people are struggling to attract others' attentions, posting selfies is the most convenient way to communicate their individuality. They do not need anyone's assistance to take their picture, and they can take it anytime and post it immediately on social media. Bodily appearance has always been an influence in how an individual is perceived and treated by her social environment. Fortunately, on social media this appearance has transformed into information, which, therefore, can be manipulated by computers or even smartphones. With the help of digital image processing software fulfilling the beauty standard of any virtual community is no longer a concern. However, this chapter argues that this technology destroys the realism of a photograph, makes its reliability almost like that of a statement, which depends on its human source not on itself. This creates the problem of trust, and many users seek to overcome it by spontaneous taking and posting a casual and inelegant selfie.

INTRODUCTION

Selfie has become a global phenomenon. Many people are taking selfies not only to record their special moments, but, most of the time, they are taking selfies as part of their daily communications. Taking a selfie is different from other ways

DOI: 10.4018/978-1-5225-3373-3.ch002

of taking photographs, not only because the taker and subject of the portrait have become one, but also it has developed to be a real-time self-presentation, because most selfies are instantly uploaded on social media. Spontaneity of taking and uploading selfies is the most important feature of this activity in the era where digital images are manipulable. Selfies, as will be shown later in this chapter, have become both an expression of individuality and an effort to gain trust. Therefore, selfies play important role in self-presentation in the era of information overload and manipulable information.

Selfies are manifestation of both our individual and social beings, which are not separated from each other. We are unique individuals, and, however, we want our individuality to be accepted by others. As individuals, we need to develop our self-esteem, which nevertheless often requires other people's confirmation that we deserve to be satisfied or even proud with our self. Most of the time our behaviors and actions reveal both our individuality and sociality, that we are unique individuals and, at the same time, sharing the same particular traits as other members of the community. Our dependence on society does not necessarily lead to the removal of our individuality. "All relationships, then, involve the problem of establishing closeness and distance, to maintain the healthy interdependencies of social life without a person feeling their identity becoming swamped and submerged" (Burkitt, 2008, p. 75). The interdependence between individuals and society is not fixed. The development of knowledge, institutions, and technologies affects the power relationship between individuals and society to the extent to which individuals must comply to the norms of society (Foucault, 1978).

Technology may make individuals less dependent on their community to satisfy their physical needs, however, their emotional needs – such as the needs to be accepted, appreciate, and loved – cannot be fulfilled by none other than their fellow human beings. The development of social media as well as selfie will only strengthen the proof of our dependence on others, even though, on social media, the others have become more impersonal and informational. Social media "has led to an enormous proliferation of relationships" (Gergen, 1991, p. 49) that enable us to have contacts with a great number of people, so great that we do not know most of them in the way we may know friends or colleagues in actual life.

Being social on social media is very different from being social in actual life. In the latter, our body makes us strongly embedded in our society that we cannot instantly appear or disappear from other people or connect and disconnect from them, and we can neither say or do anything without taking responsibility of its consequences. In actual interactions, we are and will always be under the gazes of the members of our social networks, which in turn are pressuring us to be more responsible or more responsible to the norms of our community. Accordingly, fitting into the actual social network, which makes us accepted or regarded as friends,

requires a lot of effort and time to develop relationship which is based on trust and honesty. There is a limit to the maximum number of friends that we can have (Dunbar, 1996), over which the increasing number of friends will only lead to the weakening of the social bond between us.

On social media, we can connect with any number of users, unconstrained by time and space, because some of our social acts are taken over by computer software. When we try to make friend with someone, we do not need to be at the same time and place with that person as making friend in actual life. We can send a request to be a friend to someone, then let the technology keep forwarding the request to that person until it is accepted or rejected. Social media, such as Twitter, even allows us to follow any user without asking for permission. The easiness of making contacts, with friends or strangers, using real or fake identity, allows us to make unmanageable number of virtual friends. Therefore, in a large social network, especially when the communication is carried out in textual exchanges, most of us can easily be reduced to be just a tiny package of information, which does not attract anyone's attention.

Recent development of technology has enabled social media users to easily exchange pictures and videos in addition to text. Visual self-presentation is the most convenient way of communicating our individuality, even though only take the form of external appearance. Selfie can be regarded as the peak of the development of visual communication. Certainly, there are limitations of selfie. We can only take our own picture from the front and within a short distance, which causes that not much of the background can be taken by the camera of our smartphone. However, we are ready to sacrifice the broad angle of the view in return for the self-dependence of taking it, for it gives us the sense of control over our own picture, or, if the picture is not satisfying, it is us who take it, and, therefore, makes us less critical toward the result. Besides that, "Feeling misrepresented by the camera is one common reason for beginning to take selfies instead of being the subject of other people's photographs" (Rettberg, 2014, p. 29). Today, the problem of the narrow angle of selfie is partly solved by the use of a smartphone with a broad angle camera or a much simpler technology, a stick that can securely hold any smartphone.

Selfie is a new phenomenon which is made possible by the convergence of a number of different technological developments, such as wireless Internet technology, digital camera, smartphone and social media. The combination of these technologies has introduced us to new ways of perceiving and interacting with the world (McLuhan, 1994), and seems to have made us different individuals taking part in different societies. People who are very quiet in real life, may become talkative on social media. People, who usually did not like to expose themselves, can actively publish selfies on social media no less than do celebrities. But, have the technologies really changed us, such as, made us more narcissistic or more networked than ever? Or, have the technologies just provided new platforms for us to manifest, what Heidegger

(1962) calls, our being-in-the-world? As humans, we always care, either consciously or unconsciously, of our being-in-the-world by indwelling in our surroundings, engaging in activities, and using instruments to achieve objectives. Accordingly, social media and smartphone with its camera are just new instruments through which we manifest our being-in-the-world.

This chapter does not intend to explore the empirical phenomena of selfie, which most of us have known and even have experienced them by our self. Rather, it seeks to interpret and explain those phenomena in order to understand the realities beneath what are obviously visible to us. To achieve this, it will explore and synthesize theories and views from various disciplines, such as philosophy, social psychology, sociology and art criticism. Since selfie is a very recent phenomenon, there is no ready to use theory or view to explain it. However, the author believes that by synthesizing those theories and views we can better understand selfie as manifestations of how individuals position themselves in their new social network. By positioning we also mean, following Heidegger, being-among-others or, more generally, being-in-the-world.

THE WILL TO BE IMPORTANT

Through social media, people can easily expand their social network beyond their actual ones, which are limited by space and time, and they can even experience a virtual socialization that is different from a real-life socialization. On social media, any user has the opportunity to express any view anytime without waiting for permission from others. With anonymous identity, any comment on social media will not have any consequence for the commentator in actual life. On social media we can present any self we desire, but whether other users will give attention to us is not guaranteed.

Connecting to many people, whom we have never met in person, will unlikely result in strong commitment and loyalty between friends, especially, if the number of friends is too high to make each of them under our close attention. It is because "there may be an upper limit on the extent to which individuals can credulously support even superficial relationships, and claims exceeding that limit ... backfire on successful impression management" (Tong, Heide, Langwell, & Walther, 2008, p. 533). In the worst case, social media might only put us into pseudo-social network, where we post too many messages and just read very few. While it is very easy to express our self, it becomes increasingly difficult to attract other users' attention, because in bodiless interactions we can easily ignore others as well as be ignored by them.

Unfortunately, we cannot ignore being ignored. We get online because we expect other users to give attention to anything we post. We are social individuals. One important aim of being social, either on social media or in actual life, is to satisfy our personal needs which we cannot satisfy in isolation from others. Not only do we have physical needs that can only be satisfied through cooperation with our fellow human beings, but also have psychological needs of support and confirmation from other people. Our self-esteem, having "confident conviction of being lovable" (Storr, 1968, p. 77), can only develop if we get confirmation from others that we are lovable.

Due to our different self-presentation, people respond to each of us differently, which, in turn, may cause us to develop different levels of self-esteem. For people present their self through different dimensions or domains each of which may attract different responses, therefore, even for people who have the same level of global trait self-esteem, they "may have different levels of self-esteem with respect to particular dimensions or domains, such as their intellect, physical appearance, social skill, and athletic ability" (MacDonald & Leary, 2012, p. 354). To satisfy the need for self-esteem, individuals have to adapt their self-presentation to the different demands of each social surrounding. This is why "It is interesting to realize how much of human personality, social behaviour, social structure, and psychopathology are centred on this need to maintain self-esteem, even though the central importance of narcissism is often not immediately apparent" (Behrendt, 2015, p. 1).

In social life, how we are accepted or how others respond to us, which affects what we can gain from social interaction, is in large part determined by the impression we create within our social surrounding. That is why, we seek to control our interlocutors' impression of our self through deliberate self-presentation. "Whether the objective is to gain friends, increase psychological and material well-being, or secure a preferred public identity, self-presentation can be used to accomplish interpersonal goals that can be realized only by influencing the responses of others to oneself" (Schlenker, 2012, p. 543). In face-to-face interaction, our body plays an important role in self-presentation and communication, because it transmits personal and emotional information through our gestures, facial expression and voice tone that affect the formation of interpersonal impression and the perception of communication context (Walther, 1996). The information transmitted by our body is rich, that it cannot be easily conveyed in words, but the problem is that it is not fully within our control and intention. We want to look confident, but the tone of our voice as well as body language may not show the confidence we want to show.

There are two key features of interactions on social media which differentiate them from the interactions in actual world and give us more opportunities to manage our self-presentations, namely reduced communication cues and potentially asynchronous communication, that is a communication that does not happen in real time (Walther, 1996). The reduced communication cues are caused by the disappearance of body

and physical environment where our body locates from the interactions. Body and physical context, which limit and shape what we communicate, are gone, and therefore on social media "the information one gives about oneself is more selective, malleable, and subject to self-censorship" (1996, p. 20). Because the involvement of the body in social interaction determines the development of our self-presentation and self-identity (Cooley, 1902; Goffman, 1959), the disappearance of our body will necessarily change our self in virtual world. Because on social media our body, just as anything else, has transformed into information, which can be concealed, disclosed, modified or even faked, in terms of visual appearance we can be anyone on social media. In addition to reduced communication cues, the asynchronous nature of social media interactions gives us more time to construct positive and deliberate self-presentation (Gibbs, Ellison, & Heino, 2006). This opportunity is even strengthened by the available technologies that can help us from searching to manipulating information to support our self-presentation.

However, the malleability of our constructed information does not necessarily result into the kind of impression we expect. Communicating through social media is easy, it does not require sophisticated technical and writing skill. On social media we can write anything, and there is also a lot of softwares to manipulate pictures, but producing interesting and attractive information requires special skill that not everyone possesses. Especially in textual information exchanges, we can easily get lost in the sea of messages, because our textual messages are indifferent from those of other users.

Under the above condition, selfie gives us a little help expressing our individuality, because our self can be easily identified in terms of our appearance. However, by posting selfie we do not want to be identified just as unique individuals, but, more importantly, we want "to maintain self-esteem, that is, to be loved and to be lovable, to be approved and to be approvable, and to be generally accepted by and thus to feel connected to one's social surround" (Behrendt, 2015, p. 1). While technology can help us to connect with other people, our self-esteem cannot be just satisfied by the technology alone. Regardless whatever communication channel we use, it must be real people, not an artificial intelligence or any kind of software, who give us attention, confirm our opinions, and accept our self.

Together social media and digital image technologies have seduced us to unveil our narcissistic tendencies. These technologies have led us to live in a world of hyper self-expression. We live in a constant state of being ready to report our life or to take picture of our self. The current situation is similar to that of Ancient Greece, where writing prevailed, and "Taking care of oneself became linked to constant writing activity. The self is something to write about, a theme or object (subject) of writing activity" (Foucault, 1988, p. 27). Today, it is not only writing, selfie is also prevailing and regarded as a form of one's taking care of self.

Posting selfie or any information is, however, not intended to be one-way information broadcasting, but motivated by a deep desire for validation from our virtual friends. That is why, according to Ford's *Looking Further with Ford: 2014 Trends*, that "A Facebook "like" or two makes us feel good. A dozen "likes" makes us feel great, creating a quiet but fierce need to revisit the pieces of our narrative, to tweak, color and edit them to our liking—and to the liking of others. But as we smooth out the rough edges of our public self, do we gloss over our real character?" (2014, p. 20). This report also shows that 62% of adults globally agree that "When people react positively to the things I share on social media, I feel better about myself" (2014, p. 21).

On social media we want to be recognized and feel liked by our virtual friends, whether known or unknown to us. Selfie is a manifestation of our will to be accepted as important individuals. That our face takes the largest part of the area of the selfie indicates that it is the statement that we are the central figure, the main character, in our virtual life. The image of friends or, even, of important figures in our selfie is just additional information to emphasize our desire to be important. And taking the picture with the background of beautiful scenery, or popular tourist destination, is to show our capability to go on vacation to that destination. However, selfie is more than just personal expression, it is a social expression that requires confirmation from others. A survey of teenage girls and young women for the soap brand Dove shows: "…that as teenage girls get older they increasingly measure their self-worth based on the number of "likes" they receive for photographs posted on social media sites such as Facebook…" (Bingham, 2015).

By engaging in hyper self-expression, rather than increasing our self-esteem, we may as well possess "transient, overblown, and fragile self-images that are dependent on social validation and social context or situation" (Rhodewalt, 2012, p. 573). In this case, our self-identity is fragile because it relies on and is preserved by the validation of a social network most of whose members are strangers to us. "The only way you can count [how interesting you are] is by how many people like it – how many have retweeted or favourite it…" (Sanghani, 2014). The excessive desire to be recognized and appreciated by others on social media will likely frustrate our self when others do not respond to us as we have expected.

Everybody Is a Celebrity

Our obsession with selfies might be the continuation of our obsession with celebrities. Since entertainment was a significant industry, we have been exposed to celebrities through various channels of mass communication. Celebrities have been present in front of us anywhere long before the invention of social media. In the living room, they dominate our television screen. On the street, they stared at us from various sizes

of billboards. On public transports or in magazines and newspapers, celebrities seek to communicate with us, either telling their own private life or raising our awareness about climate changes or most often selling products of industries.

Even though the communication between celebrities and public is one way, they also expect our mass responses, either by going to their movies, watching their television programs, listening to their music, or buying the products they endorse. Therefore, "we need to see celebrity culture as constituted not only by the celebrity bodies and the media productions of the bodies but also through the consumption by audiences that in turn fuels further media production and circulation" (Nayar, 2009, p. 2). The more popular a celebrity is, the more her or his audiences consume whatever information comes from her or him, which in turn strengthens her or his popularity. The audiences worship celebrities as object of desires, and therefore many people try to emulate them, behave like them, to look like them, and believe that they will be like their admired celebrities by consuming the products endorsed by them.

Prior to the era of social media, we emulated celebrities only in terms of imitating their visual appearances. On social media, we cannot just pretend, but also act like popular persons, who can communicate to the public directly, who express our opinion about anything, and even reveal our private life. Some people have been able to develop themselves to be, what Senft (2008, 2013) calls, micro-celebrity. Social media allows people to become both micro-celebrities and audiences of the other micro-celebrities at the same time.

To be a celebrity is to be a public figure, to make our private lives exposed to general public. "Celebrity culture consists of everything that is publicly available about an individual, such as images, writing, autobiography, interviews and movies" (Nayar, 2009, p. 26). On social media, if we do really want, it is very easy to make any information about us publicly available. We can immediately publish what we experience as it happens. Since we, at the same time, interact with others and use social media as part of our social interaction, social media has become more than just an announcement board. It has become the stage where we live our life. Therefore, a social media user "manages her online self with the sort of care and consistency normally exhibited by those who have historically believed themselves to be their own product: artists and entrepreneurs. Yet, at the same time that people are beginning to perceive a coherent online presence as a good and useful thing, they are also learning that negative publicity can be quite dangerous to one's employment, relationships, and self-image" (Senft, 2013, p. 347).

Our admiration of celebrities implies that we also regard them as a role model to fashion and physical beauty which makes them the object of collective desire (Nayar, 2009). They have desirable bodies and dress and look impressively. Our obsession to look like them makes us vulnerable to be exploited by the industries of beauty products that use celebrities to promote their products. However, in actual life it is

very hard and expensive to improve our physical appearance to look like celebrities. Ultimately, people may find out that the beauty products promoted by celebrities gives them only an illusion of real beauty, "like most other human predilections, the quest for beauty can become an endless and fruitless pursuit that leads to discontent rather than satisfaction" (Cashmore, 2006, p. 99)

The emergence of social media and the already existing digital image technologies allow us to have virtual visual appearance which is much less expensive. Digital photographs are just like any other digital information, namely, it is readily manipulable. Digital image processing technologies keep developing, giving us the opportunity to self-present an artificial beauty on social media with a minimum technical skill.

People's obsession with physical beauty is not only due to their admiration with celebrities, even though they may refer to celebrities as the beauty standard. Bodily appearance is often the determining factor of the extent to which individuals are accepted in society. From media or informal information, it is suggested that prejudice and discrimination based on bodily appearance is the last bastion of "socially acceptable" bias (Berry, 2007). Many people have experienced the bias either blatantly or subtly, but, we are mostly not told that we are rejected or less accepted due to this bias. This bias, which causes social inequality, is notable, even though not the only determinant, in a number of social settings, such as work, social group, and marriage. The combination of this bias and celebrity culture conditions us to feel dissatisfied with our bodily looks. While beauty industries seduce us to pursue beauty standards of the celebrities they hire to promote their products (Cashmore, 2006), our social surrounding and through their indirect and inexplicit feedbacks seem to tell us that we do not look good enough to them. This causes enormous pressure on us to change our bodily appearance, which, in turn, further boosts our consumption of beauty products, or make us go even further with cosmetic surgery. While other people may go through other body-modification practices, such as bodybuilding, tattooing, and piercing, in order to challenge the widely held standard of a good bodily outlook (Grogan, 2008).

The pursuit to achieve the beauty standard of celebrities will only give most of us discontent due to our inability to achieve it. Therefore, we will be in a constant tension between the obsession to improve our bodily appearance and the awareness that such obsession will only disappoint us, unless we can learn to accept our imperfect bodily appearance. "The gradual recognition of the realistic imperfections and limitations of the self, i.e., the gradual diminution of the domain and power of the grandiose fantasy, is in general a precondition for mental health in the narcissistic sector of the personality" (Kohut, 1971, p. 108). Such tension is not fixed, but strongly affected by the struggle between psychological maturity and social pressure as well as the seduction of new and affordable technologies. Cosmetic surgery, which until 1980s

had been a luxury reserved for stars and rich women, is now available for wider public. "The surgery is still expensive, but many more people are prepared to pay whatever it costs to affect the modification. The reason for this is simultaneously simple and complex. People are increasingly unhappy, frustrated, or in some way discontented with their own bodies…" (Cashmore, 2006, p. 100). What makes us vulnerable is that beauty industries keep exploiting our insecurity regarding our looks to make us constantly depend on their products and services.

Now we live most of our life on social media, where the self is released from the body and, hence, from its physical constraints. The body does not take part in self-presentation, but it is represented by information constituted by bits of codes, which are digitally manipulable. Even though social media increasingly takes more parts of social life, we still engage in embodied interactions with some people, and we still experience and understand the world through our bodily encounters with it (Merleau-Ponty, 2005). Therefore, bodily appearance is still important to social media users, even though the social pressure on how we present our body has become minimum in virtual interactions, but still we cannot totally remove the senses of its importance. At least we still consider that the bodily appearance is the most apparent identity, which is now can easily be shown by a photograph, which, in turn, become a proxy through which we express our self.

The presentation of body has become easier on social media, we do not need to use cosmetic products, let alone go under cosmetic surgery that is not affordable to many people. In the virtual world, we can easily access much cheaper digital cosmetics and digital cosmetic surgery. Not just the general public who needs to retouch their photographs, even the photographs of celebrities, such as Demi Moore and Kate Winslet, for cover of magazines, have been further enhanced by deliberate retouching. Through digital retouching of her photograph, Kate Winslet got her legs lengthened, her stomach flattened, and her widely known womanly curves concealed (Sheehan, 2014). Winslet objected publicly to this operation that was performed without her consent. Then was the beginning of a new era of photography which initially made people, especially celebrities who were supposed to be physically perfect, feel uncomfortable. But, today the retouching of celebrity photographs has become a common practice. Therefore, there is no reason for the fans of celebrities to feel ashamed when they get their photographs retouched.

SUBJECTIVITY AND PORTRAITURE

To better understand the phenomenon of selfie, we may need to understand the technological development of portraiture, which has made the creation of portraits cheaper and easier, but, more importantly, has affected the subjectivity and realism

of portraits. A portrait is not a functional artifact, rather it represents someone, which therefore can be very valuable to people who have special relationship the person in the portrait. A portrait can preserve memory of our loved one, but a large portrait painting put on the wall of a living room or an office is an act of self-presentation if the person being painted is the current owner of the house or office, or else a show of respect or a pronouncement of special relationship to the person being painted. Portraits were even much more valuable in the era when they could only be created by painting, because only royalty, aristocrats and other wealthy people could commission skillful artists to paint their portraits.

The Subjectivity of Painting Portraiture

Technology has always played important roles in the creation of portraits even before the invention of camera. Rembrandt would never be able to create breathtaking paintings without the advance of chemical technology which gave him the necessary painting oils. Indeed, the role of technology in painting is only to provide colors, tools to put the color, and medium of painting, such as canvas material, whereas the accuracy of imitating the visual appearance of an object depends on the skill of the artist. Even a skillful artist may not only render the subject as what the subject looks like, but also has the interest to leave the mark of his aesthetic style, which is different from those of other artists. Therefore, the resemblance of a painting and a subject being painted is not guaranteed, and even "...if a painting represents a subject, it does not follow that the subject exists nor, if it does exist, that the painting represents the subject as it is..." (Scruton, 1981, p. 579).

The relationship between a painting and a subject is intentional due to the representational act of an artist. The artist may have the skill of imitating the accurate appearance of the subject as he is in the actual world, but also has the aesthetic style and preference to deviate from the actual appearance. Paintings are the creation of human beings who do not work mechanically, therefore "No matter how skillful the painter, his work was always in fee to an inescapable subjectivity. The fact that a human hand intervened cast a shadow of doubt over the image..." (Bazin, 2005, p. 12).

The aesthetic interest of the artist is not necessarily against the interest of the sitter who has the interest to make the portrait represent her or his personality, individuality, or character, rather than merely portray the sitter's visual appearances. "The sitter should appear to be autonomous and a distinct person with unique thoughts and emotions. As a person, the sitter is embodied, but the self is there "in" the embodiment, and the artist must "realize", "concretize" or "objectify" it in the image" (Freeland, 2007, p. 98). Either the finished painting would be under, within or beyond the expectation of the sitter, it depends on the skills and aesthetic vision of the artist and the aesthetic taste of the sitter.

Even though a portrait painting may reveal the subject's personality or essence in any or some of the following four ways: "by being accurate likenesses; testimonies of presence; evocations of personality; or presentations of a subject's uniqueness" (Freeland, 2007, p. 100), a painting is still a painting which represents the subject (Walton, 1984). The artist with his skill, interest and intention becomes the distorting or deviating intermediary between the subject and the portrait. A portrait painting is like an oral statement about something, to believe that the statement represents something real we must rely on our trust in that person who makes the statement, unless we can confirm the accuracy of the statement or, in this case, the painting directly.

The Manufacturing of Images

In the 19th century, people found a new way to record the image of an object, not relying on the skill of an artist, but on technology that captures the light reflected by an object on a light-sensitive material. Just like any other technology, it has been continuously developed to increase the quality as well as to reduce the cost of image recording and therefore made it available to an increasingly growing number of people. And, now, anyone can take picture of oneself, and take the picture anytime one likes. If you have a digital camera, as a stand-alone or integrated into a smartphone, the cost of taking a photograph is zero.

Photographs are perceived and interpreted differently from paintings "...precisely because photographs and paintings come into being in different ways..." (Snyder & Allen, 1975, p. 143). Photographs are claimed to represent what they show objectively. "Photographs are transparent. We see the world through them..." (Walton, 1984, p. 251). Photographers, are considered, to not play any role in the creation of a picture, because it is the nature working according to natural laws which does the job. It is perceived that what the photographers do is just to turn on and direct the camera to the object being taken, even though it does not eliminate the opportunity for the photographers to give aesthetic touch to the photograph. "Many prominent writers have argued that photographs possess unusual veracity. Photography is said to have greater realism than painting and to be more direct, operating mechanically through light, chemistry, and machinery, so that depiction occurs without (or in spite of) the intervention of artistic intentions" (Freeland, 2007, p. 103). Before the era of digital image processing, a photograph was always a photograph of something. The accuracy of what appears on a photograph is not due to the pure skill and intentional act of photographers, but largely due to the causal work of nature, namely light. Therefore, "...if a photograph is a photograph of a subject, it follows that the subject exists, and if x is a photograph of a man, there is a particular man of whom x is the

photograph. It also follows, though for different reasons, that the subject is, roughly, as it appears in the photograph…" (Scruton, 1981, p. 579).

Seeing objects on photographs is like seeing them through eyeglasses, microscopes or telescopes. The difference is that, in the latter case, light from the object reaches our eyes in real time, while in the former case the light is captured on photographic film in traditional cameras or captured by electronic sensors in digital camera, which enable us to look at the image of the objects later. Therefore, photographs can be claimed that they "…are not *hand-made*; they are manufactured. And what is manufactured is an image of the world…" (Cavell, 1979, p. 20). For they are not hand-made, it is regarded that human beings are not playing any role in the creation of photographs, rather they are just pressing the button of the camera and letting the machine take advantage of the laws of nature. "Photography overcame subjectivity in a way undreamed of by painting, a way that could not satisfy painting, one which does not so much defeat the act of painting as escape it altogether: by *automatism*, by removing the human agent from the task of reproduction" (Cavell, 1979, p. 23). The realism of photographs is achieved because it is the result of the mechanical reproduction of reality, "…a recreation of the world in its own image, an image unburdened by the freedom of interpretation of the artist or the irreversibility of time." (Bazin, 2005, p. 21). On the one hand this mechanical reproduction of reality minimizes our creativity, on the other hand, it makes the photographs reliable and admissible as evidence in court.

Indeed, we cannot refute that photographers do play any role in the creation of photographs. There are well-known photographers who can create the photographs that not everyone can produce. Their distinctive artistic visions distinguish their works from those of amateurs. Their artistic works are resulted from the creativity of combining some or all of the following activities: selecting objects, selecting angle or perspective from which the object will be taken, selecting what to focus on, and playing and determining how much light will be captured by the camera. So, just like other visual arts, photography allows a subjective point of view of photographers to affect what and how people see the objects of photography. However, the artistic vision will not destroy the realism of traditional photography in the sense that the image captured in a photograph is the image of real object which must have been in front of the camera when the shutter was opened (Mirzoeff, 1999).

The Return of Subjectivity in Digital Image Processing

The realism that had been the privilege of photography for about a century and a half has been undone in the 1980s by the technology of digital image processing. Not only can people manipulate existing photographs digitally, with certain level

of technical skills and the help of some software they can also create photographs of objects or scenery that do not exist in real world (Mirzoeff, 1999). A photograph in digital format, either produced by digital camera or scanned from an existing photograph, is manipulable, that it can be altered or mixed with other photographs or pictures. Digital image processing software are now available not only for computers but also for smartphones, which we can use anywhere after taking selfies.

Calling digital image processing as digital cosmetic surgery is not an exaggerated metaphor of actual surgery. Even the modification of our virtual body seems to be limited only by our imagination. By using digital image processing software we can easily erase blemishes, change hair or skin colors, reshape body and even conduct body transplant in which we put someone face on another person's body, just like the infamous Oprah's "body transplant", the cover of TV Guide in August 1989 featured the head of Oprah superimposed on the photographic body of the model-actress Ann-Margaret (Sheehan, 2011). While actual cosmetic surgery does really change people's bodies, and it is promoted by many media as "a legitimate way to reduce body image concerns," digital cosmetic surgery may give us two following problems.

Firstly, digital cosmetic surgery can be regarded as misinformation, when the discrepancy between your photographic representation and your actual bodily appearance is too obvious. Secondly, if your bodily appearance can be manipulated, then anything on your photograph can be manipulated, and, hence, be doubted. Using digital image processing technology, people cannot only modify existing photographs, but also create non-existing objects and scenery where the use of this technology has almost an unlimited capacity for deception. Today many movies have been produced partially or fully using computer graphic imagery (CGI) some of which cannot be distinguished from movies with real objects and scenery. Digital improvement of our virtual appearance has a drawback which offsets its benefit and, even worst, it may damage our reputation as reliable source of information.

Digital image processing returns the subjectivity, which is missing in film photography, to users, including average users, not just skillful artists. The technology has expanded the space for us to exercise our creativity with ease. The space is even larger than the space given by painting. However, this development also causes a major drawback, it has destroyed the realism of photography. Photography can no longer be trusted as before. People who have high skill can manipulate photograph and make it still look like the images of real objects.

Realism is lost in digital photography. The unreliability of digital photographs is even worse than that of paintings because the former is more likely to deceive us than the latter. The development of digital image processing has made it increasingly difficult or even impossible for us to be certain if a photograph is real or not. Therefore, on the Internet or anywhere, any photograph can be doubted because it may have

been processed digitally. Today, to trust a photograph, we need a trusted person to confirm its reliability. The loss of realism, and so its reliability, is the cost we have to pay for the infinite manipulability of digital images.

In this information age, where our social fabric relies on information exchanges through digital infrastructure, the lost of realism of photographs is a major setback and very unfortunate. If photographs have the same reliability as texts, then truth has a fragile existence on social media. The reliability of photographs and texts will depend on the ones who post them on social media. Photographs, hence, cease to support the reliability of people, on the contrary, they need the support of the people to be claimed as true. Selfie, as I will argue later, is a way to restore the reliability of digital photographs. By posting our picture immediately on social media, we expect this spontaneity to be seen that we do not have time to manipulate our picture. And also by posting it on social media we also want that it will be confirmed by other people whose picture also taken in the photograph, or also being in the same location so that they can confirm that photograph is real.

What we have discussed in this section is summarized in Table 1. The development of technology has changed the roles of human in portrait creation as well as changed the realism of portraits.

RECLAIMING THE LOST TRUST

As social individuals, first of all we need to be part of a community, and, after that, our individuality will push us to struggle to be accepted the way we are. Even though our identity is not fixed, but can change and develop, we are well aware and feel uncomfortable when we have to pretend to be someone else, which is not our self. We are often pressured to consider the intensity of social demand, to determine whether to sacrifice our feeling and conceal our individuality, to challenge it, or to negotiate with it. If we experience a particular social demand for a long time, we may incorporate it in our own norms and values, and so regard it no longer as a demand. In many circumstances, we cannot avoid but to act in accord with social expectation (Goffman, 1959), which leads us to develop an image of our self as an object of society's approval. However, always giving in to the demand of our social environment is tiring, therefore we need also to develop circle of close friends, in which we can "act spontaneously and genuinely, since we expect with confidence others' positive reactions towards us. In other words, we have healthy self-esteem or self-confidence, confidence, that is, in our ability to elicit positive social reactions towards our self by way of our spontaneous affectionate, playful, or assertive expressions" (Behrendt, 2015, p. 212).

Table 1. The human's roles in portrait creation

	Taker	Sitter	Realism
Painting	Creating painting based on the appearance of the sitter and the impression that the painting is supposed to create, and the taker's aesthetic style.	Can make any suggestion to the taker about how she want to be seen on the painting.	No. It is a very subjective art which is dependent on the skill and intention of the taker. Visual appearance of the sitter is just one of the factors influencing the painting.
Photography	Directing the camera to the sitter, managing the light and shadow and how much they will be captured by the camera.	Must pose and dress in the way she wants to be seen on the photograph. Camera reproduces exactly what it sees.	Yes. The camera carries out the mechanical production of images.
Digital Image Processing	Anyone having the necessary skills and technologies can manipulate a photograph in the digital format in order to alter it or to mix it with other photographs or pictures.		No. However, a skillful artist can preserve the look of the manipulated picture just like a photograph taken by a camera. This development makes even unretouched photographs become doubtful.
Selfie	The taker and the sitter are one and the same. Taking selfie is like immortalizing what the taker sees in the mirror.		Spontaneous taking and posting selfie on social media in order to get the confirmation from others may reclaim the lost trust of the people on photographs.

In any social interaction, we use different self-presentation strategies in accordance with different types of audiences (Goffman, 1959). We generally tend to be more self-enhancing with strangers and more modest among friends (Tice, Butler, Muraven, & Stillwell, 1995). In face-to-face interaction with strangers, self-enhancement is likely to be our automatic style to impress others who have no previous knowledge of us. And among close friends we not only feel secure to show our modesty, but also see self-enhancement inappropriate. However, on social media, what we communicate with close friends is also visible to virtual friends whom we do not know personally, but without getting the feeling as when you are being watched in actual life. Moreover, we are consciously aware that being on social media implies that we put our self under public eye, with the exceptional advantage of being able to control our own information. Being watched virtually or stalked on social media is not considered a threat, but even wanted, because it indicates our attractiveness.

The risk of being transparent to our virtual network can be minimized because social media allows us to create our own community having only selected friends and blocking others whom we do not like to join. In practice, we may not always have such privilege, especially when the virtual community is the extension of

our actual community. As social individuals, we have a deep desire to be accepted by others, and, even more, to be accepted the way we are. Therefore, people also maintain small circle of close friends, where they do not need to pretend to be other than they truly are. Goffman (1959), who uses the metaphor of dramaturgy to explain social interaction and behavior, calls this circle as backstage, because we are much less demanded to follow the social script shaped by cultural norms as when we are on the front stage. Our social life is like a theatrical production as we need to perform on the front stage before the audiences whom we may or may not know, and the best performance is achieved if we can perfectly follow the script, which is expected by the audiences. However, performing on the front stage can be exhausting physically as well as emotionally because we have to present our self in accord with another person's demand. We need to take a rest in the back stage, such us our home, family or close friends. And in the back stage, we can rehearse and practice to prepare for the next performance on the front stage.

In the back stage, we are more relaxed and comfortable. The more familiar our surrounding, the less we hide parts of our self. Among family or close friends, we do not need to hide our weaknesses, and we can put aside our roles and status while, at the same time, we can show our mutual recognition and understanding regardless our differences of achievements in life. In this situation emphasis is given "on personal honesty, openness and lack of pretentiousness, and people aspire to a social performance aimed at mutual authoring rather than assertion of social position" (Burkitt, 2008, p. 72). Even on the front stage, where we are demanded to follow social norms more strictly, we are not expected to be dishonest by our audiences.

In the above regards, digital image processing can be more likely seen as a violation of honesty, which will make others doubt any information we post on social media. Among close friends, honesty is more important than our bodily appearance. Digital manipulation of a photograph, what was initially considered as an improvement, is later potentially suspected as a breach of trust. Nevertheless, we cannot stop posting photographs on social media, because they are the easiest way to inform others about our individuality. Without digital improvement, photographs may challenge our self-worth (Northrop, 2012), but an honest photograph will likely to win the trust of friends, which is more important to us than faked virtual appearance. There is a tension within us between to be looking good and to be honest, but among close friends the emphasis will likely be given to the latter. Especially after struggling to get attention and being ignored by so large number of virtual friends despite having applied any kind of digital manipulation, we "will deal with the disappointment of having to recognize that the idealized self-object is unavailable or imperfect" (Kohut, 1971, p. 229). However, self-esteem, having confident conviction of being lovable, can be developed even with the realization that we are imperfect beings.

In the era of "...the end of photography as evidence of anything..." (Brand, Kelly, & Kinney, 1985), many people attempt to find ways to prove their honesty, to show that their information is true and their photographs are genuine. Selfie, which is taken and uploaded to social media spontaneously, can be seen as a solution to this problem. By doing it spontaneously people want to show that they do not have time to process it. As it is not enough as a proof, we want to strengthen the integrity of selfie by social validation either by people who are in the same photograph or in the same event when the selfie was taken. By uploading the selfie to social media, we expect that those people will also give comments which imply their validation to the selfie.

Our dishonesty, which is manifest in the application of digital manipulation on our photographs, is due to our desire to look good. So, if we do not need to look good, there is no reason to rely on digital image processing technology. To strengthen the demonstration of honesty on selfie, people do not pose to look good for their selfies, many of them even dare to show their exaggerated ugly expressions, such as the ever-popular duck face. It seems that the uglier your selfies are, the better they are. And the ugly selfie does not require digital image processing software. And it is a brave statement of challenging beauty standard (Bennett, 2014). By making it spontaneous and ugly, we try to return the realism to selfie and, therefore, remove the tarnish of narcissism.

CONCLUSION

We join a community not to dissolve our self. We are social individuals, our engagement with society is also the means to promote our individuality. To be comfortable with our self-identity, we need to develop our self-esteem, which requires other people's acceptance and validation. The stronger our narcissistic tendency, the more dependent we are on another person's validation. While technology may make us more independent from others to fulfill our physical needs, our emotional needs, such as having a healthy self-esteem, the need to be loved and regarded as lovable, depend on the acceptance of other people, at least on how we perceive other people accept us. Therefore, our narcissism, self-esteem, and self-development depend on how we relate and interact with one another.

How people accept us depends on how we present our self, how we manage our impression on them. And in face-to-face interactions, the body plays an important role in self-presentation. Because it is visible, it communicates a lot of information, which is not always in accord with our intention. The body also makes us embedded in our interactions or community, we cannot just appear and disappear, therefore embodied interactions pressure us more into complying with the social norms of

the community to which we belong. When there are differences between what we say and what our body communicates, our interlocutors tend to believe the latter. Our words may describe that we are successful or confident persons, but if the body communicates the opposite, people will believe our body rather than our words.

On social media, the body no longer takes part in our interactions. It appears on social media only through a representation, a photograph or video which we post and, therefore, within our control, unless it is posted by other people. It cannot interfere in our virtual conversation by itself. However, we still have the interest to show the body, even though not allow it to show itself, because the appearance of the body, especially our face, is the most easily identifiable identity, which shows our individuality. In the sea of information, the easiest way of attracting attention to our self is to use visual information, therefore posting our self-photographs is important part of personal communications on social media.

In exchanging photographs on social media, we may take two considerations into account. Firstly, we want to look good on photographs, which is natural, and because in our long experience in actual life we learn that physical appearances do influence how people judge and accept each other. Besides that, we have lived in celebrity culture long enough, we are used to worship the beauty of celebrities, and are constantly seduced by them and their industry backers to look like them. In some cases, this consideration may contradict with the second consideration, that is the need to be trusted. Many people, if it is possible, want to be accepted the way they are. However, it is often difficult to achieve without our deliberate management of impressions. Society sets norms which we have to comply with if we are to be accepted and any kind of standard which we have to fulfill if we want to improve our social positions. One of these standards is the beauty standard. One important reason why people consume cosmetic products intensively, train like professional athletes, or even are willing to go under very expensive plastic surgery is in order to satisfy the beauty standard tacitly set by their social environment.

Even on social media, especially the ones which emphasize photographs as the basis of communication, there is a beauty standard, which might be taken over from that of actual life. However, since the interaction is mediated by digital technology, the standard can be satisfied by the varied combination of our actual body and image processing technology. At one extreme, the emphasis can even be given to the capability of technology. Retouching can be used to remove a variety of image defects but also to radically alter the image. While it can improve the quality of our appearances on photographs, it also destroys the realisms of photographs. On social media photographs are just like any other information, they can be manipulated. It does not mean that photographs have become useless. Just like words which we still use in communication, even though they are manipulable, we still regard photographs as the effective media to give visual description of something, regardless of their

reliability. The emergence of digital image processing technology removes trust in the realism of photography, and therefore the trust shifts from the photographs to humans who send them.

Just like words or texts, which may have varying degree of believability, some photographs are more believable than others. Social media users also seek to find a way to show that their photographs are honest, not manipulated. Accordingly, if we can show that we instantly upload the selfie on social media, it also indicates that we do not have time to process it. And, if we can show that we do not try to pose elegantly, we also can show that we do not need any software to improve the selfie. The photographs of us being casual is more believable than being glamorous. So, selfie is a strategy of gaining trust in the era when photographs have lost their realism.

REFERENCES

Bazin, A. (2005). *What is Cinema?* (Vol. I). Berkeley and Los Angeles, CA: University of California Press.

Behrendt, R.-P. (2015). *Narcissism and the Self*. Hampshire, UK: Palgrave Macmillan. doi:10.1057/9781137491480

Bennett, J. (2014). With Some Selfies, the Uglier the Better. *NY Times*. Retrieved February 7, 2017, from https://www.nytimes.com/2014/02/23/fashion/selfies-the-uglier-the-better-technology.html

Berry, B. (2007). *Beauty Bias: Discrimination and Social Power*. Westport, CT: Praeger.

Bingham, J. (2015). How long those "spontaneous" selfies really take. *Telegraph*. Retrieved January 26, 2017, from http://www.telegraph.co.uk/women/womens-life/11915375/How-long-those-spontaneous-selfies-really-take.html

Brand, S., Kelly, K., & Kinney, J. (1985). Digital Retouching: The End of Photography as Evidence of Anything. *Whole Earth Review*.

Burkitt, I. (2008). *Social Selves: Theories of Self and Society* (2nd ed.). London: Sage Publications.

Cashmore, E. (2006). *Celebrity/Culture*. New York, NY: Routledge.

Cavell, S. (1979). *The World Viewed, Reflections on the Ontology of Film (Enlarged E)*. Cambridge, MA: Harvard University Press.

Cooley, C. H. (1902). *Human Nature and the Social Order*. New York, NY: Scribner's.

Dunbar, R. (1996). *Grooming, Gossip, and the Evolution of Language*. Cambridge, MA: Harvard University Press.

Feenberg, A. (1999). *Questioning Technology*. New York, London: Routledge.

FORD. (2014). *Looking Further with Ford: 2014 Trends*. Ford Motor Company.

Foucault, M. (1978). The History of Sexuality: Vol. 1. *An Introduction* [Hurley R, Trans.]. New York, NY: Pantheon Books.

Foucault, M. (1988). Technologies of the Self. In L. H. Martin, H. Gutman, & P. H. Hutton (Eds.), *Technologies of the Self: A Seminar with Michel Foucault* (pp. 16–49). Amherst, MA: The University of Massachusetts Press.

Freeland, C. (2007). Portraits in Painting and Photography. *Philosophical Studies: An International Journal for Philosophy in the Analytic Tradition, 135*(1), 95–109. Retrieved from http://www.jstor.org/stable/40208798

Gergen, K. J. (1991). *The Saturated Self: Dilemmas of Identity in Contemporary Life*. New York, NY: Basic Books.

Gibbs, J. L., Ellison, N. B., & Heino, R. D. (2006). Self-Presentation in Online Personals: The Role of Anticipated Future Interaction, Self-Disclosure, and Perceived Success in Internet Dating. *Communication Research, 33*(2), 152–177. doi:10.1177/0093650205285368

Goffman, E. (1959). *The Presentation of Self in Everyday Life*. New York, NY: Doubleday.

Grogan, S. (2008). Body Image: Understanding body dissatisfaction in men, women, and children. (2, Ed.). London: Routledge.

Heidegger, M. (1962). *Being and Time*. Oxford, UK: Blackwell.

Heidegger, M. (1977). *The Question Concerning Technology and Other Essays* [W. Lovitt, Trans.]. New York, NY: Garland Publishing.

Hyman, J. (2006). *The Objective Eye: Color, Form, and Reality in the Theory of Art*. Chicago: The University of Chicago Press. doi:10.7208/chicago/9780226365541.001.0001

Kohut, H. (1971). *The Analysis of the Self: A Systematic Approach to the Psychoanalytic Treatment of Narcissistic Personality Disorders*. Chicago: The University of Chicago Press.

MacDonald, G., & Leary, M. R. (2012). Individual Differences in Self-Esteem. In M. R. Leary & J. P. Tangney (Eds.), *Handbook of Self and Identity* (2nd ed.). New York, NY: The Guilford Press.

McLuhan, M. (1994). *Understanding Media: The Extensions of Man*. Cambridge, MA: The MIT Press.

Merleau-Ponty, M. (2005). *Phenomenology of Perception*. London: Routledge Classics.

Mirzoeff, N. (1999). *An Introduction to Visual Culture*. London: Routledge.

Nayar, P. K. (2009). *Seeing Stars: Spectacle, Society and Celebrity Culture*. New Delhi, India: Sage Publications.

Northrop, J. M. (2012). *Reflecting on Cosmetic Surgery: Body image, shame and narcissism*. London: Routledge.

Rettberg, J. W. (2014). *Seeing Ourselves Through Technology: How We Use Selfies, Blogs and Wearable Devices to See and Shape Ourselves*. Hampshire, UK: Palgrave Macmillan. doi:10.1057/9781137476661

Rhodewalt, F. (2012). Contemporary Perspectives on Narcissism and the Narcissistic Personality Type. In M. R. Leary & J. P. Tangney (Eds.), *Handbook of Self and Identity* (2nd ed., pp. 571–586). New York, NY: The Guilford Press.

Sanghani, R. (2014). Why we really take selfies: the "terrifying" reasons explained. *Telegraph*. Retrieved March 30, 2017, from http://www.telegraph.co.uk/women/10760753/Why-we-really-take-selfies-the-terrifying-reasons-explained.html

Schlenker, B. R. (2012). Self-Presentation. In M. R. Leary & J. P. Tangney (Eds.), *Handbook of Self and Identity Self and Identity* (2nd ed., pp. 542–570). New York, NY: The Guilford Press.

Scruton, R. (1981). Photography and Representation. *Critical Inquiry, 7*(3), 577–603. doi:10.1086/448116

Senft, T. M. (2008). *Camgirls: Celebrity and Community in the Age of Social Networks*. New York, NY: Peter Lang.

Senft, T. M. (2013). Microcelebrity and the Branded Self. In J. Hartley, J. Burgess, & A. Bruns (Eds.), *A Companion to New Media Dynamics* (pp. 346–354). West Sussex, UK: Wiley-Blackwell. doi:10.1002/9781118321607.ch22

Sheehan, T. (2011). *Doctored: The Medicine of Photography in Nineteenth-century America*. University Park, PA: The Pennsylvania State University Press.

Sheehan, T. (2014). Retouch Yourself: The Pleasures and Politics of Digital Cosmetic Surgery. In M. Sandbye & J. Larsen (Eds.), *Digital Snaps: The New Face of Photography* (pp. 179–204). London: I.B. Tauris.

Snyder, J., & Allen, N. W. (1975). Photography, Vision, and Representation. *Critical Inquiry, 2*(1), 143–169. Retrieved from http://www.jstor.org/stable/1342806 doi:10.1086/447832

Storr, A. (1968). Human Aggression. New York, NY: Atheneum. Retrieved from https://books.google.co.id/books/about/Human_Aggression.html?id=GpZ9AAAAMAAJ&redir_esc=y

Tice, D. M., Butler, J. L., Muraven, M. B., & Stillwell, A. M. (1995). When Modesty Prevails: Differential Favorability of Self-Presentation to Friends and Strangers. *Journal of Personality and Social Psychology, 69*(6), 1120–1138. doi:10.1037/0022-3514.69.6.1120

Tong, S. T., Van Der Heide, B., Langwell, L., & Walther, J. B. (2008). Too Much of a Good Thing? The Relationship Between Number of Friends and Interpersonal Impressions on Facebook. *Journal of Computer-Mediated Communication, 13*(3), 531–549. doi:10.1111/j.1083-6101.2008.00409.x

Walther, J. B. (1996). Computer-Mediated Communication: Impersonal, Interpersonal, and Hyperpersonal Interaction. *Communication Research, 23*(1), 3–43. doi:10.1177/009365096023001001

Walton, K. L. (1984). Transparent Pictures: On the Nature of Photographic Realism. *Critical Inquiry, 11*(2), 246–277. doi:10.1086/448287

Weststeijn, T. (2008). *The Visible World*. Amsterdam: Amsterdam University Press.

Chapter 3

Motivations and Positive Effects of Taking, Viewing, and Posting Different Types of Selfies on Social Media:
A Cross-National Comparison

Fiouna Ruonan Zhang
Bowling Green State University, USA

Nicky Chang Bi
Bowling Green State University, USA

Louisa Ha
Bowling Green State University, USA

ABSTRACT

In this study, we explored the motivations and the effects of selfie taking, posting, and viewing. To understand the selfie phenomenon, we conducted in-depth interviews with 16 American and Chinese students. The findings suggest that the selfie phenomenon among American students is not necessarily related to narcissism and low self-esteem, as argued in many previous literatures. Contrarily, selfie usage among Chinese students is more associated with narcissism (self-indulgence in recreational selfie-taking) and impression management (selfie-editing to improve online self-image). In the general, selfie taking, viewing, and posting behaviors could be conceptualized as more than just a display of narcissism, but also as a new way of communication, life-recording, online impression management, and relationship management. Cultural differences between American and Chinese students' use of selfies are also discussed.

DOI: 10.4018/978-1-5225-3373-3.ch003

INTRODUCTION

Selfie, or digital self-portrait, is gradually gaining popularity since 2004, along with the world-wide spread of smart phones with camera lenses at both sides. The term was added to the Oxford Dictionaries in 2013. It has been recently defined by academics as "a self-portrait photograph of oneself (or of oneself and other people), taken with a camera or a camera phone held at arm's length or pointed at a mirror, which is usually shared through social media" (Sorokowski, Sorokowska, Oleszkiewicz, Frackowiak, Huk, & Pisanski, 2015, p. 123). It has been reported that the usage of hashtag selfie went up by 170 times from 2012 to 2014 (Bennett, 2014). Although some believe that selfie taking, viewing, and posting were behaviors adopted mostly by females and adolescents, empirical findings showed that the selfie phenomenon occurred commonly among all individuals despite differences in age and gender (Souza et al., 2015; Sorokowski et al., 2015; Barry, Doucette, Loflin, Rivera-Hudson, & Herrington, 2017).

To further our understanding of this emerging phenomenon and its rising global popularity, this study was designed to examine the psychological, communicative, and relational motivations of selfie taking, viewing, and posting, assess the positive and negative effects of selfie-related behaviors on users' psychological well-being and developmental outcome, and propose a new typology of selfies based on the functions. With in-depth interviews conducted on American college students and Chinese college students who are currently studying in America, this research also contributes a cross-national comparison of selfies as a global phenomenon by identifying the differences and similarities of selfie usage in Chinese and American contexts. In the next part of this chapter, we review previous literature on the selfie phenomenon and organized research finding into the following aspects: types of selfies, behaviors related to selfies, motivations of selfie posting, taking, and viewing, psychological effects, and American-Chinese cross-national comparison.

REVIEW OF LITERATURE

In previous literature, selfies, compared with pictures taken by others, were often conceptualized as a demonstration of negative personality like narcissism and low self-esteem (Barry et al., 2015; Sorokowska et al., 2016; Kim, Lee, Sung, & Choi, 2016; McCain, Borg, Rothenberg, Churillo, Weiler, & Campbell, 2016) or as a purposive self-constructed image to display physical attractiveness (McLean et

al., 2015) and seek peer recognition (Chua & Chang, 2016). Selfie-takers are thus often assumed to be narcissists and with low self-esteem who take and post selfies to grab attention, display physical sexiness, and seek positive peer feedback. The current study emphasizes the communicative and relational motivations of the selfie phenomenon by examining selfies as four distinctive types: individual selfie, selfie with objects, selfie with another individual, and group selfie. This study normalizes the selfie phenomenon and selfie takers, and conceptualizes selfie taking, viewing, posting behavior as a new way of communication, life-recording, image management, and relationship management. Selfies can also have very positive effects on the selfie-takers and the viewers of the selfies.

Regarding the effects of the selfie phenomenon, previous literatures have themed around negative psychological aspects like lower self-esteem, lower confidence and sense of insecurity due to negative or absence of response to selfies (Chua & Chang, 2016), and enhancement of gender stereotype through selfies featuring physical appearance (McLean et al., 2015). The current research, however, not only focus on the psychological effects of selfies, but also study the effects of this emerging phenomenon as both a form of visual communication and relationship maintenance.

Types of Selfies

With more scholarly attention given to the selfie phenomenon in the recent years, the examinations of selfies became more specialized. Barry and colleagues (2015), when examining the relationship between selfies and narcissism and self-esteem, categorized selfies into the following themes: physical appearance, activity/event/location, affiliation with others, collage, others/undifferentiated. In their examination of the relationship between personality and selfie posting, Sorokowski and colleagues (2016) categorized selfies into own selfies, selfies with a romantic partner, and group selfies (i.e., taken with one or more individuals, excluding the romantic partner). Wang and colleagues, (2016) found a wide difference between selfie-viewing and groupie-viewing in influencing life satisfaction and self-esteem. Based on previous studies, the current study categorizes selfies into four distinct types: individual selfie, selfie with object(s), selfie with a significant other, and groupie. Each type of selfie represents a different motivation to take the selfie and with different functions for the taker and the viewer.

An individual selfie is a self-taken picture featuring the face or body of the selfie owner. The emphasis of an individual selfie is solely on the person who takes it, instead of objects or the scene at the background. This type of selfies often stresses

physical appearance of the selfie taker. A selfie with object(s) features the selfie taker and his/her hand holding an object or displays the background and setting. This type of selfies often serves as digital proofs of selfie-takers doing something, showing the specific objects, being at certain events and locations, or witnessing certain activities. A selfie with a significant other features two people, one of them being the selfie taker, and the other one often being a romantically related person, a family member, or a close friend. This type of selfies often emphasizes or attempts to emphasize the close relationship between the two people featured in the picture. Taking a selfie with another person requires both physical intimacy and relationship intimacy. Hence taking a selfie with other people reveals relational intimacy, trust, and confidence in relationship. A groupie is a picture featuring more than two people with one of them holding the camera or selfie stick in his/her hand. This type of selfies emphasizes community relationship, shared experience, or shared identity.

Behaviors Related to Selfie

The previous literatures on selfie examined the phenomenon more as a personality expression (Qiu, Lu, Yang, Qu, & Zhu, 2015) or self-regulatory behaviors to fulfil narcissism (Barry et al., 2015) or to seek peer recognition (Chua & Chang, 2016). Most selfie studies emphasize selfie-posting behaviors. However, selfie-taking and selfie-viewing are also two selfie-related behaviors that need scholarly attention. The motivations of taking selfies and posting selfies on social media should be examined separately, since motivations of selfie-taking might not be psychologically driven but influenced by environmental constraints such as lack of other people to take photos. Viewing different types of selfies was found to have great impact on viewers. Viewing individual selfies on social media was found to decrease viewers' life satisfaction and self-esteem, while viewing groupies was found to increase both life-satisfaction and self-esteem (Wang, Yang, & Haigh, 2016). To understand the motivations and effects of selfie phenomenon in more detail, in this study, selfie-taking, selfie-viewing, and selfie-posting are studied as three both distinctive and related behaviors.

Motivations of Selfie Taking, Viewing, and Posting

Although gained some scholarly attention in recent years, selfie is still an emerging topic in academe. Scholars have taken difference directions in the conceptualization of the selfie phenomenon and the exploration of the motivations behind selfie-related behaviors. A number of previous research viewed selfies as a display of narcissism, low self-esteem, and certain personalities, while some studies deconstructed selfie as a way of communication and relationship management.

Narcissism and Self-Esteem

Compared with selfie viewing, selfie taking and posting received the most scholarly attention. Early scholarship often view selfie taking and posting as an abnormal social behavior derived from narcissism and low-self-esteem (e.g., Martino, 2014; Walker, 2013). However, empirical studies of the relationship between selfie taking/ posting and narcissism/self-esteem generated mixed results.

Martino (2014) argued that people who post a high number of selfies are believed to be narcissistic or attention-seeking. Fox & Rooney (2015) found that males who scored higher on self-reported narcissism also significantly scored higher on self-reported frequency of selfie posting on social media. However, Barry and colleagues (2015) found a lack of association between narcissism and general selfie posting, yet they found a positive association between vulnerable narcissism (as opposed to grandiose narcissism) and selfies featuring physical appearance. Self-esteem was found unrelated to selfie posting. McCain and colleagues (2016) found grandiose narcissism positively associated with higher frequency of selfie taking and posting, positive experience of selfie taking, and higher self-reported self-presentation motives; while vulnerable narcissism positively related to negative affect experienced in selfie taking. Self-esteem was found unrelated to selfie taking and posting. While Kim et al. (2016) found narcissism a significant predictor of intention towards selfie posting and Chua and Chang (2016) found low self-esteem a predictor of manipulating selfies with photo-editing techniques. Sorokowska et al. (2016) found no association between self-esteem and selfie posting among women, and only a weak association among men.

In general, how narcissism and self-esteem influence selfie taking, viewing, and posting is still unclear. The current study is designed to detangle the relationship by separating selfie taking, viewing, and posting as three different behaviors and examine the effects of different types of selfies on the selfie takers and viewers.

Personality

Apart from self-esteem and narcissism, researchers examined the relationship between personality and selfie-posting behaviors to find out what types of individuals are more likely to post selfies. Qiu et al. (2015) found selfies can express owners' agreeableness, conscientiousness, neuroticism and openness. For example, "emotional positivity [shown in selfies] predicts agreeableness and openness… private location in the background indicates less conscientiousness" (p. 447). However, reports from native coders recruited from Amazon Mechanical Turks indicate that viewers of selfies can only identify selfie takers' openness from those self-portraits, but no other personalities. Sorokowska et al. (2016) found self-exhibitionism and extraversion positively related to selfie posting.

Communicative and Relational Motivations

Selfies not only can be conceptualized as a display of narcissism, self-esteem, and certain personalities, but also as a functional way of immediate communication and relationship management through social media. Selfies, compared with portrait pictures taken by others, often feature a larger proportion of human face or body. Selfie takers have complete control over how to present themselves in the picture. Thus, it's safe to say that selfies better represent communicator than traditional self-portraits in the mediated communication process. As Wortham (2013) argued, selfie represented a new way of visual communication replacing or enhancing the traditional textual messaging. Communication through selfies display "new means of communicating the self and articulating a sense of connection to others (Hess, 2015, p. 1629)." Selfies not only can be viewed as objects, as argued by Frosh (2015), they can also be viewed as an expressive practice enabled by the technological development. For example, Gannon and colleagues (2016) found that beauty bloggers used selfies and group selfies as a way of recording cosmetic products' performance and relationship management at beauty bloggers' gathering.

Psychological Effects of Selfies

Literature examining the effects of the selfie phenomenon was centered around the negative aspects. Scholars have found that the selfie phenomenon can contributes to gender stereotypes in physical appearance, lower confidence and self-esteem due to absence of positive feedback, and selfie-takers' false perception of self-image. A few positive effects were also discussed in previous studies.

Negative Effects

Selfies, especially individual selfies featuring physical appearance, was found to negatively impact selfie-viewers' notion of beauty and facilitating the gender stereotype in appearance. Burns (2015) argued that selfie taking and posting are devalued gendered activity that circulates negative gender stereotypes. McLean and colleagues (2015) found that teenagers who shared selfies regularly on social media were more likely to have overvaluation of physical appearance and weight, body dissatisfaction, dietary restraint, and internalization of the thin ideal. Chua and Chang (2016) also found that the selfie phenomenon contributes to the understanding of beauty towards an ideal notion. Scholars also found that in order to appear more attractive, some selfie-takers use filters and photo-editing software to manipulate their self-portraits as a means of self-embellishment (Souza et al., 2015). The

distorted version of selfies circulated on social media may contributes to unrealistic expectations of beauty standards.

Negative effects on selfie posters derived from lack of peer recognition and peer feedback were also found in the literature. Absence of positive feedback towards selfies can be potentially dangerous for selfie-posters' confidence and self-esteem (e.g., Martino, 2014; Walker, 2013). Chua and Chang (2016) found that peer comparison was an inherent drive behind teenage girls' selfie posting. Teenage girls post selfies to gain peer recognition in the forms of "likes," "favorites," and positive "comments." If selfies posted on social media failed to get "likes" and positive comments, or fail to get any attention from peers, self-esteem and confidence of the selfie takers might be lowered.

Selfies may also contribute to a gap between selfie-takers' self-image and others' view of them. Re and colleagues (2016) found that selfie-takers view themselves as more attractive in selfies than in photos taken by others, while non-selfie takers view both as similar. However, outside observers view people in their selfies as less attractive, less likable, and more narcissistic than in photos taken by others. Selfie-posting itself might be an image-damaging behavior to selfie-takers without them knowing it.

Positive Effect

Although selfie posting is seldom examined as a positive phenomenon, scholars have found that selfie viewing, specifically viewing group selfies, can positively contribute to viewers' life satisfaction and self-esteem (Re et al., 2016). Selfies can also be contributive in self-representation and image-management, since compared to other types of pictures, selfies are more effective in grabbing attention (Souza et al., 2015). In addition, positive feedback towards selfies might contribute to self-confidence and self-esteem. But still little is known about the positive effects of selfies on the self-takers and to the viewers of the selfies.

Cross-National Comparison

The selfie-phenomenon is by no means limited to certain countries. With the international prevalence of smartphones, selfies are taken and posted by people all over the world. In general, Western scholars view the selfie phenomenon occurring as a result of narcissism and low self-esteem (e.g. Barry et al., 2015) or a display of certain personalities (e.g. Sorokowska et al., 2016). A review of Chinese literature on selfie-posting reveals different perspectives of viewing selfies as new means of gaining psychological gratification, communication, self-disclosure, emotional

disclosure, and impression management (Guo, 2015; Lu, 2015; Wang, 2013; Wei, 2016; Xie, 2015; Zhang, 2015).

Wang (2013) argued that people can purposively take selfies to gain psychological gratifications through peer recognition, peer acceptance, and positive feedback. Since people have more control in how to present themselves in their selfies, they can maximize their bright sides and hide their weakness to leave others a better impression. Therefore, selfie-takers, according to Guo (2015), are not posting self-portraits out of self-admiration or narcissism, but are using selfies as a way to highlight the best aspects of their facial or body features.

In today's visual society where visual communication is gradually replacing or enhancing textual communication, selfie-posting is also described as a more convenient and direct way to communicate with friends and family, to record life-events worthy of sharing, and to express one's emotion and thoughts (Xie, 2015; Wei, 2016). Zhang (2015) argued that Western society values individualism, confidence, and self-expression, while Chinese culture, under thousands of years' influence of Confucianism, emphasizes collectivism, social hierarchy, and humble personality. Under Western influence, Chinese youths are posting selfies with the intentions of self-expression, life-sharing, and emotional disclosure (Guo, 2015), since selfies can better feature the facial expressions of the posters than photos taken by others.

Selfies are also interpreted as a means of impression management. With self-embellishment tools like filters and photo-editing software, plus people's full control over how to pose in selfies, selfie takers have the option to display their ideal selves both to themselves and to others (Lu, 2015). Lu (2015) also argued that selfies can also serve as an incentive for people to work harder and achieve their better selves as featured in selfies.

METHOD

To explore the research questions of why people took and selected selfies to post, how people viewed others' selfies, and whether there were cultural differences between Chinese and U.S. young people, we interviewed 16 undergraduate students who were between 18 and 24 years old (9 Chinese and 7 Caucasian American students) from March 21 to 24, 2017, at a U.S.-based Midwestern public university. With the approval of institutional review board, seven American participants who were undergraduate students from an introduction course of the School of Media and Communication were recruited for this study. We went to the class held on March 21, 2017 to introduce the study and asked the students who were interested in the

study to sign up for interviews. Among all the American participants, four of them were freshmen, two were juniors, and one was a senior. Four were males and three were females. To maintain homogeneity of the participants and increase the salience of culture differences between Americans and Chinese, Chinese participants were recruited from the same university through the Chinese Student Association. Seven were freshmen, one was a sophomore, and one was a junior. The Chinese sample included three males and six females. Six Chinese students interviewed came to U.S less than two years ago, and two came to U.S more than two years ago.

Electronically-recorded and semi-structured interviews of 20 to 30 minutes for each participant were conducted. The interviews were held at a small conference room of a university building that was quiet, private, and comfortable to the participants. Consent forms were acquired from all participants who were reported to be above the age of 18 and agreed to participate in the study. To allow them to speak freely about their attitudes toward selfies, we used English to interview American participants and Chinese to interview Chinese participants. All the participants allowed us to audio record the conversations during the interview sessions. Participating the interview was completely voluntary and confidential.

Participants were asked about their motivations to take and post selfies and their perceived effects of four types of selfies including individual selfie, selfies with an object, selfies with a significant other, and groupie. We first asked about the general thoughts and behaviors about selfies such as "Are you a selfie taker?", "Which social media do you post your selfies most frequently?" We also asked questions to understand their selfie-related decision-making process such as "Why do you choose to take selfies rather than asking others to take photos for you?", "Why do you post selfies on social media?" At last, we tried to understand the effects of taking, viewing, and posting selfies such as "How do you like the process of taking selfies?", "What do you think about the selfie-posters when you are see their selfies on social media feeds?", "What do you think of people who edit their selfie using filters and photo-editing softwares?" We also asked them to provide the researchers access to their Instagram account so that we can examine the selfies they posted.

FINDINGS

The interviews of both Chinese and American students show that the medium selection of selfie-posting is different for the two samples, narcissism and self-indulgence cannot fully explain the motivations of taking and posting selfies, two samples had distinct standards of liking or disliking others' selfies they see in their social media feeds, and two samples had drastically different attitudes toward selfie-editing.

American Students' Medium Selection for Selfie Posting

The interviewed American students mainly view selfie as a form of communication, rather than merely a mere representation of themselves. They post selfies on various occasions, such as during vacation, in the street, and on the first day of a job. Selfies were used to initiate conversations or to respond to others, thus the most frequently used social media sites (SNS) to post selfies is Snapchat, given the communicative features of the platform. Since users typically send messages to one or a few people at a time on Snapchat and messages will disappear after the receiver viewed it twice, this medium is considered as a more private and safe SNS, compared to Facebook, Twitter, and Instagram. One participant said,

I am a cheerleader of the school...if I post a picture on Facebook, more than 2,000 people will see it... I can't control who sees the picture.

Another student said,

Snapchat gives users more freedom...but Facebook and Twitter, you leave it (selfie) there, people will judge it...Everyone will see.

Snapchat provides a way that people can control the message they send out, since they can choose which picture or video to send to whom. Interestingly, one participant does not consider posting self-pictures on Snapchat as posting selfies. She said,

Snapchatting is a way of communication... I want to start a conversation with my family... My mom wants to see what I'm doing at school.

Apart from Snapchat, some students also use other SNS to post selfies, such as Twitter. In general, the interviewed American students view selfies as a way of communication and life recording.

Chinese Students' Medium Selection for Selfie Posting

According to the interviews with nine Chinese undergraduate students who are currently studying in America, selfie-taking is not a peculiar behavior that need to be labeled as "narcissistic" or "attention-seeking." To them, selfie-taking is a new and common way of taking pictures enabled by technology. All of them post selfies on Wechat, their local language social media, although they are currently in the United States. Interviewees indicate that most of their peers take and post selfies. As one participant said:

If they [my parents] have the technology at their time, they would have taken selfies as well...Taking selfies in this era is a normal thing. It should not be controversial. It's just a part of life, like eating and sleeping.

Selfies, to the interviewed Chinese undergraduate students, can be categorized into three types: individual selfies emphasizing physical appearance; individual selfies with context (object/event/travel scene); and group selfies. Interviewees indicate that selfies with a significant other share similar motivations and effects with group selfies, in displaying and maintaining relationship.

American Students' Motivations of Selfie-Taking

When asked about why takeing selfies instead of letting others take pictures for them, the interviewed American students revealed that they look different in selfies from pictures taken by others, because the two are normally taken from different angles. Pictures taken by others are normally shot from the same height with the people in the pictures. Selfies, on the other hand, can be taken from any angles, typically from a higher angle so that the selfie-taker's face looks slimmer and eyes appear bigger. The individuals can have more variations with selfies and control how to present themselves in pictures. Many American participants said that they take selfies a lot but just post a few. One participant said it is normal to take selfies, but it could be a problem if a person takes too many. It may be related to low self-esteem and social insecurity. However, another participant said she literally have taken 250,000 selfies via Snapchat, but seldom post them on other SNS. She does not see it as problematic. She sees taking selfies itself entertaining. Similar to taking selfies, taking groupies is also viewed as a normal behavior to store the memories. Participants revealed that they usually take groupies with close friends or people they know really well.

Chinese Students' Motivations of Selfie-Taking

The interviewed Chinese undergraduate students revealed that selfies made them look more physically attractive than pictures taken by others. It is the first and most important motivation of taking individual selfies. Other motivations include taking individual selfies to have fun (pass time), to record events in life, and to avoid bothering others for taking pictures. As for taking group selfies, apart from the reasons like taking individual selfies, it is a less formal way to record group activities and mark friendship and interviewees prefer this casual way of taking pictures.

Selfie-takers are the ones who hold cameras and press shutters, thus they have full control over when and how to present themselves in pictures. They can try different shooting angles, expressions, lightings, and take as many as selfies they

want until getting the most "good-looking" one. Nearly all interviewed Chinese students revealed that they look more attractive in selfies than in pictures taken by others. One participant mentions:

Because you can hold the camera higher than your face, so in selfies, your face appears slimmer and eyes look bigger. If you ask others to take pictures of you, they can only shoot from the same height.

Selfie-takers not only enjoy the selfies they took, the process of selfie-taking itself can also bring pleasure. One participant said she like to take selfies during study breaks or when she's bored. Selfie-taking is a way to have fun and pass time, just like playing video games, or watching television dramas. Also, compared with the traditional way of taking pictures, taking selfies spare people from having to ask other to take pictures for them. The convenience and ease are big attractions of selfies.

American Students' Motivations of Selfie-Posting

In general, participants will post selfies to SNS when they feel good about themselves or when they want to start conversations. They mentioned posting selfies when doing work out or travelling. Some of them think it is normal to post selfies. It should not be judged, because people should have the freedom to do what they enjoy. However, some participants think posting selfies is associated with attention-seeking, but their interpretation of attention-seeking is interesting. One participant said,

This is an attention-seeking generation, compared to other older generations...but it's not necessary a bad thing...because the technology...we grow up with technology. Everyone wants to interact with others.

Although they think posting selfies is related to attention-seeking, it is not completely the same with narcissism. Making themselves look good is just a positive benefit of selfies. At least, not everyone who posts selfies is narcissistic. People use facial symbols along with text messages to make them less formal and more interesting. Similarly, posting selfies along with some words to SNS can be a quick and interesting option to communicate with others.

The interviewed American students also see selfies as a way of sharing life events. One participant said,

[Taking selfie] is showing my moments...to let other people knows what's going on... It's what you're doing...what you're interested.

Another student said,

I used Snapchat...I can post my everyday life. Snap selfies show what you're up to. Selfies can be confidence booster...But [for some people], it has psychological reasons. Some people post selfies with animals, but she dressed up.

To the American participants, it is "fine" to post selfies about their everyday lives. It is even fine to be a little attention-seeking in this technology-enabled social media environment, where online interactions is as important as real life activities. However, "showing off" with selfies and addiction to using selfies to impress others are problematic.

Groupie posting is viewed differently from individual selfie posting. One participant said he tended to take and post groupies when more females are in the group as a way of displaying social popularity. Another female student said posting groupies is a way to record life and friendship. She wants other people to see she is with people for a lot of times. Hence, to the interviewed American students, posting groupie represents their social competence in their social circle.

However, the interviewed students revealed that their parents might have different opinions on selfie-posting. The elder generation might have more privacy concern than the younger generation. One student said,

Why don't older people not post selfies? Because of private reasons...They think what we did is naive...putting so much information on the Internet.

Chinese Students' Motivations of Selfie-Posting

Unlike American participants that selectively posted their selfies using different social media, our Chinese interviewees told us that many selfies they took were not intended to be posted on social media. Some were just taken to pass time or to have fun. For individual selfies that do end up on social media, the most frequently mentioned reason is that they portrayed the selfies-takers as better-looking than other pictures. Other motivations of posting selfies were to update friends on life events, to leave good impressions, and to collect positive peer feedback. For group selfies, apart from the reasons mentioned above, they were posted to showcase, maintain, and reinforce social relationship.

Just like other pictures posted on social media, selfies can be used to inform friends and family what is going on about the selfie-takers. However, selfies are special because the selfie-takers are in full control over how to present themselves in front of friends and family through the lenses of social media. Selfie-takers can purposely take "good-looking" photos of themselves and record the activities or

life events from certain perspectives to create and manage their online images. For the interviewed Chinese students, selfies are especially important in self-promotion and online impression management. As one participant said:

Sometimes if I meet a new friend, I will go to his Wechat [Chinese social media] to see what kind of person he/she is. Similarly, people will know what kind of person I am from my Wechat feed, so I want to make sure the pictures I posted can leave people a good impression.

Interviewees also pointed out that selfies posted on social media, compared with photos taken by other people, or photos of objects and scene, typically generated more "likes" and positive comments, because they represented the people in the picture more effectively and were perceived as more genuine and spontaneous.

Like American participants, the interviewed Chinese students also found their parents have more privacy concern about posting selfies online than themselves. Some students stated that their parents might think posting selfies could disclose too much personal information. However, since Wechat is a more private platform and only friends and families can see the posts, some parents think it is fine to post selfies on it. One participant said,

Before, they think it's personal information, but I said I'm familiar with the people in my Wechat. They accepted it now.

American Students' Selfie-Viewing

In general, the interviewed American participants think selfies are as normal as eating, especially for the younger generations. Participants would like to see their friends' selfies, especially when they are not in the same geographical location. They do not see others' selfies as problematic, unless some people post shirtless pictures of themselves or are obsessed with selfies and posting in high frequency. They said that people who take shirtless selfies are pointlessly attention seeking. The context of selfies are important, differentiate selfies that aims to communicate something from meaningless selfies to show off physical appearance. One participant said,

[I don't like] the people who are obsessed to it (posting selfies). It's attention seeking... Some people posting their work out [selfies] all the time...They want people to know the image of them. [I also don't like] the pictures that have no meaning, no information, no context.

Otherwise, almost all the American interviewees think viewing others' selfies is a good way of communication and receive updates on life events. Unlike their Chinese counterpart, physical attractiveness of those in the selfies is not a big thing to the interviewed American students. They would love to see comments such as "you look cute," but they think people must feel good about themselves to post selfies on social media.

Chinese Students' Selfie-Viewing

Selfies are now showing up constantly on social media feeds. Interviewees were asked what kinds of selfies they enjoy viewing and what kinds of selfies annoy them. For most interviewees, they have positive attitude towards selfies featuring "good-looking" people within some type of contexts (e.g. travel scenes, friends and family, or activities). The kinds of selfies annoying them are the ones featuring no context but physical appearance, and frequent selfie posts from the same individuals.

Physical attractiveness plays an important role when the interviewed Chinese students make favorable or unfavorable judgement about the selfies they see. The same kind of selfies taken by an attractive person will generate "likes" and positive comments, while those taken by an "unattractive" person will bring negative thoughts like narcissism and excessive attention-seeking. Context is also critical. Selfies taken only to showcase physical attractiveness typically bring negativity, but if the intention was a mix of showing off physical attractiveness and something else (e.g. displaying travel scene or life-events), positive response were more likely to be generated.

For the interviewed Chinese students, viewing group selfies provide them information about social relationship around them. Group selfies can generate both positive and negative response depending on the relationships between the viewer and the people featured in the group selfies. As one participant said:

I like viewing group selfies. I like watching people cherishing their friendship with others, but if I see my friends hanging out with people I don't like, I will not be very happy about it.

American Students' Attitude Towards Selfie-Editing

In the eyes of the interviewed American students, selfie-editing means adding color filters to pictures to enhance the image quality, adding fun Snapchat filters to human faces like animal heads, or framing/cropping pictures so that the person/people can be featured in the center or a desired place on the screen. Snapchat is used heavily

among the interviewed American students. When asked about their opinion towards the embedded filters, the students think they are fun. One participant said,

I like to use it. Lots of them are fun. I used them all the time. Some of them are popular. Girls like the dog one...People use them (Snapchat pictures) as their Facebook portrait.

When asked about their opinion towards selfie-editing as manipulating their facial features and body shape to be more physically attractive, the interviewed American students revealed that they would not intentionally do so. When asked about their attitude towards people who did manipulate their selfies, one participant said,

They don't need to...if it makes people more confident to post it. It's fine.

In terms of how they view feedback towards their selfies, most of the participants mentioned that they did not care too much about likes and comments overall, but it depends on who are providing the feedback. One person said,

Feedback in Snapchat is not that important. It also depends on the people I'm talking to.

Another one said,

On Twitter, Facebook, I expect more responses. Snapchat, not much...If it's negative response, I'm not really bothered. If you did not like it, you don't need to look at it. I'm happy I post it.

Chinese Students' Attitude Towards Selfie-Editing

Contrary to the American participants, the Chinese students interviewed in this study view selfie-editing more as using photo-editing tools to manipulate facial and bodily features than simply adding filters. According to the participants, typical selfie-editing steps include brightening the facial complexion, blurring the fine lines, erasing the dark spots, enlarging the eyes, chiseling up the jaw lines, and slimming down the arms if they are included in the selfies. Excessive selfie-editors might also lengthen their legs, slim down their waist, and pumping up their breasts and hips. Almost all interviewed Chinese undergraduates admitted that they had used filters to embellish their selfies. All women interviewees said they had also used photo-editing tools to manipulate their selfies to appear more attractive. When asked about

their attitude towards selfie-editing, most interviewees said it is understandable that people want to be more "good-looking" in their pictures, but it is problematic if the selfies are excessively manipulated, like when you could see the signs of editing from the curved window frames at the background. Overall, compared with American students, Chinese students view selfie-editing not as a fun experience, but a time-consuming process to transform their image into a better-looking version, which indicates a lack of confidence in their natural appearance.

DISCUSSION

Based on the interviews with Chinese undergraduate students, we found three issues worthy of in-depth discussion. First, the selfie phenomenon has raised the salience of physical attractiveness among the interviewed Chinese undergraduate students. The most frequently mentioned word during interviews with almost all participants was "good-looking." It is the most important motivation for taking selfies rather than having photos taken by others. Selfies featuring "good-looking" people generate more positive feedback than otherwise. In order to appear more physically attractive, Chinese interviewees who post selfies commonly use photo-editing tools to manipulate their facial and/or bodily appearance. It is safe to say that the selfie phenomenon further emphasizes the importance of physical attractiveness above many other substantial achievements (like intellectual achievements, work experience, and academic achievements) among frequent selfie-takers and posters.

Second, the ever-popular selfie phenomenon displays a normalization of narcissism and excessive attention-seeking. Enabled by modern technology, people can take selfies to capture the physically attractive side of themselves and post this version to social media. Selfies has made it easier for narcissism and excessive attention-seeking to be exhibited than other none-displayable human characteristics like intellectual gaining and psychological development. The digital generation's level of tolerance on those narcissists and excessive attention-seekers is higher than previous generations, which is similar to this generation's higher toleration of nudity and sexually explicit content in media. What was considered as unhealthily narcissistic and extremely attention-seeking was now viewed as less problematic or as a normal part of everyday life. Perhaps we may interpret that selfie usage is such a common thing among young people that narcissism can no longer explain their selfie use. Narcissism is taken for granted as a common trait to all people in this generation rather than being considered a peculiar characteristic. Hence it is no surprise that in the latest studies, narcissism failed to predict selfie usage (Barry, Doucette, Loflin, Rivera-Hudson, & Herrington, 2017; Sorokowska et al., 2016).

Third, the common use of photo-editing tools to manipulate self-image is potentially damaging to selfie-takers' self-perception, psychological well-being, and future development. Our findings suggest people post selfies on SNS may have overvaluation of physical appearance and body dissatisfaction, which is consistent with McLean, et al. (2015)'s study.

Compared to American students who view selfies as a way of communication and life recording, Chinese students consider selfies more as a way of image management. For American students, selfie represents a new way of visual communication replacing or enhancing the traditional textual messaging (Wortham, 2013). They use selfies to form a conversation with their family and friends. This is especially apparent in their heavy use of Snapchat for posting selfies to get instant attention and feedback. For Chinese students, selfies are viewed as a new means of impression management. Chinese students are enjoying the process that they are editing the photos to make themselves appear better than what they actually are. However, the self-effects and other-effects on selfies sometimes are very different. In other words, selfie-takers may think they look much prettier in selfies than in the picture taken by others, but other people may think there is not much difference or selfies make people look less attractive and less likable (Re et al., 2016).

However, both interviewed American and Chinese students use groupies to show that they are popular and have wide social circle. There is no outstanding difference between male and female in selfie taking and viewing motivations.

In general, the younger generation of American and Chinese do not see selfie taking and posting as problematic as the older generations. Taking and posting selfies has been less associated with narcissism and low self-esteem. They view selfies more as a way of communication, life recording, relationship management, and impression management. Posting selfies could potentially cause privacy issues, but the younger generation is relatively less sensitive to the Internet security than their parent's generation.

FUTURE RESEARCH DIRECTIONS

Due to the nature of the in-depth interview approach used in this study, only 16 people were interviewed. Some of them have very distinguished opinions on selfie taking, selfie posting, and selfies in general. It is hard to generalize the results to the population at large on the psychological gratification of selfies. For example, they use different SNS to post selfies, which may lead to different effects on psychological well-being such as life satisfaction and self-esteem. In the future study, we may use quantitative methods such as a survey to establish the pattern of the motivations

and effects of selfie taking and posting and the relationship between selfie functions and the frequency of posting selfies.

CONCLUSION

In conclusion, the current study explored the motivations and effects of taking, posting, and viewing selfies through qualitative interviews. The findings among interviewed American students suggest that selfie phenomenon is a new way communication and life-sharing enabled by modern technology. In the contrast, the interview reveals that selfie usage among Chinese students are more associated to narcissism (self-indulgence in recreational selfie-taking) and impression management (selfie-editing to improve self-image). Compared to previous studies, our study proposes new aspects of analyzing and conceptualizing the selfie phenomenon as more than just a display of narcissism and low self-esteem, but also as a new way of communication, life-recording, impression management, and relationship management.

REFERENCES

王传芬. (2013). 网络自拍的传播心理探究. 编辑之友, (8), 77-78.

鲁肖麟. (2015). 社交网络自拍中的印象管理与自我认知. 陕西教育 (高教), (2015 年 02), 5-7.

郭肖. (2015). 女性网络自拍现象的文化意义解读. 东南传播, (6), 51-53.

谢钦. (2015). 从文化角度分析自拍意义. 美术教育研究, (7), 55-55.

张慧. (2015). 从自拍门 (selfie) 看跨文化交际. 考试周刊, (12), 23-23.

魏科召. (2016). 自拍现象的亚文化传播解读. 新闻世界, (7), 89-91.

Barry, C. T., Doucette, H., Loflin, D. C., Rivera-Hudson, N., & Herrington, L. L. (2017). Let me take a selfie: Associations between self-photography, narcissism, and self-esteem. *Psychology of Popular Media Culture*, 6(1), 48–60. doi:10.1037/ppm0000089

Bennett, S. (2014, July 20). A brief history of the #selfie (1839–2014). *Mediabistro*. Retrieved from http://www.mediabistro.com/alltwitter/first-ever-selfie-historyb58436

Burns, A. (2015). Self(ie)-discipline: Social regulation as enacted through the discussion of photographic practice. *International Journal of Communication*, 9, 1716–1733.

Chua, T. H. H., & Chang, L. (2016). Follow me and like my beautiful selfies: Singapore teenage girls' engagement in self-presentation and peer comparison on social media. *Computers in Human Behavior*, *55*, 190–197. doi:10.1016/j.chb.2015.09.011

Fox, J., & Rooney, M. C. (2015). The Dark Triad and trait self-objectification as predictors of men's use and self-presentation behaviors on social networking sites. *Personality and Individual Differences*, *76*, 161–165. doi:10.1016/j.paid.2014.12.017

Frosh, P. (2015). The gestural image: The selfie, photography theory, and kinesthetic sociability. *International Journal of Communication*, *9*, 1607–1628.

Gannon, V., Gannon, V., Prothero, A., & Prothero, A. (2016). Beauty blogger selfies as authenticating practices. *European Journal of Marketing*, *50*(9/10), 1858–1878. doi:10.1108/EJM-07-2015-0510

Guo, X. (2015). Cultural explanation of women's online selfie phenomenon. *Northeast Communication*, (6), 51-53.

Hess, A. (2015). Selfies: The selfie assemblage. *International Journal of Communication*, *9*, 1629–1646.

Kim, E., Lee, J. A., Sung, Y., & Choi, S. M. (2016). Predicting selfie-posting behavior on social networking sites: An extension of theory of planned behavior. *Computers in Human Behavior*, *62*, 116–123. doi:10.1016/j.chb.2016.03.078

Lu, X. L. (2015). Impression management and self-recognition from selfies on social media. *Shannxi education*. 2, 5-7

Martino, J. (2014, April 7). Scientists link selfies to narcissism, addiction, and mental illness. *Collective Evolution*. Retrieved from http://www.collectiveevolution. com/2014/04/07/scientists-link-selfies-to-narcissism-addiction-mental-illness/

McCain, J. L., Borg, Z. G., Rothenberg, A. H., Churillo, K. M., Weiler, P., & Campbell, W. K. (2016). Personality and selfies: Narcissism and the Dark Triad. *Computers in Human Behavior*, *64*, 126–133. doi:10.1016/j.chb.2016.06.050

McLean, S. A., Paxton, S. J., Wertheim, E. H., & Masters, J. (2015). Selfies and social media: Relationships between self-image editing and photo-investment and body dissatisfaction and dietary restraint. *Journal of Eating Disorders*, *3*(1 Suppl. 1), O21. doi:10.1186/2050-2974-3-S1-O21

Qiu, L., Lu, J., Yang, S., Qu, W., & Zhu, T. (2015). What does your selfie say about you? *Computers in Human Behavior*, *52*, 443–449. doi:10.1016/j.chb.2015.06.032

Re, D. E., Wang, S. A., He, J. C., & Rule, N. O. (2016). Selfie indulgence: Self-favoring biases in perceptions of selfies. *Social Psychological & Personality Science*, *7*(6), 588–596. doi:10.1177/1948550616644299

Rutledge, P. (2013, April 18). #Selfies: Narcissism or self-exploration? *Psychology Today*. Retrieved from http://www.psychologytoday.com/blog/positively-media/201304/selfies-narcissism-or-self-exploration

Sorokowska, A., Oleszkiewicz, A., Frackowiak, T., Pisanski, K., Chmiel, A., & Sorokowski, P. (2016). Selfies and personality: Who posts self-portrait photographs? *Personality and Individual Differences*, *90*, 119–123. doi:10.1016/j.paid.2015.10.037

Sorokowski, P., Sorokowska, A., Oleszkiewicz, A., Frackowiak, T., Huk, A., & Pisanski, K. (2015). Selfie posting behaviors are associated with narcissism among men. *Personality and Individual Differences*, *85*, 123–127. doi:.2015.05.00410.1016/j.paid

Souza, F., de Las Casas, D., Flores, V., Youn, S., Cha, M., Quercia, D., & Almeida, V. (2015, November). Dawn of the selfie era: The whos, wheres, and hows of selfies on Instagram. In *Proceedings of the 2015 ACM on conference on online social networks* (pp. 221-231). ACM. doi:10.1145/2817946.2817948

Walker, M. (2013, August). The good, the bad, and the unexpected consequences of the selfie obsession. *Teen Vogue*. Retrieved from http://www.teenvogue.com/advice/201308/selfie-obsession

Wang, C. F. (2013). Psychological analysis of online selfie communication. *Editorial friends*. (8), 77-78.

Wang, R., Yang, F., & Haigh, M. M. (2016). Let me take a selfie: Exploring the psychological effects of posting and viewing selfies and groupies on social media. *Telematics and Informatics*, *34*(4), 274–283. doi:10.1016/j.tele.2016.07.004

Wei, K. Z. (2016). Sub-cultural communication displayed in the selfie phenomenon. *News world*, (7), 89-91

Wortham, J. (2013, October 19). My selfie, myself. *The New York Times*. Retrieved from http://www.nytimes.com/2013/10/20/sunday-review/my-selfie-myself.html?pagewantedall&_r0

Xie, Q. (2015). Analyze the meaning of selfies from a cultural perspective. *Art Education Research*, (7), 55.

Zhang, H. (2015). Intercultural communication displayed by selfies. *Exam Weekly*, (12), 23.

KEY TERMS AND DEFINITIONS

Attention-Seeking: The act that people take to let others to notice, acknowledge, and praise them.

Impression Management: Behaviors that people take to let others think highly of them professionally.

Narcissism: Self-indulgence with one's physical attractiveness or social attractiveness.

Self-Editing: The act to make oneself more attractive in selfies, like adding a filter using photo editing software to change facial features or body shape.

Self-Esteem: The perception of how successful one can complete tasks

Selfie: A self-portrait photograph of oneself, taken with a camera or a camera phone held at arm's length or pointed at a mirror, which is usually shared through social media.

Selfie Obsession: A mental state of people who need to take selfies constantly due to narcissism or for confident boost.

APPENDIX: INTERVIEW QUESTIONS
(STRUCTURED QUESTIONS)

General Thoughts/Behaviors About Selfie

1. What words can you think of to best describe your personality?
2. Are you a selfie taker? (individual/object/spouse/groupie)
3. If yes, what do you think about selfie taking/viewing/posting?
4. How often do you post selfies in the past month?
5. Which social media do post your selfies most frequently? (strong ties, weak ties)
6. Can I see your Instagram posts from your phone?
7. If not a selfie taker, what do you think about other people's selfies? What would you think of the person when seeing his or her selfie? (individual/object/spouse/groupie)
8. Will you share another person's groupie if you are in it. (Sharing behavior)
9. Do you tag others when posting groupies on social media?

Decision Making Process

1. Why do you choose to take selfies rather than asking others to take photos for you? (individual/object/spouse/groupie)
2. Do you think you are more attractive in selfies than in photos taken by others?
3. Why do you post selfies on social media? (individual/object/spouse/groupie)
4. Why do you view other people's selfies? (individual/object/spouse/groupie)

Effects of Taking/Viewing/Posting Selfies

1. How do you like the process when you are taking selfies? (individual/object/spouse/groupie)
2. What do you think about the people when you are looking at their selfies on social media? (individual/object/spouse/groupie)
3. Do you think people edit their selfies before posting them online? (individual/object/spouse/groupie)
4. What do you think of the people who edit their own selfies?
5. After posting your selfies online, how do you expect people to respond to them? (individual/object/spouse/groupie)
6. "Third person effects" how do you like ur selfie and how do you like other people's selfie.
7. Comparison of you in selfies and you in photos taken by others

Section 2
Socio–Cultural Aspects of Selfie–Taking and Selfie–Sharing

Chapter 4
Selfies:
New Visual Culture of New Digital Society

Ayşe Aslı Sezgin
Osmaniye Korkut Ata University, Turkey

ABSTRACT

In this study, digital culture emerging with new communication technologies after oral culture and the written culture will be examined in a critical perspective with the example of selfie. As expressed previously, many studies conducted with the same content has focused on the individual psychological effects of selfies. But study will be focusing on the social effects of selfies which are considered as a new visual culture of the new digital society in this study. The new cultural environment in Turkey created by the selfies in which the impacts of globalization can be observed is being discussed in this study and it will try to evaluate the sociological dimensions of selfies shared publicly by the most widely followed users in Instagram which is among the social media network based on visualization while highlighting the disappeared properties of oral and written culture

INTRODUCTION

Internet and latest information technology that create a revolutionary impact in our lifestyle has brought some hidden risks in the new environment that communication is fast and easy, actually. While selfies are evaluated within these risks, a number of elements that can especially effect mental health negatively in the long term in terms of psychological has come to the fore. It draws attention in this technological environment to the harmful consequences for the millennium generation of the selfies which is likely to cause an identity crisis in terms of socially and proposed to be used with productivity purpose (Gupta & Pooja, 2016).

DOI: 10.4018/978-1-5225-3373-3.ch004

In this study, digital culture emerging with new communication technologies after oral culture and the written culture will be examined in a critical perspective with the example of selfie. As expressed previously, many studies conducted with the same content has focused on the individual psychological effects of selfies. But study will be focusing on the social effects of selfies which are considered as a new visual culture of the new digital society in this study. The new cultural environment in Turkey created by the selfies in which the impacts of globalization can be observed is being discussed in this study and it will try to evaluate the sociological dimensions of selfies shared publicly by the most widely followed users in Instagram which is among the social media network based on visualization while highlighting the disappeared properties of oral and written culture. Clothing, jewelry-accessories, space, hair style, make-up, gestures and facial expressions will be defined as analysis code in the assessment. This regulation system of the indicators, which we confront in more than one dimension with certain regulations in real life, is called coding. All codes are generated and used depending on social communication. We are based on learned-acquired social codes while explaining the image and language. The form of the message is transformed into the form of appearance in coding. We should pay attention to social and historical reasons, which explain why we use physical properties that enable us to express our feelings (Türkoğlu, 2000). These concepts, which are defined as analysis code in the study, are important especially in terms of reflecting cultural values. In the modern world, fashion is considered as one of the main resources that they establish their identities and position themselves relative to others. The analysis codes selected in the study also communicate visual messages about the status of the individual who is closely related to fashion and is the essential feature of the cultural function that fashion shows in everyday life (Bennett, 2013).

At the end of the studies, it is aimed to comment about the social dimension of selfies and find traces of cultural codes which are transferred to different cultures via new communication technologies or disappeared with the effect of globalization via selfies which are New Visual Culture of New Digital Society

Culture based on word and oral which is the basis of the communication between people and exist before writing should constitute the starting point for every researcher who study the cultural development of communities. Sounds piece by piece that makes the language to be heard and the language which mainly dominate the communication not only connected with communication but also with thought in a special way. After writing, words wrapped into a concrete object view and turned into a structure that we can touch as visual cues can tap (Ong, 2003).

Verbal lecture has a different significance in terms of participation, social interaction and integration. Verbal lecture has also an importance cannot be underestimated in the development of interpersonal relationships and the creation of a network of the experiential relationships. In the tradition of Verbal lecture;

storytelling, communication based on words and the words to be used constitute important dimensions. Verbal lecture in which sometimes didactic competence and sometimes pragmatic competence come in the forefront, a smile or a tear drop has even a special effect. (The power of the spoken word: Orality in contrast with literacy, nd.)

Culture which includes all social relationships and holds our beliefs, our values, our attitudes, our traditions and social institutions as together is also an important unifying force position in social, environmental and economic sustainability. Oral culture has played an important role in analyzing the behavior of the dominant culture with regard to this important function of culture (Polistina, 2009).

With the impact of technological developments in modern society, written communication (communication established by writing) began to be used more than verbal communication. However, cultural impact consisting through written and oral communication has had a significant impact on local cultures, individual psychology and society in general (Olson, 2006).

The language of a community could be transferred to future generations in space and time through writing. Writing was continued to be used as the dominant method of communication through records kept and letters. But writing was also evaluated as a very limited representation of the word at the same time. It is not possible to transfer the meaning of a verbal expression via writing as one to one. Meaning transferred by speaking has been quite different from the one being transferred by means of a written text (Olson, 2006).

An important point to be emphasized here is that oral and written culture which has a say in the historical process of social life one after the other should not be considered independently from one another. Oral and written culture intertwined with each other over time and taken place in society life together. The importance of this study clearly arises at this point. After oral and written culture, when we refer to visual culture which is created in the digital world, we are mentioning a new approach that replaces oral and written culture. With a critical perspective, it has become possible to say that we live in a world filled with icons which takes the place of the oral culture by expressing with vocabulary and letters that is declining today. Selfies accompanying to stereotypes and standard sentence starts to create a new culture as the most visible example of the new digital imagery.

While examining the issues of visual culture; cultural structure, artistic, social, technological infrastructure should also be examined in which the visual concepts discussed under this heading (Mitchell, 2002). The effect of these can be felt on the visual of the related society. But with the effect of globalization in recent years, it is possible to say that a general cultural structure established in the world regarding visual culture. New communication technologies which has the unquestionable impact on the overall social life have quite intense effect on this structure. Due to

these impacts of technological developments, it is possible to make comment about this new culture when the selfies are examined in this culture which is named as digital visual culture.

Visual culture which is studied under different disciplines took place under the examination titles in the field of the survey conducted in the field of art history, the methodological work in the social sciences, media studies, philosophy, education and visual arts (Buhl, 2011). Visual culture now should be considered as a separate inspection area in the content established by new communications technologies and this concept is benefited in sociological and psychological assessments along with personal development.

Many studies examining the issue selfie which enters into our daily lives through social media, it was tried to reach conclusions related to the personality of selfie owners (adolescents, celebrities, and so on.) has tried to reach conclusions for the study about personality. However, selfie craze has reached to a more surprising cultural dimension. Selfie reaching an infectious size has started a new trend in technology (Murray, 2015).

BACKGROUND

Culture, Visual Culture, and Social Media in Turkey

When we look at the general structure of society in Turkey and examine this social structure in terms of modernization, we can determine that the concept of culture has been a major problem since the beginning. While doing this, it will be possible to see that serious memory problems, which especially the transition from the empire to the nation state and the Republic has brought, are also being experienced in culture phenomenon. Three different stages can be mentioned in the formation of cultural structure in Turkey. The first of these is the period between 1923 and 1950. In this new period that started with the establishment of the Republic, it has been observed that breakage is experienced away the traditional in the cultural sense (Kahraman, 2013). We talk about a living space that modernity has determined and should be studied with that in daily life. The concept of daily life is also about the culture because it should be evaluated together with social and economic life of the society. Leisure time in Turkey in the 1940s that is between 1923 and 1950 was being spent by reading newspapers, listening to the radio, going to the cinema and making the country trips intensively. In this period, a controller generation, which was also effective in changing the regime with the effect of the War of Independence and then the establishment of the Republic and the opposing generation against this controlling generation were mentioned. While controlling generation was constantly

repeating moral and corruption complaints regarding the period, every phenomenon and change that capitalism has shaped has been given the meaning morally. The change in the country in that period was sometimes criticized, a generation, which is fond of pleasure with extreme westernization and consumes materially and spiritually, was mentioned. It has been suggested that the European (Western) influence gradually left its place to American admiration after 1940's in Turkey. While this effect was being talked about in every field in daily life, criticisms were also made on consumption culture (Cantek, 2013).

In Turkey, women were also affected criticism of popular culture products and consumption culture especially with the influence of America. Trends in women's luxury products and increase in consumption was considered as a degeneration indicator in the context of ethics. It was emphasized that expenditures were made in accordance with requests rather than needs (Cantek, 2013).

The second stage of the formation of cultural structure in Turkey is transmitted in the period between 1950 and 1980. Mass media have also begun to increase their impact on society at this stage that especially the influence of America, which started in 1940's, has been intensified. In this period, written culture received a significant blow against television (Kahraman, 2013).

The third stage in the formation of cultural structure is specified with the period between the 1980s and the 2000s. In this period, Turkey started to enjoy the consumption, hedonism was started to be felt intensely in the society. Urban life has gained a new meaning with this period, rural was dissolved. Local preferences, which were dominant previously, have changed over time and articulation culture has taken the place of dissolving culture and the past was started to be remembered. This period is defined as Tradition in modernism, modernism in tradition (Kahraman, 2013).

It is argued that Turkey is experiencing significant changes in the way of becoming a consumer society at important junctions such as 1980, 1990 and 2002. In Turkey, Culture industry that constitutes the cultural structure of consumer society began to develop and strengthen as a result that private radio and television have begun broadcasting especially since the 1990s. The Turkish economy has begun to integrate into the world capitalist system with the change in the Turkish economy since 1980, liberalization, opening up to the world, reducing the barriers in imports for foreign investments. Liberalization that began in the 1980's formed social structure of consumption and by ensuring the growth of middle class and increasing purchasing power and provided increase in luxurious consumer goods. At this point, television had an affect on Turkish society by being an instrument of entertainment as much as a means of transmitting consumption codes (Demirezen, 2014).

Westernization process in Turkey has often been referred as a transformation of values that collectively form the society. This process has been evaluated by different approaches. One of these approaches is that westernization transforms current values

in society by radicalization. According to this approach, westernization is the process of transferring contemporary norms and values. In another approach, it is defended that some norms and values together with western social forms of modernization process are transferred but final determinant emerges as a result of an interaction with current social structure in this process (Sunar & Kaya, 2014).

The specific qualities of a society will become evident by encountering, gathering the people living in that society with different societies, differences and incompatibilities will show themselves in this way (Aksan, 2008). It is necessary to look at communication tools to understand and interpret that society in such an environment. By understanding and interpreting the media, it will be possible to have information about that society (Kejanlıoğlu, 2005).

Today, it has become possible that communication technologies, which have become one of the most important carriers of the culture, can transmit information to a wide range of masses very quickly. Besides this, efforts to create a uniform culture are being pursued through communication technologies in the globalizing world. The individuals who have been removed from local culture and stranger to their own culture have been started to talk about due to the intensive use of these technologies in daily life. In this alienation process, societies establish a glocal relationship with elements from their own culture by attempting to localize the global (Kırık & Aras, 2015).

Culture, which is defined as all kinds of traditional thought, belief, art, emotional elements that are applicable to a society, is a historical process from the past to the present day and social dynamic that needs to be transmitted to future generations. Culture concept is not independent of language and date elements. Degeneracy phenomenon of any of these elements also brings about alienation in terms of culture of that society (Kırık & Aras, 2015).

Castells's thought (2003) regarding that our belief systems and traditions convert with the new technological system as culture is transmitted through communication and starts with communication, can be observed by the cultural changes of societies after the use of internet and especially social media today.

Media culture has become a dominant socialization force where names of celebrities take the place of families, schools and belief system as determiner of media images and pleasure, value and idea and produce compatible images of style, fashion and behaviour with new identity models (Kellner, 1995).

Media has become one of the dominant elements of daily life. Media has an important role in the formation of a new cultural environment called contemporary culture. Media is now an integral part of the cultural doctrine of daily life. However, even if the media provide representation resources and formats to viewers, viewers who take such information and carry it to their daily lives also continue to benefit

from some local information, which this information is framed and placed in a certain context (Bennett, 2013).

First-rate publishers of life experiences about modernism are the publications that carry the language of that world. These publications, which are also carriers of political language, are also a tool for the consuming magazine at the same time. Discourse, indicators, expeditions are defined as "Hollywood effect" through these publications, i.e. media. In the stories, relations that are not possible to be lived as much as possible to be lived, clothes, houses, places can be transmitted. These transmissions have not been only to offer a consumption ideology but they have also created a consumer that matches the consumer's own ideals (Cantek, 2013).

The universalization of consumption by the influence of the media has also influenced daily culture. The use of the media has a separate importance for young people. Especially young people have an important role in society about adapting foreign sources to local. Internet has achieved an extraordinary success with its structure that makes a large area of connection to a large number of people possible. Now there are societies consisting of individuals who are satisfied with the meaning of consumption by browsing on the internet and able to reflect themselves and their emotions. Internet can also be criticized by its structure that is exhausting, directing to incorrect, making lonely despite its individual and collective gaining (Maigret, 2011).

New communication technologies and the internet offer us different options today. For example, our privacy, openness to people, sharing or not sharing, to agree or disagree with someone are examples of these options. They can also be considered as risks or opportunities. Connections do not only connect us to web pages, they also allow us to connect with each other, information, different actions and transactions. Connections help us to create new societies. Especially young people are making great use of these connections. Millions of people share many things over the internet in cultures with the ability to interact with different cultures. People all over the world are now living more and more public lives increasingly (Jarvis, 2012).

We can specify the results for Turkey for 2016 as follows in the report, which is prepared by digital marketing agency We Are Social every year with global web index data and includes global and local digital statistics (We Are Social, 2016):

- 46 million people have internet connection in Turkey of which population is approaching 80 million people
- 42 million of internet users are actively involved in social media
- Instagram in Turkey is used by 16% of 42 million social media users
- 56% of the population has a smart phone
- 77% of the population is connected to the internet every day

While social media, which now has a separate position and a place in social life through the Internet, can be considered as the most popular consumption area in recent times, it is also thought to carry some missions related to the country where it was produced. Therefore, social media can be considered as an extension of the national and cultural values of the country in which it is used (Kırık & Aras, 2015).

Expansionary American culture and its cultural products, life forms are a threat element for the national culture in the process of globalization. This situation also affects Turkish society as a problem of cultural expansionism. In the emergence of this effect, social media has an important role as one of the most open areas of intercultural interaction. Social media, which carries culture quickly and permanently, has a distinct effect on the society as a whole because it is massive. In these areas where the identity is being rebuilt, the virtual environment is influential in this reconstruction process. Individuals who persist in social media can share information and content as much as they wish and be affected by the influence of different cultures (Kırık & Aras, 2015).

Acceptance of social media to influence every aspect of daily life is also a revolution in terms of individuals' communication skills, habits, lifestyles and forms of socialization. New groups of people, who gathered around common interests in social media, have also discovered new social formations that can respond to the search for belonging and identity. Especially with the influence of social media, new communication and social dynamics of communities are intertwined. In such a case, these communication environments will have to be observed for the analysis of culture of a society, the underlying causes of society members' behaviours, consciousness and identities (Varnalı, 2013).

Social media has brought about structural changes in social life in terms of culture, alienation phenomenon has come to the agenda. Local cultures both in Turkey and in the world, have become under the pressure of social media (Kırık & Aras, 2015).

As a result of social media entering society life, selfies are also an important data through which the changes in culture can be observed. Social media users share their photographic images with other users intensively also in Turkey as in other parts of the world.

The person should continue to be seen to continue to see himself culturally. Visual field view is outside. "I am being looked, i.e. I am a picture; the external look determines me visually at the deepest level". In patriarchal societies, women's point of view also suits the characteristics of this society. In the media where patriarchal culture is dominant, men and women are idealized by the look of the other through photographic images. Photographic images reflected in the media will reflect the cultural values of the male dominant society. In such a society, a male dominated discourse will be the subject. In this discourse, there are idealized types of female body. These typologies invite viewers into their boundaries through the effect of

identification. There are features that are constantly demanded from women through photographic imagery (İmançer & Özel, 2006).

It is possible in selfies to make cultural observations and to be found in certain inferences especially also when sharing in their living spaces in addition to the images that are reflected by the characteristics of the community in which the women are. Individual who is alienated and gets away from local cultural values also includes traces of his/her life habits in particular in selfies that he/she reflects himself/herself in social media, and designs the messages that it wants to give to other users through these images. One of the images that are often seen in selfies is images of metropolitan life. A different environment has emerged that has become a purely objective form of life in the place of every kind of value and spirituality in modern life. The metropolis has become a new cultured area that ignores all kinds of personal lives. In the metropolitan lives, there is a different soul getting away from being personal and new technologies and comfortable environments that capture these spaces in the places where private life can be shared with everyone. Individual tries to keep himself/herself in the face of this new spirit, these environments offer through intense stimuli to individual interesting occupations and innovations that make life easier. The individual who is got caught by a stream because of all these, does not realize that his/her individual culture has become smaller in the face of growing objective culture (Simmel, 2009).

Apart from metropolitan life, we can say that another important visual element in selfies, which are reflected through social media, is fashion and features related to fashion. Especially young social media users in Turkey can also follow and apply world fashion. Uniform individuals take their places in daily life in this area where local culture is gradually disappearing.

Wearing fashionable clothes is not the only way for individuals to build themselves visually. In this sense, other visual features like hair style, make-up and jewellery have also the same level of importance. Fashion also provides for the elimination of the need for social adjustment as an imitation of a defined structure. The individual contributes to the formation of a single type of individual by going the way that everyone is following (Bennett, 2013).

An important part of social media's changes to society life are also in written cultures. Both in selfies and other social media contents, it is possible to say that societies have gradually moved away from written cultures that carry their own local features.

Increasing use of computers and internet is influential in the emergence of vocabulary usage that are broken and changed from its essence. It is possible to encounter results in the form of inattention in Turkish letter usage, never writing some letters, changing some letters in Turkey. The Internet and social media continue to create their own writing style and culture (Karahisar, 2013).

MAIN FOCUS OF THE CHAPTER

Changing Forms of Culture: Words, Scripts, and Visuals

In a society that has the tradition of oral culture; it is observed that members of that society transmit their tradition and cultural values of the past to future through ideas and feelings. Members of such societies are responsible for preserving and maintaining all forms of oral tradition. In this respect, it can be argued that memory and cultural elements are transmitted through sounds, words, and expressions in oral tradition. In such a cultural atmosphere where rhetorical skills become significant, culture is recreated through the word. The roots of oral narratives trace back to ideas and the detailed transmission of these ideas. Dynamic cultural elements of society (narratives, folk songs, dances, etc.) as well as artistic and rhetorical factors also contribute and enrich oral narratives. Likewise, in oral narratives, silence also has an impact upon culture just as sounds do. Elements of silence should also be evaluated within the scope of oral narratives which has a significant share in the culture of oral tradition. In a culture which is formed by oral narratives, it is possible to observe the traces of a transmission from the past to future (Devantine, 2009).

In societies that have different cultural structures, there are different communication models. Concepts of communication, society and culture cannot be evaluated separately, and they provide clues regarding one another. The communication system in a society provides information regarding the societal structure and culture of that very society. Low-populated traditional primitive communities have an oral culture where oral communication dominates. In these societies where speech and listening enable communication, information is received through hearing. Besides listening and hearing, memory also has an important role in oral culture with its collecting and transmitting qualities. In an oral culture where information is of paramount importance, stories also have a significant role as a form of narration (Batuş, 2007).

Anthropologists and historians have continued to use oral narratives as a communication tool even after the invention of writing due to its practicality and durability. As a matter of fact, oral narratives were still regarded as a tool to be shaping cultural and social contexts. In illiterate or partially illiterate societies, oral narratives are either used instead of written narratives or they were used where there were no written narratives. Literacy and oral narratives have been two different communication methods between people. Unrecorded information of oral narratives was preserved through written narratives. Yet, oral narratives have also contributed for the transmission of information throughout generations with its own unique, evocative techniques. Positive and negative factors that were offered to societies by oral and written communication in the formation of their own cultures might be characterized separately (Innes, 1998).

In societies that have the tradition of oral narration and oral culture, it is possible to observe participation, social interaction, and unity. There are interpersonal and experience-related networks of relationships in oral narratives. There is a social event in participant-prone oral narratives where there are at least one narrator and listener. Oral tradition sometimes transmits social values with its didactic aspect and thus extends societal identities. This very transmission and extension itself are achieved through paper and ink in written culture. Time and space-related organizations are recorded through archives and therefore, history is recorded in written culture. In written culture, meanings and information have been independently self-sufficient. Unlike oral narratives, information is directly transmitted without any media in written narratives. It is possible to speak about a process which can be experienced and objectified on its own in written narratives (The power of the spoken word: Orality in contrast with literacy).

Some sources refer to writing as an art and highlight its introduction to social life at different times and spaces. As a tool for cultural expansion in certain areas, writing has been a research topic due to its significant impact upon the rise of civilization and the beginning of history. Writing, utilized by people who witness history, has an important role in the transmission of culture. Messages that were broken away from time and space were transferred to different periods through writing. As a result, transition from oral to written narratives, communication tools also went through a transformation while the quality of messages has changed. Messages have turned into a tangible structure through writing, and they were transferred through multiplication. Writing has also assumed an important role on the basis of developing analytical skills and reasoning. As writing extended throughout societies, written culture and its impacts started to play an important role in the process of democratization (Panosa, 2004).

Changes in the social sphere along with the developments in writing technologies have brought about certain changes in written culture. Speaking of a literate society does not necessarily refer to a society that has the fundamentals of written culture. Here, the difference is about which functions of literacy are utilized by that society. Written culture is also defined as the determination of the differences between social and legal contracts and written and oral codes in society by implementers. The seeds of a powerful written culture have been sawn with social and technological transformations which took place in the West. People reading what has been recorded through written culture have developed their writing and reading skills through formal learning in modern times (Baron, 2005).

Following oral and later the written culture which was formed as a result of transmitting written texts to next generations with the invention of the printing press, visual culture should be mentioned which has an indispensable place in modern times with the development of new technologies.

Buhl (2011) mentions about the two different approaches regarding studies on visual culture. According to Buhl, the first approach is a visual culture approach where any kind of visuals are examined and the second one is a movement where visual culture is explained with a methodological approach throughout the social construction process.

It is possible to state that visual culture stems from different disciplines. Academicians who study in art history have collaborated with social scientists in order to extend the visual field and to enrich methodologies that are applied in this field while academicians in the field of media have made important studies with academicians in the fields of philosophy and education. As a result, research on visual culture are available in the fields of media and education as well as in visual arts (Buhl, 2011).

Due to the gap between contemporary cultural elements and visual resources as well as the lack of relevant observations regarding these visuals have necessitated further studies on visual culture. Visual culture is related to the acknowledgment of information and meanings about a visual by spectators of visual technologies. It is observed that images and visuals design post-modernism in visual culture, unlike in written texts. Visual culture does not necessarily refer to images; this culture is about creating an image or visualization. With the development of internet technologies in our everyday life along with social media platforms called web 2.0, as well as digital videos and high-definition TVs, keep improving the importance attributed to visual culture and visuality (Mirzoeff, 1999).

Unlike traditional art history, visual culture is related to mass culture and popular art. Images, instead of scripts and texts, have been highlighted by researchers who support new visualities and who study on new visuality. We might need to focus more on these visuals while living in a world that is surrounded by images. Emotional experience is especially important in visual culture instead of oral, verbal experiences that are related to language. According to another point of view, visual culture can be regarded as a tool for post-modernism. An interdisciplinary approach with an anthropological perspective which is culture-related is applied in visual culture (Homer, 1998).

The concept of visual culture has reached to a different dimension as a result of its evaluation within the framework of social events with a daily-life perspective rather than being approached in terms of art history. Evaluating visuality within the framework of a social and cultural process, "Visual Culture" (Jenks, 1995) can be regarded as an example to this. This book has explanations regarding the images of ordinary social relationships of the routine. Questions such as what we see, how we perceive, how the things we see are related to the society we live in, sources of information regarding the images, power relations and what personal desires are

as well as whether we can realize those informal social relationships between the image and reality are addressed in this book (Jenks, 1995).

There might be many different reasons why transformation into visual culture has occurred in social life. Yet probably one of the most important reasons that should be highlighted is the fact that prying has become a habit in the society of the spectacle which has economically developed. The society has gone through a cultural transformation and evolved into a visual one. Visuality has never been at the forefront in the history of man and has never been utilized to this extent in the formation of identities or in the acquisition of information. This is the first time that production and open distribution of visuals have been so intense and widespread. There used to be no aesthetic concerns regarding images and visuals, and these images have never been used for the purpose of manipulation. Today, styles and images have a crucial role in the production of pragmatic items and services. Images are no longer in line with reality while visuals refer to one another and reconstruct reality (Duncum, 2001).

Visual culture has created a brand new cultural sphere where new technologies develop new economic orders and where social formations evolve. Apart from the things we visually see through our eyesight, visual culture defines the meanings and impacts of images upon social life in line with social conditions (Duncum, 2001).

The Internet and especially social media have paved the way for a totally different approach to visual culture. Culture, which cannot be perceived without the concept of society, (Giddens, 2000) is reformed with visual elements of the new communication technologies. Especially social networking sites have a crucial role in this reformation. In this new sphere which is referred to as network culture by Van Dijck (2013), visual elements draw attention. Apart from network culture, information is interactively distributed in this new sphere which is defined as the digital culture (Şişman, 2012).

As a community platform where people from different spaces and time zones can get together, social media (Van Dijck, 2013) and traditional media tools (Durham & Kellner, 2006) that are studied in the fields of media and culture should be examined within the scope of cultural studies as a new media platform considering their impact upon social life.

It is possible to state that with the introduction of writing in human history and transition of societies into written culture, the concepts of gathering, assembly, acting together, and dynamic elements of culture (such as story-telling and singing, etc.) which were observed in oral culture have turned into a rather individualistic state. Since a pen, paper and ink were sufficient in written culture, a narrator and a listener was no longer mandatory in the formation or transmission of written culture. Yet this alienation and solitude are much more prevalent in the new culture of the

contemporary digital world which emerged following the coexistence of oral and written culture. Today, digital screens and keyboards have replaced pen and ink. In this brand, new cultural spheres where words and writings are no longer needed, people have created a new world which is self-centered where there is only "me" and "myself."

Being Only "Me" in a Society and Creating a New Culture

Selfies that first made a quick entrance into our lives by simply turning the cameras on smartphones and tablets to ourselves now have special selfie features in various technological toys and multifunctional visual filters. Almost every day a new selfie with different contents can become a social media phenomenon all over the world. Well, then what is a selfie? A selfie can be defined as an imagery object transferring humane emotions in a relational way of photography. References are made to the relations between the photographed and the photographer, to the viewer and audience, to users and social media architects, to images and individuals. Selfies are generally designed to be transferred to different individuals, communities, and masses for the purpose of sharing them. As a result of this, reactions (censorship, criticism, making comments, etc.) are followed through social media. Selfies have turned into images that show how discourses of people are documented and expressed as they became one of the ordinary practices of everyday life (Senft & Baym, 2015).

It can be argued that we live in the age of selfies today. Self-portraits that are captured via cameras are distributed through networks which are used as a means of visual communication that declares where we are, what we think about, what we do and transfer all these to other people. In sociological and psychological terms, it can be argued that selfies transform social interactions, personal awareness, body languages, privacy, sense of humor, etc. (Saltz, 2014). Selfies that have their own structural features have provided a brand new visual presentation to self-portraits. Selfies that present quick and improvised moments of everyday life are shared with other people that we are not familiar with through social networks (Saltz, 2014).

There are two approaches regarding the reason why people take selfies. The first approach argues that people feel a sense of satisfaction while viewing themselves as an indication of narcissism. The other argument claims that taking selfies indicates self-confidence. Looking at its historical process, it is seen that Robert Cornelius has first taken his own photograph in 1839 in the USA. Selfies in its contemporary meaning are first seen in 2004 on a website called Flickr (Fausing, 2013; Gupta & Pooja, 2016). Today, it is observed that selfies are negatively impacting individuals' everyday life. For example, a term *selfitis*, a psychological disorder, can be found in the literature which refers to the obsessive desire to take photos of one's self and share them on social media (Gupta & Pooja, 2016).

Selfies are now an indispensable part of social media. Yet selfies should not solely be considered as a social media trend considering their production and consumption. Selfies are produced by the culture that they are in, and they provide and design social messages regarding that culture. Selfies can be utilized while analyzing certain messages regarding a specific culture. Race and gender which are important elements while analyzing the content of social messages are influential even while analyzing the selfie culture (Williams & Marquez, 2015).

As a result of the widespread use of mobile phones with cameras, selfies are preferred by many people and have evolved into a movement in social life. The new technological features of smartphones (front cameras) have greatly contributed to this movement. Selfies have assumed the role of a tool in representation and identity formation of people, especially of youth and even children. The interesting part is that especially young people are under the influence of how celebrities look like. These model visuals that are propagated in commercials can be observed in the selfies taken by young people. Contradictory behaviors that do not fit in the norms of different cultures can emerge as a result, and controversial outcomes in social behaviors might be observed in that culture (Mascheroni et al., 2015).

A research on the use of selfies among college students in USA, UK, and China was conducted in 2014 by Boston University Center for Mobile Communication Studies. This research was about the use of mobile communication methods in different cultures, and its purpose was to understand the production and consumption methods of personal digital images. Research outcomes show that selfies are used for multiple purposes, and it was found that visual information that emerges out of selfies during a communication process swiftly changes. Visuals with unknown sources which are distributed through social media, such as caricatures, seem to be replacing words. Similar visuals are used in dialogues now. Selfies are also amongst such visuals that are utilized during this communication process (Katz & Crocker, 2015).

While Fausing (2013) details the emergence of selfies, he highlights the fact that selfies are about controlling one's own image and that selfies are a form of reflection and recognition of an identity. Claiming that the act of taking your own photo which creates the idea of selfie had already been existent in the past, Fausing argues that the action itself has become a phenomenon under the name of selfie in contemporary times. Through selfies, other people have the chance to evaluate us. Our inner world has become to be a reflection of our image (Fausing, 2013).

Selfies that are published on social media through smartphones and webcams have started to create a new culture as a rising visual experience. Selfies now have a different yet important place in the complex structure of networking. Selfies that reach audiences in social networks through digital devices and photographs are actually transferring the language and logic of belonging which can be related to one

another. This new culture which is designed by technology is becoming widespread through networks and our private images in our personal spheres become public (Hess, 2015).

An important point made in studies on this new culture which is created by through social media is that especially young women have an intense interest in taking selfies. Usually, research on women's utilization of selfies are seen on news media (Murray, 2015). (e.g. BBC "Muslim woman's cheeky selfie with anti-Islam group goes viral," New York Times "Make up for the selfie generation").

The concept of *beauty* which is defined by popular culture in line with its own values can be observed among the selfies of young women all over the world which have the same makeup, hair and clothing styles. Young women who are inspired by the looks of Hollywood stars try on these styles and fashions on their own bodies whether they fall in line with their age, culture and social lifestyles or not. The following statement made by a participant of a study which was about selfies of young women in Singapore is extremely interesting: "even though I do not find this look beautiful, I start to like and practice that makeover after I receive compliments on social media" (Chua & Chang, 2016). As it is understood from this statement, a brand new cultural sphere is created on social media through selfies irrespective of the cultural elements of the very society itself.

In their new cultural sphere where they go beyond time and space, selfies have brought about new concepts which are specific to this culture. A social media user from any part of the world can learn about all these concepts right away. Apart from selfies, *usies* where more than one person is smiling into the camera, *felfies* where farmers capture their own photos with a sense of humor and *healthies* which are captured at sports centers (Fausing, 2014) can be regarded as examples for this.

Selfies that emerged out of technological convergence has become an area of study in different disciplines as a result of the phenomena they created. Selfies have become a subject matter in various disciplines such as media and cultural studies, art history, visual culture, the internet and social media studies, anthropology, sociology and cinema studies (Warfield, 2014).

Interesting outcomes have been gained about the new role of selfies in people's lives that creates a new culture as a result of being studied under different names and disciplines. A study by Gibbs et al. (2014) entitled Funerals: Remediating Rituals of Mourning can be considered as an example to this. This study argues that even mourning has reached to a different level in the age of smartphones and claims that selfies taken at funerals and published on social media has created a new culture especially among young people in the digital age. Taking selfies at funerals that can be considered as a tragic act before the reality of death seems to have reached a state which is beyond narcissism, self-confidence or simply a popular act conducted by youth.

Another study highlights a different aspect of selfies and argues that they can be considered as a political act which is related to activism and narcissism. Another study by Boon and Pentney (2015) entitled Virtual Lactivism: Breastfeeding Selfies and the Performance of Motherhood has made a sociological research on selfies taken by breastfeeding mothers who publish them on social media. This study argues that mothers who take selfies while breastfeeding are aware of the power of visuality while constructing and shaping realities.

According to Nemer and Freeman (2015), discussions that regard selfies as a form of narcissism, self-confidence or simply the desire of young people to imitate celebrities are rather limited and inadequate. Their ethnographic research has investigated the intense socio-cultural contexts of selfies in a study made on Brazilian people living in slum areas. This study reveals that selfies taken by these people who live under oppression and economic difficulties are perceived as the representation of power in socio-cultural terms. People living in slum areas have faced with their social, emotional and physical needs through digital technologies.

DISCUSSION: A SOCIOLOGICAL ANALYSIS ABOUT SELFIES

This study focuses on the societal impact of selfies, namely the new visual culture of the digital world. This new cultural sphere which is created by selfies that are influenced by globalization will be studied in the case of Turkey. Selfies that are publicly shared by most followed accounts on Instagram, a social media platform which is based on visuals, are sociologically analyzed in this study where codes of analyses are determined as clothes, accessories, spaces, hair-makeup styles, gestures, and mimics.

Codes that are defined as indicators which are united in certain forms as speech, writing and images are evaluated as the micro units of communication. Communication that is achieved through verbal, visual codes and indicators, (Günaydın, 2006) follows the same process on social networking sites. Selfies, in which visual factors serve as the only power, enable us to observe global elements rather than specific, cultural factors. This study has attempted to reach the global influences of this visual culture through codes. Instead of being evaluated as a simple form of expression or an indication of narcissism and self-confidence, this study underlines the fact that selfies are utilized by various sociological means and purposes among different societal segments where a new culture is created.

After the internet and social media has become an indispensable part of social life, various studies have been made on this issue in many different disciplines, primarily in communication sciences, sociology, and psychology. These studies where the positive and negative impacts of the internet and social media upon people's lives are

discussed also include interesting researches on selfies. As a social media network based on images, Instagram is a virtual platform where users publish their selfies.

Selfies that are publicly shared by top three most followed users on Instagram in the category of phenomena in Turkey on September 20, 2016, are examined within the framework of the subject matter of this study, namely *visual culture*. Data from Boomsical which makes up-to-date analyses on social media statistic are utilized for this study. As a Social Media Analysis System, Boomsical compares, reports and follows the existences of brands on social media. Boomsocial, which offers free service like Google Analytics, is the product of Boom Sonar, one of the social media monitoring systems not only of Turkey but also of Europe. Boomsocial offers its users different statistics about social media (fan number, sector averages, current up-to-date increase information on the pages) (Barutçu & Tomaş, 2013). Similar studies have also used Boomsical data whose tasks are defined as measuring, reporting, analyzing and creating statistical programs of social media free of charge (Boomsical, 2016).

According to data gathered from Boomsical as of September 20, 2016, Hande Erçel is the most followed user on Instagram in Turkey with 3.133.750 followers, and all her photographs are shared publicly on the net. This account is chosen as a sample for being a personal account, sharing selfies and being the most followed account in Turkey under the category of phenomena. Hande Erçel, 23, is an actress mainly followed by Turkish youth. Recognized as a styling icon by young women, Hande Erçel has shared 185 photos on her Instagram account. It has been detected that 76 of these photos, as of September 20, 2016, are selfies. 347 thousand people have liked, and more than 11 thousand comments are made for the last photo that Erçel has shared. Erçel has more than 3 million followers. Looking at the content of comments made on Erçel's posts by her fans is mainly about the beauty of her hair, makeup, clothing, and style.

Norms that create culture can be explained as written and unwritten codes, traditions, and customs, behaviors, interaction and communication between people. It is possible to argue that especially new technologies have a great influence on the process where interaction and communication are at their heights and where they are deconstructed and reproduced in modern societies (Anık & Soncu, 2011). In this study, Instagram is studied as a tool in the formation of a new visual culture and Instagram is interesting in the reproduction process of culture in terms of the interaction and communication of people.

From industrial revolution to current technological developments and propagated consumption should be highlighted while explaining the economic aspect of modernism. Today, modern man leads their lives through various technologies in metropolises. Individual life is completely under supervision and surveillance (Anık & Soncu, 2011). Hande Erçel's Instagram account in which her posts are publicly

shared with her 3.1 million followers is an example to this surveillance with its implications on modern man.

Considering the codes in her posts (clothes, accessories, place, haircut style, makeup, gestures, and mimics) are interesting in terms of their propagation and promotion of consumption which is an aspect of modernism. Sunglasses, accessories, clothes, makeup and other details in Hande Erçel's 76 selfies are liked by many followers (Figure 1).

In sociological terms, electronic media is of paramount importance in mass communication. Electronic media comes first among tools that applaud modern world, and that carry modern ideologies and social norms (Lull, 2001).

Examining the selfies of Hande Erçel, who is a phenomenon in the social media platform of Instagram in Turkey which is popularized by mass communication tools that are especially used by young people, it is understood that her posts are mainly about the fun environments and places she is in (Figures 2 and 3). Here mass communication tools exceed certain limits and constantly repeat certain perspectives while reproducing meaning which is a routine for transferring information and examples of how information and fun are made widespread can be observed (Lull, 2001).

Figure 1.

Figure 2.

Figure 3.

It is observed that fashion trends influence culture and awareness in all over the world through the power of homogenization. As a result, certain standardizing values and practices are offered and reinforced (lull, 2001). In this study, the sampling which is composed of a certain social media network was intended to be evaluated within the framework of Lull's (2001) argument which claims that cultural-political-economic impacts are not introduced to cultural spheres in a single form and that they are usually in interaction with local spheres where these impacts encounter a myriad of ideologies and traditions. However, after these selfies were examined, no images that reflect Turkish culture and social life were encountered. Instead, mainly clothes and accessories that are in line with fashion trends, as well as hair and makeup styles, are highlighted in these selfies (Figures 4,5, and 6).

Six images with selfies feature the actress who was chosen as an example in the study and accepted as Instagram phenomena in Turkey were examined. A user profile that is within the metropolitan life, is far from local cultural traces, closely follows the contemporary world fashion has been identified in the images generally. The actress, who takes her selfies alone, gives messages to his followers with his gestures and mimics. The pressure of social media on cultures, which was expressed in the previous sections of the study, can also be observed clearly in this study that the sample of Turkey is examined through selfies.

Figure 4.

Figure 5.

Figure 6.

CONCLUSION

Early studies on this topic have regarded selfies as a form of narcissism and act of self-confidence, especially among young people and women. However, later works argue that selfies seem to have reached a different stage in social terms. It is possible to state that selfies that imitate Hollywood stars create new consumption habits and a new cultural sphere where cultural differences and norms are no longer valid. Selfie culture that has had the chance to become widespread in a sphere where there are no burdens regarding time and space has paved the way for the emergence of new areas of study as a visual culture. This new selfie culture that finds its place in all kinds of realities of life reveals itself with a different aspect in all fields from funerals to politics, and from sports to many other fields.

The written culture which was introduced to man's history with the invention of the printing press following oral culture has been replaced by a visual culture in the digital age where oral or written culture are no longer needed as much. As one of the most important tools of this new cultural sphere where even one image alone can be sufficient, selfies have become such visuals that we share almost every moment of our everyday lives with other people. Selfies that are selected to be studied in this research are examined within a Turkish context on a social network where visuality is the most powerful way of expression. The purpose of this study was to make a discussion on the social position of selfies in cultural terms rather than evaluating them in the context of narcissism and a form of self-confidence. It is possible to state that selfies that were examined in this sampling do not reflect the socio-cultural features of the society that they originate from, and instead they are especially in line with the boundless structure of new communication technologies; moreover, the sampling shows that those selfies have such elements that are unique to this new culture where people from almost all over the world can perceive that mutual language.

REFERENCES

Aksan, D. (2008). *Türkçeye yansıyan Türk kültürü*. İstanbul: Bilgi Yayınları.

Anık, C. & Soncu, A. (2011). Kültür, medeniyet ve modernizm üzerine "yaprak dökümü" bağlamında bir değerlendirme. *Global Media Journal*, 2, 52-83.

Baron, N. (2005). The future of written culture envisioning language in the new millennium. *Journal of the European Association of Languages for Specific Purposes*, 9, 7–31.

Barutçu, S., & Tomaş, M. (2013). Sürdürülebilir sosyal medya pazarlaması ve sosyal medya pazarlaması etkinliğinin ölçümü. *Journal of Internet Applications & Management*, *4*(1), 6–23.

Batuş, G. (2007). Sözlü kültürden kitle kültürüne geçiş sürecine direnen değerler. Retrieved from: http://cim. anadolu. edu.tr/pdf/2004/1130853303.pdf

BBC. (2016, May 18). Muslim woman's cheeky selfie with anti-Islam group goes viral, Anisa Subedar. Retrieved from http://www.bbc.com/news/blogs-trending-36323123

Bennett, A. (2013), Kültür ve gündelik hayat. Nagehan Tokdoğan, Burcu Şenel, Unut Yener Kara (çev.), Ankara: Phoenix.

Boomsocial. (2016). Retrieved from http://www.boomsocial.com

Boon, S., & Pentney, B. (2015). Virtual lactivism: Breastfeeding selfies and the performance of motherhood. *International Journal of Communication*, *9*, 1759–1774.

Buhl, M. (2011). So, what comes after? the current state of visual culture and visual education. *Synnyt Origins: Finnish Studies In Art*, (1), 1-7.

Cantek, L. (2013). *Cumhuriyet'in buluğ çağı, gündelik yaşama ilişkin tartışmalar 1945-1950*. İstanbul: İletişim Yayınları.

Castells, M. (2003). *Ağ toplumunun yükselişi*. İstanbul: Bilgi Üniversitesi Yayınları.

Chua, T. H. H., & Chang, L. (2016). Follow me and like my beautiful selfies: Singapore teenage girlsengagement in self-presentation and peer comparison on social media. *Computers in Human Behavior*, *55*, 190–197. doi:10.1016/j.chb.2015.09.011

Demirezen, İ. (2014). Türkiye'de tüketim toplumuna doğru: Sekülerleşme, muhafazakarlık ve tüketimin dönüşümü. In L. Sunar (Ed.), Türkiye'de Toplumsal Değişim, Ankara: Nobel Yayıncılık.

Devantine, F. (2009). Written tradition and orality. *Shima. The International Journal of Research into Island Cultures*, *3*(2), 10–14.

Duncum, P. (2001). Visual culture: Developments, definitions, and directions for art education. *Studies in Art Education*, *42*(2), 101–112. doi:10.2307/1321027

Durham, M. G., & Kellner, D. M. (2006). *Media and cultural studies: Keyworks*. UK: Blackwell Publishing.

Fausing, B. (2013). *Become an image. On selfies, visuality and the visual turn in social medias*. Digital Visuality.

Fausing, B. (2014). Selfies shape the world. Selfies, healthies, usies, felfies. *Academia. edu.*

Gibbs, M., Carter, M., Nansen, B., & Kohn, T. (2014). Selfies at funerals: Remediating rituals of mourning. *Selected Papers of Internet Research, 15,* 21–24.

Giddens, A. (2000). *Sosyoloji.* Ankara: Ayraç Yayınları.

Günaydın, A. U. (2006). Akbank reklamlarında folklorik unsurların, kültürel kod ve göstergelerin işlevi. *Milli Folklor, 18*(71), 56–59.

Gupta, R., & Pooja, M. (2016). Selfie: An ınfectious gift of ıt to modern society. *Global Journal for Research Analysis, 5*(1), 278–280.

Hess, A. (2015). The selfie assemblage. *International Journal of Communication, 9,* 1629–1646.

Homer, W. I. (1998). Visual culture: A new paradigm. *American Art, 12*(1), 6–9. doi:10.1086/424309

İmançer, D., & Özel, Z. (2006). Psikanalitik açıdan fotoğğrafik görüntüde toplumsal cinsiyetin sunumu. In D. İmançer (Ed.), Medya ve Kadın, Ankara: Ebabil Yayınları.

Innes, M. (1998). Memory, orality and literacy in an early medieval society. The Past and Present Society, 58, 3-36.

Instagram, H. E. (2016). Retrieved from https://www.instagram.com/handemiyy/?hl=tr

Jarvis, J. (2012). *E-sosyal toplum. Çağlar Kök (çev.).* İstanbul: Media Cat.

Jenks, C. (1995). *Visual culture.* Psychology Press. doi:10.4324/9780203426449

Kahraman, H. B. (2013). *Türkiye'de görsel bilincin oluşumu, Türkiye'de modern kültürün oluşumu.* İstanbul: Kapı Yayınları.

Karahisar, T. (2013). Dijital nesil, dijital iletişim ve dijitalleşen Türkçe. *Online Academic Journal of Information Technology, 4*(12), 71–83.

Katz, J., & Crocker, E. T. (2015). Selfies and photo messaging as visual conversation: Reports from the United States, United Kingdom and China. *International Journal of Communication, 9,* 1861–1872.

Kejanlıoğlu, B. (2005). *Medya-toplum ilişkisi ve küreselleşmenin yerel medyaya sunduğu olanaklar. Sevda Alankuş (der.), Medya ve Toplum.* İstanbul: IPS İletişim Vakfı Yayınları.

Kellner, D. (1995). *Media culture: Cultural studies, identity, and politics between the modern and the postmodern.* New York: Routledge. doi:10.4324/9780203205808

Kırık, A. M., & Aras, N. (2015). Sosyal medyanın kültürel yabancılaşma olgusundaki rolü. In A. Büyükaslan, & A. M. Kınık (Ed.), Sosyalleşen Olgular, Sosyal Medya Araştırmaları 2. Konya: Çizgi.

Lull, J. (2001). *Medya iletişim kültür. Nazife Güngör (çev.).* Ankara: Vadi Yayınları.

Maigret, E. (2011). *Medya ve iletişim sosyolojisi. Halime Yücel (çev.).* İstanbul: İletişim Yayınları.

Mascheroni, G., Vincent, J., & Jimenez, E. (2015). Girls are addicted to likes so they post semi-naked selfies": Peer mediation, normativity and the construction of identity online. *Cyberpsychology (Brno), 9*(1). doi:10.5817/CP2015-1-5

Mirzoeff, N. (1999). *An introduction to visual culture.* London: Routledge.

Mitchell, W. J. (2002). Showing seeing: A critique of visual culture. *Journal of Visual Culture, 1*(2), 165–181. doi:10.1177/147041290200100202

Murray, D. C. (2015). Notes to self: The visual culture of selfies in the age of social media. *Consumption Markets & Culture, 18*(6), 490–516. doi:10.1080/10253866.2015.1052967

Nemer, D., & Freeman, G. (2015). Empowering the marginalized: Rethinking selfies in the slums of Brazil. *International Journal of Communication, 9*, 1832–1847.

Olson, D. (2006). Orality and literacy: A symposium in honor of David Olson. *Research in the Teaching of English, 41*(2), 136–143.

Ong, W. J. (2003). *Sözlü ve yazılı kültür sözün teknolojileşmesi, Sema Postacıoğlu Banon (çev.).* İstanbul: Metis.

Panosa, I. (2004). The beginnings of the written culture in Antiquity, *Revista Digital d'Humanitats, 6.*

Polistina, K. (2009). Cultural literacy: Understanding and respect for the cultural aspects of sustainability. In A. Stibbe (Ed.), The handbook of sustainability literacy: Skills for a changing world (pp. 117-123).

Saltz, J. (2014). Art at arm's length: A history of the selfie. Retrieved from http://www.vulture.com/2014/01/history--of--the--selfie.html

Senft, T., & Baym, N. (2015). What does the selfie say? Investigating a global phenomenon. *International Journal of Communication, 9*, 1588–1606.

Simmel, G. (2009). *Bireysellik ve kültür. Tuncay Birkan (çev.).* İstanbul: Metis Yayınları.

Şişman, B. (2012). Sayısal kültür, toplum ve medya: Msn örneği. *Gümüşhane Üniversitesi İletişim Fakültesi Elektronik Dergisi, 3,* 89–101.

Sunar, L., & Kaya, Y. (2014). Toplumsal yaşamda değerler: Modernleşme, muhafazakarlaşma ve kutuplaşma. In L. Sunar (Ed.), Türkiye'de Toplumsal Değişim. Ankara: Nobel Yayıncılık.

The New York Times. 22 September 2015, Makeup for the selfie generation, Courtney Rubin. Retrieved from http://www.nytimes.com/2015/09/24/fashion/selfie-new-test-makeup.html?_r=0

The Power of the Spoken Word. (n. d.). Orality in contrast with Literacy. Retrieved from http://www.lib.uidaho.edu/digital/turning/pdf/orality.pdf

Türkoğlu, N. (2000). *Görü-yorum gündelik yaşamda imgelerin gücü.* İstanbul: Der Yayınları.

Van Dijck, J. (2013). *The culture of connectivity: a critical history of social media.* New York: Oxford UP. doi:10.1093/acprof:oso/9780199970773.001.0001

Varnalı, K. (2013). *Dijital kabilelerin izinde, sosyal medyada netnografik araştırmalar.* İstanbul Mediacat.

Warfield, K. (2014, October 29-30). Making selfies/making self: digital subjectivites in the selfie. *Presented at the Fifth International Conference On The Image And The Image Knowledge Community,* Freie Universität, Berlin, Germany.

We Are Social. (2016). Digital in 2016. Retrieved from http://wearesocial.com/

Williams, A. A., & Marquez, B. A. (2015). The lonely selfie king: Selfies and the conspicuous prosumption of gender and race. *International Journal of Communication, 9,* 1775–1787.

KEY TERMS AND DEFINITIONS

Culture: Characteristics of a society, particular group of peope which define the structure of this society with language, knowledge, beliefs, experiences, attitudes, values, roles, religion, habits etc.

Digital Society: New form of a society which formed by using new technologies like new media, new communication technologies.

Instagram: Popular social media network which transfers, capture and share the moments of social and private life of a person through especially with the photos and images by using special visual effects.

Oral Culture: Traditions and charaecteristics of a society before written culture by consisting speech and words, form of a human communication.

Selfie: A style of taking photo and also photographic object that indicates the self of human via internet and social media.

Social Media: New media channels (e.g. Facebook, Twitter, Instagram) which offer content producing, unlike traditional media channels (e.g television, radio, printed media products) for its users in digital age at 21st Century.

Visual Culture: Visual culture is a culture about visual technology and culture concerned about visuals, expressing culture with visual images.

Written Culture: Culture of a society after and together with the oral culture which consist of written, printed texts.

Chapter 5
Self–Objectification vs. African Conservative Features in the Selfies of Black African Women:
A Study of Nigerian Social Media Users

Endong Floribert Patrick Calvain
University of Calabar, Nigeria

ABSTRACT

Though popularly construed as a universal phenomenon, selfie taking is gendered and culturally determined. This could be evidenced by the fact that the two socio-cultural forces of conservatism and traditionalism continue to tremendously shape African women's style of taking and sharing selfies on social media. Based on a content analysis of 200 selfies generated and shared by Nigerian women on Facebook and Instagram, this chapter illustrates this reality. It argues that Nigerian women are generally more conservative than liberal in their use of selfies for self-presentation, self-imaging and self-expression in public spaces. Over 59% of their selfies have conservative features. However, despite the prevalence of conservative myths and gender related stereotypes in the Nigerian society, the phenomenon of nude or objectified selfies remains a clearly notable sub-culture among Nigerian women. Over 41% of Nigerian women's selfies contain such objectification features as suggestive postures; suggestive micro-expressions and fair/excessive nudity among others.

DOI: 10.4018/978-1-5225-3373-3.ch005

INTRODUCTION

The act of taking and sharing selfies on social networks is arguably considered a universal tradition, as it transcends ages, races, cultures and genders. As a remarkable revolution in self-portraiture, self-representation and self-expression in the digital era, the tradition has become part and parcel of virtually everybody's life, particularly those equipped with the necessary gadgets: a smartphone, a (sex) selfie stick, webcam and internet connection. From simple students through entertainment divas to influential politicians, people from all walks of life have embraced this culture. Such a popular culture stems from the fact that the act of taking and sharing selfies is very much inline with the two neo and fashionable trends of publishing/ "broadcasting" oneself to digital audiences and appropriating the social networks through citizen journalism. As Klomp (2014) rightly puts it, publicizing oneself to digital audiences through social media sites such as Instagram, Twitter, Facebook, YouTube and the like has simply become "a norm" which enables people irrespective of age, walks of life, race, culture and gender to communicate themselves in a completely new way. The advent of the new media and other digital technologies has thus engendered a situation where in, audiences have ceased to be mere consumers of media contents. They have progressively become "pro-sumers" (producers of online contents) and citizen journalists. Using selfies has thus become just an integral aspect of striving to be a part of social/online communities.

However, despite its globalization and universal nature, the use of selfies, is, in many respects, culturally and gender determined. Gender-based variations in the use of selfies seem to be the most evident of these two categories; no doubt the tradition is popularly described as being gendered in nature or gender-driven. According to a transcontinental study conducted by SelfieCity, it was discovered that women use selfies more than men. The study equally revealed that women tend to take more expressive, provocative and sexy poses than men in their selfies. This is illustrated by the fact that, on average, the head tilt of a woman's selfie is 150% higher than for men (12.3° vs. 8.2°). This signifies that many awful women take selfies holding their cameras way above their heads, mostly to fit their bikini in-frame (Brownlee, 2016; Rettberg 2015; SefieCop, 2016; Tifentale & Manovich 2015). Based on this observation and related indexes, it has been argued that selfies have become a veritable site of women self-objectification. In fact, it has become a common culture among feminist scholars to equate selfies to "the male gaze gone viral" or to an experience through which, women think that they must look hot and feel "fuckable" for them to be visible or achieve social acceptability (Dine 2011, D'Eon, 2013; Kite & Kite 2014). Such a situation has further informed the coinage of a variety of pejorative (women-unfriendly) neologisms, one of which is "selfie-

objectification". Derived from a combination of "selfie" and "self-objectification", the portmanteau term ("selfie-objectification") refers to the act of presenting oneself as an object, especially of sight or other physical sense, through a photograph that one takes of oneself, for posting online. This process manifests itself in three steps: (i) capturing photos of oneself to admire and scrutinize (ii) ranking and editing those photos to generate an acceptable final image, and (iii) sharing those photos online for others to validate (Kite & Kite, 2014).

Given the fact that the use of selfies is also culturally determined, there is a high probability that Black African women's models of employing selfies differ to some extent, from that of their counterparts from the western world. Despite the increasing influence of westernization or Americanization on the Black Continent, the two concepts of conservatism and traditionalism still continue to govern many aspects of the lives of Africans. In fact, conservatism still shapes many Black African women's philosophy of life, beauty and sexuality. Segoete (2015) shares corollaries as she enthuses that religion and culture are the major custodians of morality across the Black African Continent. Their agents and institutions tend to perpetuate the shaming and ridiculing of women who dare challenge the status quo, notably through the adoption of western liberal ideologies on sexuality, fashion and beauty. In line with this, women who do not conform to the conservative dictates of society are summarily, wantonly and often impulsively considered rebels, loose and lacking in virtue. A good number of African women internalize these conservative, religious and traditionalist precepts in their social enterprises (notably in the way they appear, dress, speak and interact in public). This is not to negate the thesis that the two forces of modernity and globalization have facilitated the westernization of many among them, so much so that, some of them may not perfectly be influenced by African conservatism.

This virtual conflict between the forces of conservatism and westernization systematically creates an interesting situation where in we note two types of selfie takers: the conservative selfie takers and the liberal (modernized/westernized) ones. A conservative selfie taker from Black Africa will certainly act under a degree of social structure and avoid to sexually objectify herself; while liberal Black African women will pay less or no attention to both the conservative norms and the intimidating gaze of the society in her manner of using selfies in such public spaces as social media platforms. Based on all the above presented premises, this book chapter seeks to investigate the extent to which African women (particularly Nigerian women) are influenced by African conservative values in their use of selfies. It specifically focuses on selfie-objectification versus conservatism in over 200 selfies posted on Facebook and Instagram by Nigerian women.

THEORETICAL FRAMEWORK

This book chapter is principally anchored on two theories namely African conservatism and (sexual) objectification/self-objectification. This section aims to elicit these theories and highlights the theories' keystones that will be considered in the study.

African Conservatism Theory

African conservatism can be defined by analogy to the broader idea of conservatism, a socio-political philosophy which favors tradition (in the forms of cultural, religious and nationally-inclined customs and beliefs), in the face of external forces of social change. Conservatism is generally antithetical to the ideas of liberalism, socialism and radical societal change. Its proponents prefer organic to revolutionary social change. They anchor their reflection on the axiom that any attempt to dramatically reconfigure human interactions within the complex web of the society is extremely risky as it is susceptible to challenge the law of unintended consequences and/or moral hazards (Endong and Obonganwan, 2015; Mastin, 2008). This is not to suggest that conservatives are *per se*, categorically opposed to the concept of social change. They are just very critical of the idea of radical social change. It is even important to underscore the fact that the conservative current is constituted of various schools of thought, holding slightly varying positions with regards to social mutations. A first category of conservatives (classical conservatism) advocates a slow pace to change. A second category militates for a preservation of the status quo while a third category rather advocates a return to old socio-cultural values (those observed in earlier times).

There are over seven versions/typologies of conservatism including cultural conservatism, social conservatism, religious conservatism, fiscal conservatism, paleo-conservatism, neo-conservatism and bio-conservatism. However, this work will consider the three first types within the above list (namely cultural, social and religious conservatism) as they are intrinsically related to the central topics of this discourse (selfies and self-portraiture in public). As its name indicates, cultural conservatism is a philosophy which advocates the preservation of the culture, language tradition and heritage of a nation through the adaptation of norms handed down in the past. A subset of this typology of conservatism is social conservatism, which seeks to establish an inextricable link between social norms and morality. This is for instance viewed in societies where issues like heterosexuality (rather than homosexuality) and the integral veiling of women faces are considered moral imperatives. Religious conservatism likewise supports the preservation of religious dogmas and ideologies by example or through such institutions as the law. Religious conservatism is often a vector of pertinacious and dogmatic advocacy in favor of

the return to old traditions and customs, or the preservation of precepts in their original or pristine form. Little wonder, religious conservatism is often at the root of religious fundamentalism.

Cultural, social and religious forms of conservatism are related to selfie and public self-imaging in the sense that, in most conservative societies, culture, traditions and religion are among cardinal custodians of morality. They dictate how both men and women should appear in public; how they should interact with the opposite sex and how they should dress in public or project themselves. For instance, in most conservative societies, normative dress codes recommend the wearing of so-called conservative dress/cloths for both men and women, particularly in public. These conservative dresses are attires that reasonably cover genitals and shoulders among other sensitive parts of the human body. They thus include long dresses, pants, skirts that fall below the knees. Using muslin and traditionalist African communities as case study, Malin (2011) notes that the more flesh a woman reveals in public spaces (including in the social media), the more unwanted attention she receives. In the same line of argument, Segoete (2016) remarks that in most Black African societies, women in particular are most often discouraged to dress according to their taste/ preferences "because they are habituated to attribute self-worth to being covered and hidden from the world" (para 8). Social, cultural and religious conservatisms oblige these Black African women to base their self-image on a set of patriarchal ideals set by religious and cultural fundamentalists. Women who "dare" depart from these conservative cultural and religious norms are wantonly branded "femme fatale", and westernized. This is evidenced by the plurality of fighting words often used by conservative/traditionalist critics (particularly in Black African countries) to censure recent tendencies by female celebrities of taking and sharing provocative and sexualized selfies in the social networks. The Nigerian online magazine *The Capital* (2016) refers to such tendencies by local female celebrities as a cultural import from Europe and America and a social pathology which is becoming worrisome to such local observers "who believe a woman's femininity is best preserved and motherhood better ennobled if the contemporary woman could endeavor to keep her hidden graces covered and shielded from the glare of an increasingly nosy and narcissistic world." In the same line of argument, Sikhonzile (2016) describes the act by local African celebrities, of taking and sharing nude or suggestive selfies as an antithesis of the two civilities of modesty and respect of the Black woman's dignity. She enthuses that, as black African women, local celebrities should be conscious of the fact that they must be positive role models, who will drive home the wisdom that, as women, they have much more to offer this world than their bodies.

As intrinsically shown in the preceding paragraphs, conservatism has continental, regional or national accents. This means that American conservatives may not seek to conserve the same cultural values as their counterparts from Black African countries.

Going by this premise, Black African conservatives are believed to be advocates of the preservation of traditional African cultural values or the return to these values. Some of these cultural values include communalism, ancestral worship, respect for authority and the elders, hospitality, solidarity, sense of sacredness of life, sense of good human relation, sense of the sacred and the sense of language, proverbs and more especially "modesty" in dressing habits and self-imaging among others (Emeka, 2014; Endong & Obonganwan, 2015; Ezenagu & Olatunji, 2014). According to the online journal *Social Pathologies* (2016), African conservatives (particularly traditionalists) "prefer to live in the past rather than in the real world". This is to say they adamantly preach adherence to old African cultural values, irrespective of the forces of modernity. As *Social Pathologies* (2016) further observes, conservative/ traditionalist Africans seem to be driven by the assumption that their forefathers had answers to all social problems, including those faced by modern African societies. They see African traditional wisdoms on sexuality, femininity, female beauty and other socio-political problematic not as "conservative" but as progressive when contrasted with the "aggressive" and antithetical or imperialistic values from the West (Wambu 2015). Because of their virtual opposition to what could be viewed as westernized "popular cultures" and "(post-)modern social change, they are often profiled and censured by liberal Africans who view cultural imports – notably nudity and pornographic cultures from the West – as an inevitable and "progressive" force (*The Capital,* 2016; Wambu, 2015; Yetunde, 2014).

(SEXUAL) OBJECTIFICATION AND SELF-OBJECTIFICATION THEORIES

As a theory, objectification is multi-dimensional in nature. It may be approached from a plurality of perspectives. However, this paper will basically consider the feminist perspectives of the theory. To begin with, objectification is viewed as the act of treating someone – particularly a woman – as an object. There exist many types of objectification. However, this discourse will be anchored on sexual objectification which is the act of seeing a person as a body which is valued predominantly for its use or consumption by others. As Tomi-An (1997) insightfully puts it, women sexual objectification occurs whenever a woman's body, body parts or sexual functions are dissociated from her person, reduced to the status of mere instruments or systematically relegated to sexual symbols that can represent her. Objectified women are thus treated as mere bodies that predominantly exist for the pleasure of others (particularly that of the heterosexual male folk). Over eleven characteristics of objectification can be identified. These include:

1. **Ownership:** Treating someone as a commodity that can be owned (bought or sold)
2. **Instrumentalism:** The treatment of someone as a means to satisfy ones' personal desires or reach one's purpose.
3. **Denial of Subjectivity:** Viewing a person as not having a personal desire or opinion. It also means treating such a person without taking his/her view into account.
4. **Denial of Autonomy:** Treating someone as lacking in autonomy or self-determination.
5. **Denial of Humanity:** Treating someone as if he/she is not a human being.
6. **Fungibility:** Viewing or treating someone as being interchangeable with other objects.
7. **Inertness:** Treating someone as being inherently passive and lacking in agency.
8. **Violability:** Treating someone as if he/she has no integrity.
9. **Silencing:** Treating someone as lacking the capacity to speak or complain.
10. **Relegation to the Physical:** Treating someone in terms of his/her appearance (most often his or her level of beauty, ugliness and so on) and
11. **Reduction to Body:** Treatment of someone as identified with his/her body or body parts. (Kant, 1963; Langton, 2009; Nussbaum, 1995)

The sexual objectification theory was originally advanced by feminist schools of thought as a framework to examine women's quotidian experiences in socio-cultural contexts which sexually objectify female bodies. Such sexual objectification is often perpetrated through a variety of agencies including interpersonal interactions (sexual harassment and rape among others), the arts (painting) and media representation (in pop video, cinema, photography, advertising and TV among others). Of all these agencies, mediated nudity or pornography is counted among the principal sites of women sexual objectification as it most often favor the male gaze; while presenting the women folk as object existing for the pleasure of the (heterosexual) men folk. A good number of feminist theorists actually view mediated pornography as a sexist experience which dehumanizes women, presenting them as things, commodities and sexual objects which men can touch, enjoy, possess, consume and exploit without "penalties" or consequences. Mackinnon (1987) notes that:

Pornography defines women by how we look; [and] according to how we can be sexually used. ... Pornography participates in its audience's eroticism through creating an accessible sexual object, the possession and consumption of which is male sexuality, as socially constructed; to be consumed and possessed as which, is female sexuality, as socially constructed. (p. 176)

Many radical feminists therefore construe mediated nudity or pornography as a phenomenon harmful to feminine dignity, given its objectifying/depersonalizing potential. In tandem with this, radical feminists, regard the whole idea of women sexual objectification as a manifestation of chauvinism; therefore as a problematic which needs to be addressed, as one of the preliminaries to achieving gender equality.

It is expedient at this juncture to mention the possibility that a woman decides to treat herself as an object. This scenario brings to the fore the concept of women self-objectification, a situation in which the objectifier and the objectified is one and the same person (the woman herself). Female self-objectification occurs when women or young girls are, through active socialization, made to internalize a third-person view of their bodies and sexualities as the best way to think about themselves. Kroon and Perez (2013) thus define female self-objectification as the "regular exposure to objectifying experiences that socialize girls and women to engage in self-objectification, whereby they come to internalize this view of themselves as an object or collection of body parts" (p. 16).

According to feminist lines of argument, female self-objectification stems principally from the fact that in most of today's societies, women are identified and associated with their bodies more than are men. Equally, in most contemporary societies, women are to a great extent valued for their physical appearance. This motivates women to seek social acceptability through multifaceted techniques of body and appearance correction. Such corrective approaches – otherwise called disciplinary practices – ultimately aim at helping women meet socially idealized models of feminine beauty or sexuality. They are of three categories. The first category deals with size correction of the body through dieting, plastic surgery, and physical exercises among others. Such approaches to size correction often aim at enabling women to acquire a slim(mer) body, massive breasts and generous backside (ideal feminine body). The second category of disciplinary practices is directly concerned with the display of women faces as an "ornamented surface". They include issues like excessive/spirited body cares and make-ups, to enable their skin to be smooth, hairless and wrinkle-free. Such skin cares generally seek to "purify" the skin of any imperfection (Bartky, 1990; Papadaki, 2015). In some Black African societies, these women also resort to de-pigmentation to acquire a fair complexion as well as artificial air-styles (long hair). These two attributes (fair complexion and long hair) are often viewed as two of beauty essentials in some Black African communities.

The third and final category of disciplinary practices relates to gesture, postures and movements. By frantically correcting their bodies and appearances women "relegate" their bodies to sexual objects to be decorated and gazed upon (mostly by heterosexual men). In line with this, women self-portraiture (through selfie or classical photography) has mainly been inspired by the male gaze and the profound

desire to achieve social acceptability. This is somehow underscored by Micheo-Marcial (2015) when he observes that:

The image of a woman in a bikini shouldn't be taken at face value. One must take into account the fact that the person behind the lens is most likely a man, the person who came up with the concept was most likely a man, and most of the creative force behind the image is likely stemming from ... a man. That is not to say that there aren't female photographers or creative geniuses, but we shouldn't deny the skewed gender ratio within most professions, or the fact that the standards of beauty and sensuality are imposed by industries that are largely domineered by men. (p. 18)

Most female selfies takers or sharers have strongly been driven by such a desire for social acceptability. Many of them have consciously or unconsciously sought to follow male imposed standards of feminine beauty and sexuality in their productions of self-portraitures. Haunted by the belief that they are watched and "rated" by (heterosexual) men they have, in their use of selfies, endeavored to always be sensually pleasing and sexualized in various magnitudes. This particular scenario will amply be discussed in the subsequent section of this chapter.

SELFIES AS A SITE OF GENDER STEREOTYPING AND WOMEN SELF-OBJECTIFICATION

It will be important to begin this section with a brief definition of the term selfie. The word selfie refers to a digital self-portrait picture taken with the use of a webcam, a smartphone or a selfie stick, for posting on social networking sites (notably facebook, instagram and fotolog among others). The culture of taking and sharing selfies on social networks has become so ubiquitous and universal that it is viewed as one of the most principal revolution of the digital age. No doubt in 2013, the term "selfie" was named the word of the year by the Oxford English Dictionaries. A particularity of selfies is that they are deeply rooted in narcissistic and exhibitionistic thinking. They are not ordinary photos of oneself, taken by and for oneself. As Kite and Kite (2015) beautifully put it selfies are not just "images you take of yourself *for* yourself; they are images you take of yourself *for others to see*" and eventually give you a positive tick (p. 2). Such an obsessive search for social acceptation or approval from peers has been viewed by some as an epidemic/syndrome (the narcissism epidemic) and others as a kind of "revolutionary self-love" (Day, 2013; Kofman, 2016).

The selfie culture has engendered a wide range of lexical innovations corresponding to various self-representation techniques that depend on such factors as photo filters, photographic angle, situation and perspective among others. In line with this, lexical

innovations have been developed to refer to a variety of selfie subgenres, some of which include "fitness-selfies", "healthies", "welfies" and "work-out selfies" (all four used to mean the type of selfies one takes in a context of outdoor work). Other lexical innovations include prelfie (for selfies of pregnant women), "drelfie" (to refer to drunken selfies) and "belfie" (for back side selfies) (Doring, Reif & Poeschi, 2016; Lush, 2015; Oxford English Dictionaries, 2013).

Many studies have sought to establish the gendered nature of the selfie phenomenon. In effect, such a gendered nature is visible in the gender-stereotypical selfies both male and female (especially youths) take and share on social media platforms. A variety of gender expressions are present in selfies irrespective of cultures and races. Such gender expressions are manifest in the choice of postures, the choice of attire and the micro-expressions (facial expressions) displayed in the photo. While (young) men most often display/brandish their physical strength (by showing their muscles or robustness), the female tends to display seduction (for instance by making a kissing pout or by adopting a seductive gaze or posture). The female also often displays themselves in postures suggesting submission, passivity or weakness for instance by lying down. Scholars such as Tifferet and Vilnai-Yavetz (2014) have argued that most male facebookers tend to emphasize their social status (in their selfies), by choosing photos taken in cars or those showing them dressed in formal or corporate attires. On the other hand, female Facebookers are fond of using selfies that display emotional expressions through eye contact, extensive smile and sensual postures. According to Doring, Reif and Poschi (2016), though selfies offer women the opportunity to challenge or reverse traditional gender-related self-representation, the present state of research on the issue shows that most internet users continue to present themselves according to old and patriarchal gender stereotypes. As they succinctly put it, virtually no effort is done by such internet users to create alternative gender stereotypes or imageries that are gender-equal or stereotype-debunking. Doring, Reif and Poschi extensively demonstrate their thesis through a study which sought to show that gender related stereotypes observed in most magazine advertising copies are similar to those viewed in selfies generated by young adults. They note that "male and female Instagram users' selfies not only reflect traditional gender stereotypes, but are even more stereotypical than magazine adverts" (p.955). In the same line of argument, Steeves laments the fact that unfavorable gender-related stereotypes and myths have so "infested" the totality of social spaces that, it has become extremely difficult for the female folk (particularly young women) to use selfies and the social media platforms as empowering arsenals. Based on this premise, she concedes that selfies and social networking have simultaneously opened some opportunities for women emancipation while closing others. As she puts it:

This [scenario] has further complicated the already complex task of creating and inhabiting emancipatory feminine identities, because mainstream stereotypes are now embedded by commercial interests into the sociotechnical spaces that girls inhabit. This makes it more difficult for girls to retreat into a private sphere where they can try on a variety of identities with few or no social consequences. (Steeves 2015, p. 153)

A more curious phenomenon which has attracted the attention of the feminist school of thought, has been females' use of selfies as a tool of self-objectification. The selfie culture seems actually to have motivated most female youths to internalize stereotypical narratives on female beauty and sexuality. These female youths are made to replicate what our chauvinistic societies have taught them to be in their entire live: being images or "objects" to be looked at. This entails displaying images of posed, styled, "fuckable" and sensual persons – who, otherwise, could be dynamic human beings – for viewers to gaze upon and comment. Based on this observation, the young girls and women are often taxed with "misusing" selfies and the social networks; that is, using an otherwise women emancipatory arsenal as a tool to demean and depersonalize themselves. As Kite and Kite (2015) enthuse, selfies are not inherently evil but when such a female-driven phenomenon is put in the context of the culture in which we live, selfies aren't just a trivial trend or a form self-expression. Rather, they are a perfect reflection of what girls and women have been taught to be or resemble from Day 1. "And what have girls and women been taught from Day 1 brings them the most value? Looking good. Not being smart or funny or kind or talented — mostly just looking hot. Thus, the validation females have been taught to seek is the approval of others regarding their appearances" (para 3). The self-imposed imperative of looking hot or "fuckable" often pushes women and young girls to generate very provocative selfies that will excite if not seduce the male viewers while attracting the admiration of other women. In tandem with this, the concept of objectified selfies has been developed and associated with the controversial practice of intentionally sexualizing or "pornifying" visual artefacts or media. An "objectified selfie" is therefore defined as one that emphasizes the person's sexuality usually by showing a fair amount of skin. In most cases, objectified selfies are images portraying semi-clothed women's bodies intended to emphasize her sexuality. According to popular thinking, heterosexual men are always attracted to images of semi-nude or naked women – for instance those often exhibited in advertising, TV reality shows or sexualised pop videos. On this premise, most women strive to resemble hot reality TV stars, "curvy" film actresses as well as models paraded in advertising and stars performing in pop videos, in the course of seeking the attention of male viewers. As Whitbourne (2016) succinctly puts it:

In a world peopled with semi-clothed female models, being sexy to a woman too often means showing more of her skin. When self-esteem becomes largely dependent on how sexy one looks—and not how intelligent, kind, friendly, or inwardly attractive one is—other problems result, especially in their interactions with the men in their lives, who themselves may have become conditioned to objectify women. (p. 30)

This position intrinsically suggests that female self-objectification – manifested by the sharing of suggestive, pornified or nude selfies in social networks – is, in some sense, an unconscious reaction to females' images deployed in commercials, and pop video. Such a self-objectification is equally a reaction to people's comments on women's selfies/pictures posted in image sharing platforms. As can be observed, the social media have an evaluative function or potential. In social media platforms, selfie-crazed audiences comment on outward qualities, attractiveness and other aspects of sexualities which enable selfies takers and sharers to "rate" their physical appearance (including some of their hidden graces) and eventually adopt corrective measures to amend their self-representation and self-portraiture in these social media platforms.

Another form of female self-objectification has been observed in the sex selfie genre often generated with the help of a stick - what Kofman (2016) calls "sex selfie stick". According to Kofman (2016), while the classical selfies have basically tended to be inspired by the male gaze, sex selfies have, according to the alarmists, taken "the masturbatory metaphor of the selfie's "looped gaze"—the idea that the author, sitter, editor, and viewer of the photo are all the same person—and makes it literal."

Though censured by alarmist and conservative quarters, the sex-selfie and nude selfie genres have been interpreted by more liberal schools of feminists as a suitable arsenal to challenge the stereotypical representations of women in the media. In line with this, nude and visibly objectifying selfies may be viewed as a signifier of female liberation and empowerment rather than symbols of a pernicious and pornographic culture (Cruz & Thornham, 2015; Hayley, 2016; Lush 2016). A number of liberal female selfie takers posit that such a genre may facilitate advocacy for the normalization of other body types – that is body types other than slenderness. In line with this, nude selfies may facilitate "fat advocacy" or project/celebrate old women bodies thereby challenging popular/dominant narratives – on feminine sexuality and beauty – which extensively hail the young and slim female body. As a socializing institution, the media have mostly – and somehow exclusively - projected idealized models of feminine beauty and female sexuality; leaving categories of female bodies that fall outside these idealized models, and presenting them as odd and unattractive. By capitalizing on idealized models of feminine beauty (slenderness and youthfulness), "vulnerable" groups such as old and fat women often adopt a negative mindset. They tend to be driven by the mindset that they are not "sexy"

and so not useful objects (Whitbourne 2016). The selfie gives the opportunity to women possessing "odd" and "unattractive" bodies to (re)claim their bodies and systematically problematize these gender-related stereotypes. This liberal feminist argument is debunked by the "conservative" feminists who rather view such an attempt at defying the normative social narratives on female sexuality and beauty as a naive act which, instead of facilitating an emancipatory experience for women, may intensify women stereotyping. This is so as a woman's self-portraiture is often mistakenly viewed as a symbol or specimen representing the multitude of women. In line with this, the naked selfie of a so-branded sex-positive, body accepting or affirmative woman may turn out to be exploitative of the other women. In reaction to the naked selfies of reality TV star Kim Kardashian, Rutledge (2016) diligently underscores this possibility as she posits that:

Kim Kardashian's nude photos are empowering for her, but exploitive of her audience. She is empowered all the way to the bank. She not only controls her image, she cultivates it. She is a brand. Cyberbullies are her best friends. The more rude things people say, the more people watch to see what will happen. (cited in Hayley 2016)

Rutledge's reflection is anchored on the fact that though having the potential to economically empower some women, the act of posting nude selfies is bound to tarnish the general image of women in the society. Sharing nude selfies in social networking sites, may seemingly be affirmative and body accepting. However, it is bound to be read as a demeaning index for categorizing most women.

SELFIES AS A CULTURALLY DETERMINED PHENOMENON

According to some observers, the selfie is a universal phenomenon given the fact that it transcends races, ages, works of life and gender. Such a thesis is further anchored on the fact that the selfie constitutes a contemporary aspect of digital culture which, according to popular imaginations, is just bound to expand across borders and continents. Klomp (2015) notes that the phenomenal proliferation of the selfie culture in the world is just a perfect illustration of the thesis stipulating that there are so many sub-cultures which interact with one another at the global sphere; and the biggest of all these sub-cultures is the digital culture. In a bid to further substantiate the thesis of the universal nature of selfie phenomenon, Klomp cites the example of female celebrities across the world, who seem to use the selfie medium in quite similar ways. She mentions the case study of Australian model Miranda Kerr and Japanese model Kozue Akimoto who, though living at millions of kilometers, take similar selfies of themselves which they share on a regular

basis on their personal Instagram sites. Indeed, similar ways of taking and sharing selfies have been observed among celebrities, particularly young female celebrities. Irrespective of cultures, many female celebrities seem to have adopted the culture of nude, sexualized or objectified selfies as a "norm" or a "convention" in the realm of stardom. Showing more skin and feeling sensually pleasing has virtually become the cardinal principles of self-portraiture and self-representation among reality TV stars, popular musicians, models, film actresses, irrespective of cultures and races. Day (2016) notes for instance that:

Adolescent pop poppet Justin Bieber constantly Tweets photos of himself with his shirt off to the shrieking delight of his huge online following. Rihanna has treated her fans to Instragrammed selfies of her enjoying the view at a strip club, of her buttocks barely concealed by a tiny denim thong and of her posing with two oversize cannabis joints while in Amsterdam. Reality TV star Kim Kardashian overshares to the extent that, in March, she posted a picture of her own face covered in blood after undergoing a so-called "vampire facial".

In the same line of argument, Nigerian observers such as *The Capital* (2016), have lamented the increasingly fashionable tendency by local Nigerian celebrities to treat their fans to nude Instagrammed or tweeted selfies of themselves. *The Capital* (2016) succinctly notes that:

The rate at which local celebrities discard their clothing to reveal their bare skin covering their embryos would leave the conservative gasping for breath and clutching at norms with frenetic speed. The roll call of local female celebrities who are subscribing to this cultural import from Europe and America has become worrisome to folk who believe a woman's femininity is best preserved and motherhood better ennobled if the contemporary woman could endeavor to keep her hidden graces covered and shielded from the glare of an increasingly nosy and narcissistic world.

Just recently, Dior Chidera Adiele, shocked her fans and raised serious eyebrows by posing completely nude for a photo shoot celebrating her baby bump. ... Probably lacking the courage and daring of Adiele, Kaffy Ameh, otherwise known as Kaffy the Dance Queen, unclothed her belly to show off her baby bump to the world before she put to bed. And the roll keeps increasing to include more celebrities or wanna-be celebrities.

As noted by Day (2016) on one hand and *The Capital* (2016) on the other hand, the nude or objectified selfie genre is, to an extent, a universal phenomenon among celebrities. Though regarded as a universal phenomenon, the selfie has some subtle

cultural colorations. This has inspired many anthropologists and digital culture critics to see the phenomenon as a window into cultures and communities, values and ideologies (Cruz & Thornham, 2015; Lim, 2016). In effect, selfie takers are generally guided by cultural or social codes in their approach to using the technology for self-representation, storytelling and impression management. Fabello corroborates this position as she posits that, in general, women "don't make choices in a vacuum" when it comes to taking and sharing selfies. In fact, "the social messages [socio-cultural arbiters] that influence how much value we place on women's bodies can play a role in any choice that we make about ourselves" (cited by Hayley, 2016).

Lim (2015) similarly uses cultural parameters to rationalize a number of research findings purporting that the selfie culture is more accentuated in most Asian countries, than in the developed world. She notes that most selfies takers from developed countries tend to be animated by individualism meanwhile most Asian are guided by collectivism. The Collectivistic ideology systematically guides most Asians' use of selfies and social networks in that they have the tendency "to do the same as others or follow trends to feel belonged to a group". In other words, they tend to believe that by participating in the selfie culture they belong to an imaginary community – which may be international in its definition. Such a belief makes them to imitate others (people from other cultures) in a way, in guise of integrating a community. As put by Lim, this theory equally validates the findings by *TIME* stipulating that most young Asians who make the V-sign in selfies do so without premeditation or thinking and are most often confounded when asked why they do it.

In Africa, the art/act of taking selfies similarly continues somehow to be culturally determined. Despite the fact that cultural globalization and cultural synchronization have motivated a good number of Black Africans (particularly celebrities) to adopt a western style of taking and sharing selfies, the conservatism/traditionalist philosophy continues to guide people's conception of self-portraiture and self-imaging and self-presentation in public spaces. It is important here to re-iterate the fact that, for most conservative Black Africans, sexualized cultural artifacts or products and mediated pornography/nudity are arguably considered an infamous cultural importation from the west (Endong & Obonganwan, 2015, Ojo 2008). On such a premise, most African conservatives will read the phenomenon of objectified selfies as a form of *westoxification* (a cultural pollution originating from the west) and an ugly side of socio-cultural change in the modernizing African communities. The conservative and traditionalist sentiments are therefore, still notable in Black African communities. This is illustrated in how women dominantly – or are "expected to" – dress, interact with the opposite sex and express their sexualities in public. In tandem with this, many selfie takers and consumers continue to proffer a conservative selfie culture that will shun objectified selfies taking and sharing, what some feminists have termed selfie-objectification. A serious gap in knowledge however lies in measuring Black

African selfie takers' degree of attachment to conservatism and traditionalism, when it comes to using selfies as mode of self-representation and self-imaging in the public space. Indeed, studies devoted to exploring African conservatism versus westernization/self-objectification in selfies generated by Africans are very rare and somehow new. It is this gap in knowledge that this discourse hopes to fill.

METHODOLOGY

Sample and Variables Measurement

This study is based on a content analysis of 300 selfies portraying Nigerian women and shared on the two social networks of Facebook and Instagram. These selfies were randomly selected from the multitude of self-portraits shared by these female Nigerians on social networks. Though some of the selfies were captioned and/or accompanied by comments formulated by followers, this author exclusively gave attention to the visual composition of the selfies. The author equally considered three variable labels for the content analysis namely:

- **Types of Selfie:** Objectified or conservative
- **Conservative Features:** Conservative cropping or total absence of nudity
- **Objectification Features:** Posture, nudity, micro-expressions and multiple features

Definition of the Various Categories Considered

The author adopted Whitbourne (2016) definition of an objectified selfie. This definition states that an objectified selfie is one that emphasizes the selfie takers' sexuality, generally by portraying a fair or excessive amount of skin. An egregious illustration of an objectified selfie is the image portraying the semi-nude or a scantily clad woman-body intended to emphasize her sexuality (see Figure 1 in Appendix). A conservative selfie on the other hand perfectly reflects conservative philosophies of feminine beauty and sexuality which include modesty and secrecy. Conservative selfies portray women in modest attires and postures. Such attires and posture keep the selfie takers' natural graces hidden thus making no allusion to their sexualities (see Figure 2 in Appendix). In line with this, conservative features were defined as aspects of the selfies that permitted the selfie takers to appear modest and avoid exhibiting their genitals and/or other sensitive parts of their bodies. Conservativeness – in the context of this content analysis – was therefore defined in terms of the

nudity content of the selfies, not really in terms of whether the selfie takers wore indigenous (or traditional) attires and other artifacts.

Objectification features were defined according to a good number of researchers' conception of selfie-objectification (Day, 2013; Doring, Reif & Poeschi, Kite & Kite 2015; Whitbourne, 2016). These features were thus defined in terms of posture (provocative or seductive posture) (see Figure 3 in Appendix), nudity (fair or excessive portrayal of female genitals and other sensual parts of the body) (see Figure 4 in Appendix); micro-expressions (such as kissing pout or seductive gaze) (see Figure 5 in Appendix). As clearly explained by Day (2013), in the "art" of selfie taking, "sexiness is suggested by sucked-in cheeks, pouting lips, a nonchalant cock of the head and a hint of bare flesh just below the clavicle". The category labeled "multiple features" was used in reference to objectified selfies that combined two or more of objectification features (see Figure 6 in Appendix). This was specifically conceived to measure the degree of objectification in this category of selfies.

Data Analysis and Presentation

The data collected through the use of a data sheet was statistically analyzed using the SPSS (Statistical Package for Social Sciences) program, and presented in tabular form (see Tables 1, 2, and 3). Simple statistical manipulations were used including simple frequencies distributions. This data was discussed, and buttressed with the aid of suitable illustrations (selfies) drawn from the sample.

FINDINGS AND DISCUSSIONS

The findings reveal that most (59%) of the selfies portraying Nigerian women are conservative in nature. However, a considerable portion (41%) of the selfies considered for the study were variously objectified as shown in Table 1. This finding is visibly in line with popular imaginations stipulating that conservative and traditionalist sentiments still dictates female Nigerians' philosophy of self-imaging. Though it may be difficult, if not futile to establish a direct connection between the high frequency of conservative selfies (from our sample) and the conservative social strictures under which Nigerian women are compelled to live, it must be emphasized that African communities have developed the tradition of shaming and stigmatizing women who dare challenge dominant Nigerian values (particularly modesty) as regards female sexuality, decency and religion. An egregious illustration of this argument is the fact that so frequently, the country's media and public opinion have severely cracked down on local celebrities who, for the purpose of achieving stardom, "have gone the extra mile" of sharing (semi)nude selfies of themselves on social network platforms.

Table 1. Types of selfies

Types of Selfies	Conservative		Objectified		Total	
	n	%	n	%	n	%
Frequency	118	59	82	41	200	100

Furthermore, Nigeria is considered a very religious society. Religious arbiters (Christian, Muslim and animistic precepts) – which strongly advocate modesty as a form of social morality – tremendously affect public opinion, sub-cultures and fashion, even in atheistic quarters. Religiosity thus shapes the mindset of a good number of Nigerian women as well as their interactions in public spaces. It will therefore not be surprising that such a religiosity be partially responsible for the high number of conservative selfies registered in the context of this study.

The findings of the study equally reveal that two distinct conservative features are observable in the selfies of Nigerian women: "conservative" cropping and non-sexualization. Based on the result of the study, non-sexualization is dominant as it is observed in 64.4% of the conservative selfies sampled for the study; meanwhile conservative cropping is notable in 35.6% of the sample. Non-sexualization entails the production of selfies which are totally nudity-free. Such selfies portray women dressed in traditional attires or corporate cloths that cover their neck, shoulders and genitals. This category of selfies is equally not suggestive (see Figure 2 in Appendix).

Conservative cropping could be seen in selfies framed in a way as to eliminate parts of the female body that could look seductive or "indecent". This is principally seen in selfies that portray only a decent part – generally only the head, the neck and parts of the shoulders – of the selfie taker, while living out the rest of the body (see Figure 8 in Appendix). In some cases, the cropping is done in a way that the viewer can only visualize the uncovered rest of the body (see Figure 7. in Appendix).

As earlier mentioned, findings indicate a considerable number of objectified selfies. These findings somehow rationalize the thesis that despite the prevalence of the conservatism, liberal views about sexuality, self-representation and self-expression remain notable among Nigerian women. One will need a well-articulated

Table 2. Conservative features

Conservative Features	Cropping		Non-Sexualization		Total	
	n	%	n	%	n	%
Frequency	42	35.6	76	64.4	118	100

inquiry to actually know whether concepts such as liberal feminism, the desire by the female folk to (re)claim their body and challenge gender related stereotypes, or cultural synchronization may be responsible for this form of selfie culture among Nigerian women. The least one may say here is that the nude-selfie genre is already "appropriated" or "domesticated" by Nigerian women. Some of them are actually not different from their counter part from the West.

The various objectification features observed in the selfies generated by liberal Nigerian women include suggestive postures, fair/excessive nudity and suggestive/ seductive micro expressions (for instance kissing pout, seductive gaze among others). The study also revealed that some (18.29%) of the selfies combine two or more of these objectification features as shown in Table 3. Good examples of selfies with multiple objectifying features include Figure 1 and 6 (see Appendix) where elements such as posture and nudity are combined.

CONCLUSION

This chapter has attempted to establish the fact that African conservatism and traditionalism continue to tremendously shape Nigerian women's style of taking and sharing selfies on social network platforms. This is in line with the thesis stipulating that the selfie is a culturally determined phenomenon and that women are generally guided or influenced by the dominant ideologies ruling the socio-cultural contexts in which the live. As a cultural and religious force, conservatism seems to shape Nigerian women's philosophy of self-presentation, self-imaging and self-expression in public spaces. Female self-objectification and objectified selfies is dominantly considered a taboo in Nigerian cultures. However, despite the prevalence of conservative myths and gender related stereotypes in the Nigerian society, the phenomenon of nude or objectified selfies is increasingly becoming a sub-culture among Nigerian women.

Table 3. Objectification features

Objectification Features	Frequency	
	n	**%**
Suggestive posture	42	51.21
Fair/Excessive Nudity	17	20.73
Seductive Micro-expressions	08	9.77
Multiple Features	15	18.29
Total	82	100

As demonstrated by this study, the culture has already been adopted or appropriated by local female celebrities and an impressive number of ordinary women within the Nigerian society. Though most conservatives will likely associate such a development with cultural synchronization or cultural globalization, the phenomenon deserves to be counted among projects for further research.

REFERENCES

Bartky, S. (1990). *Femininity and Domination: Studies in the Phenomenology of Oppression*. New York: Routledge.

Browmlee, J. (2016). Cultural stereotypes. *Fastcodesign*. Retrieved June 14, 2016, from http://www.fastcodesign.com/3026620/russians-are-miserable-and-brazilians-love-to-smile-what-selfies-reveal-about-cultural-stere

D'Eon, K. (2016). The "selfie": Sexualization and objectification of... ourselves? *MSinthebiz.com*. Retrieved June 14, 2016, from http://msinthebiz.com/2013/11/04/the-selfie-sexualization-and-objectification-of-ourselves/

De Lima, C. C. (2015). The selfie as expression of contemporary fashion and narcissism. *Moda Documenta: Museu. Memoria e Design*, *II*(I), 1–14.

Doring, N., Reif, A., & Poesichi, S. (2016). How gender-stereotypical are selfies? A content analysis and comparison with magazine adverts. *Computers in Human Behavior*, *55*, 955–962. doi:10.1016/j.chb.2015.10.001

Edmunds, S. (2015). *Scammers and online dating fraud. 2015 trends and tactics*. New York: Global Dating Insights.

Emeka, A. (2014). *African cultural values*. Retrieved June 1, 2016 from http://www.emeka.at%2Fafrican_cultural_vaules.pdf&usg=AFQjCNE30utItcG7XsbdR3DN913O-3p6wg&sig2=i8AEKQ6Xd-BEsFZbtHmSSQ

Endong, F. P. C., & Obonganwan, E. E. (2015). Sex in Christian movies: A study of Roger Young's The Bible: Joseph and Mel Gibson's Passion of The Christ. *SSRG: International Journal of Communication and Media Science*, *2*(2), 11–21.

Ezenagu, N., & Olatunji, T. (2014). Harnessing Awka traditional festival for tourism promotion. *Global Journal of Arts Humanities and Social Sciences*, *2*(5), 43–56.

Greeley, S. (2015). Testing Technology's Conservatism. *The Imaginative Conservative*. Retrieved August 30, 2016, from http://www.theimaginativeconservative.org/2015/09/testing-technology-conservatism.html

Heyley, P. (2016). Is the naked selfie good for feminism? Let's take a closer look. *ELLE*, Retrieved September 1, 2016 from http://www.elle.com/culture/a34928/naked-selfie-and-feminism/

Kant, I. (1963). *Lectures on ethics*. New York: Harper and Row Publishers.

Kite, L., & Kite, L. (2014). Selfies and self-objectification: Not-so-pretty picture. *Beauty Redefined*. Retrieved June 14, 2016 from http://www.beautyredefined.net/selfies-and-objectification/

Kofman, A. (2016). Why women are using selfie sticks to look inside their vaginas. *Vice*. Retrieved June 14, 2016, from https://broadly.vice.com/en_us/article/why-women-are-using-selfie-sticks-to-look-inside-their-vaginas

Kroon, V. D. A., & Perez, M. (2013). Exploring the integration of thin-ideal internationalization and self-objectification in the prevention of eating disorders. *Body Image*, *10*(1), 16–25. doi:10.1016/j.bodyim.2012.10.004 PMID:23182310

Langton, R. (2009). *Sexual solipsism: Philosophical essays on pornography*. Oxford: Oxford University Press. doi:10.1093/acprof:oso/9780199247066.001.0001

Losh, E. (2015). Feminism reads big data: "Social physics", atomism and selficity. *International Journal of Communication*, *9*, 1647–1659.

Mackinnon, C. (1987). *Feminism unmodified*. Cambridge, Massachusetts and London: Harvard University Press.

Mallin, C. (2011). How to dress for conservative countries. *Travels Fashion Girl*. Retrieved August 30, 2016, from http://travelfashiongirl.com/how-to-dress-for-conservative-countries-modest-clothing-essentials/

Mastin, L. (2008). Conservatism. *The Basics of Philosophy*. Retrieved August 30, 2016, from http://www.philosophybasics.com/branch_conservatism.html

Meghan, M. (2013). Putting selfie under a feminist lens. *The Georgia Straight*. Retrieved June 14, 2016, from http://www.straight.com/life/368086/putting-selfies-under-feminist-lens

Micheo-Marcial, F. (2015). The misunderstanding of objectification, *HuffPost Entertainment*, 28, 17-22.

Murray, D. C. (2015). Notes to self: The visual culture of selfies in the age of social media. *Consumption Markets & Culture*, *18*(6), 490–516. doi:10.1080/10253866.2015.1052967

Nussbaum, M. (1995). Objectification. *Philosophy & Public Affairs*, 24(4), 249–291. doi:10.1111/j.1088-4963.1995.tb00032.x

Ojo, A. O. (2005). *Religion and sexuality. individuality, choice and sexual rights in Nigerian Christianity.* Lagos: Africa Regional Sexuality Resource Centre.

Papadaki, E. (2010). Feminist perspectives on objectification. In *Encyclopedia of Philosophy* Retrieved May 2, 2016, from http://www.feminist-perspectives-on-objectification/encyclopedia-of-philosophy.htm.

Perloff, R. M. (2014). *Social media on young women's body image concerns: Theoretical perspectives and agenda for research. Feminist Forum Review* (pp. 1–15). New York: Springer.

Pyne, M. (2015). Can there be deeper meaning behind our selfies? *Dazeddigital. com.* Retrieved June 14, 2016 from http://www.dazeddigital.com/photography/article/30096/1/can-there-be-deeper-meaning-behind-our-selfies

Qiu, L., Lu, J., Yang, S., Qu, W., & Zhu, T. (2015). What does your selfie say about you? *Computers in Human Behavior*, 52, 443–449. doi:10.1016/j.chb.2015.06.032

Rettberg, W. Jill (2015). Seeing ourselves through technology. How we use selfies, blogs and wearable devices to see and shape ourselves. London: Palgrave Macmillan.

Ringrose, J., & Harvey, L. (2015). BBM is like match.com: Social networking and the digital mediation of teens' sexual cultures. In B. Jane & S. Valerie (Eds.), *eGirls, eCitizens* (pp. 199–228). Ottawa: University of Ottawa Press.

Segoete, L. (2015). African female sexuality is past taboo. *This is Africa*. Retrieved June 10, 2016, from http://thisisafrica.me/sexuality-taboo/

SelfieCop. (2016). *Selfie & Sexting. The perfect storm*. London: Selfie Cop Research Review.

Shoshitaishvili, Y., Kruegel, C., & Vigna, G. (2015). Portrait of a privacy invasion. *Proceeding on Privacy Enhancing Technology*, 1, 41–60.

SiKhonzile, N. (2016). Kim's Naked Selfie. *Black African Woman*. Retrieved June 14, 2016 from https://blackafricanwoman.org/2016/03/08/guest-post-kims-naked-selfie-by-sikhonzile-ndlovu/

Steeves, V. (2015). "Pretty and just a little bit sexy, I guess". Publicity, privacy and the pressure to perform "appropriate" femininity on social network. In B. Jane & S. Valerie (Eds.), *eGirls, eCitizens* (pp. 153–174). Ottawa: University of Ottawa Press.

Stieffer, V. J. (2016). Internalizing beauty ideals: The health risks of adult women's self-objectification. *OPUS: Applied Psychology*, *12*(2), 12–34.

The Capital. (2016). Fad or faux pas? Nigerian celebrities strip nude to show baby bump. *The Capital*. Retrieved September 1, 2016 from http://www.thecapital. ng/?p=3184

Tifentale, A., & Manovich, L. (2015). *Selficity: Exploring photography and self-fashioning in social media*. New York: The Selficity Project.

Tifferet, S., & Vilnai-Yavetz, I. (2014). Gender differences in facebook self-presentation: An international randomized study. *Computers in Human Behavior*, *35*, 388–399. doi:10.1016/j.chb.2014.03.016

Wambu, O. (2015). Tradition versus modernity. *New African Magazine*. Retrieved August 30, 2016 from http://newafricanmagazine.com/tradition-versus-modernity/

Wendt, B. (2014). *The allure of the selfie. Instagram and the new self-portrait*. Amsterdam: Institute of Network Cultures.

Whitbourne, K. S. (2013). Your body on display: Social media and your self-image. *Psychology Today*, December 3, 30-31.

Yetunde, A. (2014) Mystery of the waist beads and modern sexuality. Vanguard, December 27, 23-28.

KEY TERMS AND DEFINITIONS

Conservatism: Term used in reference to a socio-political philosophy which proffer tradition (in terms of nationally defined beliefs and customs) in the face of exogenous forces of changes. The philosophy equally prefers progressive rather than revolutionary/radical change, arguing that any attempt at changing the social order of things overnight may instead end up running afoul the law of unintended consequences and/or of moral hazard.

Femininity: Neologism often used to refer to the qualities of being a woman. It is often used interchangeably with womanliness. Other synonyms include girlishness and womanhood. Femininity is therefore used to refer to all the attributes, roles and behaviors associated with women. These roles, attributes and behaviors are often both social constructs and biologically determined. For instance, attributes often associated with women include gentleness, empathy and sensitivity. However, postmodern forms of sexualities have utterly challenges traditional conceptions on femininity.

Male Gaze: The term "male gaze" is used to refer to the lens through which men – particularly heterosexual men – view the world and women. This lens is described by most feminist theorists as one of entitlement: entitlement to view, discuss, touch and (sexually) exploit feminine body without consequences. In the realm of visual art specifically, the term is used to refer to the way in which the world and women are depicted from a male point of view. This entails portraying women as sex objects existing principally for the pleasure of the male folk.

Micro-Expressions: This term is generally used in reference to (brief and involuntary) facial expressions that are shown on the face of humans depending on the emotions that are being experienced. In principle, micro-expressions are either not faked or hardly simulated. However, in the context of selfie taking, facial expressions can be pro-longed according to the kind of impression one wants to give his/her viewers.

Selfie: A self-portrait, typically taken with the help of a hand-held digital camera or a smart/camera phone.

Self-Objectification: It is a situation whereby, being actively socialized, women come to internalize the belief of themselves as sexual object and collection of body parts existing for the pleasure of the male folk.

Selfie-Objectification: This is neologism recently developed by feminists to refer to the act of presenting oneself as an object, especially of sight or other physical sense, through a photograph that one takes of oneself, for posting on social networking sites. The process involves three steps including (i) capturing photos of oneself to admire and scrutinize (ii) ranking and editing those photos to generate an acceptable final image, and (iii) sharing those photos online for others to validate

APPENDIX: FIGURES FOR THE BOOK CHAPTER

Figure 1. Objectified selfie

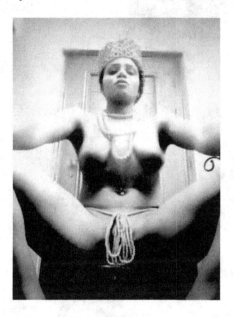

Figure 2. Conservative selfie

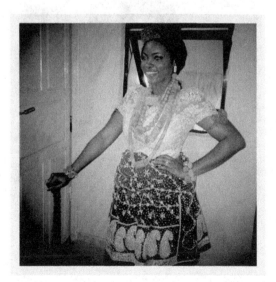

Figure 3. Posture

Figure 4. (Fair) nudity

Figure 5. Kissing pout

Figure 6. Multiple features

Figure 7. Conservative cropping 1

Figure 8. Conservative cropping 2

Chapter 6

Work–Based Self–Portrayals:
Signaling Reciprocity on Social Media to Reassure Distant Work–Based Project Collaborators

Shalin Hai-Jew
Kansas State University, USA

ABSTRACT

One degree out from an image "selfie" are text-based self-generated user profiles (self-portrayals) on social media platforms; these are self-depictions of the individual as he or she represents to the world. This work-based self-representation must be sufficiently convincing of professionalism and ethics to encourage other professionals to collaborate on shared work projects through co-creation, support, attention, or other work. While project-based track records may carry the force of fact, there are often more subtle messages that have high impact on distant collaborations. One such important dimension is "indirect reciprocity," or whether the target individual treats collaborators with respect and care and returns altruistic acts with their own acts of altruism. This work describes some analyses of professional profiles on social media platforms (email, social networking, and microblogging) for indicators of indirect reciprocity.

INTRODUCTION

The propositions from strangers usually come in a few basic ways. One modality would be emails in which the inviter will suggest that it would be a good idea to spend hundreds of hours working on a project for minimal return (say, a PDF copy

DOI: 10.4018/978-1-5225-3373-3.ch006

of that article). In many cases, the invitations are clearly created for broad-scale consumption. In other cases, there is a light merge-sort, in which a 'bot-captured title is melded with one's name, and then the proposal goes on as pre-written (often without any tie between the published work or the project for which work is being elicited). The cold-ask, without any prior relationship, requires a certain finesse so as not to offend. The objective is to capture the invitee's attention and interest and to motivate them to cooperate. There could be polite blandishments and promises of moneys, professional growth, reputational enhancements, friendship, or any number of rewards. Some are requests based on the goodness of the respondent: Would you share a site license key to enable a student in a developing country to analyze his or her qualitative data? Would you work with the individual to create a fraud detection tool for use with a third-party vertical? Would you share protected and sensitive data from an instructional design project with a private security company's agent? The mix has to be right because for any one individual, what may be considered attractive may actually be aversive. If initial communications are started, individuals may self-disclose information to lower uncertainty about themselves and increase their sense of likeability to others (Kashian, Jang, Shin, Dai, & Walther, 2017, p. 281), and often based on the "prospect of future interaction" (PFI) (Shaffer, Ogden, & Wu, 1987, p. 95). In most cases, the cold-ask goes unanswered, the invitee indifferent, and the electronic elicitations dumped in the spam folder. After all, the stranger generally is not in a position to ask, and there are many who are known quantities and who are in a position to ask for collaboration and whose requests will require work and focus.

In some cases, the inviter already has a light relationship with the invitee, and in these cases, there are friendly overtures and professions of friendship and polite language. The tradeoffs are usually the same, without much on offer, but that is the state of publishing today and the state of electronic hypersociality. Social media platforms and the cultural practices that come with them have pushed out the limits of the Dunbar number (the 150 people that individuals are said to be able to manage socially in established relationship), and individuals who head projects can gain partners on projects through hustle, social introductions, and mere talk. Such connections would not have been common in an earlier age when potential project partners usually had to be formally included in a funded project and people socialized in a more traditional way, say, face-to-face. Here, the "contact, proximity and neighboring" promote "the reciprocal exchange of services" (Plickert, Côté, & Wellman, 2007, p. 410). Certainly, people connect F2F even now, but it is not uncommon to collaborate on projects with people one has never met physically. These include constructive long-term and co-beneficial professional associations.

For all the expanded potentials of social connectivity, people do generally interact and collaborate in smaller groups: dyadic (pairs) or triadic (three individuals) groups, even when the human gatherings have a n>3. One researcher describes this:

Most interaction in real time is a sequence of fast decisions about how to behave toward a small number of individuals who are immediately present. What group size of n does is to affect whom one is likely to be interacting repeatedly with. It is a mistake to collapse all these interactions into one large n-adic interaction with the additional restriction near-universal benefit or cost for any act" (Trivers, 2006, p. 75).

In the language of social network analyses, in human populations, these are interactions at the level of motifs (subgraphs), with small numbers of nodes (individuals) connected in various ways. While people generally engage in homophilous ways with others who are similar and build bonding social capital, bridging involves moving between social clusters to build bridging social capital.

"Do Unto Others as You Would Have Them Do Unto You"

According to social exchange theory, people strive to maximize benefits for themselves and to minimize costs. In relationships, people keep score subjectively. Even objectively, there are various bases on which to understand balance, fairness, and proper repayment (Gouldner, 1960, p. 177). If relationships are out-of-balance, people will often take efforts to balance it. Reciprocity was theorized as a "moral norm" and "one of the universal 'principal components' of moral codes" (Gouldner, 1960, p. 161). The construct of the reciprocity norm has been operationalized empirically, with "a validated reciprocity scale in the China context" with both universal and culturally specific applications (Wu, et al., 2006, pp. 378- 379). Reciprocity as a critical part of human relationships "all Confucian societies" (Yang & Wang, 2010, p. 2011) (see Box 1).

In encouraging reciprocation, game-based research shows that "participants reciprocated more positively when treated positively in general" (Jung, Hall, Hong et al., 2014, p. 160). In collaborations, especially complex ones, "small wins" early on encourage persistence in the work (Weick, 1984); "small wins" are actions "that could be built upon, action that signaled intent as well as competence" (Weick, 1984, p. 42). K.E. Weick elaborated:

A small win is a concrete, implemented outcome of moderate importance. By itself, one small win may seem unimportant. A series of wins at small but significant tasks, however, reveals a pattern that may attract allies, deter opponents, and lower

Box 1.

Related Real-Life Case: An Offer to Return in Kind
A provost at a Southern university called the author to ask for information about a software program that the author had written about on a slide-sharing social site. After various questions were answered, he asked, "Why are you helping me?" with a little skepticism in his voice. After all, I was not in his chain-of-command. I had no benefit in terms of any relationship with the software maker. Then, he asked, "How can I help you?" He was counting costs in a mental ledger, and he wanted to dissipate a sense of debt or IOU. It could be that there was a dynamic described in a research work about the disruptiveness of power imbalances in reciprocity (Callard & Fitzgerald, 2015). Another issue could have been the realization that there might have been some "risk" in receiving the advice. For example, one researcher suggests that reciprocation is so ingrained that accepting even small favors may lead to a person's manipulation or compromise (Dobelli, 2013). Ultimately, nothing was requested in return.
Lesson: Reciprocity is a highly ingrained norm, even among strangers in a likely one-off.

resistance to subsequent proposals. Small wins are controllable opportunities that produce visible results (Weick, 1984, p. 43).

In situations when there is an expectation of return for effort, that refers to the expectation of direct reciprocity. "Altruism," though, refers to costly behaviors taken by an individual for another who is not "kin" or "closely related"—even at cost the individual (Trivers, 1971, p. 35). The differing types of reciprocity have different assumed time frames: "Altruistic reciprocity is based on long-term repayment, and strong reciprocity on short-term repayment" (Trivers, 1971, as cited in Jung, Hall, Hong, Goh, Ong, & Tan, 2014, p. 160). The latter theory offers more insights on cooperation with strangers:

Altruistic reciprocity is derived from the theory of kin selection (Hamilton, 1964), which posits that early humans learned reciprocity through communal living with kin. According to this theory, reciprocity is altruistic since kin co-operate to protect relatives with similar genes, not due to expectations of immediate or calculated repayment (Ashton, Paunonen, Helmes & Jackson, 1998). However, reciprocal altruism has been criticized for being too simplistic to account for the strong co-operative behaviours demonstrated by humans. A common alternative theory cited is strong reciprocity (Eisenberger, Lynch, Aselage & Rohdieck, 2004; Engelen, 2008). Strong reciprocity posits that humans engage in both positive and negative reciprocity. Positive reciprocity refers to rewarding someone for a favour received, and negative reciprocity refers to punishing someone for a disservice or antisocial act (Engelen, 2008). Contrary to the theory of kin selection, early human ancestors frequently travelled and lived among strangers, making it impossible to learn reciprocity solely through interactions with kinsmen (Engelen, 2008). The rewards and punishments associated with interactions with non-kin required early humans

to develop mechanisms of strong reciprocity, which suggests that human beings are biologically predisposed to co-operate with strangers through norms of reward and punishment. (Jung, Hall, Hong, Goh, Ong, & Tan, 2014, p. 160)

Those who practice naïve (non-strategic) altruism will end up giving away something for nothing, at least as pertains the dyadic relationship. (There may be benefits from third parties who reward the collaborative project if crediting is accurate to the work of the respective contributors.) When people observe altruistic behavior, they may be sufficiently influenced to engage in such behavior themselves (Test & Bryan, 1967, p. 15). This finding has implications for how altruism may be encouraged and disseminated through societies (see Box 2).

In an age when professionals may collaborate with each other using web-based connectivity, it would make sense that individuals may curate reputations

Box 2.

Related Real-Life Case: Opportunistic Costs
A former employee at a big-name software company had taken a spin-off product from that company in order to take it open-source. He personally put in moneys and time to publicize the software, which was a free add-on to a spreadsheet software. For years, he supported new users to the tool by providing interactive support to the website. He had published and co-published a number of academic works related to the tool and its use. So far, so good. A lot of people caught up in the open-source phenomenon have experienced the same.
After some interactions with the author, he elicited some chapters for several books-in-progress. The only websites claiming that the books were in progress were those he ran. A Google Search did not show any others. Then, over time, no publications actually emerged, so the author published the works with other publishers in order to protect the work's validity in time. (The works were not under contract with the individual.)
Then, later, the individual asked the author if she would share her contacts at software companies because he was thinking about selling all or parts of the open-source software. They had a web meeting during which he described his ambitions for a large-scale virtual community around the use of this tool (which never quite materialized). He let drop that his investments in the free software ran approximately three-quarters of a million dollars. He did not specify how he arrived at that amount, but he seemed to suggest that he would be asking for that amount in talks with software companies (if they might be interested).
Nothing ultimately came of the web meetings or the connections with software companies. As happens so much in high tech, everyone is innovating at the same time, and what may have seemed like an expensive and major advancement years ago had dated out. It is also hard to assign a value to something that had been given away for free for years in an open-source way. There are competitor packages from other makers that are stand-alone and do not require the original proprietary software to run. There are built-in features of the same capabilities in proprietary packages as well as in high level programming languages.
Lessons: Sometimes, all it takes is for circumstances to shift for different interests and aspects of a person to emerge. A person has to be aware of the differences between "cheap talk" and "costly signaling." Reputations may seem very solid, at least initially, but if there is a pattern of inaccuracy, that has to trump initial senses of solid reputations. Also, apparent "altruists" may actually be "selfish types" based on motivations, not "forced altruist" outcomes.

to maximize the potential number of quality coworkers on projects. A core part of human relating involves reciprocation or the returning in kind of both positive and negative actions. However, while reciprocity is a core social norm in many societies, it is not a certainty and may involve some contingencies:

Reciprocity – doing for others if they have done for you – is a key way people mobilize resources to deal with daily life and seize opportunities. In principle, reciprocity (the Golden Rule) is a universal norm. In practice, it is variable. Personal networks rarely operate as solidarities and as such, people cannot count on all the members of their networks to provide help all the time. Rather, social support comes uncertainly from a variety of ties in networks...The evidence is extraordinarily clear on one subject – giving support is strongly associated with getting it. (Plickert, Côté, & Wellman, 2007, p. 405)

A more complex form of positive reciprocation actually goes beyond simple mutuality but also into not harming the beneficent individual. Gouldner (1960) wrote:

Specifically, I suggest that a norm of reciprocity, in its universal form, makes two interrelated, minimal demands: (1) people should help those who have helped them, and (2) people should not injure those who have helped them. Generically, the norm of reciprocity may be conceived of as a dimension to be found in all value systems and, in particular, as one among a number of "Principal Components" universally present in moral codes. (p. 171)

In a social network, tie strength between individuals seems closely related to positive social reciprocity. Two-way trust indicates a more resilient relationship than one-way (Nguyen, Lim, Tan, Jiang, & Sun, 2010, p. 72); further, social networks with a higher number of two-way trust links "is likely to be more robust than that with few such links" (p. 72). In terms of trust-seeking, individuals may elicit this actively or passively (by imbuing trust-inducing characteristics, as one method, and by having a trustworthy reputation). Mutual (reciprocated) information sharing in a network strengthens the network and raises the level of directed network efficiencies (Zhu, Zhang, Sun et al., 2014). Tie strength may be defined a number of ways, but some common factors may be the numbers of constructive interactions between the two nodes, maybe the length of the relationship, and the resilience of the relationship. A "strong tie" is defined as having "at least two of the attributes of social closeness, voluntariness, and multiplexity" (Plickert, Côté, & Wellman, 2007, p. 408). People are most likely to share major resources through kinship lines, such as between parent and adult child (Plickert, Côté, & Wellman, 2007, p. 421).

Direct reciprocity enables individuals to cooperate over time based on repeated encounters. At each turn, an individual may cooperate or defect; they may continue to work with the other individual or may choose to stop cooperating. If there is a sense that the relationship will continue into the future, there may be more incentive to cooperate instead of defect. Indirect reciprocity refers to the phenomenon that individuals "will tend to help those who help others" (Alexander, 1987, as cited in Roberts, 2008, p. 173), based on social reputation. Part of the decision-making in whether to engage altruistically with another individual will depend on the others' reputation for "indirect reciprocity" concerns like cooperation and fair play, along with other concerns like capability, personality, social ties, work habits, follow-through, professional reputation, skills, and education. There is an assessment of whether the individual is prone to defect and cause harm to the cooperator (Trivers, 1971, p. 54). The social context itself may be informative of the likelihood of cooperation, based on the prevalent social norms. The more accurate reputations for "indirect reciprocity" are, the more trust individuals can have that their altruistic actions benefitting others will be noted and result in a return on initial investment to another stranger. Indirect reciprocity works even in contexts where people meet again when reputations are "as reliable a guide to cooperative behavior as does experience" (Roberts, 2008, p. 173).

Indirect reciprocity refers to one individual altruistically helping another, and this action is observed by others. The effect of that initial altruistic helping leads to "upstream reciprocity" if the recipient of that altruism then performs an altruistic act for a third party sometime in the future. Indeed, research has borne out the existence of "prosociality," with subjects for whom others had stopped reciprocating this consideration for other drivers, in a natural field experiment (Mujcic & Leibbrandt, 2016, 2017). For decades now, the "obligation to repay" has been thought to limit free ridership (advantaging oneself at the expense of others) and so promoting social advancement (Gouldner as cited in Jung, Hall, Hong et al., 2014, p. 160). The ideal suggests the following: In healthy societies, everyone works to benefit each other, and everyone gains.

Figure 1 was created using Network Overview, Discovery and Exploration for Excel (NodeXL). This shows a one-degree article-article network for "Reciprocity_ (evolution)" on the crowd-sourced encyclopedia, Wikipedia. The linked articles offer a basic way in to the topic of how living creatures may live in society and give-and-take with others through strategic cooperation. Studies in social networks also found that there can be equilibria states in which cooperation among members is favored ("Reciprocity (evolution)," 2016).

Or, that initial altruistic act may lead to "downstream reciprocity" if the altruistic actor is benefitted later in the future. ("Reciprocity (evolution)," 2016). For indirect reciprocity to work effectively, though, the reputational cues should be accurate, so

Figure 1. A one-degree article-article network for "Reciprocity_(evolution)" on Wikipedia

indirect reciprocity efforts are not spent on the wrong individuals. In generalized or indirect reciprocity, people will sometimes compete to offer altruistic help to other strangers maybe not for the others' sake but for the sake of "image scoring" or how they will look to others who may be observing and labeling them (Nowak & Sigmund, 1998, p. 573). Over time, people have learned to create cooperative societies, in which "strong reciprocity" ("a predisposition to cooperate with others, and to punish (at personal cost, if necessary) those who violate the norms of cooperation") occurs (Gintis, Bowles, Boyd, & Fehr, 2005, p. 8). At the individual ego level, the "tradition of reciprocity" may be consciously identified as core traditions shaping a life, with people showing "mutually rewarding" care for each other (Nader, 2007, p. 94).

One important personality feature to convey publicly is that of "indirect reciprocity." Generally speaking, there are two basic types of reciprocity: positive reciprocity refers to returning a favor to another individual, and negative reciprocity refers to returning a harm to another individual. There have been found to be cultural underpinnings to various responses by individuals to perceived benefits and harms. Direct reciprocity refers to a quid pro quo or a tit-for-tat, a direct return in kind, between individuals in dyadic, triadic, or other small-group relationship, or even between larger entities:

"You start with the first draft, and I'll …" That is not to say that associations are purely exchange-based with all costs and risks measured out, because the public and private association itself may entail costs, risks, and benefits.

While it may seem satisfying to "give as good as you get," negative reciprocity can lead to escalating spirals of harmful interactions, leading to outright conflict and ultimate dissolution of even long-term relationships. "Conflict avoidance" and "neutrality" are healthier relational options for protecting long-term relationships (Salazar, 2015, p. 116).

Now, many years into the age of social media, its participants report a sense of feeling constantly monitored (Freitas, 2017, pp. 11 - 12) with audiences both imaginary and non-imaginary. Young adults work at "craft(ing), cultivat(ing), (and) curat(ing)" self-identities and creating "marketing campaign(s) for me") (Freitas, 2017, p. 75). On the one hand are identities linked to themselves as identifiable individuals, and on the other, false and ephemeral identities that allow them to function freely without risks to personal brands (Freitas, 2017, p. 125 and p. 128). Apps with disappearing messages offer another way for people to explore and express their authentic selves, without others' judgment (Freitas, 2017, pp. 132 – 133) (see Box 3).

Box 3.

Related Real-Life Case: Balancing With "Friendship"
In academic publishing, especially with colleagues who work in similar fields, sometimes, one works on the other's project as a contributor, and vice versa. The general rule is that one may invite others to participate, but there cannot be an expectation of return simply because people are busy, and they have different pulls on their time and energy. Sometimes, though, a project can make or break depending on the numbers of contributors. In an incident that I now regret, I had asked an editor I'd worked with for years if she would be willing to contribute to a text. She expressed interest, but after deadline after deadline had passed, I finally expressed frustration at the lack of a contribution. Her reply: She was hurt because she had thought we were "friends." This, even though we had no friendly relationship, had never met in person, had never exchanged a non-work-based message, and knew nothing about each other beyond a professional reputation. Ultimately, the project worked out successfully. The former editor did not contribute to any part of the work. She did initiate a few other invitations to her own projects, but the relationship lapsed into purposeful silence. Her play was true-to-form, though, because people focus "directed altruism" to "friends over random strangers" (Leider, Möbius, Rosenblat, & Do, 2009, p. 1815). People also tend to offer cooperation and altruism more, in the shadow of the future, based on iterated or repeated Prisoner's Dilemma games. In a one-off, it may not make sense to risk the effort, without any return; after all, it may be sufficiently easy to burn the other person (what was known as "do unto others and then split") in a single play without further repeated engagements. Likewise, if there is little promise of future interactions or benefits, it gets harder and harder to maintain ties. Relationships—as character, too—reveal over time with more data points, which might suggest diminishing risk with the collection of more information. There would be no recouping any sunk costs, in this case. In some conditions, "natural selection favors these altruistic behaviors because in the long run they benefit the organism performing them" (Trivers, 1971, p. 35).
Lessons: Sometimes, highly exaggerated professions of friendship stand in for non-reciprocation by offering a faux rebalancing of the relationship. Also, the author was actually wrong to ask for a reciprocation because such asks are not fully fair and do not seem to result in quality work generally.

Strategy and Signaling

It would seem to be a gauche strategy to signal indiscriminate direct reciprocity to a broad audience because that cheapens the collaboration. Such offers are like #followback promises in user accounts trying to game the system by raising numbers of followers to create the impression of popularity. Practically, it is not possible to take on all comers, even with the affordances of social robots and other technological means. Even in the following of social accounts for information consumption, people tend to commit to sources with information similarity but unfollow alters based on "information overload and redundancy" (Liang & Fu, 2017, p. 1); practical considerations are paramount, and following entails an attentional cost and other costs.

Direct reciprocity makes more sense in private channels between individuals who may negotiate roles and shared work (and turn taking) to a point of agreement. What makes better sense would be to publicly signal "indirect reciprocity" or the openness to collaborate without any outright promise to. This public signal of indirect reciprocity should show the individual as both giving and receiving support on shared projects. It should convey an openness to be contacted, with available contact information. The emotional message should be welcoming. That said, such signals are "cheap talk," and "costly signaling" still would not happen until a person decided to sign on the dotted line, and actually follow through on costly actions.

Virtual Collaboration Project Types

The particular project types that involve virtual collaboration, using computer-mediated communications, refer to both formal and informal ones. In the first category are collaborations around defined funding sources and those in which members are formally included in grants. In the informal case are ad hoc projects in which individuals contribute to an online crowd-sourced project or work on a shared piece of writing for publication (which "pays" in byline credit, a complimentary digital copy of the publication, or some other light acknowledgment). While the rewards are generally minor, the work itself can be challenging. A case in point is publishing. There are peer reviews and editorial board reviews that have to be addressed, and there are additional burdens that are emotionally challenging. There are no guarantees that a work will be published, and sometimes, there is a lot of invested effort that results in no publication and a need to propose publication to other publishers (who will want a total reworking of a piece of writing if it's to appear in their publications). The publishing process is a drawn out one. Based on the respective topics of books, the contributors will be from a variety of locales, and many of them will not have direct face-to-face interactions with each other—but only have thin ties based on the project and maybe shared professional interests.

The potential project collaborators do not know each other except through virtual means, such as through published work, professional affiliations, formal and informal word-of-mouth, and reputation metrics. These prior indicators are generally indirect ones and rely on the truthfulness of others. The work itself often exists outside the super-structures of work places that enable cooperation and third-party trust. Trust itself is not a single dimensional phenomenon. It is wholly possible for people to trust one aspect of a person but not another, depending on the available information and the available impressions and the truster's internal heuristics for trust. In this context, people are self-organizing, and their lack of knowledge about others can be highly inhibitory. In this context, there is a cost to work on others' projects: effort, resources, time, and talent; there are also opportunity costs (time spent on one project precludes the spending of that same time on other projects or endeavors).

When such endeavors go off-script, it is often because one side expects something in return from the other. It may be that authors sign contracts without reading them, assuming that they will be better treated than they ultimately are. It may be that typos have somehow slipped into the final draft. Or maybe authors expect the editors to offer some sort of *quid pro quo*, such as contributing to one of their editorial projects or helping one of their friends who may be in town (local to the editor) or other issues. Maybe the author would like to use the editor's professional standing to get invitations to visit or to collaborate, a situation not uncommon in international publishing. If social norms tend to be geographically local and culture-based, international publishing would be a venue in which social norms may clash. Even if social norms of sharing and cooperation predominated, these do not erase people's self-interests; rather, there is a tendency for people to adhere to "relevant social norms inasmuch as they can enhance their self-image or reputation as a moral person" (Krueger, Massey, & DiDonato, 2008, p. 31). Unsurprisingly, in such a context, "cheap talk" is not uncommon, and promises may be insincere. While there are ways to resolve differences, the channels for such resolutions are few: handle the issue between the individuals, bring in the publisher, or take the issue widely public (but at the risk of mutual loss of public reputation and respect).

Because of the inherent risks in virtual collaborations around projects, those who would engage generally need to do due diligence. They are not in an environment in which there is a dearth of information; rather, there is usually a lot of information to explore and process to arrive at a decision of whether to proceed with a project or not. People joke about "cyber-stalking" others, but it is not uncommon to "check out" people on Google Search, on people-finding sites (which enable access to all public records about that individual), on professional sites, on social media, and other sites. In a reputation economy, though, people's reputations are both self-created and other-created. For example, even if there is derogatory information about an individual, they may hide that information by ensuring that other links appear in the top few pages

of search engines (with the help of professional reputation management businesses, even). They can try to burnish their own reputations. They can change their names, so they can create "clean skins" through which to interact with the world. While such efforts will not deter a determined researcher, misinformation may be able to mislead some. The ability to create a faux reputation not only enables freeriding but it also weakens the "tag-based altruism" because the tag itself is not an accurate indicator of an underlying true state of the individual to find fellow cooperators (Trivers, 2006, p. 73). It can be hard to determine whether a public reputation is honestly earned and real, or bought and faux. If others' reputations are accurate, credible, and accessible online, that may be low-cost way to know. There are other ways to know—by a few elicited interactions—to test the individual's approach to the world and to potential colleagues (with varying degrees of accuracy). In one work, the research team found that a spiral of effects that combined "affirming trust perceptions" and "acts of cooperation between the actor and partner over time" was optimal in arriving at a healthy working state (Ferrin, Bligh, & Kohles, 2008, p. 162).

Ascertaining the accuracy of reputations is not a one-off or initial assessment; rather, potential online collaborators may be assessing throughout the interactions—from initial introduction to the lifespan of the relationship. After all, an individual may be fully credible and honorable but still have projects fail due to circumstances beyond their control. (There are collaborative projects that change mid-stream, with contributors having to go elsewhere in order to publish or present a work.) People do constantly have to decide whether or not to continue a relationship, and if not, how to end such relationships with finesse (most often with a polite explanation and an end, or silence).

"Selfie" and "Work"

Reputations online can be a bit of a mixed bag of information. There are no digital doppelgangers that are exact to a person, and representations of people may vary in accuracy. The "selfie" is a combination of "self" and the diminutive "ie," which gives it an informal feel. A workplace is generally considered a formal space, with people in their polished best. A Google image search for "selfie and work" resulted in the top-level imagery in Figure 2. This small sampling of photos shows individuals in various work-based contexts, some with colleagues, and others alone, and all in professional dress (whether uniforms or others). The moods range from somber to cheery. Some are engaged in using various types of equipment, one holding a phone to his ear and sitting in front of a computer screen. These work-based or professional selfies (self-portrayals)—in some ways like typical generic selfies—

showcase the individual in positive light in the midst of their individual brand. They depict something that others may aspire to—with their importance and skills and access to resources. The images may show snippets of interactions. They may show intercommunications with others—who may be seen as stand-ins to the co-collaborators of the target individual. The selfie-takers seem to be communicating with a narrowcast audience of close-in friends, families, colleagues, and even supervisors, but based on their choices of venues, also a broadcast audience of strangers. These images self-disclose work contexts and include personally identifiable information (PII) in many cases. Social imagery offers one modality for people to share their work-based self-portrayals. Another, which will be the focus of this study, involves text-based professional selfies—on public social media platforms and on generally private email exchanges.

A core underpinning for reciprocal altruism is the human capability "of thinking of self and other in equivalent ways—as selves and persons" (Barresi, 2012, p. 120). The respect for others enables altruism—acts that cost the actor in the service of another's interests. Language, in written and spoken forms, is a powerful tool to enable people to plan and cooperate. Human culture is conceptualized as having evolved in order to enable people to work together for the survival of the species. In *Wired for Culture: Origins of the Human Social Mind,* Mark D. Pagel writes:

Figure 2. "Selfie" and "work" on Google Images

Contrary to what most of us probably take for granted, then, it is not the main function of language merely to communicate, as when, say, two computers send information back and forth. Rather, language evolved as a self-interested piece of social technology for enhancing the returns we get from cooperation inside the survival vehicles of our cultures. (Pagel, 2012, p. 281)

Cultural altruism evolved over time to help people gain mutually but only if they could differentiate fellow cooperators, so they would know whom to benefit. The enforcement of social norms for cooperation is sufficiently hard wired that people are willing to respond with violence if they "think justice is imperiled by selfish behavior" (Pagel, 2012, p. 201).

If altruists help each other even just some of the time, but avoid helping non-altruists or non-cooperators, collectively the altruists will be better off than the non-altruistic or selfish players who never help each other. Avoiding selfish or uncooperative people is important because helping a non-altruist means helping a competitor to the fledgling mutual aid society. This raises the possibility that natural selection has favored in us a heightened sensitivity to detecting what we might think of as social cheats or free riders, people who might take advantage of others' goodwill without intending to return it—they are the enemies of the mutual aid societies (Pagel, 2012, p. 208).

Differentiating will enable people to decide whether to reward a person for prior acts of altruism or to punish a person for failing to be reciprocating of others' acts of altruism. People who can differentiate can affirm the social norms of reciprocation. In dyadic (pairwise) relationships in iterated games, Robert Axelrod (1981) famously found that there can emerge "cooperation among egoists) and that TIT FOR TAT is the optimal strategy for players in a context without central authority; in this construct, this involves treating others with fair play but also protecting one's own interests.

Reciprocity is not necessarily always a net positive for virtual teams. On work teams, excessive reciprocation can prove unwieldy and introduce conflict (Nohria & Berkley, 1994, as cited in Wong & Burton, 2000, p. 353) and may actually hinder the work.

This is not a judgment about people as deterministic types because all individuals can be either altruistic (other-serving at the expense to self) or cheating (self-serving at the expense of others) depending on the circumstance; they can even be simultaneously working in the service of others and themselves. General assumptions of rational actor decision models consider that people are instrumental and pragmatic. They strive to maximize gains but are not always fully rational. People have some agency over how to respond to their tendencies, and they decide a balance "appropriate to

the local social and ecological environment" (Trivers, 1971, p. 35). Altruism is not an absolute loss to the altruistic actor but may be part of a larger chain of social equitability and justice in the long term (Barresi, 2012, p. 129), which allows for rational considerations and definitions of prudent choices. Dyadic pairs may engage in a circular process of trading favors with others, for turn-taking of benefits, from one project to another. As has been noted, for reciprocal altruism to work, there has to be some common metric which "requires a theory of mind in order to judge how costs and benefits appear to different individuals and to the same individual across time" (Barresi, 2012, p. 126).

With the wide prevalence of social media, it is possible to acquire more of a 360-degree view of a person, with feedback from others who have had interactions with that individual. The idea here is that an initial read of a person has to be sufficiently positive to encourage even an initial interaction, and that initial interaction likewise needs to be sufficiently positive to continue to the next step. Once a relationship is started, individuals may collect additional information that informs them on whether they should deepen the relationship, start or continue shared endeavors, and proceed with the interactions or not. The more investment people have put into a relationship, the more risks they may have, and the harder it may be to untangle the ties. At any point in the work sequence, any member may choose to defect instead of cooperate.

A Professional Selfie

A "professional selfie" or "work-based self-portrayal" may be part of the package of trust conveyance, to encourage or discourage virtual collaborations on projects. Included photos may show an individual as more real and approachable. The shared information may be verifiable through third-party sources. For example, if a person claims to have graduated from a particular university, that is a fact that may be verified. The "force of facts" may be fairly compelling for initial trust. Some of this may be indirectly arrived at: "Since this individual works for Company A, and Company A has a reputation for rigor and high employment standards, this individual must be all right."

The work sequence steps in Figure 3 include the following:

- Project Proposal
- Research Design
- Research
- Data Analysis
- Writing
- Data Visualizations
- Draft Review

Figure 3. Opportunities to cooperate or defect at any point in the work sequence

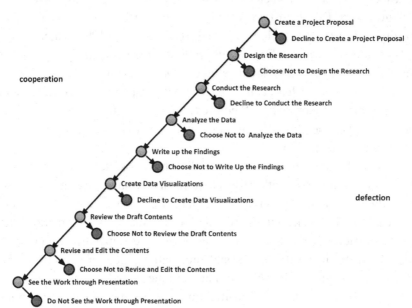

- Revision and Editing (refinement) and (Typography and Layout)
- Presentation

The sequence can apply to different types of projects with different work sequences. Initially, at first contact, with insufficient information, people may assume that others have potentials and interest that may not actually exist. As more data points are acquired, it is easier to be more accurate in terms of understanding others. For example, does the individual make promises but either not deliver or under-deliver? (Is there a "say-do" gap?) In terms of colleagues, do they meet deadlines or not? How easy are they to work with? How do they reason in times of stress? How do they treat the other members of the team? For those with long-term cooperation, it is reasonable to assume that there will likely be occasional interpersonal tensions, some mix of competition and cooperation, and a level of aligned interests. To optimize long-term cooperation, individuals likely need to ensure that each side's interests are met, and that there is long-term development of trust and respect. In collaborative groups, members who generally do not deliver end up being socially pruned (or left out of the group). Likewise, unreciprocated edges "have a shorter lifespan—they are more likely to be dissolved by the unreciprocated party" (Hallinan, 1978; Tuma & Hallinan, 1978; et al., as cited in Raeder, Lizardo, Hachen, & Chawla, 2011, p. 1). The points at which such decisions are made may be between projects when

individuals come against hard scrutiny for their value. For virtual informal projects, in general, there are times of work intensity and then long periods of quiet and non-activity, in a kind of punctuated equilibrium. There can be a sense of decay of the tie over time, which may lapse from non-use, or even a purposive breaking off of relationships due to disagreements, misunderstandings, competition, jealousy, and other relational sundry. There are material, ego, and practical reasons to go it alone without collaborations if individuals can afford not to. Joining onto a team project can dilute credit and rewards. First authors of teams with more than five collaborators get all the glory, and sometimes, that also means all the moneys.

The Research

This work explores two basic hypotheses about "professional selfies" shared through public and private channels—to both broadcast and narrowcast audiences.

Hypothesis 1: In self-created work-based selfies ("self-portrayals") that are publicly shared on social media, persons will communicate general "indirect reciprocity" in various ways to invite more invitations for collaborations (to broaden choice and to raise competitive desirability). To this end, there will be more messaging indicating "indirect reciprocity" than those that offer counter-messaging about the individual's "indirect reciprocity" state.

Hypothesis 2: In direct person-to-person work-based intercommunications (such as through email), persons will communicate work-based self-profiles indicating general "indirect reciprocity" and specific "direct reciprocity" in various ways to invite a wider choice of collaborations (to broaden choice and to raise competitive desirability). To this end, there will be more messaging indicating both "indirect reciprocity" and "direct reciprocity" than those that convey counter-messaging about the individual's reciprocity states.

This chapter describes how the two above hypotheses were tested with both public data from social media and more private data from the author's emails and other work correspondence. Also, this work entails the creation of some initial coding of messages in the "indirect reciprocity" and "direct reciprocity" categories, as well as counter-messaging. Finally, an initial tool for "Auditing a Work-Based Selfie" (AWBS) is introduced.

REVIEW OF THE LITERATURE

Certainly, there are ego preferences for collaborators and work conditions well beyond how others signal. What may go into collaboration decisions? There may be considerations for the type of collaborative work, the likelihood of success, the access to resources and technologies, the personalities of the work partners, the physical closeness or distance of the project partners, the funding, and others. This may be informed by contexts and knowledge well beyond that of particular work-based partners' professional selfies, such as the institution of higher education or corporation, and others. Also, the local conditions for the particular individual will also affect availability for collaborative work. For a rational actor, various discriminatory strategies need to be applied.

People are seen to transfer existing real-world power structures and practices into social media. In one study, reciprocation is seen as a necessity for people to pursue their goals as rational agents by maintaining sequential reciprocities with others with whom they cooperate. The researcher describes the dynamics.

People develop patterns of exchange to cope with power differentials and to deal with the costs associated with exercising power. One of the crucial patterns is reciprocity. The process begins when at least one participant makes a 'move,' and if the other reciprocates, new rounds of exchange initiate. Once the process is in motion, each consequence can create a self-reinforcing cycle. (Surma, 2016, p. 343)

In this study, social reciprocity was empirically observed in dyadic relationships maintained on Facebook in alignment with real-world social norms to "maximize strength of their relationship and minimize the cost of communication" (Surma, 2016, p. 346).

Social Competition

In intercommunications, "actors in an exchange relationship delay reciprocation as a means of subtly claiming dominance when relative status is ambiguous" (Park & Kim, 2017, p. 142), and this may be a dynamic in some types of distant relationships. Certainly, this occurs in email exchanges. Ignoring another's email may be perceived as a social slight, a studied ignoring, a lack of respect, and an active non-responding. It might speak, "This is not worth my time." On social media, the powerful nodes are those that are positioned in social networks so as to gain the main resources and information from others, the ones with high centrality. These nodes have high in-degree and low out-degree, in the same way that celebrity individuals have a lot of followers but few that they follow themselves. Most of the mapped relationships

between user accounts on social media show high rates of non-reciprocation and imbalance. Celebrityhood is about power and elitism (Clarke, Murphy, & Adler, 2016). "Parasocial" relationships (as experienced by fans of mega celebrities) are one-way relationships (such as followee to follower), without reciprocation or two-way interchanges (beyond a one-to-many type of broadcast messaging). Such asymmetries are a dynamic from conventional media, with one-to-many broadcast relationships and little in the way of narrowcast interchanges.

Researchers have observed that reciprocity "is a defining feature of social media" and the cultural norm of reciprocity "may be a more important antecedent of trustworthiness than trust propensity" (Aggarwal, Rai, Jaiswal, & Sorensen, 2016, p. 411). Relationships in online social spaces are generally of two kinds: declared and formal ones (such as followership) and *ad hoc* ones (such as replying to a posting by another, forwarding a message by another, mentioning another, and so on). In some social networking sites, reciprocal relations may be the norm, with people agreeing to be followed by others and vice versa. In others, like some microblogging sites, asymmetric relationships may be the norm, with individuals not having to approve accounts that want to follow theirs. This phenomenon applies to Twitter:

In fact Twitter shows a low level of reciprocity; 77.9% of user pairs with any link between them are connected one-way, and only 22.1% have reciprocal relationship between them. Twitter shows a low level of reciprocity; 77.9% of user pairs with any link between them are connected one-way, and only 22.1% have reciprocal relationships between them. Thus, social links on Twitter represent an influence relationship, rather than homophily (Ahn, Han, Kwak, Moon, & Jeong, 2007, as cited in Kwak, Lee, Park, & Moon, 2010).

Reciprocity is not just about returned messages, information sharing, and work. They also reciprocate emotions, both positively and negatively: "Humans tend toward other types of reciprocity as well, such as emotional ones, reflecting back positive emotions ("interest, curiosity, enjoyment, compassion, and so on") as well as negative (with "resentment, anger, demands, disrespect")" (Stosny, 2016, p. 65). On social media, only a tenth of users are observed as "continuously active in social networks" (Thordsen, Murawski, & Bick, 2016, p. 394), so observed dynamics may be only from a subset of a subset.

At a cost to privacy, people self-disclose information about themselves on social networks for both social reasons ("reciprocity," "relationship building," and "self-presentation"), and non-social ones "related to convenience" ("personalization," "entertainment," and "security & safety"), the latter group if data apparently to social media service providers (Thordsen, Murawski, & Bick, 2016, p. 392). Reciprocity between communicators may communicate interest in an interpersonal

(and potentially transactional) relationship and shows a willingness to be mutually vulnerable (Thordsen, Murawski, & Bick, 2016, p. 393) because such information-sharing requires effort and potentially opens both to personal vulnerabilities and risks. On social media platforms, expressions of interest in others—whether based on "person-interest" or "content-interest"—may be expressed in implicit and explicit ways (Jacovi, et al., 2011, p. 27).

Trust is a necessary part of human collaboration, and its presence enables individuals to collaborate more deeply and take on higher challenges and greater risks. Evolving relationships to this level of trust requires hard work on all sides. Trust propensity itself is a psychological feature of a person's tendency to have generalized trust in others (and involves their general risk posture in relation to people). While trust is described in different ways in the research literature, it has recently been described as confidence that the person being trusted "has attributes that are beneficial" to the trustor (McKnight, Choudhury, & Kacmar, as cited by Aggarwal, Rai, Jaiswal, & Sorensen, 2016, p. 412). In other words, trust may be an indication that there is an anticipation of constructive interactions and future benefit from future interactions. There are precursors to trust, including the trustworthiness of the trustee (including "ability, benevolence, integrity" as some trustworthiness dimensions) as well as "trustee's reciprocity, social ties, and reputation" (Aggarwal, Rai, Jaiswal, & Sorensen, 2016, p. 412). Trustors also have differing propensities to trust or not trust in a generalized way. Trust, when combined with social norms of reciprocity, may enable strangers to move beyond short-term self-interest and build something constructive and mutual with "members of social media" (Aggarwal, Rai, Jaiswal, & Sorensen, 2016, p. 414). These dynamics convey the sense of people having to "give to get," in the common parlance, and to take some risks. On social media, there is a sense of social risk in putting out a message that is not responded to or ignored by others (Lev-On & Adler, 2013, p. 88). People are often socialized to care about others' impressions. To that end, some social sites enable easy ways to convey light acknowledgments of others through "paralinguistic digital affordances," such as various ways to like, favorite, upvote, and otherwise affirm (Carr, Wohn, & Hayes, 2016), with individuals interpreting such messages "phatically, deriving exchanged meaning in a cue with little innate or denoted meaning" (Carr, Wohn, & Haye, 2016, p. 385). ["Phatic" language refers to language used for socializing, not to convey meaning per se] (see Box 4).

Different reputational cues affect different types of trust. How people interpret reputation cues depends on features of the reputation cues. Online system generated ones affect two important facets of trust while profile pictures apparently appeal only to one:

Box 4.

Related Real-Life Case: Socio-Technical Systems as Mediators for Research-Sharing and Virtual Collaborative Work
In recent years, several online sites have emerged which encourage academics to join to share their publications (to acquire more citations and raise their influence metrics), interact with colleagues, and raise their professional profiles. As a byproduct of these socio-technical systems, many offer reputation metrics, with indicators of reciprocity: how welcoming and fit a person may be for virtual collaborations.
These reputation metrics include the following: many works have been published (showing collaboration with the publishing companies), how many co-authors he or she has published with, how responsive he or she is to other members of the virtual community (on the site), how much he or she shares information about current ongoing projects, how many reads he or she gets for his / her shared papers, how many people he or she follows, and how many follow him or her, how many of his / her colleagues also sign on to the platform, and so on. There are elements of "persuasion design" that harness "social proof" (how people are influenced to take certain courses of action when others do it) strive to encourage the sharing of uncopyrighted papers as well as status updates on ongoing projects. (The quality of the algorithms to the sites vary, with some suggesting co-authors with zero ties to the self. Likewise, the security of the respective sites varies as well.)
There has been a long lineage of using social computing technologies to change human behaviors, with varying degrees of (in)effectiveness. One near example: In the same way that an awareness of fairness norms may result in more balanced agreements in an online e-mediation system (Druckman, Mitterhofer, Filzmoser, & Koeszegi, 2014, p. 193), shared awareness of virtual work expectations may potentially result in more balanced shared work.
Researchers have found that people can bring "overlearned social behaviors such as politeness and reciprocity" to their interactions with inanimate computers (Nass & Moon, 2000, p. 81) and by extension socio-technical systems. Even nuanced design elements can subliminally induce human cooperation with computer systems (Nass & Moon, 2000, p. 87). [People may be social-engineered based on their learned politenesses in a cybersecurity sense, so the idea is to not be unthinking in how others are dealt with].
Lessons: Socio-technical spaces can encourage heightened reciprocation, at least on the margins—such as the sharing of available articles (many of which are already hosted elsewhere online) and sharing light information, but these spaces do not change fundamental rules (of intellectual property) or work-based incentives or necessarily relationships. Such systems should be used in a thinking and non-automatic way. In some cases, users of such sites may benefit with an actual real-world connection and constructive collaboration.

Reputation cue, generated by the system, was found to influence both affective and cognitive dimensions of trust, whereas the self-generated cue of profile picture affected only affective trust. Reputation cue had a direct influence on perceived review credibility, whereas the influence of profile picture on perceived review credibility was dependent upon review valence. (Xu, 2014, p. 136)

There are controls over opportunism (absolute selfishness), including social guilt (as a psychological cost) and anticipatory empathy (Pelligra, 2011)

When triggered by inequality or by opportunism, the guilt factor produces a cost whose negative effects agents tend to anticipate and avoid by behaving pro-socially. In this interpretation, thus, individual sensitivity to guilt should affect, ceteris paribus, the likelihood of pro-social behavior. Psychologists from different perspectives suggest that the cognitive and affective basis for feeling guilt is the capacity to feel or anticipate the suffering and distress of others, in other words, to empathize with others (Hoffman, 1982; 2000; Baumeister et al., 1994; Singer and Fehr, 2005; Tommasello et al., 2005, as cited in Pelligra, 2011, p. 3)

Potential trustors (those who take risks by placing trust in others) are informed by previous interactions with the potential trustee (person being trusted), and this information helps the trustor anticipate future behaviors; this assessment is continuously updated (Delgado-Márquez, Hurtado-Torres, & Aragón-Correa, 2012, p. 226). Repeated interactions offer opportunities for individuals to gather information about others, and trust itself may transfer reciprocally (Delgado-Márquez, Hurtado-Torres, & Aragón-Correa, 2012, p. 231). There is also trust transfer among agents based on word of mouth (WOM), which is yet another communications channel.

Environmental conditions can be shown to inform the amount of cooperation and investment between agents in a cooperation game with variances of investments "within a certain range" (Feng, Zhang, & Wang, 2017, p. 71). Knowing how to respond as a player involves sensitivity to the relevant indicators in the environment and the adaptive dynamics of the individual.

"Strong reciprocity can be understood as 'a propensity to co-operate and share with other similarly disposed, even at personal cost, and a willingness to punish those who violate co-operate and other social norms, even when punishing is personally costly'" (Bowles & Gintis, 2000, p. 37, as cited in Jung, Hall, Hong, Goh, Ong, & Tan, 2014, p. 161). Acting on negative reciprocity is thought as being distinct from those favoring positive reciprocation. Researchers write:

Students' degree of endorsement of the negative reciprocity norm was related to (a) beliefs in people's general malevolence; (b) inclination toward anger in everyday life; (c) anger, disagreement, and ridicule directed toward a new acquaintance who treated them unfavorably; and (d) reduced anxiety, positive emotional engagement, and encouragement of a new acquaintance who treated them favorably. Endorsement of the negative reciprocity norm showed little relationship to endorsement of the positive reciprocity norm, need for dominance, or impulsivity. (Eisenberger, Lynch, Aselage, & Rohdieck, 2004, p. 9)

Individualistic cultures and collectivist ones were found to differ in terms of negative reciprocity: in individualistic cultures, members would return harm for

harm, but in collectivist cultures, members would tend to display "consistently neutral responses to both friends and strangers when they were treated negatively" (Jung, Hall, Hong, Goh, Ong, & Tan, 2014, p. 167).

Reciprocity in online spaces is not a given, with sociologists suggesting that "information sharing in online spaces is likely to form networked individualism rather than communal reciprocity" (Reich, 2010; Wellman, 2001, as cited in Wu & Korflatis, 2013, p. 2070). An analysis of data from Yahoo! Answers resulted in empirical evidence of collective reciprocity—specifically that "the more effort (relative to benefit) an asker contributes to the community, the more likely the community will return the favor. On the other hand, the more benefit (relative to effort) the asker takes from the community, the less likely the community will cooperate in terms of providing answers" (Wu & Korflatis, 2013, p. 2069). The findings are somewhat surprising given that information-sharing communities are "usually one-directional and nonreciprocal" (Wu & Korflatis, 2013, pp. 2070-2071).

INDIRECT RECIPROCITY IN SOCIAL MEDIA PLATFORM PROFESSIONAL PROFILES AND DIRECT RECIPROCITY IN PRIVATE EMAIL-BASED PROFESSIONAL SELFIES

Data Sourcing

To explore the two hypotheses, it was important to collect data. Initially, a social slide-sharing site and a microblogging site were explored for work-based profiles, but these did not offer sufficient depth of textual contents for sufficient data analytics. Some sites just offered a space for a name and a photo and not much else.

Then, there were explorations of author biographies in a major bookselling (and other products) site, profiles in a jobs site, profiles in a fund-raising site, a freelance site on a social networking platform, a community data sharing site, and others—to collect insights, in a broad but shallow sampling. In terms of the private / semi-private messages, these were from over a decade of work-based emails. These respective profiles—separated into public and private collections—were captured in text files for verbatim examples. From these examples, themes were extracted.

To show how this could work with "distant reading" (Moretti, 2000), a public single-set analysis is shared initially below. This first approach shows a predominant use of computational means to find some indicators of "indirect reciprocity" and "direct reciprocity" messaging at a high (meta) level. This approach does not use much in the way of human close reading except for the work in engaging a word tree in Figure 8.

Public Single-Set Analysis With Distant Reading

To get a sense of how this might work, in Figure 4, there is a word frequency cloud of the terms found in a work-based freelancer Facebook profile and its poststream. There are focuses on freelancer, project, work, employers, and other frequently listed terms. There are some high-level indicators of "indirect reciprocity" such as the communication of trust in "private message," and reward in "payment" and "great," and opportunity and promise in terms of "entry," as in the sense of achieving something better and higher. Some of the words indicate direct reciprocity as well, with indicators of money for work.

In terms of high-level auto-extracted topics and themes (Figure 5), some possible indicators of indirect reciprocity may include indicators of availability like "freelancer," of challenges like "bid" and "job" and "project," and about inclusion with "private message."

The top-level themes are autocoded into a treemap in Figure 6. The autocoding was done in NVivo 11 Plus and was autocoded at the level of cellular granularity (not sentence level, not paragraph level).

In terms of sentiment, the words used in this Facebook account tend towards the moderately positive and the very positive (Figure 7).

Figure 4. Word cloud of a freelance account on Facebook and its Poststreams

Figure 5. A listing of autocoded top-level themes from the freelance account's messaging on Facebook

Auto Code Wizard - Step 2 of 4 ? ✕

Themes in your sources have been identified. Please review the information provided below.

A node will be created for each selected theme.

Identified themes:

☑	Themes	Mentions ▽
⊞ ☑ ○	project	1580
⊞ ☑ ○	freelancer	1376
⊞ ☑ ○	job	707
⊞ ☑ ○	message	691
⊞ ☑ ○	work	689
⊞ ☑ ○	good	632
⊞ ☑ ○	payment	621
⊞ ☑ ○	design	568
⊞ ☑ ○	account	530
⊞ ☑ ○	time	455
⊞ ☑ ○	page	409
⊞ ☑ ○	contest	398
⊞ ☑ ○	employer	388
⊞ ☑ ○	bid	386
⊞ ☑ ○	private message	379
⊞ ☑ ○	entry	351
⊞ ☑ ○	profile	344
⊞ ☑ ○	app	334
⊞ ☑ ○	great	333

Press Finish to auto code, or Next for more options.

 Cancel Back Next Finish

Figure 6. Autocoded themes and subthemes of a freelance account on Facebook and its Poststream

155

Figure 7. Sentiment analysis of the messaging of a freelance account on Facebook and its Poststream

A word tree with "interest" as the seeding term brings up some of the communications in the profiles and poststreams (Figure 8).

In terms of specific focus on profiles, there are discussions of a variety of profile types, in a very practical way, in Figure 9. For example, in descending order: profile page, profile picture, freelancer profile, employer profile, fake profiles, profile summary, company profile, profile details, complete profile, workers profile, profile image, freelancer profile page, user profile, and others. Profiles and related identifies—at the individual, team, company, and others are important in the job marketplace, according to the extracted information.

Public and Private Multiset Analysis With Computational and Close Human Reading

As noted earlier, a collection of over 100 public profiles were collected from a mixed set of social media… depending on various levels of access. (The > 100 is arbitrarily set based on a convenience sample. This work is considered a preliminary one to explore the efficacy of the concepts. The approach can be scaled up for more in-depth analysis. The point of this initial exploration is also to extract some exemplars, observations, and themes.)

In terms of text snippets from the cumulative text file from public profiles and a separate collection of private ones, the following was captured from all the sources mentioned above…with a special focus on textual expressions that may indicate direct and indirect reciprocity. So as not to take people's verbatim quotes without their permission, the comments in the cells are paraphrases. In the analysis, certain

Figure 8. "Interest"-based word tree from the freelance account on Facebook

Figure 9. Auto-extracted "profile" theme and subthemes in the freelance account on Facebook

Table 1. Work-based self-portrayals: coding for direct and indirect reciprocity via public and private channels (messaging and counter messaging)

	Public Channels (Profiles on Public Accounts on Social Media Platforms)	Private Channels (Email Messages, and Others)	Notes/Observations of Strategies and Tactics
Direct Reciprocity in Work-Based Profiles			
Messaging Direct Reciprocity (Straight Trade)	I have served in these professional roles and will continue to bring what I learned from those roles to this project.	• I will have this to you by the end of work day today. • Let me know if you have anything else you want changed. • It's been really great working with you. • This project sure turned out well.	• Inclusion of live, valid, and direct contact information • Timely responsiveness • Friendliness • Follow-through • Forwarded emails to verify information from the earlier email chain and to convey trust
Counter Messaging vs. Direct Reciprocity (Straight Trade)	I'm not sure why my job rating is down on this site, but…	Is that all the feedback you're going to give to me?	• Non-inclusion of live, valid, and direct contact information • Non-responsiveness • Delayed responsiveness • Non-friendliness • Non-follow-through • No sharing of any information that may be sensitive • Non-follow-through of work
Indirect Reciprocity in Work-Based Profiles			
Messaging Indirect Reciprocity (Openness to Engagement)	• I live with my family and have pets who are very spoiled. (I am a relatable and kind person.) • My history and experiences make me a trustworthy person. • My job is to make the client look good. • I am adaptable and will "flex my style" to whatever the client needs. • I am "a bit of a jack" (of all trades). • I bill in a fair way. • I am interested in knowing what your needs are. • Please refer to me by my first name. • Portfolio pieces are available if there is interest.	• If you have any project in mind, let me know. I'd like to be a part. • I really enjoy working on teams. • I might have something for you next term.	• Effusive thanks and expressions of appreciation for work done or opportunities given • Inclusion of live, valid, and direct contact information • Timely responsiveness • Friendliness • Follow-through • Forwarded emails to verify information from the earlier email chain and to convey trust
Counter Messaging vs. Indirect Reciprocity (Openness to Engagement)	If you have a book project or some other collaboration, the presenter is not taking any proposals right now.	• Do you know who will be first author on this? • Do you know how much time this work might take? • Is there any funding for this?	• A lack of politeness • A lack of gratitude • Non-inclusion of live, valid, and direct contact information • Non-responsiveness • Delayed responsiveness • Non-friendliness • Non-follow-through • No sharing of any information that may be sensitive • Declinations of work opportunities

key words seemed to be common to particular sites—maybe based on users of those sites copying each other.

Meta-Themes in Indirect Reciprocity in Public Work-Based Profiles

Some themes conveying indirect reciprocity emerged in the analyses of the profile messaging. They include the following:

Communicating Friendliness

Friendly approachability—expressed in smiling photos and warm-toned text—conveys availability. This may be followed through the sharing of contact information (email addresses, Twitter handles, Facebook addresses, telephone numbers, and physical mailing addresses, among others), with timely responses when reached out to, with maintained social media accounts (through which people contact individuals), and other means. If prices for services are listed, having something within reasonable ranges (within two σ of the mean). The curated public persona should not be off-putting, and it should be approachable.

A sub-element here may be the communication of generalized trust. This suggests that a person generally approaches others by giving them the benefit of the doubt and suspending their own sense of suspicion or over-caution. Too

Showing Work Fitness and Collaborations

For authors, co-authorship and co-publishing show a fitness for and interest in work-based collaborations. The fact that these works ended in successful collaborations speaks to social skills and expertise. Having third-party testimonials may communicate the target individual's fitness even more powerfully than signaling by the target individual. The social network of work-based partners may be indicative of how inclusive and diverse-friendly an author may be, across various demographic dimensions such as gender, race, ethnicity, and age, and also across expertise domains. (A counter-message here would be indicators of elitism and selecting work partners on monolithic demographic dimensions.)

Demonstrations of Expertise

Demonstrations of expertise refers to actual work achieved, not claims of work achieved. Costly signaling trumps cheap talk in virtually every case. A rising trendline in terms of productivity is another positive sign of expertise. This says that the

individual can go it alone and can still function effectively. (Developed curriculum vitaes and other signs of achievement can also affirm the sense of expertise.) Expertise is attractive by itself, but it also conveys several messages. The individual is grounded in the real and does not have to be "read into" the work context in a major way. The professional affiliations mean that the individual has been vetted by a trusted entity and generally works within the rules of the organization. Also, the individual has access to work-place resources, like equipment, software, data, published works, and human resources.

Communicating Procedural Justice

Procedural justice refers to fairness in the treatment of others. For example, if a person has done the most work on a project, *ceteris paribus*, he or she should receive first author position. If a person has contributed to a project, he or she should get credit. If a person supports work on a grant, he or she should receive payment. These basics do not always happen in academia, and there are many cases with people using either position or reputation to gain advantage over others less endowed. (Those who invite work collaborations with others should not communicate that they are interested in taking advantage of others. That is a non-starter for a rational and capable actor.)

Giving out public kudos, acknowledgments, and thanks to others shows a tendency towards acknowledgement and gratitude. A sense of respect bodes well for collaborations as well, contrasted against public criticisms and other types of negativity. (Negativity should be handled privately.)

Affirming Upstream and Downstream Reciprocity

In terms of upstream reciprocity, a reputation for paying favors forward will be helpful because it means that a favor bestowed on that individual will not be wasted. In terms of downstream reciprocity, the idea that a person doing a good deed will receive that in kind, may be affirmed by a person's messaging that he or she has been altruistic and has also received in kind (as a model). Further, a person can message a general norm of cultural and other type of indirect reciprocity, which may affirm the sense that a person who acts altruistically (with the target individual or others) will benefit in the long run.

Being Charitable and Prosocial

The sharing of works through open-source means, and in a lesser sense, open-access means, indicates something about appreciation for the broader public and the willingness to engage in *pro bono* work, if you will.

In terms of counter-messaging, the opposite of the above would suffice. Also, silence on matters such as the above may be indicators.

Meta-Themes in Indirect and Direct Reciprocity in Private Work-Based Profiles

"Indirect reciprocity" messaging shows that an individual is interested in and available for work collaborations and will treat altruistic interactions with returned acts of altruism or that the collaborator will benefit somewhere down the line through reputational benefits and the good will and actions of others. In terms of private work-based profiles, the themes are generally the same as in public ones. Oftentimes, the indirect reciprocity messaging is bolstered by actual direct reciprocity messaging (inclusive of communications and actions). In other words, potential work-based collaborators are friendly, fit for work and collaborations, expert, procedurally just, practitioners of upstream and downstream reciprocity, and charitable and prosocial. The messaging here is in the communications and the follow-through actions.

Conducting an Audit of a Work-Based Selfie (Self-Portrayal)

From this initial work and data exploration, a simple list of questions was created to enable a semi-structured audit of work-based selfies. While this is phrased as addressing public-facing work-based selfies, these questions may also apply to private-facing work-based selfies. While the work here is focused on text-based communications, this audit list may also be applied to imagery, multimedia, and other forms of communications—that may be used to comprise profiles. The following would benefit from testing in the world, but that is current beyond the purview of this work.

Public Messaging:

1. What is the public messaging?
2. What public venues are used? The social media platforms? The modalities (digital images, text, audio, video, work product, and others)? What private ones are used?

Target Audiences:

3. Who are the apparent audiences of the work-based selfie messaging? Who are the narrowcast audiences? The broadcast audiences?

Information Quality:

4. What is ascertainable from the information? What is leaked unintentionally?
5. What information may be verified with third-party sources?
6. What parts of the work-based selfie are bedrock facts, and what parts are aspirational?
7. How often is the work-based selfie updated? Why? (Or apparently, why?)
8. Are there information gaps in the work-based selfie? Are there parts of the work-based selfie that is undefined? Neglected?

Third-Party Sources of Additional Information:

9. Who are the other voices that contribute to one's professional selfie? What is positive? What is negative? What sorts of counter-messaging are there?

Cultural and Technological Influences on the Work-Based Selfie:

10. What influences (cultural, technological, other) contributed to the various parts of the work-based selfie?
11. Are there serendipitous influences on the work-based selfie? If so, what are they?

Inferences about the Individual's Authorizing Environment:

12. What inferences may be made about the individual's local authorizing environment, based on the information in the work-based selfie?

Convergence into a Whole or Partial Identity:

13. Do the facts in a work-based selfie converge into a sense of a whole person? Or only a partial one? In which areas of life is the work-based selfie silent? Or less than transparent? Are relevant parts missing?

(In)direct Reciprocity Messaging and Counter Messaging:

14. What aspects of the work-based selfie convey direct reciprocity? Indirect reciprocity? What sorts of counter messaging is there? On the whole, what does the work-based selfie convey about the approachability of the individual?

The questions may be enhanced with the addition of private messaging in terms of work-based self-representations, and many of the same questions, with minor adjustments, may be made to accommodate the private communications approach.

DISCUSSION

Hypothesis 1, broadly, is supported: work-based self-portrayals do show general communicates of "indirect reciprocity." At the individual public work-based profiles levels, though, these were more elusive to find in a general sampling of profiles across various types of social media platforms. As may be expected, the researcher found instances of both pro "indirect reciprocity" messaging as well as counter-messaging (sometimes in the forms of silences, and sometimes in the form of actual messaging).

Hypothesis 2 suggests that person-to-person work-based intercommunications also communicate both "indirect reciprocity" and "direct reciprocity," and this was borne out. Those engaged in private communications with a target individual already have some organizational context in which to communicate. This is not to say that there are not cold calls in which non-acquaintances of the target individual try to strike up a conversation and begin a relationship. Those messages especially contain messaging about "indirect reciprocity" and proposals for "direct reciprocity" (I'll do this if you do this).

This initial research did not offer a sense of how much of the public or private communications showed messaging / countermessaging for either "indirect reciprocity" or "direct reciprocity." First, the sample size was too small. Second, the examples of "indirect reciprocity" (pros and cons) and "direct reciprocity (pros and cons) were fairly sparse, with close reading and manual coding. All to say that this work did not give a sense of whether work-based self-portrayals tend towards the positive messaging for both indirect reciprocity and direct reciprocity. That research question will be for a future time.

FUTURE RESEARCH DIRECTIONS

Some future research directions may be direct spinoffs of this work. For example, others may build on the coding of messaging for the various types of reciprocity and non-reciprocity messaging on public and private channels. There may be assessments of the "Auditing a Work-Based Selfie" (AWBS) tool, which has yet to be pilot tested.

In addition, there are ways to expand the current work. One easy way is to move this out from individual level to a group level. Alternatively, these messages may be explored through richer digital modalities. There may be explorations into cultural differences behind work-based selfie messaging. More information about each of these approaches follows.

Group Functions

There may be research value in exploring not only individual "work selfies" but also group selfies ("we-fies," "us-ies"), to see how these may differ from the individual ones (in terms of both direct and indirect reciprocity, messaging and counter-messaging).

Rich Communications Modalities

One spinoff future angle may be the analysis of "selfie" and "work" imagery to identify various aspects of both direct and indirect reciprocity across public and private channels. In other words, this same generally framework may be applied to self-portrayals of individuals in workplace settings, but for a non-textual image-based modality (such as through image-sharing social networking sites). What visual aspects convey fair play, empathy, follow-through, and collegiality? How do the respective visual features differ across cultures? The same questions may be asked of people's work-based self-portrays in analog and digital modalities, including video, web pages, work objects, and others. There may also be approaches to analyze synthesis of various communications products—so CVs with text and imagery (and maybe multimedia), digital photo albums, digital stories, and other objects.

Cultural Differences

In the future, it may be possible to build on this initial exploration of work-based selfies to see what cultural differences there may be in terms of direct and indirect reciprocity in informal virtual work and in communications about the self in this issue.

Certainly, there are a number other approaches as well. This work suggests that "selfies" or "self-portrayals" may be extended beyond the original titular phenomenon. Spin-offs and derivatives may be considered for study and research.

CONCLUSION

To summarize, this preliminary work found some support for Hypothesis 1 and more support for Hypothesis 2. This work assumes that there is some alignment between a person's signaling behavior—in public and in private—with the actual true self, particularly in terms of interests in virtual teaming with outside partners. Self-revelatory work-based profiles reveal not only explicitly but also implicitly, purposively but also unintentionally. This alignment of messaging and actions go to believability. Those who have discrepancies will be called out by others—in private and also often in public. (However, there are more legal and reputational liabilities

to calling out people in public.) Also, there is a light assumption of individuals "staying in character" over time and not making huge deviations from that, except in rare cases.

If nothing else, this chapter suggests the importance of conscientious messaging for those who are interested in collaborating with others on virtual or distance projects.

ACKNOWLEDGMENT

This project has brought to mind how I have benefitted from many virtual collaborators over the years, mostly in open-source projects and in publishing. I have benefitted from F2F collaborators who have co-authored works and virtual partners who have provided constructive writing critiques (many anonymously) and chapters. I'm pretty sure I said thanks at the time, but I'll say thanks again for the collaborations and supports.

REFERENCES

Aggarwal, S., Rai, S., Jaiswal, M. P., & Sorensen, H. (2016). Norm of reciprocity—antecedent of trustworthiness in social media. In *IFIP International Federation for Information Processing* (pp. 411–418). Springer International Publishing. doi:10.1007/978-3-319-45234-0_37

Axelrod, R. (1981, June). The emergence of cooperation among egoists. *The American Political Science Review, 72*(5), 306–318. Retrieved June 19 2017 from http://www.jstor.org/stable/1961366 doi:10.2307/1961366

Barresi, J. (2012). On seeing ourselves and others as persons. *New Ideas in Psychology, 30*(1), 120–130. doi:10.1016/j.newideapsych.2009.11.003

Callard, F., & Fitzgerald, D. (2015). Against reciprocity: Dynamics of power in interdisciplinary spaces. In Callard and Fitzgerald's *Rethinking Interdisciplinarity across the Social Sciences and Neurosciences*. Basingstroke: Palgrave Macmillan. Retrieved May 13, 2017, from https://www.ncbi.nlm.nih.gov/books/NBK333550/

Carr, C. T., Wohn, D. Y., & Hayes, R. A. (2016). as social support: Relational closeness, automaticity, and interpreting social support from paralinguistic digital affordances in social media. *Computers in Human Behavior, 62*, 385–393. doi:10.1016/j.chb.2016.03.087

Clarke, T. B., Murphy, J., & Adler, J. (2016). Celebrity chef adoption and implementation of social media, particularly Pinterest: A diffusion of innovations approach. *International Journal of Hospitality Management, 57*, 84–92. doi:10.1016/j.ijhm.2016.06.004

Delgado-Márquez, B. L., Hurtado-Torres, N. E., & Aragón-Correa, J. A. (2012). The dynamic nature of trust transfer: Measurement and the influence of reciprocity. *Decision Support Systems, 54*(1), 226–234. doi:10.1016/j.dss.2012.05.008

Dobelli, R. (2013). *The Art of Thinking Clearly* (N. Griffin, Trans.). New York: Harper Collins.

Druckman, D., Mitterhofer, r., Filzmoser, M., & Koeszegi, S.T. (2014). Resolving impasses in e-negotiation: Does e-mediation work? *Group Decision and Negotiation, 23*, 193-210. doi:.10.1007/s10726-013-9356-4

Dunbar, R. I. M. (1993). Coevolution of neocortical size, group size and language in humans. *Behavioral and Brain Sciences, 16*(04), 681–735. doi:10.1017/S0140525X00032325

Eisenberger, R., Lynch, P., Aselage, J., & Rohdieck, S. (2004, March). Who takes the most revenge? Individual differences in negative reciprocity norm endorsement. *Personality and Social Psychology Bulletin.* PMID:15155041

Feng, X., Zhang, Y., & Wang, L. (2017). Evolution of stinginess and generosity in finite populations. *Journal of Theoretical Biology, 421*, 71–80. doi:10.1016/j.jtbi.2017.03.022 PMID:28363863

Ferrin, D. L., Bligh, M. C., & Kohles, J. C. (2008). It takes two to tango: An interdependence analysis of the spiraling of perceived trustworthiness and cooperation in interpersonal and intergroup relationships. *Organizational Behavior and Human Decision Processes, 107*(2), 161–178. doi:10.1016/j.obhdp.2008.02.012

Freitas, D. (2017). *The Happiness Effect: How Social Media is Driving a Generation to Appear Perfect at Any Cost.* New York: Oxford University Press.

Gintis, H., Bowles, S., Boyd, R., & Fehr, E. (2005). *Moral Sentiments and Material Interests: The Foundations of Cooperation in Economic Life.* Cambridge, Massachusetts: The MIT Press.

Gouldner, A. W. (1960, April). The norm of reciprocity: A preliminary statement. *American Sociological Review, 25*(2), 161–178. http://www.jstor.org/stable/2092623 doi:10.2307/2092623

Jacovi, M., Guy, I., Ronen, I., Perer, A., Uziel, E., & Maslenko, M. (2011, September 24 – 28). Digital traces of interest: Deriving interest relationships from social media interactions. In *ECSCW 2011: Proceedings of the 12th European Conference on Computer Supported Cooperative Work*, Aarhus, Denmark. doi:10.1007/978-0-85729-913-0_2

Jung, Y., Hall, J., Hong, R., Goh, T., Ong, N., & Tan, N. (2014). Payback: Effects of relationship and cultural norms on reciprocity. *Asian Journal of Social Psychology*, *17*(3), 160–172. doi:10.1111/ajsp.12057

Kashian, N., Jang, J., Shin, S. Y., Dai, Y., & Walther, J. B. (2017). Self-disclosure and liking in computer-mediated communication. *Computers in Human Behavior*, *71*, 275–283. doi:10.1016/j.chb.2017.01.041

Krueger, J. I., Massey, A. L., & DiDonato, T. E. (2008). A matter of trust: From social preferences to the strategic adherence to social norms. *Negotiation and Conflict Management Research*, *1*(1), 31–52. doi:10.1111/j.1750-4716.2007.00003.x

Kwak, H., Lee, C., Park, H., & Moon, S. (2010, April 26 – 30). What is Twitter, a social network or a news media? In *Proceedings of WWW '10*, Raleigh, NCarolina. Retrieved June 21, 2017 from http://www.ece.ucdavis.edu/~chuah/classes/EEC273/refs/%5BKL+10%5Dwww-twitter.pdf

Leider, S., Möbius, M. M., Rosenblat, T., & Do, Q.-A. (2009). Directed altruism and enforced reciprocity in social networks. The Quarterly Journal of Economics, 124(4), 1815 – 1851.

Lev-On, A., & Adler, O. (2013). Passive participation in communities of practice: Scope and motivations. In A. Jatowt et al. (Eds.), *SocInfo 2013. (pp. 81-94)*. Springer International Publishing. doi:10.1007/978-3-319-03260-3_8

Liang, H., & Fu, K. (2017). Information overload, similarity, and redundancy: Unsubscribing information sources on Twitter. *Journal of Computer-Mediated Communication*, *22*(1), 1–17. doi:10.1111/jcc4.12178

McKnight, D. H., Choudhury, V., & Kacmar, C. (2002). Developing and validating trust measures for e-commerce: An integrative typology. *Information Systems Research*, *13*(3), 334–359. doi:10.1287/isre.13.3.334.81

Moretti, F. (2000, January – February). Conjectures on world literature. *New Left Review*, *1*. Retrieved June 22, 2017 from https://newleftreview.org/II/1/franco-moretti-conjectures-on-world-literature

Mujcic, R., & Leibbrandt, A. (2017). Indirect reciprocity and prosocial behavior: Evidence from a natural field experiment. The Economic Journal. Retrieved June 10, 2017 from http://onlinelibrary.wiley.com/doi/10.1111/ecoj.12474/abstract

Nader, R. (2007). *The Seventeen Traditions*. New York: HarperCollins Publishers.

Nass, C., & Moon, Y. (2000). Machines and mindlessness: Social responses to computers. *The Journal of Social Issues*, *56*(1), 81–103. doi:10.1111/0022-4537.00153

Nguyen, V.-A., Lim, E.-P., Tan, H.-H., Jiang, J., & Sun, A. (2010). Do you trust to get trust? A study of trust reciprocity behaviors and reciprocal trust prediction. In Proceedings of the SIAM International Conference on Data Mining (SDM '10) (pp. 72-83). Retrieved May 11, 2017 from http://epubs.siam.org/doi/abs/10.1137/1.9781611972801.7

Nowak, M. A., & Sigmund, K. (1998). The dynamics of indirect reciprocity. *Journal of Theoretical Biology*, *194*(4), 561–574. Retrieved June 20 2017 from https://homepage.univie.ac.at/karl.sigmund/JTB98b.pdf doi:10.1006/jtbi.1998.0775 PMID:9790830

Pagel, M. (2012). *Wired for Culture: Origins of the Human Social Mind*. New York: W.W. Norton & Company.

Park, P. S., & Kim, Y.-H. (2017). Reciprocation under status ambiguity: How dominance motives and spread of status value shape gift exchange. *Social Networks*, *48*, 142–156. doi:10.1016/j.socnet.2016.08.004

Pelligra, V. (2011). Empathy, guilt-aversion and patterns of reciprocity (Working paper). Centro Richerche Economiche Nord Sud. (CRENoS).

Plickert, G., Côté, R. R., & Wellman, B. (2007). It's not who you know, it's how you know them: Who exchanges what with whom? *Social Networks*, *29*(3), 405–429. doi:10.1016/j.socnet.2007.01.007

Raeder, T., Lizardo, O., Hachen, D., & Chawla, N. V. (2011). Predictors of short-term decay of cell phone contacts in a large scale communication network. Retrieved June 19, 2017 from https://arxiv.org/pdf/1102.1753.pdf

Roberts, G. (2008). Evolution of direct and indirect reciprocity. *Proceedings of the Royal Society*, *275*(1631), 173–179. doi:10.1098/rspb.2007.1134 PMID:17971326

Salazar, L. R. (2015). The negative reciprocity process in marital relationships: A literature review. *Aggression and Violent Behavior, 24*, 113–119. doi:10.1016/j. avb.2015.05.008

Shaffer, D. R., Ogden, J. K., & Wu, C. (1987). Effects of self-monitoring and prospect of future interaction on self-disclosure reciprocity during the acquaintance process. *Journal of Personality, 55*(1), 75–96. doi:10.1111/j.1467-6494.1987.tb00429.x

Stosny, S. (2016). *Soar Above: How to Use the Most Profound Part of Your Brain Under Any Kind of Stress.* Deerfield Beach, Florida: Health Communications, Inc.

Surma, J. (2015). Social exchange in online social networks. The reciprocity phenomenon on Facebook. *Computer Communications:* 73(2016), 342 – 346.

Test, M. A., & Bryan, J. H. (1967). Dependency, models, and reciprocity. *Research Bulletin (Sun Chiwawitthaya Thang Thale Phuket).*

Thordsen, T., Murawski, M., & Bick, M. (2016). The role of non-social benefits related to convenience: Towards an enhanced model of user's self-disclosure in social networks. In IFIP International Federation for Information Processing (pp. 389-400).

Trivers, R. (2006). *Reciprocal altruism: 30 years later. Cooperation in Primates and Humans* (pp. 67–83). Berlin: Springer. doi:10.1007/3-540-28277-7_4

Trivers, R. L. (1971, March). The evolution of reciprocal altruism. *The Quarterly Review of Biology, 46*(1), 35–57. http://www.jstor.org/stable/2822435 RetrievedJune112017 doi:10.1086/406755

Weick, K. E. (1984). Small wins: Redefining the scale of social problems. *The American Psychologist, 39*(1), 40–49. Retrieved June 16 2017 from http://psycnet. apa.org/journals/amp/39/1/40/ doi:10.1037/0003-066X.39.1.40

Wikipedia. (2016, December 21). Reciprocity (evolution). Retrieved June 16, 2017 from https://en.wikipedia.org/wiki/Reciprocity_(evolution)

Wong, S.-S., & Burton, R. M. (2000). Virtual teams: What are their characteristics and impact on team performance? *Computational & Mathematical Organization Theory, 6*(4), 339–360. doi:10.1023/A:1009654229352

Wu, J. B., Hom, P. W., Tetrick, L. E., Shore, L. M., Jia, L., Li, C., & Song, L. J. (2006). The norm of reciprocity: Scale development and validation in the Chinese context. *Management and Organization Review, 2*(3), 377–402. doi:10.1111/j.1740-8784.2006.00047.x

Wu, P. F., & Korflatis, N. (2013). You scratch someone's back and we'll scratch yours: Collective reciprocity in social Q&A communities. *Journal of the American Society for Information Science and Technology, 64*(10), 2069–2077. doi:10.1002/asi.22913

Xu, Q. (2014). Should I trust him? The effects of reviewer profile characteristics on eWOM credibility. *Computers in Human Behavior, 33*, 136–144. doi:10.1016/j.chb.2014.01.027

Yang, Z. & Wang, C.L. (2010). *Guanxi* as a governance mechanism in business markets: Its characteristics, relevant theories, and future research directions. *Industrial Marketing Management, 40*, 492-495.

Zhu, Y.-X., Zhang, X.-G., Sun, G.-Q., Tang, M., Zhou, T., & Zhang, Z.-K. (2014, July). Influence of reciprocal links in social networks. *PLoS ONE, 9*(7), 1–8. doi:10.1371/journal.pone.0103007 PMID:25072242

ADDITIONAL READING

Pagel, M. (2012). *Wired for Culture: Origins of the Human Social Mind.* New York: W.W. Norton & Company.

KEY TERMS AND DEFINITIONS

Altruism: Selflessness in terms of considering and responding to others' interests.

Cheap Talk: Communications between actors that are not serious signals and which do not impact payoffs (in game theory); the opposite of costly signaling.

Costly Signaling: Communications between actors that work potentially costly to express and to follow through on.

Direct Reciprocity: Mutual cooperation between two actors over time, with each benefitting the other in various turn-taking.

Downstream Reciprocity: When an individual act altruistically, this person may experience future altruism from another whom he or she does not even know yet (based partly on cooperative social norms in the social environment).

Fairness Norms: A culture's sense of equal, just, and unbiased treatment of persons.

Hyper Sociality: An active and intense level of interactions between people, partially based on the affordances of social media platforms and cultural changes.

Indirect Reciprocity: The uses of another's public reputation to gauge their likelihood to cooperate and to return favors in kind to decide whether or not to cooperate altruistically with that individual.

Negative Reciprocity: The return of a harm by another.

Network Motif: Subgraph (with varying connection patterns among nodes) in a larger social network.

Parasocial: Non-reciprocated one-directional connections between people, often described as follower-followee relationships (such as those experienced by fans-celebrities, with many following the few).

Positive Reciprocity: The return of a favor by another.

Profile: A textual or multimodal description of an individual on a social media platform, for public consumption.

Reputation Economy: A person's or entity's public standing based on feedback from others.

Self-Disclosure: The sharing of what is considered private and personal information.

Self-Interest: Consideration of factors that would benefit the individual.

Selfie: A self-portrait, a self-portrayal.

Social Proof: The observation of how others behave in order to know how to act in a particular context (in a kind of bandwagon effect).

Strong Reciprocity: A tendency to cooperate with those who cooperate and to punish those who do not cooperate or engage in other social norms (with both positive and negative reciprocity).

Upstream Reciprocity: When a recipient receives an act of altruism, that individual may later offer altruism to a third party in terms of "paying it forward" (based on the recipient's appreciation for the first altruistic act and social norms); a type of "generalized altruism" (Trivers, 1971).

Section 3
Formalizing the Analysis of Selfies

Chapter 7

Creating an Instrument for the Manual Coding and Exploration of Group Selfies on the Social Web

Shalin Hai-Jew
Kansas State University, USA

ABSTRACT

A subgroup of the images shared as part of the "selfie" phenomenon is group selfies (aka "groupies" and "we-fies" or "us-ies") or self-portraits of groups (three or more individuals of focal interest) that are shared on social media. These images have informational value that has thus far been only thinly explored. In this work, an instrument—Categorization and Exploration of Group Selfies Instrument (CEGSI), pronounced "segsy"—was constructed of three parts: (1) Group Selfie Content and Context, (2) Group Selfie Image Creation, and (3) Group Selfie Messaging. It was tested against two image sets: group selfies and dronies, which were scraped from Google Images. This chapter describes the work, the analytical findings, and the resulting instrument for the manual coding of group selfies, and other insights.

INTRODUCTION

- A group of skydivers makes formation, and they capture their shared descent using helmet cameras. This image is uploaded to their group account on a photo-sharing site, and it is an immediate hit.

DOI: 10.4018/978-1-5225-3373-3.ch007

- A grinning group of elementary school classmates stands with their arms around each other and beam in youthful exuberance at the camera. They have just completed a science experiment, and taking a group selfie is part of the assignment. This image captures a critical lesson about teamwork.
- Fellow broadcast food critics are meeting at a formal event, and they pose for a "we-fie" in their professional kitchen. Each of the critics are high-profile and maintain fanatical followings.
- At the courtyard, a group of politicos is being interviewed by the members of the press, who are carrying video and still cameras. Flying above is a drone, which is used to capture multiple aerial shots of the event.
- Hundreds of runners are crossing a bridge as part of a city-wide race. High-up is a drone that is capturing an overhead view of the runners below.

The above are all recent real-world examples of group selfies. "Group selfies" (or "groupies" or "we-fies" or "us-ies"), by definition, feature more than one person, with the image captured by one of the members of the depicted group. Two individuals in a selfie have been defined as "us-ies" (especially if they are positioned as couples) or "duo selfies" (Hai-Jew, 2017). Those images with three or more individuals fit in the category of group selfies, or what some call "groupies" (LaFrance, 2014), at the risk of being lumped in with fanatical followers of various celebrities and musicians. Group selfies capture multiple selves or egos in a shared self-portrait.

"Selfie" was the Oxford Dictionary's Word of the Year in 2013, and it describes a photograph that one has taken of oneself or a "self-portrait." While group selfies have been around for some years, it is only after the ground-breaking talk show host Ellen DeGeneres selfie at the 2014 Oscars that these became all the rage. There was a Heidi Klum and elite friends image taken with a selfie stick. There was a follow-on Bart Simpson and company sendup with a mix of characters. And there was a major outpouring of group selfies from the general public. In the same way that stand-alone selfies may be part of a collective public conversation—think of the father who posed like his daughter in order to lessen her interest in social media (Howard, July 1, 2016)—group selfies are having a fleeting public moment. However, the practice of group selfies has not yet entered the formal book space. For example, these terms—"selfies," "group selfies," "wefies," do not appear in the Google Books Ngram Viewer up through 2008 (the most recent moment available) and are new to the modern lexicon.

People do bring out other dynamics in each other. A photographer of groups observes, "The first thing that happens is a commemoration of some kind. But when an organization or a club gets together for a picture, it's a celebration," Neal Slavin said. Group photos capture various reasons for human togetherness and affirms humanity ("Photographer Neal Slavin…" Dec. 24, 2016). At its most simple, group

selfies are self-portraits of groups. While "'me' selfies" are about displaying the self through profile pictures, group selfies "capture the moment" in timelines and image albums (Georgakopoulou, 2016, p. 307).

As yet, very little work has been done on "group selfies". For example, what is the average number of people in a group selfie on the Social Web? In the same way that individual personalities may be interpreted from solo selfies, is it possible to read group personalities from group selfies? What kinds of technologies are commonly used for group selfies? What sorts of messages are communicated through these we-fies?

This work is built on two basic and interrelated hypotheses, both of which deal with the informational value inherent in group selfies:

Hypothesis 1: Group selfies shared on social media platforms and the Web and Internet contain informational value.

Hypothesis 2: Based on extant research and publicly available group selfies, it is possible to build and refine a tool to systematize the extraction of some of the relevant information from group selfies.

To study the phenomenon of group selfies, the author first conducted a review of the literature. From this, an early draft of an instrument for analyzing group selfies was drafted. An instrument—Categorization and Exploration of Group Selfies Instrument (CEGSI), pronounced "segsy"—is constructed of three parts:

1. Group Selfie Content and Context,
2. Group Selfie Image Creation, and
3. Group Selfie Messaging.

The first part involves descriptive metrics of the respective group selfies, the second about the technical aspects of the group selfie creation, and the third part about the apparent messaging. The intuition is that it is possible to create a useful parsimonious instrument to analyze group selfies and to learn from them.

Then, the author conducted a "group selfies" search on Google Images and used a Google Chrome add-on called Picture Downloader Professional to capture hundreds of returned images in the wild. First, 1,356 images were captured in a first foray (Figure 1), and of these, 1,315 were openable and uncorrupted images. A second foray was conducted using "dronie" as the seeding image search term, and 682 usable images were captured (with 18 others unopenable and not viewable). [As an aside, why wasn't "group dronie" used? In a Google Image Search using those two terms as a seeding element, only 25 images were found. In other words, the uses of those two terms to seed an image search was too restrictive.] From these image sets,

unopenable files were omitted from the counts. However, images that did not fit the classic description of "group selfies" or "dronies"--images with individuals or duos, images without people in them, and other images that did not fit the minimum "group selfie" concept—were not omitted. Any images that seemed like they might fit even in a small way were included. All the images were decontextualized from their original contexts (appearing *ex nihilo*) and were interpreted generally only as stand-alone images or as part of a sequence if there was a recognizable sequence. Then, emergent coding was applied to these image sets, and insights about the image sets were extracted and summarized. The process of coding informed the building of the coding instrument, and the coding instrument informed what was findable in the image sets, in a mutually interactive way. The summary data are recorded and shared in this work. Also, this Categorization and Exploration of Group Selfies Instrument (CEGSI) instrument was revised based on the findings from the emergent coding, and a current draft form is shared as Appendix 1. This is not to suggest that CEGSI is the go-to coding playbook for group selfies. After all, the informative image sets are inherently incomplete and imprecise. Also, the methods here are not low-cost and involve a fair amount of human time. That said, computational analyses and programs and sequences often benefit from human coding first or at some point in the analytical sequence in order to identify what is valuable for research purposes. While computer vision has made remarkable advances, those capabilities are nowhere near the human vision capability for this type of coding (which is nuanced and which requires complex background knowledge). CEGSI was brainstormed first, and then operationalized to enable the coding based on observations in the respective image sets; after its first run, CEGSI was lightly revised based on insights from its first run.

Figure 1. "Group selfies" on Google Images with a filters menu (by popular folk tags) across the top

REVIEW OF THE LITERATURE

With the popularization of the Social Web and the wide proliferation of smartphones, the sharing of smartphone photography on social media platforms became a "thing" followed shortly by selfies with the creation of self-facing cameras on those devices. This is not to argue technological determinism but rather technological enablements. In a social context, the camera is acting as a "quasi-social actor" (Dinhopl & Gretzel, 2016, p. 132), with its own effect on social dynamics. A camera may serve as a witness, a sharer, an amplifier, and an instrument for human ambitions and endeavors. Currently, cameras are also common in "drones" or "unmanned aerial vehicles" (UAVs), which are controlled by remote control or onboard computers, and these have also been used for the capturing of both solo selfies, duo selfies, and group selfies. In a very real sense, technologically, the selfie is "the progeny of digital networks" and "nonrepresentational changes," along with innovations in the areas of "distribution, storage, and metadata" (Frosh, 2015, p. 1607). This work makes a simple assumption about selfies in general—that they are an expression of agency and personhood, what one researcher describes as "narrative autonomy" (LaFrance, 2014). Individual and group selfies are expressions of belongingness to groups; these amplify sociality (Lu & Dugan, 2016). Selfies are created to meet individual needs, such as those for self-expression and socio-psychological fulfillment, but also for instrumental needs, such as public impression management (such as for career needs). In selfie-sharing, it becomes a socially networked image, a "gestural image" that feeds "kinesthetic sociability" (Frosh, 2015, p. 1608). In the attention economy online, selfies compete for center stage. Images have to be novel or informationally original or eye-catching in order to capture and hold attention, even fleetingly. A selfie image shares a self-referential social performance:

But the selfie does more than this: It deploys both the index as trace and as deixis to foreground the relationship between the image and its producer because its producer and referent are identical. It says not only "see this, here, now," but also "see me showing you me." It points to the performance of a communicative action rather than to an object, and is a trace of that performance. (Frosh, 2015, p. 1610)

The arms holding the smartphone "assume the role of the pointing finger: They implicitly designate the absent hands and their held devices as the site of pictorial production," writes Frosh (2015, p. 1610). In many selfies, the hands are replaced by a selfie stick, or they are invisible altogether, with the smartphone camera triggered by timing or a radio signal. The self-referential nature of a selfie applies also to group selfies: to wit, group selfies are about groups that want to share a public profile on social media platforms as a form of self-expression and self-enactment

(of groupness). The inclusion of group selfies taken with a humanoid robot has been interpreted as social acceptance and inclusion of the robot in the human social circle (Onchi, Lucho, Sigüenza, Trovato, & Cuellar, 2016).

Using a sociomaterial understanding of selfies, based on "interactive technologies, social processes, and psychology," researchers see selfie-taking and sharing a part of social practice; even more, they are based on "social calibration, social probing, and social feedback" (Svelander & Wiberg, July – Aug. 2015, pp. 36). The spaces for the sharing of selfies is a socio-technical one, and those who create selfies are prosumers: they both produce and consume. Interestingly, based on a survey of 275 people, those who consume solo selfies apparently have decreased self-esteem, but those who viewed groupies apparently had increased self-esteem:

Results indicated frequent selfie viewing behavior led to decreased self-esteem whereas frequent groupie viewing behavior led to increased self-esteem. Frequent selfie viewing behavior led to decreased life satisfaction while frequent groupie viewing behavior resulted in increased life satisfaction. However, neither selfie nor groupie posting behavior was associated with self-esteem or life satisfaction. In addition, individuals high in need for popularity were more likely to be affected by selfie viewing behavior in terms of life satisfaction and self-esteem compared with individuals low in need for popularity. (Wang, Yang, & Haigh, 2016, p. 1)

Selfie-sharing is a form of self-disclosure behavior, but viewing others' selfies may be part of people's social comparisons behavior and may thus lead to "decreased psychological well-being," or this behavior may indicate the viewer's loneliness, which may lead to "lower self-esteem and life satisfaction" (Wang, Yang, & Haigh, 2016, p. 7); personal jealousies may be triggered with selfie viewing (p. 8). Seeing others' selfies and groupies may motivate some to improve aspects of themselves and allows them to be aspirational and encourage personal goal-setting (Georgakopoulou, 2016). Beyond unintentional effects of selfie-taking and consumption, some researchers have harnessed selfie-taking to improve well-being. In one, participants "were instructed to take one photo every day in one of the following three conditions: a selfie photo with a smiling expression, a photo of something that would make oneself happy and a photo of something that would make another person happy" (and were asked to send the third image to make someone else happy to someone else (Chen, Mark & Ali, 2016, p. 4). They found that all three actions enhanced personal affect. Further, they write:

Those who took photos to make others happy became much less aroused. Qualitative results showed that those in the selfie group observed changes in their smile over time; the group taking photos to improve their own affect became more reflective and those taking photos for others found that connecting with family members and friends helped to relieve stress" (Chen, Mark & Ali, 2016, p. 1).

The pre-digital history of selfies is artist self-portraits (Rettberg, 2014, "Written, visual and quantitative self-representations," p. 1). Historically, there have been self-representational genres that are "strongly serial: time-lapse selfie videos, profile photos in social media, and photo booths, one of the closest pre-digital precedents of today's selfies" (Rettberg, 2014, "Serial Selfies," p. 33). Understanding selfies and sequences of selfies in a time context enables a deeper engagement with the contents of the imagery. Social norms define what is "worthy of being photographed" and explain some current discomfort with the proliferation of selfies (Rettberg, 2014, "Automated diaries," p. 53). The practice of selfie-sharing is inclusive of "sexting" among young adults or the self-portraits of individuals in a sexualized context (Burkett, 2015).

Alexandra Georgakopoulou's idea of selfies as "small stories" is particularly useful. She suggests that selfies shared on social networking sites like Facebook enable narrative contexts, through tools such as "temporal framing and notifications of activities that have just happened," "localizations," "assessments-emotive states," "events/ activities," "references to characters (and relationships)," and other evocative details (Georgakopoulou, 2016, pp. 307 – 308).

There is a sub-category of selfies, which are taken during touristic travel. In former days, people would capture images of themselves at iconic locations, and the touristic looking was generally outward at the respective locales and spectacles. Touristic selfies make the tourists themselves "the objects of the self-directed tourist gaze" (Dinhopl & Gretzel, 2016, p. 126). The authors explain the sense of import within the tourists, which makes them worthy of attention:

Through these processes, tourists are able to ascribe the characteristics they otherwise associate with tourist sights onto themselves. Rather than fetishizing the extraordinary at the tourist destination, tourists seek to capture the extraordinary within themselves. Traditional tourist sights and attractions take on different relative importance. (Dinhopl & Gretzel, 2016, p. 126)

Such photos are about creating social relations "between tourists and hosts at the destination, between tourists at the destination and between tourists and those that stayed home" (Urry & Larsen, 2011, as cited in Dinhopl & Gretzel, 2016, p. 126). To capture a sense of the daring nature of some travel selfie capture contexts, it is helpful to understand some documented selfie-related traumatic risks, including the following: animal injuries, extreme weather, falls from railway bridges, falls from steps or stairs, lightning strikes, muggings, natural disasters, pedestrian injuries, pilgrimages, road traffic accidents, selfie stick injuries, self-inflicted gunshot wounds, sporting event injuries, and violations of local laws (Flaherty & Choi, 2016, p. 2). Many engaged in selfie-taking are not focused on situational awareness, and they sometimes fail to properly navigate the situation for their own safety (Flaherty & Choi, 2016, p. 1).

Some researchers suggest that group selfies are a product of collectivist cultures, and being part of a group provides a sense of "belonging and safety" for those who may be too shy otherwise to participate (Guo, 2015, pp. 56 – 58). In another sense, a group selfie may be an expression of female friendship (Wang, 2016, p. 58). There are social upsides in being a part of "groupies" rather than only showcasing a lot of lone or solo selfies. The group selfie is valued above the lone selfie because too many lone selfies makes one look friendless and left out (Reagle, 2015, p. 9).

The technologies involved in selfie-taking have evolved from the back-facing camera on smart phones. The cameras themselves have improved for better selfies. There have been innovations like the low-tech selfie stick. Some newer technologies in this area include selfie drones that help create "dronie" images (Chen, Liu, & Yu, 2015), and applications such as those that enable "cooperative photography," which brings together strangers to collaborate around capturing images of each other on networked mobile devices. In cooperative photography scenarios, there is very much a sense of old style image capture, such as two co-located individuals with one acting as a photographer and the other as the subject. In other permutations, there may be more complex setups that harness serendipitous encounters:

Cooperative photography redefines some fundamental notions of the photographic process by using mobile devices to synchronously coordinate multiple parties in a collaborative image capturing task. Using wireless communication and geolocation technologies, the photographer takes on a support role as content enabler rather than as the content creator, opening up creative possibilities. However, unreliable wireless networks and misunderstandings between users can make the coordination challenging and lead to a premature termination of the task. (Wen & Ünlüer, 2015, p. 37)

Besides the social interaction aspects in cooperative photography, the image capture and retention is also fairly unique. Only the subject the photo retains a copy, not the photographer. The authors write:

In cooperative photography, a user who has opted-in as a willing photographer is tasked with the capturing of an image for a user who wishes to be the subject of a photograph. The captured image is automatically sent from the photographer's device to the device of the subject. The photographer does not retain a copy of the image, which makes the process distinct from the standard photographic process where the photographer, as the content creator, owns the created content. (Wen & Ünlüer, 2015, p. 37).

Those in public and private industries have looked to harnessing group selfies for various purposes. Group selfies have been used to create a sense of community in college classrooms (Johnson, Maiullo, Trembley, Werner, & Woolsey, 2014). When used in selfie marketing campaigns, selfies have to seem authentic to be effective (Gruber-Muecke & Rau, 2016). In a consumer context, authenticity is understood as being an expression of the self. For groups, authenticity may be expressed in "authoritative performances: cultural events or activities that express group values, offer opportunities to integrate with the group and are produced by the group through participation" (Gannon & Prothero, 2016, pp. 1860 - 1861). A group selfie may reaffirm group identity and emphasize group norms of real-time interaction and sharing. In the celebrity milieu, group selfies are an important part of a social *quid pro quo* among elites in the same reference group:

In asserting their belief in the celebrity of other stars, through the taking of group selfies, celebrities assert their social capital in both the celebrity community and the online community and in agreeing to be celebrities together, they demure to each other as mutual fans, recognising each other's status. If the delicate balance of online and celebrity capital is negotiated stars reinforce their celebrity through a selfie product which has a cumulative capital beyond that of the individual, increasing the star's reach, recognisability and value. (Wright, Nov. 2015, p. 11)

Group selfies may be created by colleagues who share collaborative photo co-creation in the workplace, in designed selfie station photo kiosks.

We have designed and implemented a photo co-creation activity, "Stitched Groupies," in a photo-taking and sharing platform called the #selfiestation. The system allows users to take and combine photos with peers so that they can create photos collaboratively and asynchronously across physical boundaries. Our work aims to connect users through creative photo co-creations and we are especially interested whether the mechanism can provide a light-weight and playful way to create new social ties. (Lu & Dugan, 2016, p. 69)

At a number of IBM employee locations and related tradeshows and industry conferences, the group photo kiosks have been used; to build on this, there has been work to enable "stitched groupies" to connect people who are not physically co-located and those who are having their photos taken in asynchronous time (Lu & Dugan, 2016).

Biological Factors in Selfie-Taking and Sharing

An engaging study explored whether patterns found in artworks transferred to selfie-taking, particularly whether artist preferences for showing the left side of the subject's face in a portrait but preferring the right side for self-portraits. The researchers also explored the preference for putting key features in a composition on the right of the picture from the viewer perspective. To test their hypothesis, they sampled 104 British schoolchildren and teenagers:

We analysed posing biases in individual photographic self-portraits ("selfies") as well as of self-portraits including also the portrait of a friend ("wefies"). Our results document a bias for showing the left cheek in selfies, a bias for placing the selfie-taker on the right in wefies, and a bias for showing two left cheeks over two right cheeks, again in wefies. These biases are reminiscent of what has been reported for selfies in adult non-artists and for portraits and self-portraits by artists in the 16th–18th centuries. Thus, these results provide new evidence in support of a biological basis for side biases in portraits and self-portraits independently of training and expertise. (Bruno, Bode, & Bertamini, 2016, p. 1)

This is an example of extracting macro-level insights about human behaviors from the formalized study of image sets.

Psychology of Group Selfie-Sharing

In terms of group selfies, those who share those tend to be extraverted and agreeable, with "the need for popularity" (Kim & Chock, 2016, p. 1). Age and social networking site-usage "significantly predicted the frequency of posting group selfies" (Kim & Chock, 2016, p. 8). Also, younger participants "with higher narcissism were more likely to post group selfies" (Kim & Chock, 2016, p. 10).

Demographic Profiles of Selfie Sharing

There have been studies about demographic patterns in selfie sharing, including for group selfies. An online survey sample of 3,763 Norwegian social media users found the following:

This study provides the first empirical evidence on how adolescents (aged 12 to 19), young adults (20-30) and adults (31-50) differ in terms of selfie behaviour. Females were more likely to take personal and group selfies, post personal selfies, crop photos and use photographic filters compared to males. Adolescents were found

to be more likely than young adults to take own and group selfies, post own selfies, and use photographic filters. Similarly, young adults were more likely to take own and group selfies, post and edit photos than older adults. The predictive effect of age was stronger among women than among men regarding selfie taking, posting and editing behaviour. (Dhir, Pallesen, Torsheim, & Andreassen, 2016, p. 549)

This published research suggests that group selfies will generally be captured by females, and these images will likely feature younger people (as they tend to for selfies in general).

EXPLORATION OF GROUP SELFIES AND DRONIES

Before introducing the designed instrument, it is important to define the desirable features. The tool has to be sufficiently flexible to enable acceptance of a number of group selfie images, so provisional conclusions may be arrived at based on empirical observations. This instrument should surface relevant and meaningful insights and information. An instrument should be coherent to users and to those who might use the data. The instrument should be as simple and parsimonious as possible; otherwise, it will not travel well across contexts and users. It should also be sufficiently flexible and not be overfit to the initial sets of data that informed its creation and evolution.

To understand the instrument, it may help to see it in several ways. First, an outline of the instrument follows. There are three parts:

Part 1: Group Selfie Content and Context
Part 2: Group Selfie Image Creation
Part 3: Group Selfie Messaging

The first part involves a descriptive examination of the selfie content and context. The second part focuses on the methodological, technological, and artistic aspects of the group image creation. The third part focuses on the image messaging in a more analytical way beyond simple descriptives. Parts 2 and 3 are meta-aspects of the image. In a sense, these parts show sequencing from first visual impressions and then higher levels of analytics.

Part 1: Group Selfie Content and Context

1. Composition of People in the Image, Group Sociality
 a. Group Membership

 b. Group Size

 c. Demographics

 d. Individual Recognizability

 e. Group Membership Social Dynamics

 f. Member Closeness / Distance

 g. Group Member Actions

2. Place and Time

 a. Natural Space or Built Space

 b. Daytime or Nighttime, or Dawn/Dusk

3. Group Selfie Context(s) / Scenario(s)

 a. Image Context

 b. Group Selfie Rationale

 c. Non-Commercial or Commercial Purpose(s)

 d. Meeting of Human Needs

4. Animals, Non-Human Agents, and Ego Representations

 a. Animals? Non-Humans?

 b. Props?

5. Group Selfie Mood(s): Moods

Part 2: Group Selfie Image Creation

6. Apparent Relationship between the Photographer and the Subject

 a. Is the apparent relationship between the photographer and the subject close or distant?

 b. What is the relevance of this relationship between the photographer and subject?

7. Group Selfie Image-taking Setup

 a. Apparent Relationship of Photographer with the Subjects

 b. Mobile Devices and Cameras

 c. Technologies Used for the Image Capture

 d. Ad Hoc Image Capture or Planned Setup for the Capture

8. Group Selfie Image Post-Production: Image Post-Production

Part 3: Group Selfie Messaging

9. Group Selfie Focal Point

 a. Focal Point(s) of the Image

 b. Image Sequence

 c. Visual Movement

10. Group Selfie Main Messaging and Sub-messaging
 a. Main Messaging
 b. Informational Value
11. Apparent Audience(s) for the Group Selfie: Main Audience(s)
12. Anomaly(ies): Image Anomalies
13. Others: Miscellany

Within each of the subcategories in CEGSI are finer points. Part 1.1, "Composition of People in the Image, Group Sociality" involves analysis of the individuals in the image: the group membership, the size of the group, demographics, and whether individuals are recognizable or not in the image. This also focuses on the social aspects of the group selfie: group membership social dynamics, membership closeness / distance, and group member actions. Part 1.2, "Place and Time," focuses on whether the image is captured in a natural space or a built space (although most locations are a mix of the two), and it also focuses on time factors such as whether an image is taken in daytime or night-time, dawn or dusk. For Part 1.3, "Group Selfie Context(s) / Scenario(s)," this part provides more analysis about the situation surrounding the group selfie: image context, the apparent rationale for the group selfie, non-commercial or commercial purpose(s) for the image, and what human needs are met by the group selfie. Part 1.4, "Animals, Non-Human Agents, and Ego Representations" taps into the fact that many selfies include other non-humans, like animals or dolls or other entities. These representations and other props may communicate visual information in engaging ways. Part 1.5, "Group Selfie Mood(s)," explores the interpreted sense of mood, what this might mean, and how this mood was likely created.

Part 2.6, "Group Selfie Image-taking Setup" focuses more on the technological aspects about how the group selfie was created. These include the apparent mobile devices and cameras used, the technologies used for the image capture (beyond the mobile devices and cameras), and whether the image capture seems ad hoc or planned. One part of 2.6 involves counting how many mobile devices and cameras appear in one group selfie image; this question arose after viewing multiple group selfies in which multiple devices were in view but with the device taking the image actually out-of-frame (but serving as the framing device). Part 2.7, "Group Selfie Image Post-Production," continues on this track of technological aspects. Some group selfies are apparently fairly rough-cut and unedited while others go through a fair amount of post-production. It may be helpful to analyze works to understand how much effort went into the post-production handling of the group selfies.

Part 3.8, "Group Selfie Focal Point," examines if there is a particular area of focus in the group selfie image and why that spatial point may be the center of the image. If the focus is spatially distributed, then that phenomenon is examined. Also, another

point of interest is whether there is dynamism or movement to the image. Part 3.9, "Group Selfie Main Messaging and Submessaging" explores what is actually being communicated by the image, whether that messaging is intentional or unintentional, and what the informational value of the particular group selfie may be. Part 3.10, "Apparent Audience(s) for the Group Selfie" involves the identification of the apparent main target audience for the image. Part 3.11 points to anomalies in the image to make the image stand out. Finally 3.12 focuses on "Other" or miscellaneous features of the group selfie. This instrument is available in Appendix A. What follows are the insights arrived at in each section of CEGSI based on the scraped image sets. Note that there are no assertions that the sets are any sort of randomized sample, and these sets fall far short of any N = all. Given what is possible and the practical limits of manual image analysis, the two image sets contained 1,997 images once the unviewable ones were removed. In some cases, the coding will result in more counts than available images; the reason for that is that some of the images contained multiple separate images such as picture-in-picture, diptychs (side-by-side or top-and-bottom), triptychs (horizontal or vertical), quadtychs, and so on. On the high end, one scraped image contained within it some 23 smaller images.

DELIMITATIONS

To be clear, this work has some natural limits. For one, the images scraped using "group selfies" and "dronies" as seeding terms did capture over a thousand images, but these are a small sample of what is available in the world. It is likely that these are not a random sample, but it is unclear in what ways these are not random. So in multiple ways, the images are not directly representational. Also, the seeding term "dronies" was used in lieu of "group dronies" because the latter only resulted in a handful of images. The coding of the respective image sets is not comprehensive coding, but these approaches—a mix of *a priori* and emergent coding—provides a start and gives a sense of the challenges. Two hypotheses follow:

Hypothesis 1: Group selfies shared on social media platforms and the Web and Internet contain informational value.

Hypothesis 2: Based on extant research and publicly available group selfies, it is possible to build and refine a tool to systematize the extraction of some of the relevant information from group selfies.

Of the two hypotheses, the first is almost a given based on others' research that has informatized social imagery. The latter, too, is almost a given in a general sense, but the reliability, validity, applicability, and general usefulness of the created tool

will take a lot more effort to explore. One risk in this effort is that the instrument may be overfit to the data, these limited image sets. These approaches are for follow-on works. As such, this chapter is an initial work only with a draft instrument proposed. To avoid unintentionally advocating for particular products, given the soft product placement and the presence of some advertisements (for candy, cameras, smart phones, drones, nail polish, helmet cams, and tourist locations), individuals' names, company brands, and so forth, were not mentioned in the finalized draft. Rather, only the main image information was captured.

Also, for targeted groupies captured for investigations with some known individuals, the more posed the group selfies are, the less incidental subtext (data leakage) that may be captured. Beyond that observation, though, this work is about general learning from group selfies and will not include the analysis of group selfies for targeted oppo (opposition) or other research.

Analysis of the "Group Selfie" (Groupie, We-fie, Us-ie) and Dronie Image Sets

To test the Categorization and Exploration of Group Selfies Instrument (CEGSI), it may help to see how it works on the extracted image data. This following section then offers a disaggregated look at CEGSI and the linked analytics for each section.

Part 1: Group Selfie Content and Context

Composition of People in the Image, Group Sociality

1. *Group Membership:*
 a. *Who are the individuals in the image?*
 b. *What are the main appearances of the individuals in the image?*
 c. *What are the gestures, stances, facial expressions, and behaviors of the people in the group selfie? What are they collectively and individually communicating?*

Group membership refers to the social glue or apparent social rationale in the group selfie and dronies imagery. With emergent coding, some 57 types of social glue were observed. These are listed in alphabetical order:

- Appreciation for Antiquity
- Appreciation for Art
- Appreciation for Heights

- Appreciation for Shared Endeavor / Activity / Experience
- Appreciation of Natural Light
- Appreciation of Technology
- Commentary on Selfies and Group Selfies
- Conflict
- Crowds
- Dangerous Work
- Documenting a Disaster
- Documenting Event
- Family and Shared Fun
- Family Ties
- Female Bonding and Friendship
- Fitness and Endurance
- Going Places
- Group Friendship, Camaraderie
- Having Fun
- Healthcare
- Holidaying
- Human in Connection with Earth
- Human-Animal Bond
- Human-Made Sites
- "I'm Attractive" / Overt Sexuality
- Influencers, Connections with Power
- Laughing Children
- Leisure
- Making a Statement, Messaging
- Male Bonding and Friendship
- Mix of Human and Natural Sites
- Motorcycle Ride
- Musicians
- Natural Sites
- Neighborhoods
- Neighborliness
- Party, Dress-up
- Performance
- Politics
- Power and Self-Efficacy
- Profession of Faith
- Recognition on Stage
- Romance / Attraction

- Self-Love, Ego, Self-Focus
- Self-Revelation, Information Sharing
- Shared Adventure
- Solitude
- Solo Adventure
- Spectacle, FX
- Stardom, "Beautiful People"
- Students and Learning
- Team Members
- Tourism, Trip, Travel
- Toys and Dolls
- Variant Interpretations of Gender and Sexuality
- Wedding
- Workplace Collegiality

Clearly, the different image sets had quite different counts of these respective types of social glue depicted. The "social glue" found in the respective sets are shown in Figures 2 and 3, in descending order. Also, six images from the "Group Selfies" set were seen as too muddled to code in this set and so were omitted.

Figure 2. Types of group membership in the group selfies image set

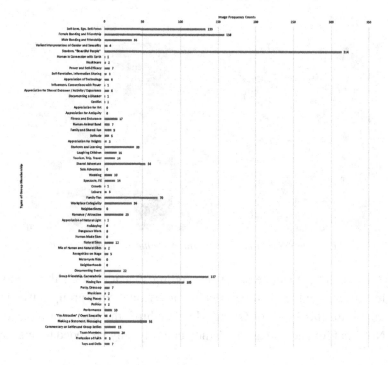

Figure 3. Types of group membership in the dronies image set

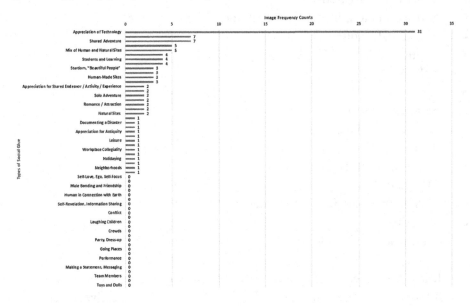

Figure 4. Types of group membership in the "group selfies" social image set (combined)

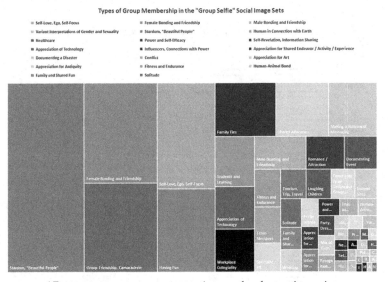

**For a more accurate representation see the electronic version.*

It may be helpful to understand the coding that identified the predominant social glue enhancing the bond between the individuals in a group selfie. In Table 1, "Codebook for the Types of Group Membership," the basics of the coding are shared. Note that for each image, it would generally only be coded to one category,

Table 1. Codebook for the types of group membership

Type of Group Membership (What is the Social/Bonding Glue Holding the Group Together?)	Coding Description
Appreciation for Antiquity	images of objects from antiquity, images representing antiquity
Appreciation for Art	images that show artworks and / or people interacting with artworks
Appreciation for Heights	images of people engaged in rock climbing, mountain climbing, buildering, scaffold running, roof-top exploration, and other types of engaging with extreme heights (often without any apparent safety gear)
Appreciation for Shared Endeavor / Activity / Experience	images of people engaging in a shared activity
Appreciation of Natural Light	images of individuals and people during sunrise or sunset, with the focus on light; images of plays of natural light on nature (water, various land masses, and others)
Appreciation of Technology	images that show an appreciation of technology by depicting various technologies in functional, utilitarian, or glamorous light
Commentary on Selfies and Group Selfies	images that communicate opinions and messaging about selfies and group selfies, in a metacognitive and self-reflective way (whether in support of or against); may include bi-medial imagery with both images and text
Conflict	images of people in various forms of conflict, both direct and indirect
Crowds	images of crowds of people outdoors for various purposes: commemoration, political statement, competition, commercial sponsorship, and others
Dangerous Work	images of individuals or people engaged in dangerous work
Documenting a Disaster	images of high-impact and disastrous events, such as weather events, earthquakes, fires, and accidents
Documenting Event	images documenting various event types (including races, concerts, meetings, funerals, public marches, concerts, religious commemorations, plays, dignitary visits, and others)
Family and Shared Fun	images showing family members engaging in shared experiences, especially entertaining ones
Family Ties	images of individuals who appear to be family members in various activities: relaxing at a home, sharing a meal at a table, walking along a street, lying on a hammock, worshiping at a religious service, flying a drone together, and others
Female Bonding and Friendship	images showing females from childhood to adulthood in mutual understanding and socializing and in shared activities
Fitness and Endurance	images showing people working on their health through exercise (running, bicycling, walking, kayaking, canoeing, mountain-climbing, swimming, scuba diving, skiing, hiking, and other activities)
Going Places	images of people in vehicles or other modes of transport going places
Group Friendship, Camaraderie	images of people enjoying each other's company in various contexts (with a focus on the inherent friendships, not the activities per se)
Having Fun	images of people engaged in entertaining activities with others of both genders (friends, acquaintances, strangers)…with the focus on the activities

continued on following page

Table 1. Continued

Type of Group Membership (What is the Social/Bonding Glue Holding the Group Together?)	Coding Description
Healthcare	images showing people in healthcare settings including surgical theatres, hospitals, and nurse-training classrooms
Holidaying	images of people on holiday in holiday locales and engaging in holiday activities
Human in Connection with Earth	images showing people as reveling in nature and working to protect and preserve it
Human-Animal Bond	images showing the relationship between humans and animals (whether wild or domestic), in a variety of contexts
Human-Made Sites	images of people enjoying fountains, artificial ponds, and other human-made sites (and sights)
I'm Attractive / Overt Sexuality	images that show men and women falling out of their clothing or communicating sexual availability based on their facial expressions or poses or states of dress / undress
Influencers, Connections with Power	images of people wearing power suits in power contexts as influencers; people at the center of attention
Laughing Children	images of children at play and camaraderie
Leisure	images showing people spending leisurely time in relaxation
Making a Statement, Messaging	images making a general non-commercial statement, such as about politics, gender differences, human nature, environmentalism, particular industries, privacy, "school spirit," fandom, and other phenomena (but not including commentary on selfies or "group selfies" as these are captured in a different category)
Male Bonding and Friendship	images showing males from childhood to adulthood in mutual understanding and socializing and in shared activities
Mix of Human and Natural Sites	images showing people in environments that are a combination of human- (built) and natural sites (and sights)
Motorcycle Ride	images of people riding motorcycles to scooters, as individuals and as groups
Musicians	images of people performing music with various instruments and in various contexts, both formal and informal
Natural Sites	images of people enjoying natural sights like streams, mountains, deserts, water falls, hills, starry night skies, and others
Neighborhoods	images of locales where people live
Neighborliness	images showing people in a neighborhood sharing a mutual experience
Party, Dress-up	images of partygoers in various costumes (such as as wizards, zombies, public people, and others)
Performance	images of people performing dances, music, acting, and / or speaking
Politics	images of political leaders with their constituents
Power and Self-Efficacy	images showing people in various tasks that require skill, training, education, and such, in a positon of power
Profession of Faith	images of people with religious dress, religious verse, and / or context (such as people in a church group)

continued on following page

Table 1. Continued

Type of Group Membership (What is the Social/Bonding Glue Holding the Group Together?)	Coding Description
Recognition on Stage	images showing events occurring on a stage and the relationship between those performing and those watching (and the mix of complex interrelationships)
Romance / Attraction	images of couples in romantic scenarios: lying on the grass, walking together, standing under a starry sky, scuba-diving, riding together in a convertible, running together, and others
Self-Love, Ego, Self-Focus	individual and group selfies showing self-importance / self-affirmation, group importance / group-affirmation
Self-Revelation, Information Sharing	images that capture self-revelatory and personal information, including (partial) nudes, with the suggestion of vulnerability
Shared Adventure	images showing individuals and people sharing an adventure, such as scuba diving, rock climbing, experiencing a safari, mountain climbing, spending a night on the town, and other activities; the sense of discovery is forefront in these images
Solitude	images showing individuals or people in remote landscapes (deserts, forests, mountains) or those in crowded areas but in ruminative thought (or "their own world")
Solo Adventure	images showing an individual experiencing an adventure (without a sign of others nearby)
Spectacle, FX	images as expressions of "special effects" (visual wit, visual punning, technical and / or other feats); "FX" refers to "effects" by pronunciation; artful imagery
Stardom, "Beautiful People"	images showing individuals with global- and national- level recognition ("star power" in the attention economy) in the realms of entertainment, politics, media, fashion, and others
Students and Learning	images of students—from childhood to adulthood—in learning environments or contexts (including field trips)
Team Members	images of people who are members of a team (based on work, school, sports, and social organizations like sororities and fraternities)
Tourism, Trip, Travel	images of individuals and people engaged in tourism at various locales and tourism-based activities (sight-seeing, photography-taking, dining out, and others)
Toys and Dolls	images of toy characters
Variant Interpretations of Gender and Sexuality	images showing individuals in cross-dressing, transgendering, and other non-traditional expressions of gender and sexuality
Wedding	images of brides and grooms and marriage parties in various contexts: photo studios, churches, the great outdoors, and other locales
Workplace Collegiality	images showing colleagues / coworkers in various contexts: collaborating around a table, attending a conference, standing together shoulder-to-shoulder in uniform, taking a shared group image in a parking lot, and others

but if it seemed to equally fit in two, then it would be coded to those two. In the respective cells are cumulative counts of images belonging to that cell and brief phrases describing the salient aspects of that image that led to its categorization. In some cases, screenshots of the images were included to enhance the coding. For each category, the number of images in the category and the phrases describing salient aspects of the included imagery were recorded. There were columns for both the "group selfies" and the "dronies" image sets. How transferable the codebook below is to other contexts depends in part on how "overfit" this codebook is to the informing sample of image data here and the level of generality (vs. specificity) of the respective types of group membership described. If nothing else, this offers a basic start.

2. *Group Size: How many people's faces may be seen in the group selfie?*
3. *Demographics:*
 a. *Are there any clear genderized features of the image? How so?*
 b. *Are there any clear age features of the image? How so?*
 c. *Are there clear class features of the image? How so?*
 d. *Other demographic features?*

To understand some of the demographics in the imagery, in terms of the visible countable faces in the "group selfies" image set, there were 784 adult females vs. 580 adult males (or 58% female to 42% male). Besides the broad macro summary of gender, there were counts of every observable combination. In Figure 5 are the top 12 combinations of people per image in the group selfies image set. The min-max range of number of individuals per image in this first set was 1 – 100s.

In the dronies image set, there were 229 countable females vs. 380 countable males in the images (or 38% female to 62% male). The min-max range for the numbers of people in this image set also were from 1 – hundreds. Figure 6 contains the twelve top-ranked combinations of people counts in this set. Of note is the observation that there are many larger crowds like "dozens" and "hundreds" in the Top 12. This is possibly because of the aerial affordances of cameras borne by drones, which enable a wider area of coverage.

Why was some of the coding a little ambiguous? some of the images employed visual synecdoche, such as a pair of feet in sandals or a hand or an eye to represent a person. In other cases, images of people were partially occluded. Also, children were counted in the various patterns, but their presence was not incremented in the adult female and adult male counts.

Figure 5. Top twelve combinations of people per image in group selfies image set

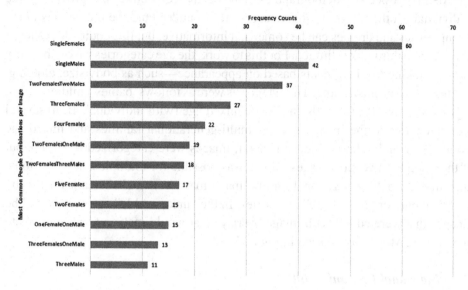

Figure 6. Top twelve combinations of people per image in dronie image set

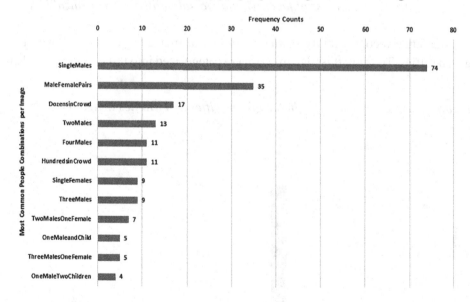

Another aspect of demographics may be the respective age groups of the individuals in the image. Using visuals to try to understand the individuals in the group selfies and dronies can be somewhat informative, but this coding like a lot of the others in this work is limited. For this to work, the age categories have to be fairly broad. Making age judgments based on appearance—such as body size, clothing, context—can be misleading. The categories were as follows: babies, children, teens, 20s – 30s, 40s, 50s, 60s, 70s and older, mixed age (with individuals from several age categories in the image, such as multi-generational families and mixed-age colleagues), and unknowable. In general, images were categorized by group, but if there were a diversity of ages, then it was possible for multiple categories to be included. A multi-generational family image may show a checkmark for a baby and then one for "mixed age" categories. In the "unknowable" category would be images that were edited with image overlays that would make a fair age estimate impossible. More may be seen in Figure 7.

4. *Individual Recognizability:*
 a. *How far away are the group members from the image? (estimate)*
 b. *Are the individuals individually recognizable in the image? Or is the group just a mass of faces without actual individual recognizability?*

Individual recognizability of the people in an image is yet another aspect of group selfies. To study this, the images were categorized into three groups based on

Figure 7. Age group estimates in the group selfies and dronies image sets

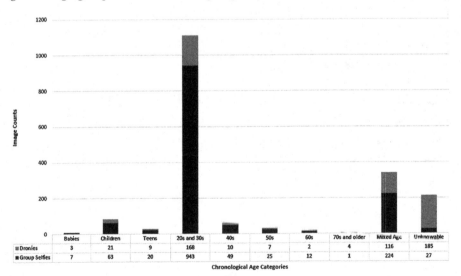

	Babies	Children	Teens	20s and 30s	40s	50s	60s	70s and older	Mixed Age	Unknowable
Dronies	3	21	9	168	10	7	2	4	116	185
Group Selfies	7	63	20	943	49	25	12	1	224	27

Chronological Age Categories

■ Group Selfies ■ Dronies

the closest image to the camera: (1) zoomed-in (from close-up to about five meters (around 15 feet); (2) mid-zoom (defined as with recognizable faces beyond five meters), and (3) zoomed-out (defined with unrecognizable faces, including high-aerial images and panoramic images). In other words, images were coded based on the first point-of-focus. From the half-dozen animated GIFs included in the image collections, some of the videos zoom-in or zoom-out, and these then go through all three categories: zoomed-in, mid-zoom, and zoomed-out.

In the "group selfies" image set, most of the images were zoom-in ones, from close-ups to about 5 meters or approximately 15 feet out. Here, the facial features are generally clear. In this set, there were few images at mid-zoom or at the fully zoomed-out view. In terms of the "dronies" image set, those were a balance between zoomed-in, mid-zoom, and zoomed-out, as may be seen in Figure 8.

Figure 9 shows a combined frequency analysis of the views, with a majority 1738 (82%) zoomed in, 199 (9%) mid-zoom, and 186 (9%) zoomed-out. These numbers are, in part, a factor of the larger amounts of scraped images from the "group selfie" set but are tempered also by the fact that drone imagery tends to include some fair amount that are mid-zoom and zoomed-out.

In these image sets, there were a few animated GIFs. Two from the group selfie set were as follows: a music star posing for a photo with a friend and a group of three men dressed as women taking a selfie on a couch. There were five from the

Figure 8. Zoomed-in, mid-zoom, zoomed-out views in the group selfie and dronie image sets

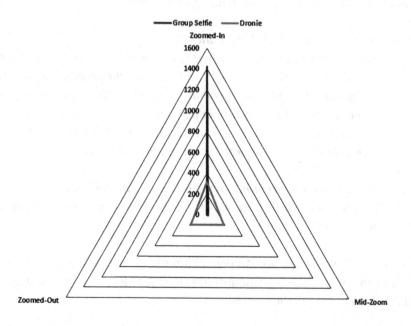

Figure 9. Frequency of views: zoomed-in, mid-zoom, and zoomed-out for both image sets

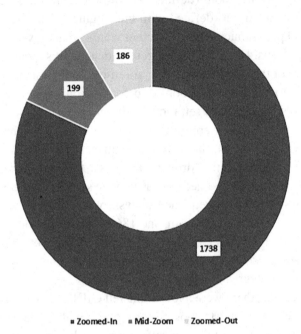

■ Zoomed-In ■ Mid-Zoom ■ Zoomed-Out

dronies set: several of various drones with movable propeller arms, a zoom-out view from people, a zoom-out from a pair of people sitting on a roof-edge, and a zoom-out view from a single man standing on a beach.

5. ***Group Membership Social Dynamics:***
 a. *How are the individuals arrayed? Is there one main person in the image supported by others (sort of the follower-with-followees dynamic, the foreground-background dynamic)? Or are all the members apparently somewhat equal in standing in the image?*
 b. *What are the respective individuals' roles in the image?*
 c. *What do the social aspects of the group selfie say about the depicted group?*
 d. *What is the apparent nature of groupness in the image? (Why are the people connected? What makes them a group, at least for a particular time period or moment?)*

This portion would require deeper within-image analysis and is beyond the purview of this work. This question would suggest a deeper understanding of the social culture depicted in the images.

6. ***Member Closeness/Distance:***
 a. *How apparently close are the members indicated in the group selfie?*
 b. *Does the group seem cohesive or not? Why or why not?*
 c. *What is the nature of their "group selfie"-ness? What is the nature of their online sociality?*
7. ***Group Member Actions:***
 a. *Are the individuals static (sitting, standing, posing in a static fashion, etc.)? Or are they in motion (walking, skating, running, dancing, etc.)?*
 b. *How much agreement is there between the expressions and mannerisms among the members of the group? Or is there misalignment? Is there convergence or divergence of actions?*

Group selfies may be categorized by the activities of its depicted members. In general, the individuals in the images are static, whether in pose or pause mode. In other cases, the motions that they are engaged in include walking, skating, running, marching, skateboarding, snowboarding, skiing, and other such activities. To generalize, in most images, there is convergence of actions. In other words, most members are engaged in a shared activity. This is even so in larger crowds and audiences, which are apparently sharing an activity or experience. Where there is divergence is in a mid-range image, in which different people may be engaged in multiple different activities. One example may be a snowy landscape in which one group may be skiing and posing with friends in their snow-wear, and others are throwing snowballs, and others are on a ski lift, and so on. They are all co-located in a particular area, but they are engaged in different activities with different individuals. More on this may be seen in Figure 10.

To get a sense of how much each of the image sets contributed to the various themes, a 100% bar chart is viewable in Figure 11.

Place and Time

1. ***Location Type:*** *Is the location a "natural" space or a human built space?*
2. ***Time of Day or Night:*** *Is the image taken in daytime or nighttime? Or dawn / dusk?*

The Place and Time section deals with where the respective images are apparently captured. To work at a general level, the places are broadly categorized as indoors, outdoors, motor vehicle, and unclear locations, for both the group selfies and dronies image sets. From these observations, some patterns have emerged. Most of the images from both sets are taken in the daytime. A large proportion of the group selfies images that are taken indoors do not have a clear time-of-day. To understand

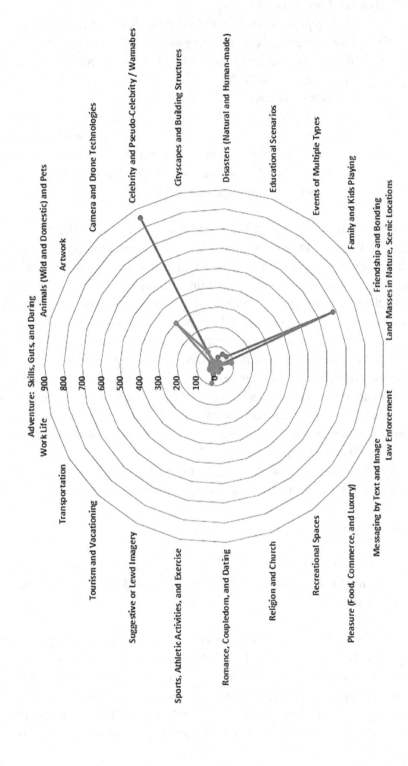

Figure 10. Extracted themes from group selfies and dronies image sets

Figure 11. Extracted themes from group selfies and dronies image sets

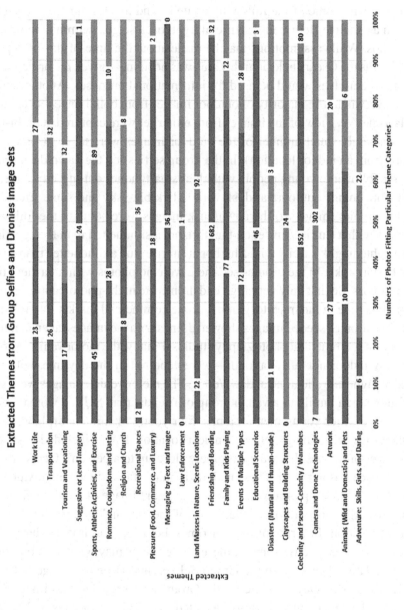

Extracted Themes from Group Selfies and Dronies Image Sets

this UnclearTimeofDay in the group selfies image set, events on stages and in rooms without windows will not have a clear time-of-day apparent in the image. In this category are also images in elevators, an underground subway, a hotel lounge, a dance floor, and other locales. In terms of the dronies image set and unclear times, there were images with some of the following contents and locales: a man in a shower, a drone on a concrete floor under artificial light, back stage, swimming pools, and photo studios. While assumptions may be made about the time-of-day of depicted events (such as the Oscars held at night), this was not done—given the principle that the images themselves would be used for informational purposes. Another pattern is that an overwhelming majority of outdoor images from both image sets are taken in the daytime. Very few of the images from either set were captured at night-time, and a vanishingly small number of the outdoor images were taken at dawn/dusk (and none from an indoor location). In the group selfies set, the dawn/dusk images include the following: young people with their smartphones out in a cityscape, and some 20-somethings outdoors at dusk with a dark blue sky and some streetlights out. In the dronies image set, the dawn/dusk images were some of the following: a land mass with a sunrise/sunset on the horizon, a silhouetted man flying a drone against a lightening sky, a city with a harbor at sunrise, and a silhouetted man against a partially starry sky. In the dronies set, there were no photos without a clear time-of-day. It is possible that only very high end drones are night-photo-capture capable at least at this time in the trajectory of the drone commercial market. Interestingly, many of the "dronie" seeded images showed drones with the images taken in interior spaces, such as commercial photography studios. Finally, the motor vehicle shots— neither fully indoor nor fully outdoor—were captured in the daytime, with none captured at nighttime and none at dawn/dusk. The motor vehicle images were some of the following: a family in a van, a group of friends in an SUV, a woman taking a selfie in a car, four young men on a bus, four young men in an airplane, and so on. In the group selfie image set, the UnclearLocation images included abstract or blurry images or images that were extremely close-up to a person's face so that no locational space was not clear. These included a man's face edited with textures and pink overlays, a close-up of a woman's face, a grainy image of a child's face (in a b/w image), and a close-up of an eye. None of the "dronie" images were unclear in terms of location. In terms of unclear times, both sets had images that did not indicate a clear time-of-day. Some of these observations may be seen in Figure 12, "Places and Times Depicted in the Group Selfies- and Dronies- Image Sets" and Figure 13, "Times-of-Days Depicted in the Group Selfies and Dronies Image Sets."

In Figure 14, "General Locations Depicted in the Group Selfies and Dronies Image Sets," the 100% stacked bars show the proportionality of contribution of image types from the respective group selfies and dronies image sets. There is a constant sum (to 100%) in each bar and then the data labels to show the respective

Figure 12. Places and times depicted in the group selfies- and dronies- image sets

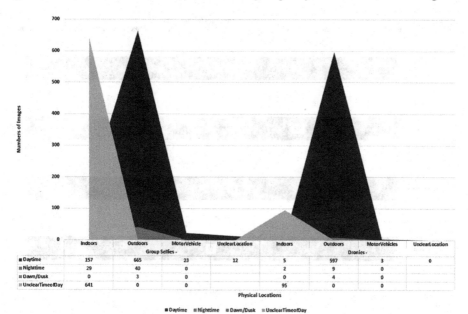

	Group Selfies -				Dronies -			
	Indoors	Outdoors	MotorVehicle	UnclearLocation	Indoors	Outdoors	MotorVehicles	UnclearLocation
■ Daytime	157	665	23	12	5	597	3	0
■ Nighttime	29	40	0		2	9	0	
■ Dawn/Dusk	0	3	0		0	4	0	
■ UnclearTimeofDay	641	0	0		95	0	0	

Physical Locations

■ Daytime ■ Nighttime ■ Dawn/Dusk ■ UnclearTimeofDay

**For a more accurate representation see the electronic version.*

Figure 13. Times-of-days depicted in the group selfies and dronies image sets

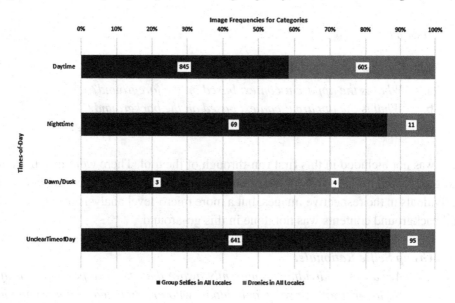

■ Group Selfies in All Locales ■ Dronies in All Locales

Figure 14. General Locations Depicted in the Group Selfies and Dronies Image Sets

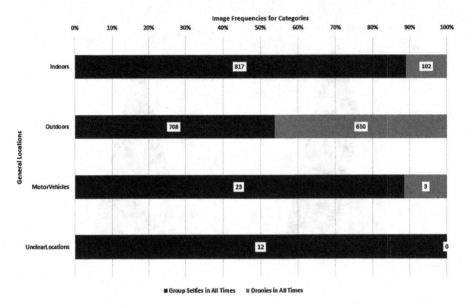

contributions from each of the datasets. Note that these combine all locations from the respective image sets.

Group Selfie

1. **Image Context:**
 a. *What is the apparent context based on the foreground?*
 b. *What is the apparent context based on the background?*
 c. *What is the apparent (inferred) context in the group selfie?*

This was not included in this first run-through of the tool. There were instances of foreground and background analysis to understand foci of the images and to count individuals in the respective images, but a more micro-level analysis of foreground and background contents was not done in this go-around.

2. **Group Selfie Rationale:**
 a. *Are all the individuals apparently aware that they are part of a group selfie, or are there some individuals who are included in the frame but not apparently aware that they are part of a selfie?*

b. *What is the apparent (inferred) rationale for the selfie? Is this about an event? A commemoration? A celebration? What seems to be behind the image?*

In a majority of the images, those in the foregrounds of the images seemed to be very aware of the camera, with many waving at it or gesturing. Beyond the foreground, though, it is not clear if people included in an image were aware that they were. In zoomed-out drone image captures, it is not clear at all if people were aware that they were included in the image.

3. *Non-Commercial or Commercial Purpose(s):*
a. *Is the group selfie part of a professional messaging campaign? Commercial endeavor? Non-profit endeavor? If so, how so?*
b. *Are there observable differences between formal group selfies and informal ones? Commercial and non-commercial ones?*

The images of both sets were analyzed for whether the images were non-commercial or commercial in focus. In the group selfies image set, the numbers of noncommercial images slightly outnumber those that are directly commercial (with labeled products both hard sold and soft sold) combined with unlabeled images that show commercial-level production quality and / or a kind of commercial intent (to sell a product or service). This dynamic was also observed in the dronie image set, with near-numerical balance between commercial/unlabeled commercial and non-commercial imagery. For group selfies, commercial imagery involved images from media organizations like sitcoms, actors, reality show personalities, singers, global church leaders, political personalities, branded toys, and cartoon characters. These were included in the set because the idea is that each of the representatives are linked to commerce and affect monetary flows. In the unlabeled but probably commercial set in the group selfies image set were images that looked like stock images, with commercial image production value. In the non-commercial image set from the group selfies set, there were images of families, friends, colleagues, and others, in a shared activity, and animal images (penguins, a seal, and horses). In the dronie set, the commercial images included an event sponsored by a well known candy brand, Hollywood imagery, a news agency's event, buildering stars (who have large followings on social media and draw in big money), a global religious figure, and various forms of labeled ads. In terms of unlabeled but probably commercial images in the dronie set, there were various glamorous images of drones in action—used in snowboarding, used in snowy landscapes, used in tourist areas, and others. In terms of noncommercial images in the dronie set, there were beautiful aerial images of

landscapes (otherwise unidentified) and documentation of events (like races, but without identifying sponsors). The findings may be seen in Figure 15.

4. ***Meeting of Human Needs:*** *What human need is being met by the image (if only one main need is being addressed)? Is the image about feats of daring, sociality, "brags," foodie-hood, couple-dom, or some other purpose? How can one tell?*

 This approach has value in terms of understanding human motivations. This currently was beyond the purview of the particular chapter.

Animals, Non-Human Agents, and Ego Representations

1. ***Animals/Non-Humans:***
 a. *Are there animals who are part of the group selfie? Any non-humans that may stand in for people?*
 b. *If there are animals or other non-human entities, do they stand in for people, or do they represent something else?*
 c. *What are some other types of "ego" or "entity" depictions?*
2. ***Props:*** *Are there other props that appear in the group selfies? Visual tropes?*

Figure 15. Commercial, unlabeled commercial, and noncommercial imagery from the group selfie and dronie image sets

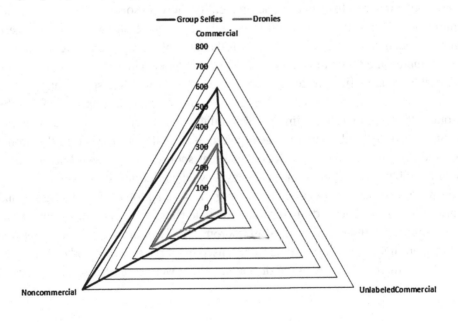

There were three identified categories of ego representations beyond humans in the group selfies and dronies sets: (1) animals, (2) non-human objects, and (3) props. In the group selfie images, various non-human entities like animals and objects were left as stand-ins for people. In some cases, people were personified as animals. For example, one image shows three kittens holding up a smart phone to take a group selfie. A dog in a photo studio wears glasses and human clothing items. Non-human objects were also the focuses of group selfie images: these included plastic toys in humanoid and animal shapes, dolls, video game characters, and fashion accoutrement. In these images, there were a number of props used to set the scene: flowering plants, a chair, a glass of wine, an umbrella, an inflatable globe, a guitar, jewelry, masks, blindfolds, hats, various smart phones and cameras, and others. In some cases, the props served as direct representations. For example, two group selfie images had blow-up female dolls in scanty dress—to stand in for females. In other cases, props were symbolic, such as the blow-up globe to represent the world (or maybe environmentalism). Further, quite a number of group selfies showed costumes and dress-up. In the dronies set, ego representations were generally only from the animal category, and from two photos: one involving cows, and another involving llamas.

Group Selfie Mood(s)

1. ***Moods:***
 a. *What is the mood in the selfie image? What elements of the image convey the mood? (Setting? Lighting? Props? Others?)*
 b. *What does this mood apparently "mean"?*
 c. *If there are multiple simultaneous moods, what are these, and how are they created?*

The concept of the mood in an image highlights the interpretive subjectivity of image analysis. After all, what aspects of an image convey mood, and how is the mood / are the moods conveyed? If there are people in the picture, a person might look to the facial expressions and activities and context for mood. Brighter colors often convey lighter moods, and darker colors often convey darker ones. In less obvious contexts, people may have to look at color. To simplify the concept (reduced to a binary), the two image sets were compared for "positive," "negative," and "neutral" (non-sentiment) moods.

By "positive," these refer to group selfie images that were upbeat, hopeful, energetic, positive, humorous, flirty, fun, ebullient, triumphal, sunny, and playful. "Negative" images were those that were pensive, dark, threatening, anxious, negatively humorous, critical, sad, and depicting harm. Typical positive images in the group selfie set include smiling young people who are having fun. In negative-

themed group selfie images, there was a man in a gas mask, a father holding his two children and with a depressed expression, an image with name-calling (the "stupid" appellation), and a scene of a disaster. In the dronie set, positive images include several guys bending over a drone and sharing in the joy of human endeavors, relaxing and positive landscapes, tourist spots, and smiling couples taking dronies of themselves. In terms of negative-themed dronies, one showed two people sitting on the grass with their hands behind their backs, apparently under arrest; an image of a natural disaster; and a smirking Mona Lisa holding up a cell phone. Some "neutral" dronies included a man standing in front of a brick building and flying a drone, but the visual is very distant; another involves a non-descript house. Of course, it is possible to be more fine-grained in tagging moods on images. After all, there are complexities. An image may be serious but still positive. For example, one dronie shows a young man walking on a beach in a gray landscape and following a lit-up drone; the landscape is foreboding, but the man seems somewhat equipped to handle whatever may come his way, and the overall visual effect is memorable and seductive. While some may read that as a negative mood, I took away something else—about human indomitability and maybe even a degree of fearlessness. It is possible to be critical but still funny and positive. (Trolling others and being hyper critical is never positive.) Analysis requires getting to the apparent heart of the image's meaning.

In Figure 16, "Positive, Negative, and Neutral Moods in Image Sets" shows that the group selfies tend towards the positive.

If color may inform tone, it may help to understand color breakdowns in both sets. Four color types were observed: full color, b/w (black-and-white), sepia tone, and filtered color (with generally one color overlaid over b/w). In Figure 17, "Ranges of Color Representations in the Image Sets," full color images were the most common, with vanishingly small counts of b/w, sepia tone, and filtered color.

Part 2: Group Selfie Image Creation

Group Selfie Image-Taking Setup

1. ***Apparent Relationship Between Photographer and the Subjects:***
 a. *Is the apparent relationship between the photographer and the subject close or distant?*
 b. *What is the relevance of this relationship between the photographer and subject?*

Figure 16. Positive, negative, and neutral moods in image sets

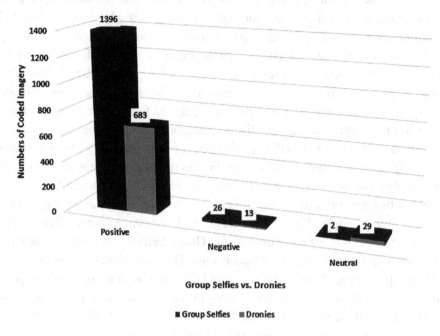

Figure 17. Ranges of color representations in the image sets

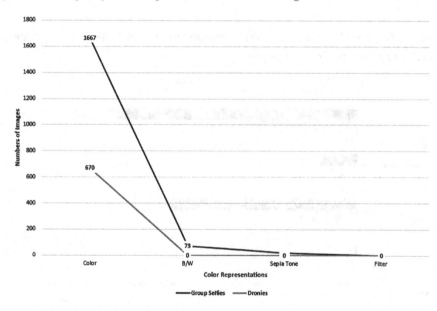

As to the question of the apparent relationship between the photographer and the subjects of the images, there were four applied categories: (1) close, intimate; (2) semi-close, semi-intimate; (3) distant, and (4) unclear. "Close, intimate" relationships would be reflexive images such as a photographer's own selfie (assuming the photographer is somewhat self-aware). Another example may be photos of the photographer's close friends or family members. In the "semi-close, semi-intimate" category, these images may be those between colleagues, fellow team members, fellow runners in a race, and so on. In the "distant" category, these may be public relations or advertising photos, photo lab captured images, star photos (with "parasocial" relationships), tourist photos, and others. For dronie images, these distant images may be highly zoomed-out photos of groups or crowds. The "unclear" category is for images that are too ambiguous to venture a code. These may include images of objects, for example. Figure 18, "Degree Closeness: Apparent Relationship between the Photographer and Subject(s) in Group Selfies and Dronies," provides some insights about the respective frequencies. This data visualization shows that the general patterning of frequencies is about the same, with most of the images in both sets "close, intimate." "Distant" comes in second place, and then semi-close, semi-intimate in third place. There are few to none images in which the closeness relationship between photographer and subject is so vague as to not enable a somewhat educated guess.

Figure 18. Degree closeness: apparent relationship between the photographer and subject(s) in group selfies and dronies

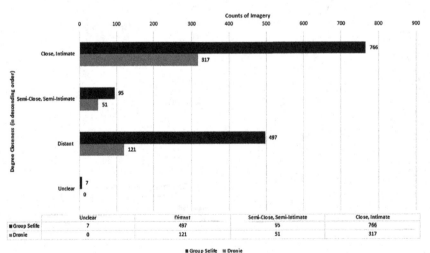

2. *Mobile Devices and Cameras:*
 a. *How many mobile devices (cameras, mobile phones, smartphones, etc.) are in the image? (These are the ones depicted and not necessarily used to capture the particular group selfie.)*
 b. *How is the main camera used for the group selfie capture positioned?*

In these images, various image-capture devices were included as part of the image. In some cases, they were the main focus of the image; in others, they were a part of the image. In many cases, the device used for the image capture is invisible: it is inferred because the image exists, or it is more directly inferred because there are arms reaching out to hold the device apparently involved in the image capture. In another case, an image looks like it was captured using a webcam based on the positioning of the camera in relation to the image and the workplace context. The depicted image capture tools shown in-frame include a variety of types: mobile devices, smart phones, manual 35 mm cameras, digital SLRs, drone cameras, and others. In Figure 19, "Image Capture Technologies Depicted in Social Imagery from Both Sets," these image-capturing devices are listed along with their respective frequencies from both image sets. Each of the image sets showed different tendencies. The "group selfies" set showed various types of mobile devices, smartphones, and cameras in-frame, and the "dronies" image set showed a lot of drones and cameras on tripods. Of note, a whopping 295 individual single smart phones were seen in the image frames in the group selfies set. For the dronie set, there were drone controllers in 258 of the images; and there were 193 drones in-frame from the dronie set. In terms of a min-max range for number of image capture devices in one image, these ranged from 1 – 31. In general, there was one device to a person, but in some cases, there were two. The average number of smartphones in social imagery with such devices was 4.9 per social image. From the group selfies image set, there were 295 images showing a single smart phone in the frame and 17 showing single mobile devices in the frame. In the group selfies set, there were two images showing multiple mobile devices in a frame, and 51 images showing a number of smart phones in the frame.

One note about manual coding: if there is one smart phone in view, a coder should not stop looking. There are possibly others. Any time there is a crowd of people, it is important to scour the image carefully because often each individual has a phone in-hand or somewhere easily accessible. (Of course, people in images hold a lot of other things besides image-capturing devices: clutches, microphones, food, musical instruments, snacks, a vase, and clothing items, etc.). In terms of various mixes of devices, the following were some of the examples in the group selfies image set: 13 smart phones and 2 mobile devices; 1 DSLR, one smartphone, and one selfie stick; 1 camera hanging off a guy's neck, 1 smart phone, and 1 selfie stick; 1 selfie stick, one DSLR, one smartphone device…but also a range of camera bags and neck

Figure 19. Image capture technologies depicted in social imagery from both sets

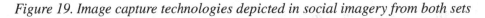
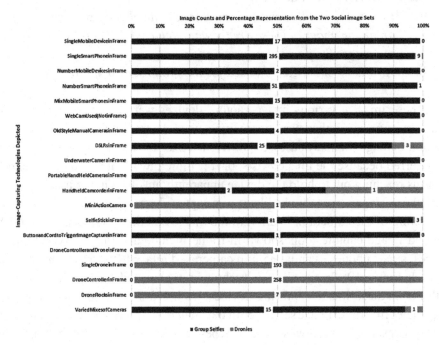

straps; 1 selfie stick and two smartphones; 2 mobile and a DSLR (outside); 2 selfie sticks and 2 smart phones; 4 smart phones and 1 DSLR; 1 smart phone and three tablet devices; 1 smart phone and 1 DSLR; 1 smart phone and a regular DSLR in another's hand; 1 smart phone and 1 small digital camera (in a side-by-side diptych); 1 smart phone and a web cam; and 2 smart phones and one camcorder. These various configurations of image capture devices show something about the diversity of the images but also about how people take a variety of devices with them for travel. In images with drones in them, there was an average of 2.7 drones each. In one image mix, there was 1 smartphone, 1 DSLR, another smartphone, and a flying drone.

So what was not coded? One with a guy holding a device, but the b/w image is high-contrast and deeply shaded, so the actual device is unclear. In another, there were two smartphones and a camera bag, with no way to know what was in the bag (although by size, it looked like one for either a DSLR or a conventional manual 35 mm). In another image, there are shadow silhouettes of a camera crew created by artificial light, but it is hard to tell what sorts of cameras they were carrying. In another, a person captured his / her shadow on the railroad tracks, but the camera type is not clear.

Dronie Capabilities Used: It would be interesting to know if the capabilities of drones—to fly to places that are not generally accessible and to enable aerial

views—were used in the "dronies" image set. In general, the affordances of the drones are used in a majority of the images in the dronies image set, as may be seen in Figure 20, "Whether Dronie Imagery Created Uses Drone Capabilities or Not." (The image set had several images taken with underwater drones, with the scuba diver controlling the underwater drone for both individual and group selfies. Several of the images showed how drones have the capabilities to fly untethered to remotely follow a person walking, a person riding a motorcycle, and people riding in cars—and these capabilities may become part of the robot-captured selfies and the phenomenon of "'bot paparazzi" and faux celebrity.)

3. *Technologies Used for the Image Capture: What technologies are apparently being used in the capture of the group selfie?*

There was not an easy way to ascertain what sort of device was used to capture an image from the images themselves. An unfocused on-the-fly image probably was taken on a mobile device. A very high-resolution high-quality image probably required a high-end DSLR. Beyond such generalizations, which themselves may not even be true—given the changing capabilities in image-capture technologies— it is not possible to generalize in a determinate way. Various visual effects may come from the camera, or they may come from post-production. Metadata riding

Figure 20. Whether dronie imagery created uses drone capabilities or not

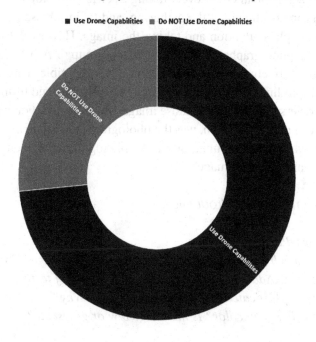

along with images may be captured on social image sharing sites, and those can be important parts of research.

4. ***Ad Hoc Image Capture or Planned Setup for the Capture:*** *Is the image apparently taken on-the-fly or in an ad hoc way? How posed is the image? Was there a lot of setup to the image?*

In this section, the question is how much setup work the image might have taken. If the image was taken on-the-fly, the image might seem somewhat haphazard and happenstance. For example, friends taking a blurry image in front of the Eiffel Tower might give a sense of ad hoc image capture. If the image was fairly complex—with just the right people, the right composition, the right lighting—then the image might have been planned. For example, buildering would take a lot of work (as would scenes of mountain climbers, convertibles on a road with a drone overhead, and so on). Incidental image captures may seem highly complex from the outside, and mundane images may have been very effortful to capture. Appearances can be deceiving.

In Figure 21, "Complexity of Image Setup: Ad Hoc or Planned Imagery from "Group Selfies" and "Dronies" Image Set," both image sets tended to have many more ad hoc images than planned images. In the group selfies set, only 2% of the images seem like they required complex planning, and in the dronies set, only 6% of the images seem to have required complex planning. It may help to note that the coding may explain some of the rarity of such codes. If there is an image of, say, a group of actors at an Oscar event taking a selfie, the setup is not high per se. After all, everyone is already at the gathering, and taking the selfie is a matter of getting select people's attention and taking the image. However, if there were no such event and a photographer wanted to gather a group of A-listers for an image, that may be prohibitively expensive and potentially impossible. This is one of those cases where the coding is difficult with ambiguous images and trying to read into an image and reverse-engineer how those images were created. For example, with a dronie image in a remote location, was the photographer going to hike that anyway, and the image was an afterthought, or did the photographer hike out to get a great remote area location dronie image?

Group Selfie Image Post-Production

1. ***Image Post-Production:***
 a. *How much image post-production went into the image? Cropping? Color balance? Adding of image overlays? Addition of text?*
 b. *How sophisticated is the post-production? Why?*
 c. *Is the image in color? Is the image b/w or grayscale?*

Figure 21. Complexity of image setup: ad hoc or planned imagery from "group selfies" and "dronies" image set

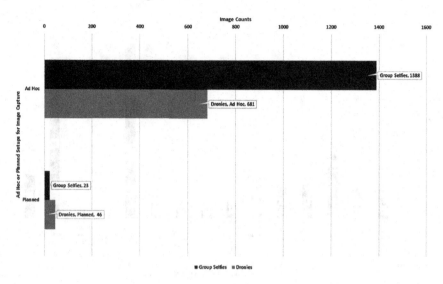

The sets of social imagery range from very basic photos to more complex images requiring sophisticated camera equipment, lenses, and post-production. In the capturing of an image, there are many factors to consider: the location of the image, the composition of the image, the perspective, the individuals in the image, the lighting, the in-scene props, the camera settings, the lenses, the legal considerations, and other factors. After images have been captured, all sorts of post-production efforts may be applied. For example, virtually all images are assumed to be cropped to enhance the viewer focus on areas of interest; also, all colors are assumed to be "jumped" in production, so that the image is represented in as accurate a way as possible (whether for screen or for print). In many cases, there may be light touch-ups but no factual changes to an image—at least in professional journalistic circles. In advertising, anything goes, which means a wider range of post-production applications, including editing the "facts" of the image. In these image sets, some 15 types of post-production elements were observed. They include the following: artificial shadows, b/w and grayscale, blur, chroma keying (with green or blue screens), color filters, contrast, hand coloring / drawing on imagery, motion, oil painting overlay, panoramic edits (and image stitching), photo editing / layering, ripple / "liquify" effects, social media filtering, tinting, and vignetting (shading the edges of an image). In some cases, multiple effects were apparently applied to an image. Figure 22, "Observed Post-Production Editing Effects" shows the common uses of photo editing and of tinting.

Figure 22. Observed post-production editing effects

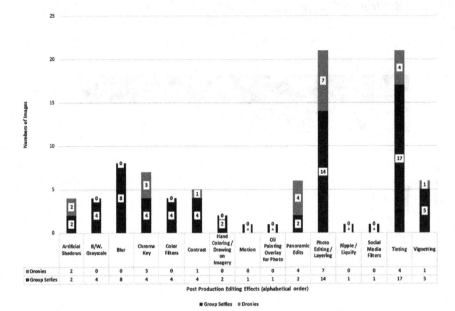

Post Production Editing Effects (alphabetical order)	Artificial Shadows	B/W, Grayscale	Blur	Chroma Key	Color Filters	Contrast	Hand Coloring / Drawing on Imagery	Motion	Oil Painting Overlay for Photo	Panoramic Edits	Photo Editing / Layering	Ripple / Liquify	Social Media Filters	Tinting	Vignetting
Dronies	2	0	0	3	0	1	0	0	0	4	7	0	0	4	1
Group Selfies	2	4	8	4	4	4	2	1	1	2	14	1	1	17	5

■ Group Selfies ■ Dronies

One form of image post-production involves whether images are spliced together to create composite imagery. In these data sets, the smallest such image consists of one, and the largest consists of some 31-combined images (min-max range of 1 – 31). In-between, there are the diptychs, triptychs, quadtychs, and so on.

The most common counts of group selfie and dronie imagery (in a combined set) is a single image, followed by picture-in-picture, then diptychs (two images side-by-side or top-and-bottom), and then quadtychs (four images in one). More on this follows in Figure 24, "Types of Composite "Group Selfie" and "Dronie" Imagery in Descending Order."

Part 3: Group Selfie Messaging

Group Selfie Focal Point

1. *Focal Point(s) of the Image:*

 a. *If there is a focal point to the image, what is it, and why is it the focal point?*

 b. *If there is not a focal point to the image, then how is the apparent focus spatially distributed, and why?*

Figure 23. Types of composite social imagery from the "group selfies" and "dronies" image sets (cumulative view)

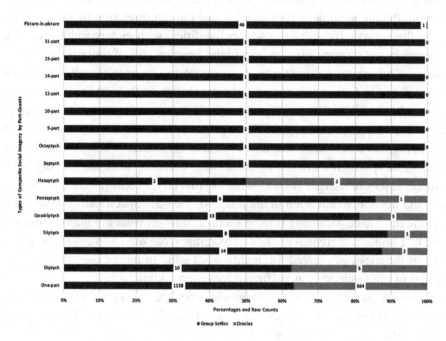

Figure 24. Types of composite "group selfie" and "dronie" imagery in descending order

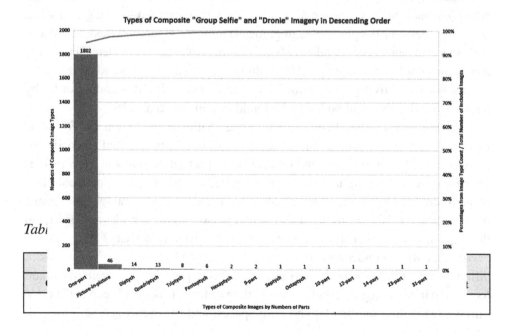

Tab

Understanding the central emphasis of images in a particular image set may be informative. The central focus or foci (focuses) may be informed by the photographer's intention, the photo subject(s)' intention, and the interpretation by the viewers—each in their respective cultures and local realities, with understandings of visual grammars based on enculturation and social practice. All of these points-of-view provide an interpretive shimmer to the image data. To operationalize the human coding of image foci, a few simple measures were used. First, how was human attention directed in the image? (Specifically: What was foregrounded in the image? What was centered in the image? What was lit vs. what was in shadowed? In terms of cropping, what was included, and what was excluded? What was in the detail vs. the white space? If there are words or other overlays, what did that suggest? If the image is part of a larger context, what did that larger context indicate?) Second, where did the human attention in the image frame go? (Specifically: What did the people in the image focus on? Is there focus a "tell" on what the main focus of the image is?) Third, if there was explicit messaging, what was the message about, and who was the message created for, and to what end? In most cases, the use of the first part of the sequence was sufficient for rough coding.

Because of the divergence in contents between the "group selfie" and "dronie" image sets, unique coding tables were used to analyze each set. For each set, a generic and undefined table (Table 2) was first used.

The idea was to capture sufficient labels to ensure that the full set of images would be sufficiently coded. The labels should be general enough to be somewhat equivalent even though the results would not mean an equal allocation (image counts) in each category. Seven areas of focus were identified for the group selfie image set: person / people, messaging, material object(s), activity(ies), animal(s), built space(s), and natural landscape(s). Four areas of focus were identified for the dronie image set: person / people, UAV / drone, natural landscapes and built spaces, and events and activities. The prior lists were mentioned in descending order by count. More details about both may be found in Figures 25 and 26.

This is not to say that there weren't coding challenges and nuances. For some images coded to "person / people," these may have been credited to "activity" because people often socialize and interact around activities. (Only in a few images are people doing nothing in them.) For example, in a wedding photo, should that photo be credited to focusing on the people or on the actual ceremony? In an image of an audience raising arms and looking at a person taking a backwards selfie on the stage in front, is that about people or about the event or activity?

Another way to understand the dronie as a type of "group selfie" is to look at different ways to categorize these images. In this approach, there were four main foci for the image category types (in descending order): (1) person / people; (2) UAV / drone; (3) natural landscapes and built spaces; and (4) events and activities. In

Figure 25. Seven identified foci of group selfie imagery

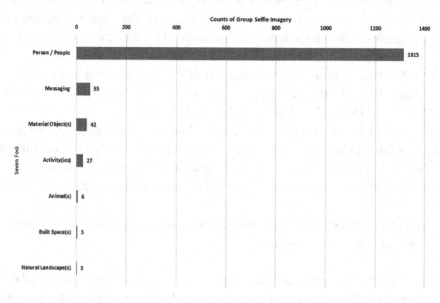

Figure 26. Four identified foci of dronie imagery

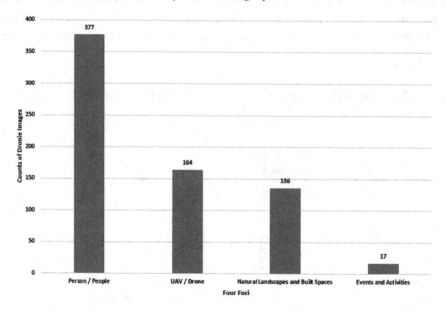

cases where there were mixes of focuses, each category was given partial credit. For example, if there was a group of people flying drones in a shared event or activity, 1/3 was given each to (1), (2), and (4). If there was a jogger running through a lush

remote landscape and flying a drone at the same time, then (1), (2), and (3) were credited with 1/3. Also, if there was a couple sitting on the edge of a building and taking a couple-selfie with a drone, that would be (1) and (3), with ½ counts going to each category.

To get a sense of how the two image sets differ, a comparison was created in a spider chart. From the dronie image set, the "Events and Activities" -> Activities, and "UAVs and Drones" -> Material Objects (Figure 27).

It is highly likely that such coding can be done computationally, probably in a fairly near future. Currently, computer vision is able to identify objects in images with fair accuracy, and some can read sentiment from the images. Coding for more complex and interpretive contents, such as in this work, will likely require more work.

2. *Image Sequence: Is the image part of a sequence? If so, what does the sequence communicate in terms of focus?*

The method of image extraction, using seeding terms in Google Images, did not actually result in the capture of a lot of sequences. There were a few individuals who recurred in between two and 11 images. Two images captured a group of women standing in front of the United Nations building in New York City. There was a couple with a drone and a motorcycle who appeared in multiple images. There were several photos of two men each wearing lanyards and smiling up at a camera on a

Figure 27. (Combined) respective focuses of group selfies and dronies image sets

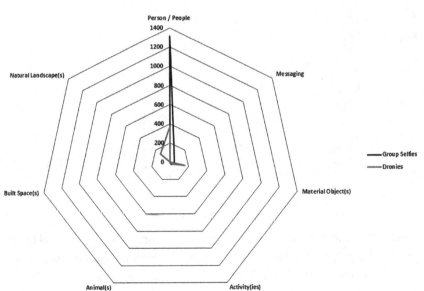

drone. A woman with gray hair had shared some artfully created self-portraits. One foreign media organization showed a head-of-state strolling with his colleagues when he came across a wedding, and he took photos with the wedding party—in what looks to be a public relations message. Beyond those, there were no clear sequences established by multiple images. Within images, there were some side-by-side images, some suggesting a before-and-after, others suggesting a comparison or contrast. There were some triptychs and quadtychs and such indicating a sequence of images. In one, a man blowing up a red balloon and wearing ponytails looked like he was trying to emulate a little girl. In a nine-tych, three friends made faces at the camera—all suggesting the passage of shared time during a short time span but not indicating anything more insightful than that. One work showed a man apparently in the process of fake-drowning in water...with his visage captured on six images (not obviously in any sequence). While this angle of exploration may be beneficial, the two image sets used in this study did not bear out the potential research value.

3. ***Visual Movement:*** *Is there a visual movement or dynamic in the group selfie? How so?*

If one were to generalize, most of the images in the "group selfies" and "dronies" image sets were static, with people stopping for a photo...or looking up from various seating arrangements. Only a few images in the sets showed movement. In the "group selfies" set, one image showed a fight about to start in a crowd, with several individuals in a blur of motion and those around them starting to pay attention to the potential fight. There were some individuals riding motorcycles in various images. A few buildering images showed heart-stopping images of young males clinging to pinnacles on rooftops and taking a selfie with the free hand. In the "dronies" image set, there were images that caught motion such as a bird flying up to a drone while the drone was in mid-flight and the bird in mid-flap. There were several depictions of motorcycles on roads, in mid motion. Also, there were people snowboarding while being pulled by a drone. One image seemed to have been captured by a head-mounted camera while the photographer was standing on skis ready to take on a steep downslope.

Group Selfie Main Messaging and Submessaging

1. ***Main Messaging:***
 a. *What main message(s) is/are being communicated? Are there any apparent themes in the group selfies? How so?*

 b. *What sub-messages are being communicated? (How were these identified? What is the interpretive range of the images? How can one read point-of-view of the viewer?)*

 c. *Is the messaging apparently intentional or unintentional, advertent or inadvertent?*

An initial coding run of the images showed 23 basic high-level themes. They are, in alphabetical order, as follows:

1. Adventure: Skills, Guts, and Daring
2. Animals (Wild and Domestic) and Pets
3. Artwork
4. Camera and Drone Technologies
5. Celebrity and Pseudo-Celebrity / Wannabees (Different Permutations of Celebrity, the Expression of Ego)
6. Cityscapes and Building Structures
7. Disasters (Natural and Human-made)
8. Educational Scenarios
9. Events of Multiple Types
10. Family and Kids Playing
11. Friendship and Bonding
12. Land Masses in Nature, Scenic Locations
13. Law Enforcement
14. Messaging by Text and Image
15. Pleasure (Food, Commerce, and Luxury)
16. Recreational Spaces
17. Religion and Church
18. Romance, Coupledom, and Dating
19. Sports, Athletic Activities, and Exercise
20. Suggestive or Lewd Imagery
21. Tourism and Vacationing
22. Transportation
23. Work Life

Between the "group selfies" and "dronies" image sets, in some of these themes, one set was predominant over the other in a particular category or sub-category. Some of these aspects are described in the following section.

"Adventure: Skills, Guts, and Daring" (1) is captured in the following scenarios: climbing mountains, diving with sharks, "buildering" or climbing vertical buildings in urban landscapes, standing on a plane fuselage, and hiking in remote landscapes.

"Animals (Wild and Domestic) and Pets" (2) show various depictions of animals. Some group selfies show animals alone: horses and cats taking respective selfies; one showed a seal "smiling" at the camera while penguins cavorted in the background on the beach. The "first animal selfie" ever (of a distinctive macaque) was also in the scraped images ("Monkey selfie," March 27, 2017). Others have humans interacting with animals, both wild and domestic. One dronie shows a wild bird flying up to a drone's camera. One group selfie image shows five caterpillars chewing on a leaf. The next category is "Artwork" (3). In group selfies, these are artfully created images that harken back to older time periods or which are photo mosaics (a la Chuck Close) or which involve some complex post-production with an artful result. In the dronies image set, there are human "stars" (people lying on their backs in a star shape) which may be captured from an aerial drone, a couple lying next to each other romantically in swirling grass, and a couple lying on a snowy roadway with a sideways umbrella overhead in a highly zoomed-in aerial view. The "Camera and Drones Technology" (4) is dominated by the dronie set, with a number of images that showcase drones, drone cameras, and drone flocks. While quite a few of the group selfies or "groupies" images show smart phones and mobile devices for capturing imagery, they are not as adoringly portrayed as the newest technologies. One of the most popular categories is the "Celebrity and Pseudo-Celebrity / Wannabes" (5) grouping, which captures different permutations of celebrity and the celebration of personal ego. This one is clearly dominated by the group selfies imagery (vs. the dronies). Group selfies feature multiple versions of the Ellen DeGeneres classic, and then stars from Hollywood (the big screen and the small screen), Washington, D.C., and the music world (both stateside and abroad). Along with the highly recognizable stars are aspirants to celebrity-inspired attention. The term "wannabe" is from less formal speech, and it is not used here with any judgment but more as a descriptor. Some of the sub-categories here and their frequency counts may be seen in Figure 28, "Subcategories of Celebrity and Pseudo-Celebrity/Wannabes in the Group Selfie Image Set".

The next category involves "Cityscapes and Building Structures" (6), and virtually all images coded to this category were from the dronie social image set. These include street views, buildings, and neighborhoods. "Disasters (Natural and Human-Made)" (7) was a sparse category. From the group selfies set, there was a shipwreck; from the dronies set, there was a scene from a apparent earthquake, a fire, and one a guy that seemed to be making a scenario of himself starting to drown in a pool of water. "Educational Scenarios" (8) had examples from both image sets, but mostly from the group selfies vs. the dronies one. There were students with their teacher, groups of students by themselves, school contexts, graduation, and sorority sisters in sorority garb. Next, "Events of Multiple Types" (9) showed the uses of group selfies to document and remember group events: public fairs, plays, races, political

Figure 28. Subcategories of celebrity and pseudo-celebrity/wannabes in the group selfie image set

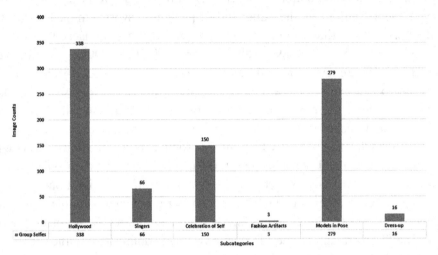

marches, strength training events, field trips, concerts, awards shows, and others. In this category were the following sub-categories: Organized Event, Beach Event, Paint Fights, Weddings, Balloon Events, Concerts, Carnivals, Camping Events, Gatherings with Media Present, Brawling, On-Stage Events, and Commercially Sponsored Events. These categories are not cleanly conceptualized (and seem to be a hodge-podge) but are a rough estimate of the types of events observed in the image sets albeit with varying numbers of examples in each. "Family and Kids Playing" (10) involved three sub-categories: Relaxing at Home, Family, and Kids Playing. In "Friendship and Bonding" (11), one of the most popular categories, people are shown connecting around shared activities and interests. There are friends sharing a drink at a bar, hiking along a shoreline, traveling together to a destination, or flying a drone together. In "Land Masses in Nature, Scenic Locations" (12), there are lush islands, wind-sculpted deserts, snow- and ice-covered mountains, mud flats, cliffs, forests, farm fields, hot springs on a mountain landscape, shorelines, beaches, and camp sites under starry night skies. "Law Enforcement" (13) was a category with only one example, from the dronie image set, showing two people with their hands cuffed behind them and a person wearing a neon-orange vest standing next to them (it is not clear that the image was captured by drone or why the image was somehow scraped in with the "dronie" set). The "Messaging by Text and Image" (14) category captured a range of (non-commercial) messages mostly from the group selfie set. Some messages decried female sexual competition among themselves by showcasing "that one friend who always puts extra effort in group selfies...tag that hoe". In this image, a group of women in bikinis are lined up, but one seems

to be more attention-getting because of a more provocative positioning. The more sexually provocative an image, the more "likes" and attention that would create—at least until that behavior got old (Freitas, 2017, pp. 37 – 38). Lighter ones addressed how men and women take different group selfies, how an egoist has expectations for what is happening when he takes a photo of himself in front of a crowd vs. what is really happening (critique), and others along the same vein. The dronie set had one shot of a drone flying with a banner below, but the banner itself was not readable. The "Pleasure (Food, Commerce, and Luxury)" (15) set involved images celebrating food and its sharing; meals at a table among family members, friends, and colleagues; and adventurous dining al fresco. Then, too, there were images of various types of commerce. At the one mundane end may be yard sales while at the other is luxurious living, such as in luxury homes on cliff tops and luxury cruise ships for vacationing. "Recreational Spaces" (16) consist of parks, ski lodges, beachside and shoreline spaces, streets, pools, and wading pools. The "Religion and Church" (17) category involved photos of people interacting at various locations: churches, streets, hilltops, and others. For some, they are celebrating weddings. For others, they are meeting global religious leaders in full formal dress. One of the coded images showed a man with his "selfie" photo and an overlay of religious verse. The "Romance, Coupledom, and Dating" (18) category showed couples in various contexts: picnicking on grass, sunbathing on lounge chairs, riding together in a convertible, running a race together, sitting together in a window box, and scuba diving. In "Sports, Athletic Activities, and Exercise" (19), there are photos of a jubilant football team cheering each other, various audiences in sports arenas, an athlete holding up her medal in a Winter Olympics event, and people in swimming pools. Both image sets had numbers of individuals in hiking contexts—on hills, on suspension bridges, on road sides, and on mountain tops. Runners may be seen in various locales. In #19, there were also photos of individuals skiing, skateboarding, ice skating and sledding, snowboarding, romping in the snow, canoeing, boating, bicycling, scuba diving, running races, mountain climbing, playing basketball, engaging in group yoga, and engaging in group stretches on open outdoor fields.

In terms of "Suggestive or Lewd Imagery" (20), the image sets had some of the usual: females and males in various states of skimpy dress and undress, a couple making out on a balcony, a man taking a selfie but positioned as if he were committing a sexual act on a statue behind him, and a group of scantily dressed women in close contact with each other. "Tourism and Vacationing" (21) was a popular category, with individuals at various well known locations taking photos, strolling down streets, sunbathing, drinking alcohol, and relaxing. Some images show ancient ruins. Some images show groups dressed for fun and making faces as they sat on airplanes. Several stood on designated selfie spots for dronie images. "Transportation" (22) involves images of people using various modes of transportation: cars, trucks, motorcycles,

mopeds, boats, bicycles, airplanes, and subways at subway stations. The "Work Life" (23) category included images of colleagues at professional conferences, fellow employees at various work sites, and people working in construction and maintenance at construction sites. In total, 23 thematic elements were observed, with 2029 from the "group selfies" set and 872 from the "dronies" image set.

Besides thematic contexts with related human activities, it is possible to understand group selfie and dronie messaging by

- The related gestures being made towards the camera, and
- The facial expressions directed at the camera.

The related gestures list include all observed gestures made using the hands, forearms, and arms but not counting the gesture of taking the image (so no inclusion of the holding of a smartphone or mobile device or drone controller). The counts below in Figures 29 and 30 are by photo, not by individuals. If several gestures are shown in an image, that will be counted as multiple gestures. It is important to note that there is inherent ambiguity to hand gestures. For example, two arms may be raised in triumph, in exasperation, in worship, and so on. To understand gestures in context, the facial expressions and the contexts have to be understood, as well as the background culture(s) of the individual(s).

In the "group selfies" image set, the most common observed gestures was the peace sign (with the forefinger and middle finger in a "v" with the palm pointing out and the rest of the fingers clenched around the palm), then waving, and then the peace sign (albeit with the palm pointing toward the person making the gesture). [As a side note, the "peace sign" gesture may also be interpreted as "victory." Usually, the "v" with the palm out and other fingers tightened around the palm means "victory." The contexts of the group selfies and dronies, though, suggests a greater likelihood of the peace interpretation. None of the images with these gestures carried a vibe of celebrating a victory per se. The spirit of most group selfies in these sets, also, tended towards inclusiveness and not one-upping the audience by celebrating and owning their victories vs. others without. This is not to say that there are not all sorts of social competitions in non-group selfies.] The thumbs-up sign was also very popular. In many of the images, the subject of the image would be holding something up to the camera, such as desserts or a different camera. Figure 29, "Observed Gestures in the 'Group Selfies' Image Set," highlights some of the other observations of common gesture types, in descending order from left to right.

In the "dronies" image set, the most common observed gesture was "waving," which stands to reason given that many are taking self-images with the camera on their drone, so they often will engage in a friendly gesture toward the machine. The second most common gesture was having two arms raised toward the camera,

Figure 29. Observed gestures in the "group selfies" image set

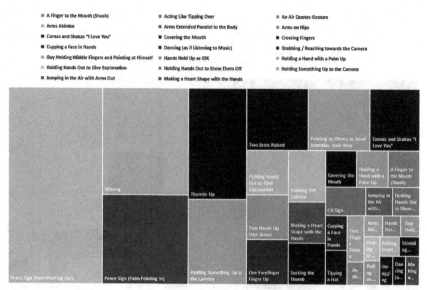

**For a more accurate representation see the electronic version.*

an act to stand out against the landscape with a zoomed-out drone. The third most common gesture was the subject holding his or her arms extended perpendicular to the body (parallel to the ground). A similar gesture, albeit with one arm raised, was common. Figure 30, "Observed Gestures in the 'Dronie' Image Set," offers some more insights about the most to least common observed gestures in the social images.

In Figure 31, "Most-to-Least Common Gestures in the Respective 'Group Selfies' and 'Dronies' Image Sets," the Pareto charts show the distinctive differences in the most common gestures in each of the respective image datasets. Some of these differences may be explained by the respective technologies, but these are likely also informed by cultural practices and social expectations.

What about facial expressions in the respective sets? In Figure 32, the most common facial expression is one of friendliness through a smile at the camera. What follows next in popularity is the preening, pouty face and unsmiling stare of high-end models and model wannabes. Sticking the tongue out is also a popular facial expression. More on the various types of facial expressions may be seen in the treemap diagram.

In Figure 33, "Observed Facial Expressions in the 'Dronie' Image Set," smiling is also very common in the "dronie" image set. "Serious Face" is the second most common facial expression, and the third is kissing.

Treemap diagrams, by design, focus on the most popular phenomena and may leave out some of the lesser-observed phenomena. To share what was coded, it may help to have a graph that shows these details in more depth. Figure 34, "Contributions of

Figure 30. Observed gestures in the "dronie" image set

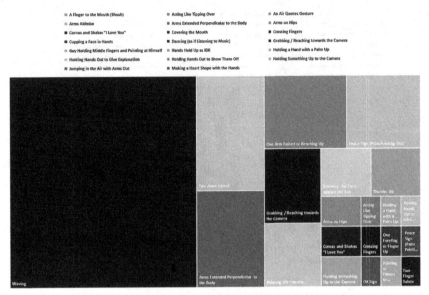

For a more accurate representation see the electronic version.

Respective 'Group Selfies' and 'Dronies' Image Sets to Facial Expression Themes," shows a comparative view of what each of the image sets contributed to each of the facial expression themes. As may be noted, the "group selfies" set accounted for a majority of the varieties of facial expressions, while the "dronies" set contributed to a few:

2. ***Informational Value:*** *What is the informational value of the group selfie? Why? What may be read from the group selfie image?*

Group selfies and dronie images, like other images, are high-dimensional data with multiple extractable meanings. As with other social images, there are intended messages conveyed as well as unintended information and data leaked. There are two approaches to understanding potential informational value from group selfies: general and specific.

A general approach could involve the study of social imagery for baseline understandings (and this work starts to define some approaches about how to set such baselines). Such images may be read to understand something about people, society, culture, and uses of social technologies. A specific approach could involve the answering of specific research questions, the mapping of specific phenomena, the understandings of certain socio-technical insights, and the targeting of particular individuals and organizations for profiling.

Figure 31. Most-to-least common gestures in the respective "group selfies" and "dronies" image sets

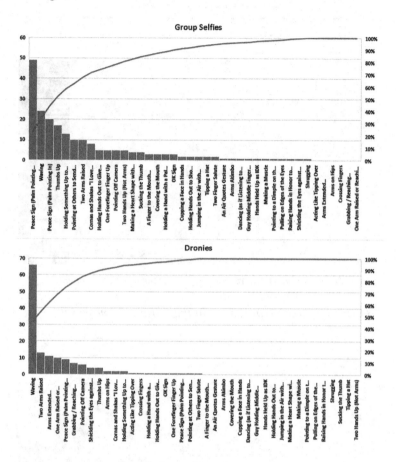

Apparent Audience(s) for the Group Selfie

1. **Main Audience(s):**
 a. *Is the group selfie narrowcast (to a target audience) or broadcast (to a wider undefined audience)? Or both? Is there a way to tell?*
 b. *Why would these particular audiences exist for the group selfie?*

The conceptual target audiences for both group selfies and dronies were explored. The "self / selves" as audience suggests that an image is taken to fulfill person- and group-based needs, including ego gratification, vanity, self-efficacy, self-expression, and other needs. The "consumers / customers" as audience suggests social messaging designed for people with purchasing power and disposable income. The "friends /

Figure 32. Observed facial expressions in the "group selfie" image set

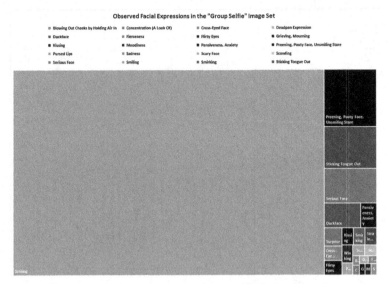

**For a more accurate representation see the electronic version.*

Figure 33. Observed facial expressions in the "dronie" image set

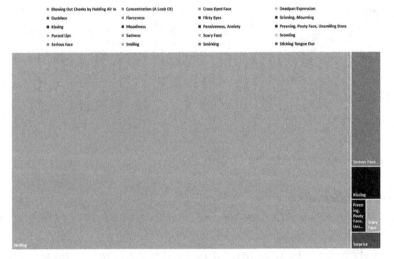

**For a more accurate representation see the electronic version.*

family / acquaintances / neighbors / religious communities" category suggests social imagery created for those within an individual's social circle. The "colleagues" category suggests imagery taken to improve workplace relationships, bring teams closer together, raise team spirit, commemorate conferences, and so forth. The "broad public" conceptual audience suggests an instrumental interest and benefit

Figure 34. Contributions of respective 'group selfies' and 'dronies' image sets to facial expression themes

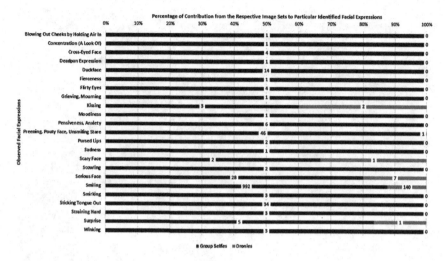

in reaching an audience beyond local concerns—to advance larger-scale aims. (In commerce, this would be to reach new markets, for example. In social imagery by governments, this would be to win hearts and minds.)

In Figure 35, "Conceptual Target Audiences for Group Selfies from the Combined Image Sets," the three most popular audiences were as follows (in descending order): "friends / family / acquaintances / neighbors / religious communities," "self / selves," and "consumers / customers."

The contributions of the respective image sets to the various conceptual audience groups may be seen in Figure 36.

One truism about social imagery is that the target of the social imagery is often also the audience. People take photos of themselves and enjoy consuming their own self-images. Colleagues take work photos and enjoy those among themselves. In such contexts, such images are "narrowcast" to a defined audience of selves, and those close to them. The meaning may be idiosyncratic and is encoded in local relationships and understandings, and these meanings may not matter to anyone else (because they are not "read in" to the local conditions). Even if the original intentionality is to share an idea broadly, it often takes a lot of effort to inform and "condition" others to understand a particular point-of-view. Such efforts to groom an audience are costly in work and time, and these often require sophisticated capabilities. Some social images have relevance beyond the local and may have some broader appeal—to non-familial strangers. When imagery is shared on social media, the social sharer may have a narrowcast audience in mind—such as friends and family, acquaintances, neighbors, and colleagues. In other contexts, the social sharer may

Figure 35. Conceptual target audiences for group selfies from the combined image sets

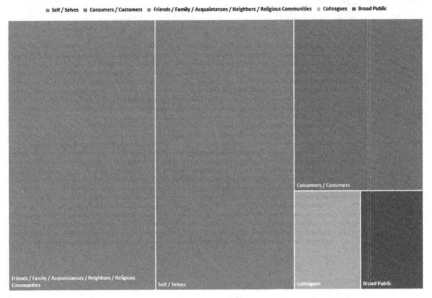

**For a more accurate representation see the electronic version.*

Figure 36. A comparison between "group selfies" and "dronies" image sets for target conceptual audiences

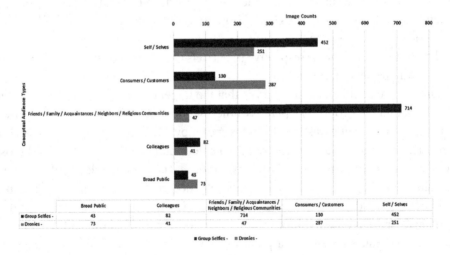

	Broad Public	Colleagues	Friends / Family / Acquaintances / Neighbors / Religious Communities	Consumers / Customers	Self / Selves
Group Selfies -	43	82	714	130	452
Dronies -	73	41	47	287	251

■ Group Selfies - ■ Dronies -

have a broadcast audience in mind—such as customers and potential customers (turning "followers" into "consumers"), a target electorate, and the unwashed masses of the world. While so much social imagery is available, what is accessible is only what is set to be viewable by others; individuals and groups may set their accounts to be private and not publicly viewable. In Figure 37, "Group Selfies: Narrowcast and Broadcast Messaging," five main audiences for group selfies were identified: self / selves, consumers / customers, friends / family / acquaintances / neighbors / religious communities, colleagues, and the broad public.

After these target audiences were identified, the various images in each category were analyzed to see whether the images appeared to be "narrowcast" or "broadcast." Narrowcast social images are targeted to a small group of individuals related to the image's main focus—without wider appeal or design features that would bring a wider audience into the image. The production values tend to be amateur and rough-hewn. Narrowcast images tend to be focused on a close-in audience to the photographer and do not seem to offer something to general viewers. These often lack the sheen of commercial productions, with proper composition, model looks, clear lighting, and edited selected elements in the visuals.

Broadcast social images have appeal to a broader public—whether through entertainment or humor or informational value. Broadcast social images tend to have higher professional production values. The focuses of the images may already be recognizable, with a user base of certain products or those attuned to advertising and mass media messaging. These may be witty or humorous. They may pack an emotional wallop—by design—with depictions that evoke emotional warmth or excitement.

In the group selfies set, a majority of "self/selves" imagery and "consumers / customers" images tended to be broadcast while "friends / family / acquaintances / neighbors / religious communities," "colleagues," and "broad public," these tended to be narrowcast, without clearer appeal to a broad non-local public. Broadcast group selfies or dronies are visually interesting, whether the interest is because of point-of-view, perspective, feats-of-daring, or beauty. These may feature known individuals with global or national-level face recognition. The physical locations may be well known and high profile as well. In broadcast images, there may be inferred audiences—such as demographic slices represented in respective ads or stock images.

Underlying this coding are a few assumptions, based on empirical research. There are costs to create social contents and to share; similarly, there are risks in sharing to a broad audience (risks of data leakage, risks to reputation, risks of being misunderstood). In an attention economy, with so much social data in the world, the power law has long been observed, with the following implications: most contents will be viewed by only a few in a niche-driven "long tail," but most of people's attention go to a few elite. And there is the assumption that social media contents are constantly changing, along with people interrelationships on social media.

In terms of the "dronies" image set, the "self/selves," "friends/family/ acquaintances/neighbors/religious communities," and "colleagues" sets tended to be narrowcast, but the "consumers / customers" and "broad public" audience sets seemed to have broadcast messaging appeal. "Dronies: Narrowcast and Broadcast Messaging" (Figure 38) shows some of these relationships.

In Figure 39, "Macro Level Contrast between Narrowcast and Broadcast Audiences for Group Selfies and Dronies," in the combined image sets, there are more narrowcast messages than broadcast ones, and the group selfies set has more representation than the "dronies" one in both categories. More broadly, 59% of the images are narrowcast to a close-in audience, and 41% are broadcast to a larger audience.

In Figure 40, "Narrowcasting vs. Broadcasting to Conceptual Audiences," the respective differences between the two datasets may be seen in this area chart.

A few caveats are necessary for this section of conceptualized audiences and narrowcasting vs. broadcasting. Clearly, there are limits to analyzing decontextualized social images and inferring intentionality by the digital artifacts alone. (In the social

Figure 37. Group selfies: narrowcast and broadcast messaging

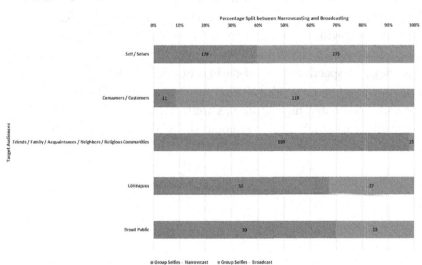

Figure 38. Dronies: narrowcast and broadcast messaging

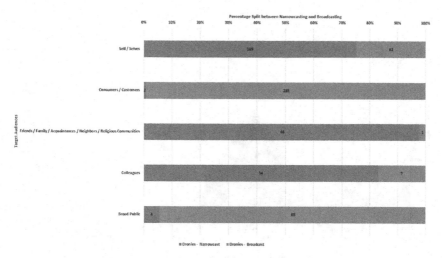

Figure 39. Macro level contrast between narrowcast and broadcast audiences for group selfies and dronies

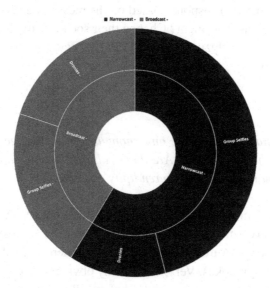

media context, this external approach to "splaining" might be concerning.) These images were coded by one person over a number of months, and broadening out the image set and coding more broadly may enhance the robustness of the results. The coding was generally conservative, to avoid overreach or reading into an image. With broadcasting, the audience is thought to have a behavioral role—an assignment or a

Figure 40. Narrowcasting vs. broadcasting to conceptual audiences

**For a more accurate representation see the electronic version.*

behavioral change or other response based on the messaging. Should the audience join up with a political movement? Change their social media behavior? Purchase a service or product? Analyzing the behavioral expectations may be a logical and analytical next step.

Anomaly(ies)

1. ***Image Anomalies:*** *Are there any anomalies in the image? What are they? What could these be about? Are there cultural or other interpretations? Or are the anomalies from mere serendipity and chance?*

What are anomalies in these image sets? What stood out? Very simply, there are rare confluences between high level conceptualizations in an image and then in the execution of that image. A majority of social images here were about documenting events and sharing light jokes. Very few had any obvious pre-concept, and of those that did, only a few were executed with aesthetically pleasing and potent results. Very few works showed a photographer's hand or signature in the work. In this coding, out of 1,997 stand-alone images (with a number of sub-images within), only about half-a-dozen to a dozen achieved this level of concept-execution integration.

In the "group selfies" image set, some images were taken of people at an outdoor yard sale, which evoked Americana in something like a "found image." A similarly-styled work showed a man reading a newspaper at a counter in a store, and this also

evoked something of a different time and mood. In the dronies image set, several individuals took photographs that capitalized on the aerial capabilities of the drone cameras. One showed a bird flying up to the camera high up, in what looked to be a serendipitous encounter. Several other drones were used to capture individuals who had climbed to the tops of skyscrapers and were holding on precariously. Several showed drones flying in formation with other drones high-up. Some used the aerial capabilities to shoot beautiful landscapes, and others showed people lying in the shapes of constructed stars (by lying spread-eagled on the ground).

One other small note about "anomalous" images. After the first "novel" one a person is exposed to, any other version becomes emulative and less visually exciting. Unless the follow-on images have some other mix of factors that create visual magic, the glow is gone. Those who would amass fame, fortune, and attention through their social imagery will need to hone their skills and develop a sensibility that is as unique as possible (while being able to transfer that to the common viewer through the medium of social photography).

Other

1. ***Miscellany:*** *Other?*

Finally, the last subsection is an open catch-all category.

DISCUSSION

This research is based on two foundational hypotheses:

Hypothesis 1: Group selfies shared on social media platforms and the Web and Internet contain informational value.

Hypothesis 2: Based on extant research and publicly available group selfies, it is possible to build and refine a tool to systematize the extraction of relevant information from group selfies.

To actualize the research, a literature review was conducted. The Categorization and Exploration of Group Selfies Instrument (CEGSI) was created and refined to aid in the analysis of captured image sets of "group selfies" and "group dronies". In this work, the author painstakingly and iteratively analyzed the image sets (over a half-year period) and offered some summary details about these sets to test Hypothesis 1, and she also simultaneously pilot-tested and refined the CEGSI tool to test Hypothesis 2. Both hypotheses were generally borne out.

It is hard to under-estimate the complexity of coding such a noisy set of images. There are no set understandings of scale (there's everything from close-ups of insects to global-level scale imagery). Images may show up multiple times, but they may be cropped very differently with different issues observed. In this work, the coding was conservative, with objects literally in-frame, before an observation may be made. Where needed, the coder worked to zoom-in and out of an image for increase clarity. Given the sizes of some of the images, though, pixelation was a challenge. The image coding work requires intimacy with the data—such as it is—and it requires a fairly high level of concentration for consistency and accuracy. If a coder has been away from the data for a week or two, there is a required period of acclimation to both the data and the target of the coding. It is wholly possible, even likely, that other coders would approach the same two image sets differently, with different extracted themes. (In this sense, a codebook and a coding "fist" may be read like a personality Rorschach of sorts.) For all the challenges, some insights about the coding process are possible. The coding work was done over multiple months and different time periods, and that meant that the coder had to re-acclimate to the coding each time she started that work again, and she found that it was easier to work on one approach for a stretch before switching to others.

It is better to use tables in which to capture themes, numbers of images, and image descriptions than a mere list. A sample generic-form table follows. It is very helpful to have screenshot thumbnails of some examples in each cell to highlight the types of imagery included, and to evoke a sense of the style, and to help with researcher memory.

For all the plodding challenges of this work, empirical data has to be collected and analyzed because these are highly informative, if queried properly. While there is a huge promise of machine vision, those capabilities are not sufficiently nuanced to enable the level of analysis in this chapter. Yet.

In the review of the literature, other researchers' works suggested two smaller hypotheses. Is it true that group selfies are captured more often by females versus males in this sample? To study this, the two datasets were coded with explicit depictions of the photographers taking the images (by holding a smartphone or mobile device,

Table 3. A sample coding table for comparative image sets and designated or emergent themes

	Image Set #1	Image Set #2
Theme #1	Number of Images Textual Descriptors of Images	Number of Images Textual Descriptors of Images
Theme #2	Number of Images Textual Descriptors of Images	Number of Images Textual Descriptors of Images

by holding a button and wire to trigger a camera, by holding a drone controller, and so on). A subject of a selfie could not be assumed to be the photographer simply because many of them are not, and there are others who are capturing their photos. What the numbers show is who is seen to be capturing an image, and it will not be 100% accurate because of various factors. For example, a model may pose as if he or she is taking a selfie, but there is a different photographer who is capturing the image with a high-end camera. Coding by gender is also a bit of an iffy business given that not all photographs capture people accurately. That said, the "group selfies" set had fairly equal gender balance in the depiction of female (52%) and male (48%) photographers, but in the "dronies" set, a majority of the photographers were male, and only 8 percent of the dronie photographers were depicted as female. For more, see the stacked bar charts in Figure 41.

Secondly, is it true that group selfies will more likely feature young people as a demographic group, as is typical of those sharing selfies in general? This latter hypothesis is borne out from this work.

FUTURE RESEARCH DIRECTIONS

Future research that builds on this work may take any of a number of tracks. One is an emulative approach with larger image sets, different socio-cultural contexts, and

Figure 41. Gender of photographers in "group selfies" and "dronies" image sets

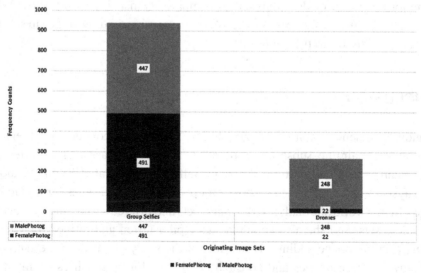

new insights. This early work enables plenty of innovations and add-on elements (and variations) to the work.

This first draft of CEGSI (Categorization and Exploration of Group Selfies Instrument) may be further pilot-tested, revised, and refined.

This initial work touched lightly on group dronies. There has not been a lot of work done on drone-captured selfies. This work proposed one systematized approach to study group selfies, but there are certainly many other effective ways to achieve this same aim. As yet, there has not been firsthand research on how group selfies originate, what it feels like to be part of one, how these may differ in various cultural contexts, how these may be datafied and informatized, and so on.

On a superficial level, selfies are "pouty face, self-congratulatory portraits that now fill Instagram and Facebook" (Marcelo, Feb. 23, 2017); they are awkward attempts at impression management, full of emulation of a few leaders. This practice of selfie sharing has been seen as inane and ego-driven. Whether the social "groupness" of group selfies mitigates that impression of individual ego expression and excessive "me-ness" is still to be seen. If the "Selfie Syndrome" is leading to generations of young people without empathy for others and to "entitled, competitive, self-centered, and individualistic" individuals (Borba, 2016, pp. xiv – xv), then what about "group selfies," which require some acknowledgment of others and mutual cooperation and maybe some shared interests? Are there constraints from peers that mitigate the extremes of individual expressions? Does the presence of others encourage people to go for less immediacy and to apply more personal filters? Are there ways to make a social "share" not something that is self-aggrandizing and other-exploitive but is an actual sharing of something worthwhile to others and other-benefitting? Is there more of a sense of actual sociality and interactions in group selfies? A sense of care for others? How do group selfies compare against singleton selfies? What are attractive features of group selfies? What are aversive features of group selfies? There are rich angles to this topic.

CONCLUSION

To study the phenomenon of "group selfies," the author conducted a literature review using mainline subscription-based academic databases. She drafted the Categorization and Exploration of Group Selfies Instrument (CEGSI) to aid in the analysis of captured image sets of "group selfies" and "dronies" from Google Images. In this work, she analyzed the image sets and offered some summary details about these sets, and she also simultaneously pilot-tested and refined the CEGSI tool, used in the image coding. At the time of the study, there was no established taxonomy for these images and no established ones for even selfies. In his work

on analyzing selfies, T. Stock and M. L. Tupot (Jan. 2014) observed that there is not yet an analyzing structure for interpreting visual data. This chapter offers an empirically designed early start.

This experience reaffirmed the benefit of using processed and raw data to inform the design and refinement of an analytical instrument. This work also showed group selfies as something of their own phenomenon, even though there are some overlapping insights that apply to both "group" and "duo" and "solo" selfies.

ACKNOWLEDGMENT

Thanks to the social media platform providers and search engine providers for making these images available for analysis. Thanks also to those whose images I've used (even though many are not directly identifiable given the descriptions). As a person who has not really engaged with much social sharing, I have felt some guilt at using such data for my own work. That said, I have worked hard to be ethical and respectful in my handling of others' images. I am hopeful that this work contributes something to the field.

REFERENCES

Borba, M. (2016). *Unselfie: Why Empathetic Kids Succeed in Our All-About-Me World*. New York: Touchstone, Simon & Schuster.

Bruno, N., Bode, C., & Bertamini, M. (2016). Composition in portraits: Selfies and wefies reveal similar biases in untrained modern youths and ancient masters. In *Laterality: Asymmetries of Body, Brain and Cognition*. Routledge: Taylor & Francis Groups. doi:10.1080/1357650X.2016.1185108

Burkett, M. (2015). Sex(t) talk: A qualitative analysis of young adults negotiations of the pleasures and perils of sexting. *Sexuality & Culture, 19*(4), 835–863. doi:10.1007/s12119-015-9295-0

CBS News. (2016, Dec. 24). Photographer Neal Slavin on what draws him to capturing group portraits. Retrieved December 25, 2016 from http://www.cbsnews.com/news/neal-slavin-40-year-chronicle-of-groups-and-gatherings-photography-portraits/

Chen, C.-F., Liu, K.-P., & Yu, N.-H. (2015, November 2-6). Exploring interaction modalities for a selfie drone. In *Proceedings of SA'15* (Posters), Kobe, Japan. doi:10.1145/2820926.2820965

Chen, Y., Mark, G., & Ali, S. (2016). Promoting positive affect through smartphone photography. *Psychology of Well-Being, 6*(8), 1–16. PMID:27441169

Dhir, A., Pallesen, S., Torsheim, T., & Andreassen, C. S. (2016). Do age and gender differences exist in selfie-related behaviours? *Computers in Human Behavior, 63*, 549–555. doi:10.1016/j.chb.2016.05.053

Dinhopl, A., & Gretzel, U. (2016). Selfie-taking as touristic looking. [Elsevier. ScienceDirect.]. *Annals of Tourism Research, 57*, 126–139. doi:10.1016/j.annals.2015.12.015

Flaherty, G.T. & Choi, J. (2016). The 'selfie' phenomenon: Reducing the risk of harm while using smartphones during international travel. *Journal of Travel Medicine.* doi:10.1093/jtm/tav026

Freitas, D. (2017). *The Happiness Effect: How Social Media is Driving a Generation to Appear Perfect at Any Cost.* New York: Oxford University Press.

Frosh, P. (2015). The gestural image: The selfie, photography theory, and kinesthetic sociability. *International Journal of Communication, 9*, 1607–1628.

Gannon, V., & Prothero, A. (2016). Beauty blogger selfies as authenticating practices. *European Journal of Marketing, 50*(9/10), 1858–1878. doi:10.1108/EJM-07-2015-0510

Georgakopoulou, A. (2016). From narrating the self to posting self(ies): A small stories approach to Selfies. *Open Linguistics, 2016*(2), 300 – 317.

Gruber-Muecke, T., & Rau, C. (2016). "Fake It or Make It" – Selfies in corporate social media campaigns. In G. Meiselwitz (Ed.), *SCSM 2016, LNCS 9742* (pp. 417–427). doi:10.1007/978-3-319-39910-2_39

Guo, Y. (2015). Constructing, presenting, and expressing self on social network sites: An exploratory study in Chinese university students' social media engagement [Thesis]. University of British Columbia.

Hai-Jew, S. (2017). Exploring identity-based humor in a #selfies #humor image set from Instagram. In S. Hai-Jew (Eds.), Techniques for Coding Imagery and Multimedia: Emerging Research and Opportunities (Ch. 1). Hershey, PA: IGI-Global.

Howard, J. (2016, July 1). Dad hilariously re-creates daughter's sexy selfies. CNN. Retrieved Dec. 28, 2016, from http://www.cnn.com/2016/06/30/health/selfie-dad-daughter-viral-photos/

Johnson, S. M., Maiullo, S., Trembley, E., Werner, C. L., & Woolsey, D. (2014). The selfie as a pedagogical tool in a college classroom. *College Teaching, 62*(4), 119–120. doi:10.1080/87567555.2014.933168

Kim, J. W., & Chock, T. M. (2016). (in press). Personality traits and psychological motivations predicting selfie posting behaviors on social networking sites. *Telematics and Informatics*.

LaFrance, A. (2014, March 25). When did group pictures become 'selfies'? The answer has more to do with language than photography. *The Atlantic*. Retrieved Dec. 26, 2016, from http://www.theatlantic.com/technology/archive/2014/03/when-did-group-pictures-become-selfies/359556/

Lu, D., & Dugan, C. (2016, February 27 – March 2). Stitched groupies: A playful self-photo co-creation activity. In *CSCW '16 Companion*, San Francisco, CA (pp. 69-72). doi:10.1145/2818052.2874327

Marcelo, P. (2017, Feb. 23). Professor has taken a selfie every day for the past 30 years. ABC News. Retrieved Feb. 23, 2017 from http://abcnews.go.com/Health/wireStory/professor-selfie-day-30-years-45678513

Monkey selfie. (2017, March 27). Wikipedia. Retrieved April 11, 2017 from https://en.wikipedia.org/wiki/Monkey_selfie

Onchi, E., Lucho, C., Sigüenza, M., & Trovato, G. (2016). Introducing IOmi—A female robot hostess for guidance in a university environment. In A. Agah et al. (Eds.), ICSR 2016, LNAI (Vol. 9979, pp. 764-773).

Reagle, J. (2015). Following the Joneses: FOMO and conspicuous sociality. *First Monday, 20*(10). Retrieved December 26 2016 from http://firstmonday.org/ojs/index.php/fm/article/view/6064/4996 doi:10.5210/fm.v20i10.6064

Rettberg, J. W. (2014). Automated diaries. In *J.W. Rettberg (Ed.), Seeing Ourselves through Technology: How We Use Selfies, Blogs and Wearable Devices to See and Shape Ourselves* (pp. 45–60). Basingstoke, New York: Martin's Press LLC.

Rettberg, J. W. (2014). Serial selfies. In *J.W. Rettberg (Ed.), Seeing Ourselves through Technology: How We Use Selfies, Blogs and Wearable Devices to See and Shape Ourselves* (pp. 33–45). Basingstoke, New York: Martin's Press LLC.

Rettberg, J. W. (2014). Written, visual and quantitative self-representations. In *J.W. Rettberg (Ed.), Seeing Ourselves through Technology: How We Use Selfies, Blogs and Wearable Devices to See and Shape Ourselves* (pp. 1–19). Basingstoke, New York: Martin's Press LLC.

Ryall, J. (2017, Feb. 16) Did Kim Jong-nam's Facebook fixation lead to his death? *The Telegraph.* Retrieved January 22, 2017 from http://www.telegraph.co.uk/news/2017/02/16/kim-jong-nams-facebook-fixation-may-have-aided-assailants/

Stock, T., & Tupot, M. L. (2014, Jan.). Analyzing Selfies: Culture Mapping the Meaning and Evolution of Selfie Shots. SlideShare. Retrieved Apr. 29, 2017 from https://www.slideshare.net/scenariodna/analyzing-selfies

Svelander, A., & Wiberg, M. (2015, July – August). The practice of selfies. *Interaction*, 35–38.

Wang, R., Yang, F., & Haigh, M. M. (2016). (in press). Let me take a selfie: Exploring the psychological effects of posting and viewing selfies and groupies on social media. *Telematics and Informatics*.

Wang, X. (2016). *Social Media in Industrial China.* London: University College London Press. Retrieved December 26, 2016 from www.ucl.ac.uk/ucl-press

Wen, J., & Ünlüer, A. (2015, November 30-December 2). Redefining the fundamentals of photography with cooperative photography. In Proceedings of the 14th International Conference on Mobile and Ubiquitous Multimedia (MUM '15), Linz, Austria (pp. 37-47). doi:10.1145/2836041.2836045

Wright, E. (2015, November). Watch the birdie: The star economy, social media and the celebrity group selfie. *Networking Knowledge*, *8*(6), 1–13.

KEY TERMS AND DEFINITIONS

Cooperative Photography: The use of a third person to help capture an image for a group (or an individual) using mobile networked devices.

Data Mining: Analyzing data for insights.

Digital Album: A collection of electronic images, often available on the Web and Internet.

Digital Timeline: An electronic timeline showing events in a time chronology.

Dronie: A selfie captured using a drone.

Group Selfie: A self-portrait of three or more people often shared on social media platforms.

Groupies: A slang term for "group selfie."

Mobile Device: A smart phone, tablet computer, or other computing device.

Selfie: A self-portrait, often using a camera in a mobile device, web cam, tripod, selfie-stick, or a selfie drone.

Selfie Stick: An extension to enable the holding of a mobile device or camera a certain distance from the body in order to capture a selfie image.

Social Performance: Actions taken by individuals and groups in order to self-present or communicate their identity to others.

Social Web: Websites enabling people to interconnect and share information, imagery, and digital contents online, and to collaborate; Web 2.0.

Web Browser Add-On: A web browser plug-in that enables additional capabilities to the browser.

Web Browser Extension: A web browser plug-in that enables additional capabilities to the browser.

Web Browser Plug-In: An add-on to a web browser that enables additional capabilities to the browser.

Web Cam: A video camera that is an input device to a computer.

Wefies: A slang term for "group selfie."

APPENDIX

Table 4. Categorization and Exploration of Group Selfies Instrument (CEGSI)

Areas of Exploration	Related Questions
	Part 1: Group Selfie Content and Context
Composition of People in the Image, Group Sociality	1. **Group Membership:** a. Who are the individuals in the image? b. What are the main appearances of the individuals in the image? c. What are the gestures, stances, facial expressions, and behaviors of the people in the group selfie? What are they collectively and individually communicating?
	2. **Group Size:** How many people's faces may be seen in the group selfie?
	3. **Demographics:** a. Are there any clear genderized features of the image? How so? b. Are there any clear age features of the image? How so? c. Are there clear class features of the image? How so? d. Other demographic features?
	4. **Individual Recognizability:** a. How far away are the group members from the image? (estimate) b. Are the individuals individually recognizable in the image? Or is the group just a mass of faces without actual individual recognizability?
	5. **Group Membership Social Dynamics:** a. How are the individuals arrayed? Is there one main person in the image supported by others (sort of the follower-with-followees dynamic, the foreground-background dynamic)? Or are all the members apparently somewhat equal in standing in the image? b. What are the respective individuals' roles in the image? c. What do the social aspects of the group selfie say about the depicted group? d. What is the apparent nature of groupness in the image? (Why are the people connected? What makes them a group, at least for a particular time period or moment?)
	6. **Member Closeness/Distance:** a. How apparently close are the members indicated in the group selfie? b. Does the group seem cohesive or not? Why or why not? c. What is the nature of their "group selfie"-ness? What is the nature of their online sociality?
	7. **Group Member Actions:** a. Are the individuals static (sitting, standing, posing in a static fashion, etc.)? Or are they in motion (walking, skating, running, dancing, etc.)? b. How much agreement is there between the expressions and mannerisms among the members of the group? Or is there misalignment? Is there convergence or divergence of actions?
Place and Time	1. **Location Type:** Is the location a "natural" space or a human built space? 2. **Time of Day or Night:** Is the image taken in daytime or nighttime? Or dawn / dusk?
Group Selfie Context(s) / Scenario(s)	1. **Image Context:** a. What is the apparent context based on the foreground? b. What is the apparent context based on the background? c. What is the apparent (inferred) context in the group selfie?

continued on following page

Table 4. Continued

Areas of Exploration	Related Questions
	2. Group Selfie Rationale: a. Are all the individuals apparently aware that they are part of a group selfie, or are there some individuals who are included in the frame but not apparently aware that they are part of a selfie? b. What is the apparent (inferred) rationale for the selfie? Is this about an event? A commemoration? A celebration? What seems to be behind the image?
	3. Non-Commercial or Commercial Purpose(s): a. Is the group selfie part of a professional messaging campaign? Commercial endeavor? Non-profit endeavor? If so, how so? b. Are there observable differences between formal group selfies and informal ones? Commercial and non-commercial ones?
	4. Meeting of Human Needs: What human need is being met by the image (if only one main need is being addressed)? Is the image about feats of daring, sociality, "brags," foodie-hood, couple-dom, or some other purpose? How can one tell?
Animals, Non-Human Agents, and Ego Representations	**1. Animals/Non-Humans:** a. Are there animals who are part of the group selfie? Any non-humans that may stand in for people? b. If there are animals or other non-human entities, do they stand in for people, or do they represent something else? c. What are some other types of "ego" or "entity" depictions?
	2. Props: Are there other props that appear in the group selfies? Visual tropes?
Group Selfie Mood(s)	**1. Moods:** a. What is the mood in the selfie image? What elements of the image convey the mood? (Setting? Lighting? Props? Others?) b. What does this mood apparently "mean"? c. If there are multiple simultaneous moods, what are these, and how are they created?
Part 2: Group Selfie Image Creation	
Group Selfie Image-taking Setup	**1. Apparent Relationship between Photographer and the Subjects:** a. Is the apparent relationship between the photographer and the subject close or distant? b. What is the relevance of this relationship between the photographer and subject?
	2. Mobile Devices and Cameras: a. How many mobile devices (cameras, mobile phones, smartphones, etc.) are in the image? (These are the ones depicted and not necessarily used to capture the particular group selfie.) b. How is the main camera used for the group selfie capture positioned?
	3. Technologies Used for the Image Capture: What technologies are apparently being used in the capture of the group selfie?
	4. Ad Hoc Image Capture or Planned Setup for the Capture: Is the image apparently taken on-the-fly or in an ad hoc way? How posed is the image? Was there a lot of setup to the image?

continued on following page

Table 4. Continued

Areas of Exploration	Related Questions
Group Selfie Image Post-Production	**1. Image Post-Production:** a. How much image post-production went into the image? Cropping? Color balance? Adding of image overlays? Addition of text? b. How sophisticated is the post-production? Why? c. Is the image in color? Is the image b/w or grayscale?
Part 3: Group Selfie Messaging	
Group Selfie Focal Point	**1. Focal Point(s) of the Image:** a. If there is a focal point to the image, what is it, and why is it the focal point? b. If there is not a focal point to the image, then how is the apparent focus spatially distributed, and why?
	2. Image Sequence: Is the image part of a sequence? If so, what does the sequence communicate in terms of focus?
	3. Visual Movement: Is there a visual movement or dynamic in the group selfie? How so?
Group Selfie Main Messaging and Submessaging	**1. Main Messaging:** a. What main message(s) is/are being communicated? Are there any apparent themes in the group selfies? How so? b. What sub-messages are being communicated? (How were these identified? What is the interpretive range of the images? How can one read point-of-view of the viewer?) c. Is the messaging apparently intentional or unintentional, advertent or inadvertent?
	2. Informational Value: What is the informational value of the group selfie? Why? What may be read from the group selfie image?
Apparent Audience(s) for the Group Selfie	**1. Main Audience(s):** a. Is the group selfie narrowcast (to a target audience) or broadcast (to a wider undefined audience)? Or both? Is there a way to tell? b. Why would these particular audiences exist for the group selfie?
Anomaly(ies)	**1. Image Anomalies:** Are there any anomalies in the image? What are they? What could these be about? Are there cultural or other interpretations? Or are the anomalies from mere serendipity and chance?
Other	**1. Miscellany:** Other?

Chapter 8
Senses of "Selfie" Around the World From Web Search Patterns Over Extended Time

Shalin Hai-Jew
Kansas State University, USA

ABSTRACT

When social phenomena and practices go viral, like "selfies," they instantiate in different locations around the world in different ways based on cultural differences, technological affordances, and other factors. When people go to search for "selfie" on Google Search, they are thinking different things as well. On Google Correlate, it is possible to identify the top correlating search terms that pattern-match the time patterns for the seeding search term. Based in this big data, these search term correlates (associated over extended time) provide a sense of the "group mind" around a particular topic.

INTRODUCTION

Selfies have undeniably been part of a global phenomenon, with people creating and posting selfies from a number of countries across the continents. The types of selfies posted, though, vary based on local cultures, and the broad senses of what selfies are varied in part based on local practices. (A perusal of selfie images from a web browser search shows some similarities but also some major differences.) One way to empirically observe what some of these senses or gists are may be acquired using the online tool, Google Correlate. Google Correlate, released in 2011, enables users to use a seeding search term (anything expressible using UTF-8, so enabling all

DOI: 10.4018/978-1-5225-3373-3.ch008

languages expressible on the Web…and not limited to one-grams but higher-sized ngrams) in order to find other search terms whose search frequency time series vary similarly (with a high r or Pearson's Correlation Coefficient) from 2003 – present. To attain the top 10 (or 20) most correlated search terms with the target term, Google Correlate compares the seeding search term's time series data with that of millions of candidate time series to find the top 20 most highly correlated time series matches.

These big data, based on logs of user searches, are anonymized, so it is not possible to use this tool to locate search patterns to a person, but these are aggregate search data that is anonymized and may be identified only to a time span and to select locations. The comparison occurs between the seeding term's time series and "the frequency time series for every query in our database" (Google Correlate Tutorial, 2011, p. 1). In these cases, the search frequencies are normalized based on the average frequency for that search term over time (either weekly or monthly) and mapping those frequencies as standard deviations from the mean for comparability across various volumes of search data.

One interesting angle is that web searches were initially thought of—by many users—as something private done in their own homes or offices. Over time, though, it became clear that search data was not only individualistic and identifiable to a person with a few data points but that such data are public albeit in a de-identified or anonymized way (Stephens-Davidowitz, 2017). The tool is designed for high precision data. Google scientists, in their white paper introducing the tool, wrote:

To further improve the precision, we take the top one thousand series from the database returned by our approximate search system (the first pass) and reorder those by doing exact correlation computation (the second pass). By combining asymmetric hashes and reordering, the system is able to achieve more than 99% precision for the top result at about 100 requests per second on O(100) machines, which is orders of magnitude faster than exact search (Mohebbi, Vanderkam, Kodysh, Schonberger, Choi, & Kumar, 2011, p. 6).

Based on the intuition that people generally search for terms when they have a particular question or a need at a particular time, the time-tested correlations based on the frequencies of web searches may be indicative of underlying in-world phenomena that may be the reason for the relatedness of the time-correlated search terms. On this tool, it is possible to click on "Show more" and acquire not only the top-10 correlations but the following 10 below as well.

Google Correlate enables access to big data, in the billions of searches ranges, and it enables access to "natural experiments" based on people's search behaviors globally (with filters for 50 countries and even greater spatial granularity, down to U.S. state levels). Google Correlate is a follow-on tool from Google Trends:

Google Trends also shows the geography of search volumes. As with the time series, the geographic data are normalized. Each number is divided by the total number of searches in an area and normalized so that the highest-scoring state has 100. If state A scores 100 and state B scores 50 in the same request, this means that the percentages of searches that included the search term was twice as high in state A as in state B. For a given plot, the darker the state in the output heat map, the higher the proportion of searches that include that term. It is not meaningful to compare states across requests, since the normalization is done separately for each request. (Stephens-Davidowitz, & Varian, 2014, p. 14)

However, as has been noted, correlations do not mean causation, and even high correlations may just be noise in big data; what this means is that sanity checks will be important based on logic, observations of empirically-arrived at small data, tests against the researcher's subjective and personal observations, and other approaches—to capture both the macro and the micro. Big data offers aggregate or summary statistics, but while comprehensive (N = all in many cases), such data is very "thin" (Christian & Griffiths, 2017, p. 191) and should not overshadow "small data" (which some term "big data in disguise") (p. 144). Other researchers have criticized the risks of "big data hubris," or "the often-implicit assumption that big data are a substitute for, rather than a supplement to, traditional data collection and analysis" (Lazer, Kennedy, King, & Vespignani, 2014, p. 1203). With big data come risks of over-confidence, misdirection, poor predictivity (of big-data derived data models), and sometimes cases of practical untestability. In terms of Google Correlate, there is no way to test results outside of Google Correlate, but Google is highly trusted as a company and as a data aggregator and as a service provider. Its data may theoretically and practically be falsifiable, assuming access to the underlying big data. The internal validity of Google Correlate findings may be tested, but it will require additional effort and other data sources to test external validity (whether the web search data itself indicates something outside or beyond the data in the world). External validity for web searches may indicate something of the public mindset or attitudes, something about public attention to certain issues. Data quantity does not enable researchers to eschew "foundational issues of measurement, construct validity and reliability, and dependencies among data" (Lazer, Kennedy, King, & Vespignani, 2014, p. 1203). For example, how researchers handle noise in big data may lead to more or less accuracy in the uses of the data.

Besides how researchers use such tools, there may be challenges with how the tools themselves function. The structure of the tool itself will lead to particular effects: "Search patterns are the result of thousands of decisions made by the company's programmers in various subunits and by millions of consumers worldwide" (Lazer, Kennedy, King, & Vespignani, 2014, p. 1207). The autocomplete feature in Google

Search may lead to higher intensities and popularizations for particular search terms over others. Search Engine Optimization (SEO) strategies may result in certain search terms used more often than others. Reengineering of tools by "blue teams" (in-house engineers) over time means that search results change over time and thus make replication of data an "open question" (Lazer, Kennedy, King, & Vespignani, 2014, p. 1208). "Red team" manipulations (such as those controlling robot networks or "botnets") may also change up results (p. 1208). The available data online, in their various digital modalities, may also drive search traffic. The modalities here include the following: text, imagery, videos, work samples, slideshows, games, simulations, and others. (Even if destinations may be identified, and they can, one cannot assume user intentionality.)

The patterning is also human-informed, of course, as indicated by the fact that Google can anticipate what people will search for and pre-sort contents up front for blisteringly fast delivery of top results to users of Google Search:

The poster child for the advantages of sorting would be an Internet search engine like Google. It seems staggering to think that Google can take the search phrase you typed in and scour the entire Internet for it in less than half a second. Well, it can't—but it doesn't need to. If you're Google, you are almost certain that (a) your data will be searched, (b) it will be searched not just once but repeatedly, and (c) the time needed to sort is somehow 'less valuable' than the time needed to search. (Here, sorting is done by machines ahead of time, before the results are needed, and searching is done by users for whom time is of the essence.) All of these factors point in favor of tremendous up-front sorting, which is indeed what Google and its fellow search engines do (Christian & Griffiths, 2017, p. 72).

To appreciate the speeds of the results, it helps to note that Google Search handles "over 3.5 billion searches per day and 1.2 trillion searches per year worldwide" ("Google Search Statistics," June 17, 2017). Also, human web search patterning may be affected by mass media (with its agenda-setting role), social networks, family and friends, and a range of other factors.

Disaggregating the various features that affect broad population-based search patterns and how much each factor affects that outcome seems fairly difficult at present. Likewise, it would be difficult to extract which factors may lead to time-based patterns that may be seen in large-scale search behaviors and time-correlated search terms with high Pearson Correlation Coefficient (or "r"). Interestingly, though, at least in terms of human-based analyses, extracting possible understandings from some of the extended time correlations does not feel intuitively difficult, and sometimes, the intuitions may be accurate. This work describes the application of

Google Correlate to better understand the similar and different senses of "selfie" in various locales around the world, based on national population-scale Google Search behaviors, writ large, as "natural experiments" based on search engine analytics. [If the Google Book Ngram Viewer is about the educated masses, then Google Search is more about the broad and inclusive public "rabble."] While the time in this tool is extended, from 2003 to the present, this enables not only lagging observations (how search patterns in the past affect the present) but also leading (and even predictive) indicators or observations since the work is updated to the present, with new information refreshed weekly (beginning on Sundays based on Pacific Standard Time or the Pacific Time Zone). Web search data that can "predict the present" (Mohebbi, Vanderkam, Kodysh, Schonberger, Choi, & Kumar, 2011, p. 2) or enable "nowcasting (broadcasting insights in near real-time for longer-lasting and continuing events) (Ross, 2013).

It may be helpful to caveat the issue. John Cheney-Lippold (2017), in addressing the roles of algorithms in people's "digital selves," writes:

Data does not naturally appear in the wild. Rather, it is collected by humans, manipulated by researchers, and ultimately massaged by theoreticians to explain a phenomenon. Who speaks for data, then, wields the extraordinary power to frame how we come to understand ourselves and our place in the world. (p. xiii)

So "selfies" are not "us" but an artifact, a construct, a social creation. A big data sense of "selfies" is a glimmer of ground truth, but only that. Duly warned, it is possible to proceed.

REVIEW OF THE LITERATURE

Web search activity has been correlated with intelligence and well-being (McDaniel, Pesta, & Gabriel, 2015). Individuals with different political leanings use Google searches in different ways (Zoorob, 2015).

For individual sharers of selfies, they may have a heightened sense of self-consciousness and awareness of the messages that they are conveying about themselves. After all, selfies are not only for the individual who is sharing the images but also for a narrowcast and broadcast audience. Recent research suggests that on social media, users have a sense of being monitored (Freitas, 2017, pp. 11 – 12), whether an audience is imaginary or real. At the micro level, users of social media may have a fairly clear on-ground sense of what is going on with their selfies. Their senses of broad-scale perceptions of selfies, at the macro level, may be less clear.

Google Correlate enables various ways for users to access Google Search data depicted over time (2003 – present, based on weekly or monthly time intervals) and space (50 countries, the U.S. states). As mentioned earlier, it is possible to using seeding search terms. It is also possible to upload a time-series dataset and to have Google Correlate find the closest search terms that are associated with the time pattern indicated in the data. (To acquire negative correlations, users of Google Correlate only have to multiple their own data by -1 to change the direction of their own numbers without changing their values, in order to acquire negative correlated search pattern data from Google Correlate. Usually, Google Correlate only outputs positive correlations based on search term frequencies over extended time data. Note that the units of measure are standard deviations above and below the mean, with the means set at 0.) It is also possible to manually draw a linegraph curve and to have Google Correlate match that based on search data.

Some Research With Google Correlate

Prior to Google Correlate's release was the seminal work based on Google Flu Trends. In the six years since Google Correlate's release (in 2011), it has been used in various research studies. Not only have many health authorities around the world taken up the initial flu trends research and applied it to their local regions, but they have evolved the techniques for heightened accuracy (Ocampo, Chunara, & Brownstein, 2013; Yang, Santillana, Brownstein, Gray, Richardson, & Kou, 2017). They have extended the related methods to surveillance of pertussis in California (Pollett, Wood, Boscardin, Bengtsson, Schwarcz, Harriman, Winter, & Rutherford, 2015), hand foot mouth disease in Asia (Cayce, Hesterman, & Bergstresser, 2014), and sexually transmitted diseases in the U.S., (Johnson, Mikati, & Mehta, 2016). among others. Some teams have studies which diseases were best suited for using Internet-based surveillance systems (and found that vector-borne and vaccine preventable diseases were best suited in their study of 64 infectious diseases) (Milinovich, Avril, Clements, Brownstein, Tong, & Hu, 2014). Also, they have also started to explore big data for non-communicable disease epidemiology. In one editorial, the authors write:

This study reports that the frequency of at least a few gastroenterological symptoms prevalent in the population can be tracked through web-based search engines with reasonable accuracy, providing a template for the utilization of open-access large datasets in the examination of variation in non-communicable disease epidemiology, thereby helping assign timely resources for efficient patient management of these diseases in inpatient and outpatient settings. Furthermore, studying the seasonal variations and geographic sources of these searches may help uncover

pathophysiologic triggers that may relate to viral outbreaks, ambient weather, and air pollution, important relationships that await validation of Google searches as surrogates of disease epidemiology. (Mansoor & Al-Kindi, 2017, pp. 562 – 563)

Such web search activity data is also used for tracking parasitic insects like bed bugs (Sentana-Lledo, Barbu, Ngo, Wu, Sethuraman, & Levy, 2016), and for animal health studies (Guernier, Milinovich, Santos, Haworth, Coleman, & Magalhaes, 2016). This tool has been used to find correlated search terms in biosurveillance research (Zhang, Arab, Cowling, & Stoto, 2014).

There are applications in the financial realm, too, such as the use of Google Correlate for finding correlated search terms to forecast or anticipate stock market volatility (Hamid & Heiden, 2015). Another looked to influences of television shows on mass moods to see if investor moods correlated with demand for stocks, and it was found that "negative mood reduces the demand for risky assets" (Lepori, 2015, p. 33). Based on web search patterns, researchers have found that a nation's income equality is correlated with heightened searches for luxury goods brand names based on Google Correlate data (Walasek & Brown, 2016). In psychology, one researcher has suggested an approach that involves "exploring small, confirming big," with Google Correlate data used as support for the (dis)confirmatory approach (Sakaluk, 2014). There are applications of web search data in the study of public awareness of environmental issues (Qin & Peng, 2014). Others have correlated particular pedestrian flows in target locations to particular search engine queries (Kostakos, Hosio, & Goncalves, 2012).

POPULAR "SELFIE" SENSES AROUND THE WORLD

There are direct and indirect ways to exploring global phenomena in the world. To understand selfies, it is totally possible to do searches with locational limitations to acquire a visual sense of selfie samples from particular regions. People may read research from the respective regions to understand what researchers are exploring and seeing. Less direct methods may include the exploration of related tags networks (networks of tags that co-occur with the target tag) from Flickr. Figure 1 shows a one-degree related tags network, with "selfie" in the center. Related thumbnail images linked to the particular tag may also be seen. The tags show general descriptors of the selfie phenomenon, with tags like the following: selfportrait (sic), mirror, self, face, reflection, and others.

Figure 2 offers a 1.5 degree related tags network from Flickr, with tags that are also somewhat related to each other.

Figure 1. "Selfie" related tags network on Flickr (1 deg.)

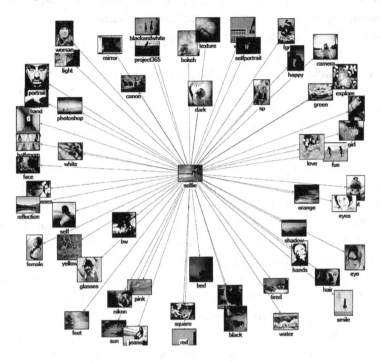

Figure 2. "Selfie" related tags network on Flickr (1.5 deg.)

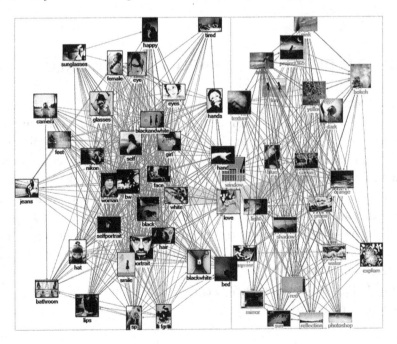

Figure 3 shows a 2-degree related tags network on Flickr based on "selfie" as a seeding term.

Looking at related folk-based tags gives an indirect sense of the image-based holdings on Flickr but also on suggested relatedness between terms. Figures 1 – 3 were created using Network Overview, Discovery and Exploration for Excel (NodeXL), an add-on to Excel.

The Targeted Data Extractions From Google Correlate

For this chapter, over fifty queries were run through Google Correlate around "selfie" (singular) as the seeding term, on May 24, 2017. This search seems to be a verbatim one and does not include the plural form ("selfies"), with the latter resulting in different correlated searches. The data was downloaded from Google Correlate and was cleaned in Notepad. Non-English terms were run through Google Translate (with auto-language identification) in order to come out with the meaning. Data visualizations were also screenshot from Google Correlate, with a few used here.

Figure 4 shows a 3D mapping feature in Excel 2016 of the included countries in this data collection.

Figure 3. "Selfie" related tags network on Flickr (2 deg.)

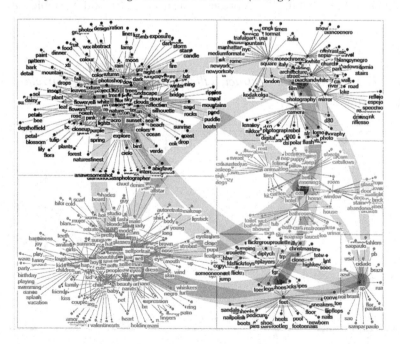

Figure 4. 3D map of included countries in the data collection

Four high-level auto extracted themes from the full 50-country set from Google Correlate include the following, in descending order: "selfie," "selfie tumblr," "clean master," and "amy anderssen." Some of the sub-themes may be seen in the subtopics areas within each high-level topics area.

Figure 6 shows a scattergraph of a high correlation between "selfie" and "селфи" (or "Sophie"). Note that the "0" represents the average for both variables, and there

Figure 5. Four top-level auto-extracted themes from the Google Correlate data set (Google Correlate)

Figure 6. Top 10 "selfie" correlations in bulgaria in a scatterplot (Google Correlate)

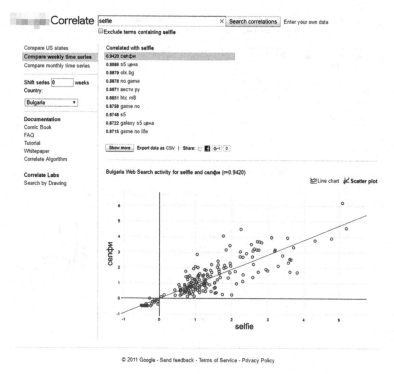

is clustering around a few standard deviations from the mean. The data here is weekly (vs. monthly).

Figure 7 shows the top 10 "selfie" correlations in terms of Google Search in Morocco. The linegraph correlation shows the association between "selfie" and "selfies" in Morocco.

At the time of these data extractions, Google Correlate enabled locational queries from the following 50 countries: Argentina, Australia, Austria, Belgium, Brazil, Bulgaria, Canada, Chile, China, Colombia, Croatia, Czech Republic, Denmark, Egypt, Finland, France, Germany, Greece, Hungary, India, Indonesia, Ireland, Israel, Italy, Japan, Malaysia, Mexico, Morocco, Netherlands, New Zealand, Norway, Peru, Philippines, Poland, Portugal, Romania, Russian Federation, Saudi Arabia, Singapore, Spain, Sweden, Switzerland, Taiwan, Thailand, Turkey, Ukraine, United Kingdom, United States, Venezuela, and Viet Nam.

Figure 9 shows the "NULL" screen for "selfie" in Italy. Five of the 50 countries sampled resulted in null values, even after multiple tries. "Null" suggests that there is insufficient information available. These include the following: Belgium, Finland, Italy, Philippines, and Viet Nam. It is possible that the users of Google Search in

Figure 7. Top 10 "selfie" correlation in Morocco in a line chart

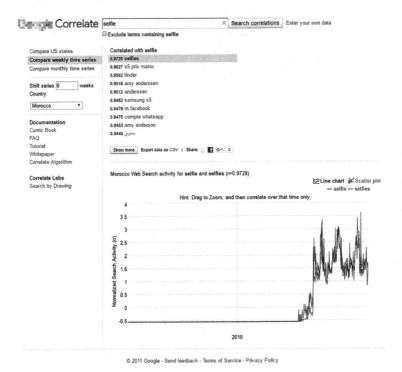

Figure 8. "Selfie" and "girls selfie" correlational searches compared in a side-by-side state map of the U.S.

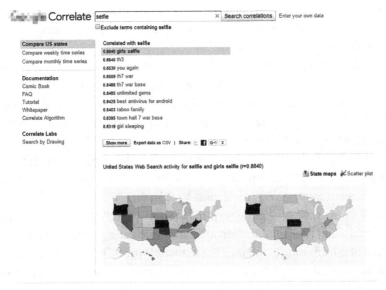

Figure 9. No responses for "selfie" correlations in Italy (among a few other countries)

these countries did not have sufficient volume to compare with other countries. It is possible that there may be other limits to the access to Google Search.

In Figure 10, a sentiment analysis of the extracted terms related to "selfie" shows generally "somewhat positive" terms.

Figure 11 shows some of the connections to "selfie" in the combined extracted "selfie" related searches on Google Search. These relationships are expressed as a word tree.

In Figure 12, one of the .csv downloads from Google Correlate is shown. The access to the normalized data enables researchers to conduct other data analytics on the data, use the data to model (including with out-of-sample testing by omitting some of the data against which to test data models), and others.

DISCUSSION

Based on this initial work, it is clear that "selfie" is conceptualized in fairly radically different ways across different locales in the popular group mind. Some countries have 4-5 different languages evoked in the top 10 search correlates with "selfie." For example, Taiwan's top-10 "selfie"-related search terms included language references to Traditional (vs. Simplified) Chinese, Korean, English, Indonesian, and Japanese. Israel's top 10 included Latin, Sindhi, Russian, and Hebrew, among others. These findings suggest something about within-country language uses and the portions

Figure 10. Sentiment of 50 countries' top 10 "selfie" correlates from Google Correlate

Figure 11. "Selfie" word tree of the 50 countries' top 10 "selfie" correlates from Google Correlate

Figure 12. Downloadable .CSV formatted data from Google Correlate

of the population on the Web and Internet…with an interest on a particular topic (selfies, in this case). Even with translation of terms, some sense of mystery remains. Language itself is polysemous. Auto translators are limited in terms of their efficacy. In virtually every case, the socio-cultural referent is unclear (at least not without further research). This work does provide leads for further exploration. While big data does not lead to the "end of theory" (Anderson, June 23, 2008), it does enable discoveries based on natural experiments in the world.

Various countries have various combinations of interests in the following selfie-related topics: smart phone technologies, brands, public figures, "how-tos," mass media, entertainment, business advertisements, and others. (A full set of the findings are available in the Appendices.) There are some intriguing patterns. In Switzerland, the search terms that co-vary with "selfie" searches on Google Search seem to be various variations on "vivofit." The author did not take these analyses further because they would have required exploration of various online social phenomena across the globe and would risk misunderstandings. The sense of gist may be partially understood in a review of the findings in the Appendices, but that is beyond the purview of this current work.

In some ways, the search-term co-varying over extended time may be based on apparent observable relationships: concept similarity, search term composites (elements that make up a larger umbrella term), multiple related instantiations of "selfie," and others.

FUTURE RESEARCH DIRECTIONS

Using Google Correlate involves a low cost-of-entry, requiring only Internet access and basic understandings of statistics. What users get is access to truly anonymized big data that may be used to answer complex questions. This tool may be used in a complementary way to understand in-world phenomena.

The potentials of the tools may be magnified with the uses of original time-series data and the ability to identify both positive correlations and negative correlations with particular searches on Google Search through Google Correlate. Google Correlate may be used to triangulate data, to support or fail to support findings from other related research.

This is not to say that it is clear how much of the search terms are a product of "blue team" effects (how engineers and data scientists are changing up the tools' functionalities, especially across multiple spaces—from converged news to analytics to search engines to online correlation tools). The design of algorithms—their selection, their filtering, their thresholds, their categorizable—and the effects of machine learning (with black box insights) all have hidden effects. (A simple test is to use different web search engines for singular terms with highly variant results, not only numerically but in terms of top-level results. Online social data are off true, but discerning how to measure this requires going to other similar tools and running comparisons that may not be comparable, given the lack of transparency about algorithms and data cleaning and other internal data company processes.) There are "red team" effects of those who are trying to manipulate advertising, popularity, virality, and election results. Then, too, there are effects from mass media, human events, social networks, and other factors. Is Google Correlate shedding light about how people become aware of issues? How they think? How they are sparked by in-world events to explore further? What explains locational differences between people and how they think and pursue information? What sorts of events are sufficiently big to enable the observation of close mirroring of search intensities over extended time? Whose voices are being included, and whose are not?

As with any tool, there is not only what is findable with a tool but also what is not findable. There are some queries which are not honored, and these include "queries with a low correlation value (less than $r = 0.6$), misspelled queries, pornographic queries, rare queries (and) queries which only correlate with a small portion of the time series" (Google Correlate Tutorial, 2011, p. 8). Beyond these limits, those correlations that are sporadic or short-term will not be captured. That said, there is broad potential for fresh research and insights through the harnessing of Google Correlate.

CONCLUSION

To summarize, this work shows that the top ten search term correlates that align with the frequency of search queries for "selfie" on Google Search differ based on different locations (by nation and by state) in terms of Google Correlate data. As for indirect ways of understanding "selfie," based on time, based on geography, there may be other approaches to capture this sense as well—through direct social imagery, through sentiment analysis of big structured and unstructured data, and other means. This work contributes a small insight, across part (50) of the countries in the world, using an engaging big data tool, Google Correlate.

ACKNOWLEDGMENT

Thanks to Alphabet, Inc., the makers of Google Correlate, without which none of this work would be possible. It still astounds me what is broadly publicly possible for the curious.

REFERENCES

Anderson, C. (2008, June 23). The end of theory: The data deluge makes the scientific method obsolete. *Wired Magazine*. Retrieved June 19, 2017, from https://www.wired.com/2008/06/pb-theory/

Cayce, R. Hesterman, K., & Bergstresser, P. (2014). Google technology in the surveillance of hand foot mouth disease in Asia. *International Journal of Integrative Pediatrics and Environmental Medicine*, 1, 27 – 35.

Cheney-Lippold, J. (2017). *We Are Data: Algorithms and the Making of Our Digital Selves*. New York: New York University Press.

Christian, B., & Griffiths, T. (2017). *Algorithms to Live By: The Computer Science of Human Decisions*. New York: Henry Holt and Company.

Data Source: Google Correlate." Google, Inc. Retrieved May 25, 2017, from http://www.google.com/trends/correlate)

Freitas, D. (2017). *The Happiness Effect: How Social Media is Driving a Generation to Appear Perfect at Any Cost*. New York: Oxford University Press.

Google Correlate Tutorial. (2011). Google, Inc. Retrieved June 11, 2017, from https://www.google.com/trends/correlate/tutorial

Google Search Statistics. (2017, June 17). Retrieved June 17, 2017, from http://www.internetlivestats.com/google-search-statistics/

Guernier, V., Milinovich, G. J., Santos, M. A. B., Haworth, M., Coleman, G., & Magalhaes, R. J. S. (2016). Use of big data in the surveillance of veterinary diseases: Early detection of tick paralysis in companion animals. *Parasites & Vectors*, *9*(303), 1–10. PMID:27215214

Hamid, A., & Heiden, M. (2015). Forecasting volatility with empirical similarity and Google Trends. *Journal of Economic Behavior & Organization*, *117*, 62–81. doi:10.1016/j.jebo.2015.06.005

Johnson, A. K., Mikati, T., & Mehta, S. D. (2016). Examining the themes of STD-related Internet searches to increase specificity of disease forecasting using Internet search terms. *Scientific Reports*, *6*(36503), 1–8. PMID:27827386

Kostakos, V., Hosio, S., & Goncalves, J. (2012). Correlating pedestrian flows and search engine queries. *PLoS ONE*, *8*(5), e63980. Retrieved June 14 2017 from https://arxiv.org/abs/1206.4206 doi:10.1371/journal.pone.0063980 PMID:23704964

Lazer, D., Kennedy, R., King, G., & Vespignani, A. (2014). The Parable of Google Flu: Traps in Big Data Analysis. *Science,* *343*(6176), 1203–1205. Retrieved March 29, 2017, from http://nrs.harvard.edu/urn-3:HUL.InstRepos:12016836

Lepori, G. M. (2015). Investor mood and demand for stocks: Evidence from popular TV series finales. *Journal of Economic Psychology*, *48*, 33–47. doi:10.1016/j.joep.2015.02.003

Mansoor, E., & Al-Kindi, S. G. (2017). The premise and promise of big data for tracking population health: Big deal or big disappointment? *Digestive Diseases and Sciences*, *62*(3), 562–563. doi:10.1007/s10620-017-4458-5 PMID:28108892

McDaniel, M. A., Pesta, B. J., & Gabriel, A. S. (2015). Big data and the well-being nexus: Tracking Google search activity by state IQ. *Intelligence*, *50*, 21–29. doi:10.1016/j.intell.2015.01.001

Milinovich, G. J., Avril, S. M. R., Clements, A. C. A., Brownstein, J. S., Tong, S., & Hu, W. (2014). Using internet search queries for infectious disease surveillance: Screening diseases for suitability. *BMC Infectious Diseases*, *14*(690), 1–9. PMID:25551277

Mohebbi, M., Vanderkam, D., Kodysh, J., Schonberger, R., Hyunyoung, C., & Kumar, S. (2011, June 9). Google Correlate Whitepaper. Google. Retrieved May 25, 2017, from https://www.google.com/trends/correlate/whitepaper.pdf

Ocampo, A. J., Chunara, R., & Brownstein, J. S. (2013). Using search queries for malaria surveillance, Thailand. *Malaria Journal, 12*(390), 1–6. PMID:24188069

Pollett, S., Wood, N., Boscardin, W.J., Bengtsson, H., Schwarcz, S., Harriman, K., Winter, K., & Rutherford, G. (2015). Validating the use of Google Trends to enhance pertussis surveillance in California. *PLoS Currents, 1*(7).

Qin, J., & Peng, T.-Q. (2014). Googling environmental issues: Web search queries as a measurement of public attention on environmental issues. *Internet Research, 26*(1), 57–73. doi:10.1108/IntR-04-2014-0104

Ross, A. (2013). Nowcasting with Google Trends: A keyword selection method. *Fraser of Allander Economic Commentary, 37*(2), 54–64.

Sakaluk, J. K. (2014). *Exploring Small, Confirming Big*: An Alternative System to *The New Statistics* for Advancing Cumulative and Replicable Psychological Research. *Journal of Experimental Social Psychology, 66*, 47–54. Retrieved June 14 2017 from http://johnsakaluk.com/wp-content/uploads/2014/06/Sakaluk_2015_JESP.pdf doi:10.1016/j.jesp.2015.09.013

Sentana-Lledo, D., Barbu, C. M., Ngo, M. N., Wu, Y., Sethuraman, K., & Levy, M. Z. (2016). Seasons, searches, and intentions: What the Internet can tell us about the bed bug (hemipteran: Cimicidae) epidemic. *Journal of Medical Entomology, 53*(1), 116–121. doi:10.1093/jme/tjv158 PMID:26474879

Stephens-Davidowitz, S. (2017). *Everybody Lies: Big Data, New Data, and What the Internet Can Tell Us About Who We Really Are*. New York: Day St., HarperCollins Publishers.

Stephens-Davidowitz, S., & Varian, H. (2014). A hands-on guide to Google data. Retrieved May 28, 2017, from http://people.ischool.berkeley.edu/~hal/Papers/2015/primer.pdf

Walasek, L., & Brown, G. D. A. (2016). Income inequality, income, and Internet searches for status goods: A cross-national study of the association between inequality and well-being. *Social Indicators Research, 129*(3), 1001–1014. doi:10.1007/s11205-015-1158-4 PMID:27881892

Yang, S., Santillana, M., Brownstein, J. S., Gray, J., Richardson, S., & Kou, S. C. (2017). Using electronic health records and Internet search information for accurate influenza forecasting. *BMC Infectious Diseases, 17*(332), 1–9. PMID:28482810

Zhang, Y., Arab, A., Cowling, B. J., & Stoto, M. A. (2014). Characterizing influenza surveillance systems performance: Application of a Bayesian hierarchical statistical model to Hong Kong surveillance data. *BMC Public Health, 14*(850), 1–18. Retrieved June 14, 2017 from http://www.biomedcentral.com/1471-2458/14/850 PMID:25127906

Zoorob, M. (2015). Soul searching? State-level search term correlates of political behavior. *Intersect, 8*(2), 1–21.

ADDITIONAL READING

Cheney-Lippold, J. (2017). *We Are Data: Algorithms and the Making of Our Digital Selves*. New York: New York University Press.

Google, Inc. (n. d.). Data Source: Google Correlate. Retrieved May 25, 2017, from http://www.google.com/trends/correlate)

Stephens-Davidowitz, S. (2017). *Everybody Lies: Big Data, New Data, and What the Internet Can Tell Us About Who We Really Are*. New York: Day St., HarperCollins Publishers.

Stephens-Davidowitz, S., & Varian, H. (2014). A hands-on guide to Google data. Retrieved May 28, 2017, from http://people.ischool.berkeley.edu/~hal/Papers/2015/primer.pdf

KEY TERMS AND DEFINITIONS

Cooperative Reputation: The widespread public impression of a person's tendency to work collaboratively with others.

Direct Reciprocity: The direct return of a favor by another as positive reciprocity and the return of a harm by another harm as negative reciprocity.

Followback: The suggestion that if a social media account formally follows another account that that followed account will reciprocate.

Followee: A social media account being formally followed by another social media account.

Follower: A social media account (and the animating person or group behind it) that officially "follows" another social media account; this action is seen as an affirmation of the followed account and its representatives.

Google Correlate: An online tool that enables access to Google Search data patterns over time (from 2003 to the present) and selected geographical locations (selected nations, U.S. states).

Group Selfie: Self-portraits of three or more individuals.

Indirect Reciprocity: The returning in kind of a positive action with the idea that the contributing individual will be repaid in kind in another context (downstream reciprocity) and the receiver of the positive action will be more likely in the future to bestow a favor on another in another context (upstream reciprocity).

Selfie: A self-portrait that is often captured with a mobile device or smartphone and shared on social media platforms.

Sentiment Analysis: The labeling of human feelings of positivity or negativity based on their self-created writing, photos, videos, and other digital artifacts.

Social Media Platform: Any of a number of sites and applications that enable people to create profiles, communicate with others, share and acquire user-generated and other-generated digital resources, and other activities.

Time-Series Data: Data based in time intervals and sequences.

Web Search: The use of target text-based terms via a web browser to locate digital resources of interest.

APPENDIX

In this section, the available raw data for "selfie" co-occurrences from Google Correlate follow, in alphabetical order. Five of the 50 countries had NULL data even after multiple tries, and those (Belgium, Finland, Italy, Philippines, and Viet Nam) are reflected as well. None of the original characters were translated to English here. (In the data analytics approaches earlier, the translations were done for more effective analytics.)

Top 10 Correlations Between the "Selfie" Search Time Trajectory and Other Search Terms on Google Search from 2003-Present (Google Correlate)

Table 1. Argentina

Argentina	
0.9588	selfie tumblr
0.957	ssundee
0.9545	wd my cloud
0.9534	alina li
0.953	my cloud
0.9527	royal games
0.952	5s 16gb
0.9517	iphone 5s 16gb
0.9513	for princess
0.9498	luxury for princess

Table 2. Australia

Australia	
0.9284	snapchat names
0.9229	d6200
0.9227	kunara
0.9206	netgear d6200
0.9182	selfie meme
0.9103	how to take a selfie
0.9099	instagram bio
0.9087	snapchat users
0.9085	best snapchat
0.9074	fshn

Table 3. Austria

Austria	
0.9716	selfies
0.9562	naruto loads
0.9533	polar v800
0.9457	server 2014
0.9447	lolskill
0.943	natürlich sicher
0.9415	urlaubshamster
0.9409	selfie tumblr
0.94	fairy tail tube
0.9396	aternos

Table 4. Belgium

Belgium	
NULL	NULL
NULL	NULL
NULL	NULL
NULL	NULL
NULL	NULL
NULL	NULL
NULL	NULL
NULL	NULL
NULL	NULL
NULL	NULL

Table 5. Brazil

Brazil	
0.9396	selfies
0.9343	technic launcher pirata
0.9333	selfe
0.9319	abrir câmera
0.929	launcher pirata
0.9264	abrir lanterna
0.9238	tiny tunes
0.9231	selvie
0.9228	me chama no whatsapp
0.9223	download technic launcher

Table 6. Bulgaria

Bulgaria		
0.942	селфи	Sophie
0.8886	s5 цена	5 price
0.8879	olx.bg	
0.8878	no game	
0.8871	вести ру	news py
0.8851	htc m8	
0.8758	game no	
0.8748	s5	
0.8722	galaxy s5 цена	price
0.8715	game no life	

Table 7. Canada

Canada	
0.9447	selfie pics
0.9347	selfies
0.9291	selfie tumblr
0.9287	selfie pic
0.9221	guy selfie
0.9215	blueshore financial
0.9213	selfie meme
0.9211	hot selfie
0.9208	vapor jedi
0.9206	blueshore

Table 8. Chile

Chile	
0.9684	selfies
0.9445	el moto
0.9412	estados para whatsapp
0.9392	el moto g
0.938	batallas de rap
0.9343	al moto
0.934	frikismo
0.9327	moto g
0.9324	phantom 2
0.9314	rap del frikismo

Table 9. China

China	
0.9444	korea
0.9361	episode
0.9299	blue
0.9282	part
0.9266	full
0.9262	drag
0.9262	lee
0.9261	king
0.9253	play store
0.9247	main

Table 10. Colombia

Colombia	
0.9415	4.4.2
0.9389	selfies
0.9357	espaebook
0.9356	niño rata
0.9353	anderssen
0.9346	amy anderssen
0.9287	www.etib.com.co
0.9286	suma sas
0.928	besame cali
0.9259	190.168.o.1

Table 11. Croatia

Croatia		
0.9573	selfies	
0.9472	enter zagreb	
0.936	zevalo	bar
0.9354	fake hospital	
0.9303	amy anderssen	
0.93	anderssen	
0.9234	promo smart	
0.9224e	mirovinsko	pension
0.9219	clean master	
0.9215	gahe	

Table 12. Czech Republic

Czech Republic	
0.9351	selfies
0.9332	clean master
0.9318	bruxx
0.9254	u nás na kopečku
0.9247	mc titan
0.9238	hpd
0.9232	gh4
0.9226	shaman deck
0.9217	fake hospital
0.9212	protiproud

Table 13. Denmark

Denmark		
0.8769	horsens	
0.8725	zwei grosse	two grams
0.8714	odder	otter
0.87	hsfo	
0.869	horsens bibliotek	horsens library
0.8689	det glade vanvid	that happy frenzy
0.8654	apotek århus	pharmacy annual house
0.8651	esbjerg	
0.8633	aarhus	
0.8609	horsens folkeblad	

Table 14. Egypt

Egypt	
0.9551	7262
0.9543	gt-s7262
0.9524	oberland
0.9504	چنوس‌ماس
0.9504	چنوس‌ماس
0.9502	berner oberland
0.9478	thun
0.947	selfies
0.9468	4.4.2
0.9466	c2305

Table 15. Finland

Finland	
NULL	NULL
NULL	NULL
NULL	NULL
NULL	NULL
NULL	NULL
NULL	NULL
NULL	NULL
NULL	NULL
NULL	NULL
NULL	NULL

Table 16. France

France	
0.9628	photo selfie
0.948	0em10
0.9478	favorite list
0.9474	omd em10
0.9467	fake hospital
0.9443	francexe
0.944	faire un selfie
0.9437	decathlon easy
0.9415	squeezie
0.9409	foxi di

Table 17. Germany

Germany	
0.9763	selfies
0.9732	selfie tumblr
0.9714	tarotpolis
0.9714	olympus om-d e-m10
0.9695	om-d e-m10
0.9682	foxy di
0.9671	e-m10
0.9663	selfie girl
0.966	hot selfie
0.9654	monkey bar

Table 18. Greece

Greece		
0.9567	selfies	
0.9429	mt 7	
0.9416	yamaha mt 7	
0.9366	fake hospital	
0.933	σελφιε	slime
0.9328	mobogenie	
0.9314	captainpanez	
0.9297	stoessel	
0.9293	phantom 2	
0.9263	ava taylor	

Table 19. Hungary

Hungary		
0.9494	osm	
0.9332	s5 ár	s5 price
0.9266	lolskill	
0.9245	selfies	
0.9243	bizalmi vagyonkezelés	trust property management
0.924	0htc m8	
0.9236	foxy di	
0.9211	spinnin records	
0.921	csakfoci	
0.9181	am1	

Table 20. India

India	
0.9876	whatsapp hindi
0.9848	whatsapp attitude status
0.9845	whatsapp attitude
0.9843	hindi whatsapp
0.9836	whatsapp sad status
0.9834	top 30 song
0.983	whatsapp images
0.9828	whatsapp in hindi
0.9827	my kutty
0.9826	app number

Table 21. Indonesia

Indonesia	
0.9805	e1272
0.9787	harga lcd advan
0.978	gt e1272
0.9778	lcd advan
0.9769	g7102
0.9768	needrom
0.9766	oppo r831
0.9764	samsung e1272
0.9762	mod apk download
0.9761	color os

Table 22. Ireland

Ireland	
0.911	selfies
0.8919	a selfie
0.8599	selfie tumblr
0.8527	stampy
0.8524	forest avenue
0.8466	yify tv
0.8442	sofia the first youtube
0.8435	does tinder work
0.8429	complete save
0.8419	minecraft games

Table 23. Israel

Israel		
0.8154	רטיל	liter
0.7638	זומיא	coaching
0.7538	quad core	
0.7363	קלאב50	Club 50
0.7314	themarker	
0.7279	الجرس	the bell
0.7269	بكرم	roller
0.7258	alluc	alluc
0.7249	عدنان ولين	adnan merger
0.7242	клаб	Club

Table 24. Italy

Italy	
NULL	NULL
NULL	NULL
NULL	NULL
NULL	NULL
NULL	NULL
NULL	NULL
NULL	NULL
NULL	NULL
NULL	NULL
NULL	NULL

Table 25. Japan

Japan		
0.9666	めぐた	mega
0.9659	すろぱちくえすと	strawberry
0.9645	モモん	Momo
0.9639	ロドスト	Rodst
0.9635	ライン qr	Line qr
0.9628	えっくすび	Echizuki
0.9626	javpop	
0.9624	dlmm	
0.9624	ライン qr コード	line qr code
0.9623	すろぱち	squirrel

Table 26. Malaysia

Malaysia	
0.9619	yify tv
0.9572	anderssen
0.9566	amy anderssen
0.9523	selfies
0.9478	my lenovo
0.9477	directd
0.9465	clean master
0.9451	passport ultra
0.945	my cloud
0.9445	tab lenovo

Table 27. Mexico

Mexico		
0.9826	blu dash	
0.9799	para whatsapp	for whatsapp
0.9795	fotos para whatsapp	photos for whatsapp
0.9786	quitar icloud	remove icloud
0.9786	anna y elsa	Anna and Elsa
0.9772	supersu	super your
0.9772	videos peppa	
0.9767	clean master	
0.9767	imagenes para whatsapp	images for whatsapp
0.9766	vipergirls	

Table 28. Morocco

Morocco	
0.9728	selfie
0.9544	s5 prix maroc
0.9532	tinder
0.9528	amy anderssen
0.9523	anderssen
0.9522	tubidy
0.9501	samsung s5
0.9486	street workout
0.9478	cawalisse
0.9474	m.facebook

Table 29. Netherlands

Netherlands	
0.9261	selfie
0.9104	18260
0.9073	hardstone
0.9066	ssundee
0.8969	snapchats
0.8959	ulub
0.8954	amy anderssen
0.8941	panasonic gh4
0.8925	primewire
0.8923	r7 250

Table 30. New Zealand

New Zealand	
0.9646	minecraft songs
0.9627	operative bank
0.9619	co operative bank
0.9602	beeg
0.9595	co operative bank
0.9566	youtube full
0.9557	minecraft games
0.9531	eur to usd
0.9531	dotabuff
0.9513	kik

Table 31. Norway

Norway	
0.954	faketaxi
0.9524	fake taxi
0.9485	selfie
0.9465	alina li
0.9442	anysex
0.9439	likuoo
0.9398	hearthstone
0.9395	snapchat users
0.9395	fake agent
0.9393	e cig

Table 32. Peru

Peru	
0.9677	peppa pig
0.9677	pig
0.9623	kmspico
0.9598	de peppa pig
0.9591	olx
0.9583	minecraft de
0.958	ator
0.9575	pc mega
0.9563	link mega
0.9562	banana kong

Table 33. Philippines

Philippines	
NULL	NULL
NULL	NULL
NULL	NULL
NULL	NULL
NULL	NULL
NULL	NULL
NULL	NULL
NULL	NULL
NULL	NULL
NULL	NULL

Table 34. Poland

Poland	
0.9657	wp.compl
0.9585	g350
0.9578	fangol
0.9567	vox fm
0.9547	needrom
0.9537	google.compl
0.9537	pandamoney
0.9534	c1905
0.9505	składanka disco polo
0.9504	love mei

Table 35. Portugal

Portugal	
0.9418	fotor
0.9379	selfie
0.9344	farm heroes
0.9324	wattpad
0.9294	jhene
0.9292	jhene aiko
0.9285	fake hospital
0.9283	lolskill
0.9257	easy urbanos
0.9252	videos de gta 5

Table 36. Romania

Romania	
0.9642	of clans
0.9641	clash of clans
0.9624	clans
0.961	clean master
0.961	klubmusic
0.9604	fishao
0.9598	adblock
0.9582	mob.org
0.958	osm
0.9563	lolskill

Table 37. Russian Federation

Russian Federation		
0.9093	смайл дог	Smile Dog
0.9075	самсунг галакси s5	Samsung Galaxy s5
0.9073	инотв	Innocent
0.9066	клаустрофобия	Klaustrofobiya
0.9064	говорит украина	Says ukraine
0.9054	галакси s5	Galaxy s5
0.9054	spizoo	
0.9047	дом 2 вконтакте	House 2 vkontakte
0.9031	жорик ревазов	Zhorik revazov
0.9016	смотреть	Sofia Series

Table 38. Saudi Arabia

Saudi Arabia		
0.9591	selfies	
0.9496	ن**	N**
0.9487	اطفال انستقرام	Kids
0.9484	instax	
0.9477	ارسيس	Arsis
0.9473	mini 8	
0.9471	instax mini	
0.9456	بنات انستقرام	Girls are getting ready
0.9438	سناب برنامج	Snape program
0.9437	clean master	

Table 39. Singapore

Singapore	
0.9547	artistry café
0.9535	iope
0.9524	the panic room
0.9515	lola café
0.9506	21 on rajah
0.9504	wd my cloud
0.9493	yify tv
0.944	my cloud
0.9439	gopro accessories
0.9438	anysex

Table 40. Spain

Spain		
0.9552	selfies	
0.9364	fishao	
0.9348	espaebook	
0.9345	hacer un selfie	do a selfie
0.9313	hilito	
0.9311	c1905	
0.9286	phantom 2	
0.9286	fotos selfie	
0.9286	d802	
0.9281	vegetta777 y willyrex	vegetta777 and willyrex

Table 41. Sweden

Sweden	
0.9647	selfies
0.9466	iran021
0.9456	selfie tumblr
0.9453	alina li
0.9448	likuoo
0.9447	makeriet
0.9407	h440
0.9386	travmasen
0.9385	my cloud
0.9382	samsung s5

Table 42. Switzerland

Switzerland	
0.936	naruto loads
0.9321	polar v800
0.9288	vivofit
0.9258	selfie tumblr
0.9249	garmin vivofit
0.9233	samsung s5
0.9218	gh4
0.9209	r7000
0.9182	squeezie
0.9179	or nah

Table 43. Taiwan

Taiwan		
0.9229	美劇 app	U.S. drama app
0.9177	網易 雲	Netease cloud
0.9155	信箱 忘記 密碼	Forgot your password
0.914	暖 男	Warm man
0.9138	打鐵 歌詞	Blacksmith lyrics
0.9117	酒 酒井	Sakai Sake
0.9105	kurs rupiah	Rupiah exchange rate
0.9102	店 到 店 運費	shop to shop freight
0.9094	okay google	
0.9091	屏 東 韓式	Pingtung Korean style

Table 44. Thailand

Thailand		
0.9606	ซัม ซุง แก รน 1	Samsung Gran Turismo 1
0.9504	แก รน 1	Gran 1
0.9491	เพลง let her go	Music let her go
0.9487	grand 1	
0.944	ฟิล์ม ถนอม สายตา	eye care film
0.9436	oppo r831	
0.9432	acer z150	
0.943	r831	
0.943	asus k450l	
0.9421	demons แปล	demons to translate

Table 45. Turkey

Turkey		
0.9459	selfie	
0.937	çatı kati akor	rooftop chord
0.928	cunning single lady	
0.9276	cunning	
0.9256	smash hit	
0.9248	ittir git	fly git
0.9212	viking 2.sezon	
0.9163	indila danse	Indila dance
0.9138	arif kurt gardaş	arif wolf gardash
0.9131	the century	

Table 46. Ukraine

Ukraine		
0.9202	селфи	Sophie
0.9192	lenov.ru	
0.9177	лрн	Irn
0.9159	server 2014	
0.9152	олег брейн	Oleg brain
0.9141	принцесса софия	Princess Sofia
0.9134	смайлик вк	Smiley face
0.913	0александр роджерс	Alexander Rodgers
0.9115	кредит 365	Credit 365
0.9114	needrom	

Table 47. United Kingdom

United Kingdom	
0.9369	funny selfie
0.936	the selfie
0.9301	selfie meme
0.9266	selfies
0.9241	selfie.
0.9229	good selfie
0.92	take a good selfie
0.9174	how to take a good selfie
0.9165	chromeca chrome
0.9156	selfie pics

Table 48. United States

United States	
0.9645	selfie
0.9608	selfie pic
0.9461	blonde selfie
0.9384	aelfie
0.9323	selfie pics
0.9282	selfies
0.9261	selfie meme
0.9256	selfie pictures
0.9235	take selfie
0.9224	selfie picture

Table 49. Venezuela

Venezuela	
0.9568	huawei p6
0.9506	htc m8
0.945	let her go letra
0.9446	un selfie
0.9436	garrix
0.9436	martin garrix
0.9435	farm heroes
0.9398	mods de vegetta777
0.9388	p6
0.9387	amy anderssen

Table 50. Vietnam

Viet Nam	
NULL	NULL
NULL	NULL
NULL	NULL
NULL	NULL
NULL	NULL
NULL	NULL
NULL	NULL
NULL	NULL
NULL	NULL
NULL	NULL

Compilation of References

Ackerman, R. A., Witt, E. A., Donnellan, M. B., Trzesniewski, K. H., Robins, R. W., & Kashy, D. A. (2011). What does the Narcissistic Personality Inventory really measure? *Assessment, 18*(1), 67–87. doi:10.1177/1073191110382845 PMID:20876550

Aggarwal, S., Rai, S., Jaiswal, M. P., & Sorensen, H. (2016). Norm of reciprocity—antecedent of trustworthiness in social media. In *IFIP International Federation for Information Processing* (pp. 411–418). Springer International Publishing. doi:10.1007/978-3-319-45234-0_37

Ajzen, I. (2005). *Attitudes, personality, and behavior* (2nd ed.). New York: Open University Press.

Aksan, D. (2008). *Türkçeye yansıyan Türk kültürü*. İstanbul: Bilgi Yayınları.

American Psychiatric Association (APA). (2013). *Diagnostic and Statistical Manual of Mental Disorders* (5th ed.). Washington, DC: Author.

Anderson, C. (2008, June 23). The end of theory: The data deluge makes the scientific method obsolete. *Wired Magazine.* Retrieved June 19, 2017, from https://www.wired.com/2008/06/pb-theory/

Anık, C. & Soncu, A. (2011). Kültür, medeniyet ve modernizm üzerine "yaprak dökümü" bağlamında bir değerlendirme. *Global Media Journal, 2,* 52-83.

Ashton, M. C., Lee, K., & Paunonen, S. V. (2002). What is the central feature of extraversion? Social attention versus reward sensitivity. *Journal of Personality and Social Psychology, 83*(1), 245–252. doi:10.1037/0022-3514.83.1.245 PMID:12088129

Axelrod, R. (1981, June). The emergence of cooperation among egoists. *The American Political Science Review, 72*(5), 306–318. Retrieved June 19 2017 from http://www.jstor.org/stable/1961366 doi:10.2307/1961366

Back, M. D., Schmukle, S. C., & Egloff, B. (2010). Why are narcissists so charming at first sight? Decoding the narcissism–popularity link at zero acquaintance. *Journal of Personality and Social Psychology, 98*(1), 132–145. doi:10.1037/a0016338 PMID:20053038

Baron, N. (2005). The future of written culture envisioning language in the new millennium. *Journal of the European Association of Languages for Specific Purposes, 9,* 7–31.

Barresi, J. (2012). On seeing ourselves and others as persons. *New Ideas in Psychology, 30*(1), 120–130. doi:10.1016/j.newideapsych.2009.11.003

Barry, C. T., Doucette, H., Loflin, D. C., Rivera-Hudson, N., & Herrington, L. L. (2017). Let me take a selfie: Associations between self-photography, narcissism, and self-esteem. *Psychology of Popular Media Culture, 6*(1), 48–60. doi:10.1037/ppm0000089

Bartky, S. (1990). *Femininity and Domination: Studies in the Phenomenology of Oppression.* New York: Routledge.

Barutçu, S., & Tomaş, M. (2013). Sürdürülebilir sosyal medya pazarlaması ve sosyal medya pazarlaması etkinliğinin ölçümü. *Journal of Internet Applications & Management, 4*(1), 6–23.

Batuş, G. (2007). Sözlü kültürden kitle kültürüne geçiş sürecine direnen değerler. Retrieved from: http://cim. anadolu. edu.tr/pdf/2004/1130853303.pdf

Baumeister, R. F., & Leary, M. R. (1995). The need to belong: Desire for interpersonal attachments as a fundamental human motivation. *Journal of Personality and Social Psychology, 117*, 497–529. PMID:7777651

Bazin, A. (2005). *What is Cinema?* (Vol. I). Berkeley and Los Angeles, CA: University of California Press.

BBC. (2016, May 18). Muslim woman's cheeky selfie with anti-Islam group goes viral, Anisa Subedar. Retrieved from http://www.bbc.com/news/blogs-trending-36323123

Behrendt, R.-P. (2015). *Narcissism and the Self.* Hampshire, UK: Palgrave Macmillan. doi:10.1057/9781137491480

Bennett, A. (2013), Kültür ve gündelik hayat. Nagehan Tokdoğan, Burcu Şenel, Unut Yener Kara (çev.), Ankara: Phoenix.

Bennett, J. (2014). With Some Selfies, the Uglier the Better. *NY Times.* Retrieved February 7, 2017, from https://www.nytimes.com/2014/02/23/fashion/selfies-the-uglier-the-better-technology.html

Bennett, S. (2014, July 20). A brief history of the #selfie (1839–2014). *Mediabistro.* Retrieved from http://www.mediabistro.com/alltwitter/first-ever-selfie-historyb58436

Bergman, S. M., Fearrington, M. E., Davenport, S. W., & Bergman, J. Z. (2011). Millennials, narcissism, and social networking: What narcissists do on social networks and why. *Personality and Individual Differences, 50*(5), 706–711. doi:10.1016/j.paid.2010.12.022

Berry, B. (2007). *Beauty Bias: Discrimination and Social Power.* Westport, CT: Praeger.

Bingham, J. (2015). How long those "spontaneous" selfies really take. *Telegraph.* Retrieved January 26, 2017, from http://www.telegraph.co.uk/women/womens-life/11915375/How-long-those-spontaneous-selfies-really-take.html

Blanchette, A. (2017, January 28). Botox is booming among millennials – some as young as 18. *The Star Tribune.* Retrieved from http://www.startribune.com

Bleske-Rechek, A., Remiker, M. W., & Baker, J. P. (2008). Narcissistic men and women think they are so hot – but they are not. *Personality and Individual Differences, 45*(5), 420–424. doi:10.1016/j.paid.2008.05.018

Blickle, G., Schlegel, A., Fassbender, P., & Klein, U. (2006). Some personality correlates of business white-collar crime. *Applied Psychology, 55*(2), 220–233. doi:10.1111/j.1464-0597.2006.00226.x

Boomsocial. (2016). Retrieved from http://www.boomsocial.com

Boon, S., & Pentney, B. (2015). Virtual lactivism: Breastfeeding selfies and the performance of motherhood. *International Journal of Communication, 9,* 1759–1774.

Borba, M. (2016). *Unselfie: Why Empathetic Kids Succeed in Our All-About-Me World.* New York: Touchstone, Simon & Schuster.

Brand, S., Kelly, K., & Kinney, J. (1985). Digital Retouching: The End of Photography as Evidence of Anything. *Whole Earth Review.*

Browmlee, J. (2016). Cultural stereotypes. *Fastcodesign.* Retrieved June 14, 2016, from http://www.fastcodesign.com/3026620/russians-are-miserable-and-brazilians-love-to-smile-what-selfies-reveal-about-cultural-stere

Brown, R. P., Budzek, K., & Tamborski, M. (2009). On the meaning and measure of narcissism. *Personality and Social Psychology Bulletin, 35*(7), 951–964. doi:10.1177/0146167209335461 PMID:19487486

Brunell, A. B., Staats, S., Barden, J., & Hupp, J. M. (2011). Narcissism and academic dishonesty: The exhibitionism dimension and the lack of guilt. *Personality and Individual Differences, 50*(3), 323–328. doi:10.1016/j.paid.2010.10.006

Bruno, N., Bode, C., & Bertamini, M. (2016). Composition in portraits: Selfies and wefies reveal similar biases in untrained modern youths and ancient masters. In *Laterality: Asymmetries of Body, Brain and Cognition.* Routledge: Taylor & Francis Groups. doi:10.1080/1357650X.2016.1185108

Buffardi, L. E., & Campbell, W. K. (2008). Narcissism and social networking web sites. *Personality and Social Psychology Bulletin, 34*(10), 1303–1314. doi:10.1177/0146167208320061 PMID:18599659

Buhl, M. (2011). So, what comes after? the current state of visual culture and visual education. *Synnyt Origins: Finnish Studies In Art,* (1), 1-7.

Burkett, M. (2015). Sex(t) talk: A qualitative analysis of young adults negotiations of the pleasures and perils of sexting. *Sexuality & Culture, 19*(4), 835–863. doi:10.1007/s12119-015-9295-0

Burkitt, I. (2008). *Social Selves: Theories of Self and Society* (2nd ed.). London: Sage Publications.

Burns, A. (2015). Self(ie)-discipline: Social regulation as enacted through the discussion of photographic practice. *International Journal of Communication, 9,* 1716–1733.

Bushman, B., Baumeister, R. F., Thomaes, S., Ryu, E., Begeer, S., & West, S. G. (2009). Looking again, and harder, for a link between low self-esteem and aggression. *Journal of Personality*, *77*(2), 427–466. doi:10.1111/j.1467-6494.2008.00553.x PMID:19192074

Buss, D. M., & Chiodo, L. M. (1991). Narcissistic acts in everyday life. *Journal of Personality*, *59*(2), 179–215. doi:10.1111/j.1467-6494.1991.tb00773.x PMID:1880699

Callard, F., & Fitzgerald, D. (2015). Against reciprocity: Dynamics of power in interdisciplinary spaces. In Callard and Fitzgerald's *Rethinking Interdisciplinarity across the Social Sciences and Neurosciences*. Basingstroke: Palgrave Macmillan. Retrieved May 13, 2017, from https://www.ncbi.nlm.nih.gov/books/NBK333550/

Campbell, W. K. (1999). Narcissism and romantic attraction. *Journal of Personality and Social Psychology*, *77*(6), 1254–1270. doi:10.1037/0022-3514.77.6.1254

Campbell, W. K., & Foster, J. D. (2007). The narcissistic self: Background, an extended agency model, and ongoing controversies. In C. Sedikides & S. J. Spencer (Eds.), *The self* (pp. 115–138). New York: Psychology Press.

Campbell, W. K., Reeder, G. D., Sedikides, C., & Elliot, A. J. (2000). Narcissism and comparative self-enhancement strategies. *Journal of Research in Personality*, *34*(3), 329–347. doi:10.1006/jrpe.2000.2282

Campbell, W. K., Rudich, E., & Sedikides, C. (2002). Narcissism, self-esteem, and the positivity of self-views. Two portraits of self-love. *Personality and Social Psychology Bulletin*, *28*(3), 358–368. doi:10.1177/0146167202286007

Campbell, W. K., & Twenge, J. M. (2015). Narcissism, emerging media, and society. In L. D. Rosen, N. A. Cheever, & L. M. Carrier (Eds.), *The Wiley handbook of psychology, technology, and society* (pp. 358–370). Hoboken, NJ: John Wiley and Sons.

Cantek, L. (2013). *Cumhuriyet'in buluğ çağı, gündelik yaşama ilişkin tartışmalar 1945-1950*. İstanbul: İletişim Yayınları.

Carpenter, C. J. (2012). Narcissism on Facebook: Self-promotional and anti-social behavior. *Personality and Individual Differences*, *52*(4), 482–486. doi:10.1016/j.paid.2011.11.011

Carr, C. T., Wohn, D. Y., & Hayes, R. A. (2016). as social support: Relational closeness, automaticity, and interpreting social support from paralinguistic digital affordances in social media. *Computers in Human Behavior*, *62*, 385–393. doi:10.1016/j.chb.2016.03.087

Cashmore, E. (2006). *Celebrity/Culture*. New York, NY: Routledge.

Castells, M. (2003). *Ağ toplumunun yükselişi*. İstanbul: Bilgi Üniversitesi Yayınları.

Cavell, S. (1979). *The World Viewed, Reflections on the Ontology of Film (Enlarged E)*. Cambridge, MA: Harvard University Press.

Cayce, R. Hesterman, K., & Bergstresser, P. (2014). Google technology in the surveillance of hand foot mouth disease in Asia. *International Journal of Integrative Pediatrics and Environmental Medicine*, 1, 27 – 35.

CBS News. (2016, Dec. 24). Photographer Neal Slavin on what draws him to capturing group portraits. Retrieved December 25, 2016 from http://www.cbsnews.com/news/neal-slavin-40-year-chronicle-of-groups-and-gatherings-photography-portraits/

Central Iowa Man. (2016, May 30). Re: Your two cents worth: Monday, May 30 [Online forum comment]. Retrieved from http://www.desmoinesregister.com/story/opinion/readers/2016/05/30/cents-worth-monday-may/85054968/

Chamorro-Premuzic, T. (2014). Sharing the (self) love: The rise of the selfie and digital narcissism. Retrieved from https://www.theguardian.com/media-network/media-network-blog/2014/mar/13/selfie-social-media-love-digital-narcassism

Chen, C.-F., Liu, K.-P., & Yu, N.-H. (2015, November 2-6). Exploring interaction modalities for a selfie drone. In *Proceedings of SA'15* (Posters), Kobe, Japan. doi:10.1145/2820926.2820965

Cheney-Lippold, J. (2017). *We Are Data: Algorithms and the Making of Our Digital Selves*. New York: New York University Press.

Chen, Y., Mark, G., & Ali, S. (2016). Promoting positive affect through smartphone photography. *Psychology of Well-Being*, 6(8), 1–16. PMID:27441169

Christian, B., & Griffiths, T. (2017). *Algorithms to Live By: The Computer Science of Human Decisions*. New York: Henry Holt and Company.

Chua, T. H. H., & Chang, L. (2016). Follow me and like my beautiful selfies: Singapore teenage girls' engagement in self-presentation and peer comparison on social media. *Computers in Human Behavior*, 55, 190–197. doi:10.1016/j.chb.2015.09.011

Clarke, T. B., Murphy, J., & Adler, J. (2016). Celebrity chef adoption and implementation of social media, particularly Pinterest: A diffusion of innovations approach. *International Journal of Hospitality Management*, 57, 84–92. doi:10.1016/j.ijhm.2016.06.004

Cooley, C. H. (1902). *Human Nature and the Social Order*. New York, NY: Scribner's.

Corry, N., Merritt, R. D., Mrug, S., & Pamp, B. (2008). The factor structure of the Narcissistic Personality Inventory. *Journal of Personality Assessment*, 90(6), 593–600. doi:10.1080/00223890802388590 PMID:18925501

Costa, P. T., & McCrae, R. R. (2009). The five-factor model and the NEO inventories. In J. N. Butcher (Ed.), *Oxford handbook of personality assessment*. New York: Oxford University Press. doi:10.1093/oxfordhb/9780195366877.013.0016

D'Eon, K. (2016). The "selfie": Sexualization and objectification of… ourselves? *MSinthebiz.com*. Retrieved June 14, 2016, from http://msinthebiz.com/2013/11/04/the-selfie-sexualization-and-objectification-of-ourselves/

Data Source: Google Correlate." Google, Inc. Retrieved May 25, 2017, from http://www.google.com/trends/correlate)

De Lima, C. C. (2015). The selfie as expression of contemporary fashion and narcissism. *Moda Documenta: Museu. Memoria e Design, II*(I), 1–14.

Delgado-Márquez, B. L., Hurtado-Torres, N. E., & Aragón-Correa, J. A. (2012). The dynamic nature of trust transfer: Measurement and the influence of reciprocity. *Decision Support Systems, 54*(1), 226–234. doi:10.1016/j.dss.2012.05.008

Demirezen, İ. (2014). Türkiye'de tüketim toplumuna doğru: Sekülerleşme, muhafazakarlık ve tüketimin dönüşümü. In L. Sunar (Ed.), Türkiye'de Toplumsal Değişim, Ankara: Nobel Yayıncılık.

Devantine, F. (2009). Written tradition and orality. *Shima. The International Journal of Research into Island Cultures, 3*(2), 10–14.

DeWall, C. N., Buffardi, L. E., Bonser, I., & Campbell, W. K. (2011). Narcissism and implicit attention seeking: Evidence from linguistic analyses of social networking and online presentation. *Personality and Individual Differences, 51*(1), 57–62. doi:10.1016/j.paid.2011.03.011

Dhir, A., Pallesen, S., Torsheim, T., & Andreassen, C. S. (2016). Do age and gender differences exist in selfie-related behaviours? *Computers in Human Behavior, 63*, 549–555. doi:10.1016/j.chb.2016.05.053

Dickinson, K. A., & Pincus, A. L. (2003). Interpersonal analysis of grandiose and vulnerable narcissism. *Journal of Personality Disorders, 17*(3), 188–207. doi:10.1521/pedi.17.3.188.22146 PMID:12839099

Diller, V. (2015). Social media: A narcissist's virtual playground. Retrieved from http://www.huffingtonpost.com/vivian-diller-phd/social-media-a-narcissist_b_6916010.html

Dinhopl, A., & Gretzel, U. (2016). Selfie-taking as touristic looking. [Elsevier. ScienceDirect.]. *Annals of Tourism Research, 57*, 126–139. doi:10.1016/j.annals.2015.12.015

Dobelli, R. (2013). *The Art of Thinking Clearly* (N. Griffin, Trans.). New York: Harper Collins.

Doring, N., Reif, A., & Poesichi, S. (2016). How gender-stereotypical are selfies? A content analysis and comparison with magazine adverts. *Computers in Human Behavior, 55*, 955–962. doi:10.1016/j.chb.2015.10.001

Druckman, D., Mitterhofer, r., Filzmoser, M., & Koeszegi, S.T. (2014). Resolving impasses in e-negotiation: Does e-mediation work? *Group Decision and Negotiation, 23*, 193-210. doi:.10.1007/s10726-013-9356-4

Dunbar, R. (1996). *Grooming, Gossip, and the Evolution of Language*. Cambridge, MA: Harvard University Press.

Dunbar, R. I. M. (1993). Coevolution of neocortical size, group size and language in humans. *Behavioral and Brain Sciences, 16*(04), 681–735. doi:10.1017/S0140525X00032325

Duncum, P. (2001). Visual culture: Developments, definitions, and directions for art education. *Studies in Art Education*, *42*(2), 101–112. doi:10.2307/1321027

Durham, M. G., & Kellner, D. M. (2006). *Media and cultural studies: Keyworks*. UK: Blackwell Publishing.

Edmunds, S. (2015). *Scammers and online dating fraud. 2015 trends and tactics*. New York: Global Dating Insights.

Eisenberger, R., Lynch, P., Aselage, J., & Rohdieck, S. (2004, March). Who takes the most revenge? Individual differences in negative reciprocity norm endorsement. *Personality and Social Psychology Bulletin*. PMID:15155041

Emeka, A. (2014). *African cultural values*. Retrieved June 1, 2016 from http://www.emeka.at%2Fafrican_cultural_vaules.pdf&usg=AFQjCNE30utItcG7XsbdR3DN913O-3p6wg&sig2=i8AEKQ6Xd-BEsFZbtHmSSQ

Endong, F. P. C., & Obonganwan, E. E. (2015). Sex in Christian movies: A study of Roger Young's The Bible: Joseph and Mel Gibson's Passion of The Christ. *SSRG: International Journal of Communication and Media Science*, *2*(2), 11–21.

Ezenagu, N., & Olatunji, T. (2014). Harnessing Awka traditional festival for tourism promotion. *Global Journal of Arts Humanities and Social Sciences*, *2*(5), 43–56.

Fausing, B. (2014). Selfies shape the world. Selfies, healthies, usies, felfies. *Academia. edu.*

Fausing, B. (2013). *Become an image. On selfies, visuality and the visual turn in social medias*. Digital Visuality.

Feenberg, A. (1999). *Questioning Technology*. New York, London: Routledge.

Feng, X., Zhang, Y., & Wang, L. (2017). Evolution of stinginess and generosity in finite populations. *Journal of Theoretical Biology*, *421*, 71–80. doi:10.1016/j.jtbi.2017.03.022 PMID:28363863

Ferrin, D. L., Bligh, M. C., & Kohles, J. C. (2008). It takes two to tango: An interdependence analysis of the spiraling of perceived trustworthiness and cooperation in interpersonal and intergroup relationships. *Organizational Behavior and Human Decision Processes*, *107*(2), 161–178. doi:10.1016/j.obhdp.2008.02.012

Flaherty, G.T. & Choi, J. (2016). The 'selfie' phenomenon: Reducing the risk of harm while using smartphones during international travel. *Journal of Travel Medicine*. doi:10.1093/jtm/tav026

FORD. (2014). *Looking Further with Ford: 2014 Trends*. Ford Motor Company.

Foucault, M. (1988). Technologies of the Self. In L. H. Martin, H. Gutman, & P. H. Hutton (Eds.), *Technologies of the Self: A Seminar with Michel Foucault* (pp. 16–49). Amherst, MA: The University of Massachusetts Press.

Foucault, M. (1978). The History of Sexuality: Vol. 1. *An Introduction* [Hurley R, Trans.]. New York, NY: Pantheon Books.

Fox, J., & Rooney, M. C. (2015). The Dark Triad and trait self-objectification as predictors of men's use and self-presentation behaviors on social networking sites. *Personality and Individual Differences*, 76, 161–165. doi:10.1016/j.paid.2014.12.017

Freeland, C. (2007). Portraits in Painting and Photography. *Philosophical Studies: An International Journal for Philosophy in the Analytic Tradition, 135*(1), 95–109. Retrieved from http://www.jstor.org/stable/40208798

Freitas, D. (2017). *The Happiness Effect: How Social Media is Driving a Generation to Appear Perfect at Any Cost*. New York: Oxford University Press.

Frosh, P. (2015). The gestural image: The selfie, photography theory, and kinesthetic sociability. *International Journal of Communication*, 9, 1607–1628.

Gabriel, M. T., Critelli, J. W., & Ee, J. S. (1994). Narcissistic illusions in self-evaluations of intelligence and attractiveness. *Journal of Personality*, 62(1), 143–155. doi:10.1111/j.1467-6494.1994.tb00798.x

Gannon, V., Gannon, V., Prothero, A., & Prothero, A. (2016). Beauty blogger selfies as authenticating practices. *European Journal of Marketing, 50*(9/10), 1858–1878. doi:10.1108/EJM-07-2015-0510

Gentile, B., Miller, J. D., Hoffman, B. J., Reidy, D. E., Zeichner, A., & Campbell, W. K. (2013). A test of two brief measures of grandiose narcissism: The narcissistic personality inventory–13 and the narcissistic personality inventory–16. *Psychological Assessment*, 25(4), 1120–1136. doi:10.1037/a0033192 PMID:23815119

Georgakopoulou, A. (2016). From narrating the self to posting self(ies): A small stories approach to Selfies. *Open Linguistics, 2016*(2), 300 – 317.

Gergen, K. J. (1991). *The Saturated Self: Dilemmas of Identity in Contemporary Life*. New York, NY: Basic Books.

Gibbs, J. L., Ellison, N. B., & Heino, R. D. (2006). Self-Presentation in Online Personals: The Role of Anticipated Future Interaction, Self-Disclosure, and Perceived Success in Internet Dating. *Communication Research*, 33(2), 152–177. doi:10.1177/0093650205285368

Gibbs, M., Carter, M., Nansen, B., & Kohn, T. (2014). Selfies at funerals: Remediating rituals of mourning. *Selected Papers of Internet Research*, 15, 21–24.

Giddens, A. (2000). *Sosyoloji*. Ankara: Ayraç Yayınları.

Gintis, H., Bowles, S., Boyd, R., & Fehr, E. (2005). *Moral Sentiments and Material Interests: The Foundations of Cooperation in Economic Life*. Cambridge, Massachusetts: The MIT Press.

Goffman, E. (1959). *The Presentation of Self in Everyday Life*. New York, NY: Doubleday.

Google Correlate Tutorial. (2011). Google, Inc. Retrieved June 11, 2017, from https://www.google.com/trends/correlate/tutorial

Google Search Statistics. (2017, June 17). Retrieved June 17, 2017, from http://www. internetlivestats.com/google-search-statistics/

Gouldner, A. W. (1960, April). The norm of reciprocity: A preliminary statement. *American Sociological Review*, *25*(2), 161–178. http://www.jstor.org/stable/2092623 doi:10.2307/2092623

Greeley, S. (2015). Testing Technology's Conservatism. *The Imaginative Conservative*. Retrieved August 30, 2016, from http://www.theimaginativeconservative.org/2015/09/testing-technology-conservatism.html

Grogan, S. (2008). Body Image: Understanding body dissatisfaction in men, women, and children. (2, Ed.). London: Routledge.

Gruber-Muecke, T., & Rau, C. (2016). "Fake It or Make It" – Selfies in corporate social media campaigns. In G. Meiselwitz (Ed.), *SCSM 2016, LNCS 9742* (pp. 417–427). doi:10.1007/978-3-319-39910-2_39

Guernier, V., Milinovich, G. J., Santos, M. A. B., Haworth, M., Coleman, G., & Magalhaes, R. J. S. (2016). Use of big data in the surveillance of veterinary diseases: Early detection of tick paralysis in companion animals. *Parasites & Vectors*, *9*(303), 1–10. PMID:27215214

Günaydın, A. U. (2006). Akbank reklamlarında folklorik unsurların, kültürel kod ve göstergelerin işlevi. *Milli Folklor*, *18*(71), 56–59.

Guo, X. (2015). Cultural explanation of women's online selfie phenomenon. *Northeast Communication*, (6), 51-53.

Guo, Y. (2015). Constructing, presenting, and expressing self on social network sites: An exploratory study in Chinese university students' social media engagement [Thesis]. University of British Columbia.

Gupta, R., & Pooja, M. (2016). Selfie: An infectious gift of it to modern society. *Global Journal for Research Analysis*, *5*(1), 278–280.

Hai-Jew, S. (2017). Exploring identity-based humor in a #selfies #humor image set from Instagram. In S. Hai-Jew (Eds.), Techniques for Coding Imagery and Multimedia: Emerging Research and Opportunities (Ch. 1). Hershey, PA: IGI-Global.

Halpern, D., Valenzuela, S., & Katz, J. E. (2016). Selfie-ists or Narci-selfiers? A cross lagged panel analysis of selfie-taking and narcissism. *Personality and Individual Differences*, *97*, 98–101. doi:10.1016/j.paid.2016.03.019

Hamid, A., & Heiden, M. (2015). Forecasting volatility with empirical similarity and Google Trends. *Journal of Economic Behavior & Organization*, *117*, 62–81. doi:10.1016/j.jebo.2015.06.005

Heidegger, M. (1962). *Being and Time*. Oxford, UK: Blackwell.

Heidegger, M. (1977). *The Question Concerning Technology and Other Essays* [W. Lovitt, Trans.]. New York, NY: Garland Publishing.

Hendin, H. M., & Cheek, J. M. (1997). Assessing hypersensitive narcissism: A reexamination of Murrays narcissism scale. *Journal of Research in Personality, 31*(4), 588–599. doi:10.1006/jrpe.1997.2204

Hepper, E. G., Hart, C. M., & Sedikides, C. (2014). Moving Narcissus: Can narcissists be empathic? *Personality and Social Psychology Bulletin, 40*(9), 1079–1091. doi:10.1177/0146167214535812 PMID:24878930

Hess, A. (2015). Selfies: The selfie assemblage. *International Journal of Communication, 9*, 1629–1646.

Hess, A. (2015). The selfie assemblage. *International Journal of Communication, 9*, 1629–1646.

Heyley, P. (2016). Is the naked selfie good for feminism? Let's take a closer look. *ELLE*, Retrieved September 1, 2016 from http://www.elle.com/culture/a34928/naked-selfie-and-feminism/

Holtzman, N. S., & Strube, M. J. (2010). Narcissism and attractiveness. *Journal of Research in Personality, 44*(1), 133–136. doi:10.1016/j.jrp.2009.10.004

Homer, W. I. (1998). Visual culture: A new paradigm. *American Art, 12*(1), 6–9. doi:10.1086/424309

Howard, J. (2016, July 1). Dad hilariously re-creates daughter's sexy selfies. CNN. Retrieved Dec. 28, 2016, from http://www.cnn.com/2016/06/30/health/selfie-dad-daughter-viral-photos/

Hyman, J. (2006). *The Objective Eye: Color, Form, and Reality in the Theory of Art*. Chicago: The University of Chicago Press. doi:10.7208/chicago/9780226365541.001.0001

İmançer, D., & Özel, Z. (2006). Psikanalitik açıdan fotoğgrafik görüntüde toplumsal cinsiyetin sunumu. In D. İmançer (Ed.), Medya ve Kadın, Ankara: Ebabil Yayınları.

Innes, M. (1998). Memory, orality and literacy in an early medieval society. The Past and Present Society, 58, 3-36.

Instagram, H. E. (2016). Retrieved from https://www.instagram.com/handemiyy/?hl=tr

Jacovi, M., Guy, I., Ronen, I., Perer, A., Uziel, E., & Maslenko, M. (2011, September 24 – 28). Digital traces of interest: Deriving interest relationships from social media interactions. In *ECSCW 2011: Proceedings of the 12th European Conference on Computer Supported Cooperative Work*, Aarhus, Denmark. doi:10.1007/978-0-85729-913-0_2

Jarvis, J. (2012). *E-sosyal toplum. Çağlar Kök (çev.)*. İstanbul: Media Cat.

Jenks, C. (1995). *Visual culture*. Psychology Press. doi:10.4324/9780203426449

John, O. P., & Robins, R. W. (1994). Accuracy and bias in self-perception: Individual differences in self-enhancement and the role of narcissism. *Journal of Personality and Social Psychology, 66*(1), 206–219. doi:10.1037/0022-3514.66.1.206 PMID:8126650

Johnson, A. K., Mikati, T., & Mehta, S. D. (2016). Examining the themes of STD-related Internet searches to increase specificity of disease forecasting using Internet search terms. *Scientific Reports*, 6(36503), 1–8. PMID:27827386

Johnson, S. M., Maiullo, S., Trembley, E., Werner, C. L., & Woolsey, D. (2014). The selfie as a pedagogical tool in a college classroom. *College Teaching*, 62(4), 119–120. doi:10.1080/875 67555.2014.933168

Jonason, P. K., & Webster, G. D. (2010). The Dirty Dozen: A concise measure of the Dark Triad. *Psychological Assessment*, 22(2), 420–432. doi:10.1037/a0019265 PMID:20528068

Jones, D. N., & Paulhus, D. L. (2014). Introducing the short Dark Triad (SD3): A brief measure of dark personality traits. *Assessment*, 21(1), 28–41. doi:10.1177/1073191113514105 PMID:24322012

Jung, Y., Hall, J., Hong, R., Goh, T., Ong, N., & Tan, N. (2014). Payback: Effects of relationship and cultural norms on reciprocity. *Asian Journal of Social Psychology*, 17(3), 160–172. doi:10.1111/ajsp.12057

Kahraman, H. B. (2013). *Türkiye'de görsel bilincin oluşumu, Türkiye'de modern kültürün oluşumu.* İstanbul: Kapı Yayınları.

Kant, I. (1963). *Lectures on ethics.* New York: Harper and Row Publishers.

Karahisar, T. (2013). Dijital nesil, dijital iletişim ve dijitalleşen Türkçe. *Online Academic Journal of Information Technology*, 4(12), 71–83.

Kashian, N., Jang, J., Shin, S. Y., Dai, Y., & Walther, J. B. (2017). Self-disclosure and liking in computer-mediated communication. *Computers in Human Behavior*, 71, 275–283. doi:10.1016/j.chb.2017.01.041

Katz, J., & Crocker, E. T. (2015). Selfies and photo messaging as visual conversation: Reports from the United States, United Kingdom and China. *International Journal of Communication*, 9, 1861–1872.

Kejanlıoğlu, B. (2005). *Medya-toplum ilişkisi ve küreselleşmenin yerel medyaya sunduğu olanaklar. Sevda Alankuş (der.), Medya ve Toplum.* İstanbul: IPS İletişim Vakfı Yayınları.

Kellner, D. (1995). *Media culture: Cultural studies, identity, and politics between the modern and the postmodern.* New York: Routledge. doi:10.4324/9780203205808

Kernberg, O. H. (1975). *Borderline conditions and pathological narcissism.* New York: Jason Aronson.

Kim, E., Lee, J. A., Sung, Y., & Choi, S. M. (2016). Predicting selfie-posting behavior on social networking sites: An extension of theory of planned behavior. *Computers in Human Behavior*, 62, 116–123. doi:10.1016/j.chb.2016.03.078

Kim, J. W., & Chock, T. M. (2016). (in press). Personality traits and psychological motivations predicting selfie posting behaviors on social networking sites. *Telematics and Informatics*.

Kırık, A. M., & Aras, N. (2015). Sosyal medyanın kültürel yabancılaşma olgusundaki rolü. In A. Büyükaslan, & A. M. Kırık (Ed.), Sosyalleşen Olgular, Sosyal Medya Araştırmaları 2. Konya: Çizgi.

Kite, L., & Kite, L. (2014). Selfies and self-objectification: Not-so-pretty picture. *Beauty Redefined*. Retrieved June 14, 2016 from http://www.beautyredefined.net/selfies-and-objectification/

Kofman, A. (2016). Why women are using selfie sticks to look inside their vaginas. *Vice*. Retrieved June 14, 2016, from https://broadly.vice.com/en_us/article/why-women-are-using-selfie-sticks-to-look-inside-their-vaginas

Kohut, H. (1971). *The analysis of the self*. New York: International Universities Press.

Kohut, H. (1971). *The Analysis of the Self: A Systematic Approach to the Psychoanalytic Treatment of Narcissistic Personality Disorders*. Chicago: The University of Chicago Press.

Kostakos, V., Hosio, S., & Goncalves, J. (2012). Correlating pedestrian flows and search engine queries. *PLoS ONE*, *8*(5), e63980. Retrieved June 14 2017 from https://arxiv.org/abs/1206.4206 doi:10.1371/journal.pone.0063980 PMID:23704964

Kroon, V. D. A., & Perez, M. (2013). Exploring the integration of thin-ideal internationalization and self-objectification in the prevention of eating disorders. *Body Image*, *10*(1), 16–25. doi:10.1016/j.bodyim.2012.10.004 PMID:23182310

Krueger, J. I., Massey, A. L., & DiDonato, T. E. (2008). A matter of trust: From social preferences to the strategic adherence to social norms. *Negotiation and Conflict Management Research*, *1*(1), 31–52. doi:10.1111/j.1750-4716.2007.00003.x

Kwak, H., Lee, C., Park, H., & Moon, S. (2010, April 26 – 30). What is Twitter, a social network or a news media? In *Proceedings of WWW '10*, Raleigh, NCarolina. Retrieved June 21, 2017 from http://www.ece.ucdavis.edu/~chuah/classes/EEC273/refs/%5BKL+10%5Dwww-twitter.pdf

LaFrance, A. (2014, March 25). When did group pictures become 'selfies'? The answer has more to do with language than photography. *The Atlantic*. Retrieved Dec. 26, 2016, from http://www.theatlantic.com/technology/archive/2014/03/when-did-group-pictures-become-selfies/359556/

Langton, R. (2009). *Sexual solipsism: Philosophical essays on pornography*. Oxford: Oxford University Press. doi:10.1093/acprof:oso/9780199247066.001.0001

Lazer, D., Kennedy, R., King, G., & Vespignani, A. (2014). The Parable of Google Flu: Traps in Big Data Analysis. *Science, 343*(6176), 1203–1205. Retrieved March 29, 2017, from http://nrs.harvard.edu/urn-3:HUL.InstRepos:12016836

Lee, J. A., & Sung, Y. (2016). Hide-and-seek: Narcissism and selfie-related behavior. *Cyberpsychology, Behavior, and Social Networking*, *19*(5), 347–351. doi:10.1089/cyber.2015.0486 PMID:27028460

Leider, S., Möbius, M. M., Rosenblat, T., & Do, Q.-A. (2009). Directed altruism and enforced reciprocity in social networks. The Quarterly Journal of Economics, 124(4), 1815 – 1851.

Lepori, G. M. (2015). Investor mood and demand for stocks: Evidence from popular TV series finales. *Journal of Economic Psychology*, *48*, 33–47. doi:10.1016/j.joep.2015.02.003

Lev-On, A., & Adler, O. (2013). Passive participation in communities of practice: Scope and motivations. In A. Jatowt et al. (Eds.), *SocInfo 2013. (pp. 81-94)*. Springer International Publishing. doi:10.1007/978-3-319-03260-3_8

Liang, H., & Fu, K. (2017). Information overload, similarity, and redundancy: Unsubscribing information sources on Twitter. *Journal of Computer-Mediated Communication*, *22*(1), 1–17. doi:10.1111/jcc4.12178

Losh, E. (2015). Feminism reads big data: "Social physics", atomism and selficity. *International Journal of Communication*, *9*, 1647–1659.

Lu, X. L. (2015). Impression management and self-recognition from selfies on social media. *Shannxi education. 2*, 5-7

Lu, D., & Dugan, C. (2016, February 27 – March 2). Stitched groupies: A playful self-photo co-creation activity. In *CSCW '16 Companion*, San Francisco, CA (pp. 69-72). doi:10.1145/2818052.2874327

Lull, J. (2001). *Medya iletişim kültür. Nazife Güngör (çev.)*. Ankara: Vadi Yayınları.

MacDonald, G., & Leary, M. R. (2012). Individual Differences in Self-Esteem. In M. R. Leary & J. P. Tangney (Eds.), *Handbook of Self and Identity* (2nd ed.). New York, NY: The Guilford Press.

Mackinnon, C. (1987). *Feminism unmodified*. Cambridge, Massachusetts and London: Harvard University Press.

Maigret, E. (2011). *Medya ve iletişim sosyolojisi. Halime Yücel (çev.)*. İstanbul: İletişim Yayınları.

Mallin, C. (2011). How to dress for conservative countries. *Travels Fashion Girl*. Retrieved August 30, 2016, from http://travelfashiongirl.com/how-to-dress-for-conservative-countries-modest-clothing-essentials/

Mansoor, E., & Al-Kindi, S. G. (2017). The premise and promise of big data for tracking population health: Big deal or big disappointment? *Digestive Diseases and Sciences*, *62*(3), 562–563. doi:10.1007/s10620-017-4458-5 PMID:28108892

Marcelo, P. (2017, Feb. 23). Professor has taken a selfie every day for the past 30 years. ABC News. Retrieved Feb. 23, 2017 from http://abcnews.go.com/Health/wireStory/professor-selfie-day-30-years-45678513

Martino, J. (2014, April 7). Scientists link selfies to narcissism, addiction, and mental illness. *Collective Evolution*. Retrieved from http://www.collectiveevolution.com/2014/04/07/scientists-link-selfies-to-narcissism-addiction-mental-illness/

Mascheroni, G., Vincent, J., & Jimenez, E. (2015). Girls are addicted to likes so they post semi-naked selfies": Peer mediation, normativity and the construction of identity online. *Cyberpsychology (Brno)*, *9*(1). doi:10.5817/CP2015-1-5

Mason, W., & Suri, S. (2012). Conducting behavioral research on Amazons Mechanical Turk. *Behavior Research Methods*, *44*(1), 1–23. doi:10.3758/s13428-011-0124-6 PMID:21717266

Mastin, L. (2008). Conservatism. *The Basics of Philosophy*. Retrieved August 30, 2016, from http://www.philosophybasics.com/branch_conservatism.html

McCain, J. L., Borg, Z. G., Rothenberg, A. H., Churillo, K. M., Weiler, P., & Campbell, W. K. (2016). Personality and selfies: Narcissism and the Dark Triad. *Computers in Human Behavior*, *64*, 126–133. doi:10.1016/j.chb.2016.06.050

McCain, J. L., & Campbell, W. K. (2016). *Narcissism and social media use: A meta-analytic review. Psychology of Popular Media Culture. Advance online publication.* Retrieved from; doi:10.1037/ppm0000137

McDaniel, M. A., Pesta, B. J., & Gabriel, A. S. (2015). Big data and the well-being nexus: Tracking Google search activity by state IQ. *Intelligence*, *50*, 21–29. doi:10.1016/j.intell.2015.01.001

McKinney, B. C., Kelly, L., & Duran, R. L. (2012). Narcissism or openness? College students use of Facebook and Twitter. *Communication Research Reports*, *29*(2), 108–118. doi:10.1080/08824096.2012.666919

McKnight, D. H., Choudhury, V., & Kacmar, C. (2002). Developing and validating trust measures for e-commerce: An integrative typology. *Information Systems Research*, *13*(3), 334–359. doi:10.1287/isre.13.3.334.81

McLean, S. A., Paxton, S. J., Wertheim, E. H., & Masters, J. (2015). Selfies and social media: Relationships between self-image editing and photo-investment and body dissatisfaction and dietary restraint. *Journal of Eating Disorders*, *3*(1 Suppl. 1), O21. doi:10.1186/2050-2974-3-S1-O21

McLuhan, M. (1994). *Understanding Media: The Extensions of Man*. Cambridge, MA: The MIT Press.

Meghan, M. (2013). Putting selfie under a feminist lens. *The Georgia Straight*. Retrieved June 14, 2016, from http://www.straight.com/life/368086/putting-selfies-under-feminist-lens

Mehdizadeh, S. (2010). Self-presentation 2.0; Narcissism and self-esteem on Facebook. *Cyberpsychology, Behavior, and Social Networking*, *13*(4), 357–364. doi:10.1089/cyber.2009.0257 PMID:20712493

Merleau-Ponty, M. (2005). *Phenomenology of Perception*. London: Routledge Classics.

Micheo-Marcial, F. (2015). The misunderstanding of objectification, *HuffPost Entertainment*, 28, 17-22.

Milinovich, G. J., Avril, S. M. R., Clements, A. C. A., Brownstein, J. S., Tong, S., & Hu, W. (2014). Using internet search queries for infectious disease surveillance: Screening diseases for suitability. *BMC Infectious Diseases*, *14*(690), 1–9. PMID:25551277

Miller, J. D., & Campbell, W. K. (2008). Comparing clinical and social-personality conceptualizations of narcissism. *Journal of Personality*, *76*(3), 449–476. doi:10.1111/j.1467-6494.2008.00492.x PMID:18399956

Miller, J. D., Hoffman, B. J., Gaughan, E. T., Gentile, B., Maples, J., & Campbell, W. K. (2011). Grandiose and vulnerable narcissism: A nomological network analysis. *Journal of Personality*, *79*(5), 1013–1042. doi:10.1111/j.1467-6494.2010.00711.x PMID:21204843

Miller, J. D., & Maples, J. (2011). Trait personality models of narcissistic personality disorder, grandiose narcissism, and vulnerable narcissism. In W. K. Campbell & J. D. Miller (Eds.), *The handbook of narcissism and narcissistic personality disorder* (pp. 56–70). Hoboken, NJ: John Wiley and Sons. doi:10.1002/9781118093108.ch7

Miller, J. D., Price, J., Gentile, B., Lynam, D. R., & Campbell, W. K. (2012). Grandiose and vulnerable narcissism from the perspective of the interpersonal circumplex. *Personality and Individual Differences*, *53*(4), 507–512. doi:10.1016/j.paid.2012.04.026

Millon, T. (1981). *Disorders of personality*. New York: Wiley.

Mirzoeff, N. (1999). *An Introduction to Visual Culture*. London: Routledge.

Mirzoeff, N. (1999). *An introduction to visual culture*. London: Routledge.

Mitchell, W. J. (2002). Showing seeing: A critique of visual culture. *Journal of Visual Culture*, *1*(2), 165–181. doi:10.1177/147041290200100202

Mohebbi, M., Vanderkam, D., Kodysh, J., Schonberger, R., Hyunyoung, C., & Kumar, S. (2011, June 9). Google Correlate Whitepaper. Google. Retrieved May 25, 2017, from https://www.google.com/trends/correlate/whitepaper.pdf

Monkey selfie. (2017, March 27). Wikipedia. Retrieved April 11, 2017 from https://en.wikipedia.org/wiki/Monkey_selfie

Moon, J. H., Lee, E., Lee, J. A., Choi, T. R., & Sung, Y. (2016). The role of narcissism in self-promotion on Instagram. *Personality and Individual Differences*, *101*, 22–25. doi:10.1016/j.paid.2016.05.042

Moretti, F. (2000, January – February). Conjectures on world literature. *New Left Review*, *1*. Retrieved June 22, 2017 from https://newleftreview.org/II/1/franco-moretti-conjectures-on-world-literature

Morf, C. C., & Rhodewalt, F. (2001). Unraveling the paradoxes of narcissism: A dynamic self regulatory processing model. *Psychological Inquiry*, *12*(4), 177–196. doi:10.1207/S15327965PLI1204_1

Morf, C. C., Torchetti, L., & Schürch, E. (2011). Narcissism from the perspective of the dynamic self-regulatory processing model. In W. K. Campbell & J. D. Miller (Eds.), *The handbook of narcissism and narcissistic personality disorder* (pp. 56–70). Hoboken, NJ: John Wiley and Sons. doi:10.1002/9781118093108.ch6

Mujcic, R., & Leibbrandt, A. (2017). Indirect reciprocity and prosocial behavior: Evidence from a natural field experiment. The Economic Journal. Retrieved June 10, 2017 from http://onlinelibrary.wiley.com/doi/10.1111/ecoj.12474/abstract

Murray, D. C. (2015). Notes to self: The visual culture of selfies in the age of social media. *Consumption Markets & Culture, 18*(6), 490–516. doi:10.1080/10253866.2015.1052967

Nader, R. (2007). *The Seventeen Traditions*. New York: HarperCollins Publishers.

Nass, C., & Moon, Y. (2000). Machines and mindlessness: Social responses to computers. *The Journal of Social Issues, 56*(1), 81–103. doi:10.1111/0022-4537.00153

Nayar, P. K. (2009). *Seeing Stars: Spectacle, Society and Celebrity Culture*. New Delhi, India: Sage Publications.

Nemer, D., & Freeman, G. (2015). Empowering the marginalized: Rethinking selfies in the slums of Brazil. *International Journal of Communication, 9*, 1832–1847.

Nguyen, V.-A., Lim, E.-P., Tan, H.-H., Jiang, J., & Sun, A. (2010). Do you trust to get trust? A study of trust reciprocity behaviors and reciprocal trust prediction. In Proceedings of the SIAM International Conference on Data Mining (SDM '10) (pp. 72-83). Retrieved May 11, 2017 from http://epubs.siam.org/doi/abs/10.1137/1.9781611972801.7

Northrop, J. M. (2012). *Reflecting on Cosmetic Surgery: Body image, shame and narcissism*. London: Routledge.

Nowak, M. A., & Sigmund, K. (1998). The dynamics of indirect reciprocity. *Journal of Theoretical Biology, 194*(4), 561–574. Retrieved June 20 2017 from https://homepage.univie.ac.at/karl.sigmund/JTB98b.pdf doi:10.1006/jtbi.1998.0775 PMID:9790830

Nussbaum, M. (1995). Objectification. *Philosophy & Public Affairs, 24*(4), 249–291. doi:10.1111/j.1088-4963.1995.tb00032.x

Ocampo, A. J., Chunara, R., & Brownstein, J. S. (2013). Using search queries for malaria surveillance, Thailand. *Malaria Journal, 12*(390), 1–6. PMID:24188069

Ojo, A. O. (2005). *Religion and sexuality. individuality, choice and sexual rights in Nigerian Christianity*. Lagos: Africa Regional Sexuality Resource Centre.

Olson, D. (2006). Orality and literacy: A symposium in honor of David Olson. *Research in the Teaching of English, 41*(2), 136–143.

Onchi, E., Lucho, C., Sigüenza, M., & Trovato, G. (2016). Introducing IOmi—A female robot hostess for guidance in a university environment. In A. Agah et al. (Eds.), ICSR 2016, LNAI (Vol. 9979, pp. 764-773).

Ong, W. J. (2003). *Sözlü ve yazılı kültür sözün teknolojileşmesi, Sema Postacıoğlu Banon (çev.)*. İstanbul: Metis.

Our Main Findings. (n. d.). *Selfiecity.net*. Retrieved from http://selfiecity.net/#findings

Pagel, M. (2012). *Wired for Culture: Origins of the Human Social Mind*. New York: W.W. Norton & Company.

Panek, E. T., Nardis, Y., & Konrath, S. (2013). Mirror or megaphone? How relationships between narcissism and social networking site use differ on Facebook and Twitter. *Computers in Human Behavior*, *29*(5), 2004–2012. doi:10.1016/j.chb.2013.04.012

Panosa, I. (2004). The beginnings of the written culture in Antiquity, *Revista Digital d'Humanitats*, 6.

Papadaki, E. (2010). Feminist perspectives on objectification. In *Encyclopedia of Philosophy* Retrieved May 2, 2016, from http://www.feminist-perspectives-on-objectification/encyclopedia-of-philosophy.htm.

Park, P. S., & Kim, Y.-H. (2017). Reciprocation under status ambiguity: How dominance motives and spread of status value shape gift exchange. *Social Networks*, *48*, 142–156. doi:10.1016/j.socnet.2016.08.004

Paulhus, D. L. (1998). Interpersonal and intrapsychic adaptiveness of trait self-enhancement. *Journal of Personality and Social Psychology*, *74*(5), 197–208. doi:10.1037/0022-3514.74.5.1197 PMID:9599439

Paulhus, D. L. (2001). Normal narcissism: Two minimalist accounts. *Psychological Inquiry*, *12*, 228–230.

Paulhus, D. L., & Williams, K. M. (2002). The Dark Triad of personality: Narcissism, Machiavellianism, and psychopathy. *Journal of Research in Personality*, *36*(6), 556–563. doi:10.1016/S0092-6566(02)00505-6

Pelligra, V. (2011). Empathy, guilt-aversion and patterns of reciprocity (Working paper). Centro Richerche Economiche Nord Sud. (CRENoS).

Perloff, R. M. (2014). *Social media on young women's body image concerns: Theoretical perspectives and agenda for research. Feminist Forum Review* (pp. 1–15). New York: Springer.

Pew Research Center. (2016). *Social media update*. Retrieved from http://www.pewinternet.org/2016/11/11/social-media-update-2016/

Pew Research Center. (2017). *Record shares of Americans now own smartphones, have home broadband*. Retrieved from http://www.pewresearch.org/fact-tank/2017/01/12/evolution-of-technology/

Pincus, A. L., Ansell, E. B., Pimentel, C. A., Cain, N. M., Wright, A. G. C., & Levy, K. N. (2009). Initial construction and validation of the pathological narcissism inventory. *Psychological Assessment, 21*(3), 365–379. doi:10.1037/a0016530 PMID:19719348

Pincus, A. L., & Roche, M. J. (2011). Narcissistic grandiosity and narcissistic vulnerability. In W. K. Campbell & J. D. Miller (Eds.), *The handbook of narcissism and narcissistic personality disorder* (pp. 31–40). Hoboken, NJ: John Wiley and Sons.

Plickert, G., Côté, R. R., & Wellman, B. (2007). It's not who you know, it's how you know them: Who exchanges what with whom? *Social Networks, 29*(3), 405–429. doi:10.1016/j.socnet.2007.01.007

Polistina, K. (2009). Cultural literacy: Understanding and respect for the cultural aspects of sustainability. In A. Stibbe (Ed.), The handbook of suistainability literacy: Skills for a changing world (pp. 117-123).

Pollett, S., Wood, N., Boscardin, W.J., Bengtsson, H., Schwarcz, S., Harriman, K., Winter, K., & Rutherford, G. (2015). Validating the use of Google Trends to enhance pertussis surveillance in California. *PLoS Currents, 1*(7).

Pyne, M. (2015). Can there be deeper meaning behind our selfies? *Dazeddigital.com*. Retrieved June 14, 2016 from http://www.dazeddigital.com/photography/article/30096/1/can-there-be-deeper-meaning-behind-our-selfies

Qin, J., & Peng, T.-Q. (2014). Googling environmental issues: Web search queries as a measurement of public attention on environmental issues. *Internet Research, 26*(1), 57–73. doi:10.1108/IntR-04-2014-0104

Qiu, L., Lu, J., Yang, S., Qu, W., & Zhu, T. (2015). What does your selfie say about you? *Computers in Human Behavior, 52*, 443–449. doi:10.1016/j.chb.2015.06.032

Raeder, T., Lizardo, O., Hachen, D., & Chawla, N. V. (2011). Predictors of short-term decay of cell phone contacts in a large scale communication network. Retrieved June 19, 2017 from https://arxiv.org/pdf/1102.1753.pdf

Raskin, R., & Terry, H. (1988). A principal components analysis of the narcissistic personality inventory and further evidence of its construct validity. *Journal of Personality and Social Psychology, 54*(5), 890–902. doi:10.1037/0022-3514.54.5.890 PMID:3379585

Reagle, J. (2015). Following the Joneses: FOMO and conspicuous sociality. *First Monday, 20*(10). Retrieved December 26 2016 from http://firstmonday.org/ojs/index.php/fm/article/view/6064/4996 doi:10.5210/fm.v20i10.6064

Re, D. E., Wang, S. A., He, J. C., & Rule, N. O. (2016). Selfie indulgence: Self-favoring biases in perceptions of selfies. *Social Psychological & Personality Science, 7*(6), 588–596. doi:10.1177/1948550616644299

Rettberg, W. Jill (2015). Seeing ourselves through technology. How we use selfies, blogs and wearable devices to see and shape ourselves. London: Palgrave Macmillan.

Rettberg, J. W. (2014). Automated diaries. In *J.W. Rettberg (Ed.), Seeing Ourselves through Technology: How We Use Selfies, Blogs and Wearable Devices to See and Shape Ourselves* (pp. 45–60). Basingstoke, New York: Martin's Press LLC.

Rettberg, J. W. (2014). *Seeing Ourselves Through Technology: How We Use Selfies, Blogs and Wearable Devices to See and Shape Ourselves*. Hampshire, UK: Palgrave Macmillan. doi:10.1057/9781137476661

Rettberg, J. W. (2014). Serial selfies. In *J.W. Rettberg (Ed.), Seeing Ourselves through Technology: How We Use Selfies, Blogs and Wearable Devices to See and Shape Ourselves* (pp. 33–45). Basingstoke, New York: Martin's Press LLC.

Rettberg, J. W. (2014). Written, visual and quantitative self-representations. In *J.W. Rettberg (Ed.), Seeing Ourselves through Technology: How We Use Selfies, Blogs and Wearable Devices to See and Shape Ourselves* (pp. 1–19). Basingstoke, New York: Martin's Press LLC.

Rhodewalt, F. (2012). Contemporary Perspectives on Narcissism and the Narcissistic Personality Type. In M. R. Leary & J. P. Tangney (Eds.), *Handbook of Self and Identity* (2nd ed., pp. 571–586). New York, NY: The Guilford Press.

Rhodewalt, F., & Morf, C. C. (1998). On self-aggrandizement and anger: A temporal analysis of narcissism and affective reactions to success and failure. *Journal of Personality and Social Psychology, 74*(3), 672–685. doi:10.1037/0022-3514.74.3.672 PMID:9523411

Rhodewalt, F., & Peterson, B. (2009). Narcissism. In M. R. Leary & R. H. Hoyle (Eds.), *Handbook of individual differences in social behavior* (pp. 547–560). New York: Guilford.

Ringrose, J., & Harvey, L. (2015). BBM is like match.com: Social networking and the digital mediation of teens' sexual cultures. In B. Jane & S. Valerie (Eds.), *eGirls, eCitizens* (pp. 199–228). Ottawa: University of Ottawa Press.

Roberts, G. (2008). Evolution of direct and indirect reciprocity. *Proceedings of the Royal Society, 275*(1631), 173–179. doi:10.1098/rspb.2007.1134 PMID:17971326

Robins, R. W., & Johns, O. P. (1997). Effects of visual perspective and narcissism on self-perception: Is seeing believing? *Psychological Science, 8*(1), 37–42. doi:10.1111/j.1467-9280.1997.tb00541.x

Ross, A. (2013). Nowcasting with Google Trends: A keyword selection method. *Fraser of Allander Economic Commentary, 37*(2), 54–64.

Rutledge, P. (2013, April 18). #Selfies: Narcissism or self-exploration? *Psychology Today*. Retrieved from http://www.psychologytoday.com/blog/positively-media/201304/selfies-narcissism-or-self-exploration

Ryall, J. (2017, Feb. 16) Did Kim Jong-nam's Facebook fixation lead to his death? *The Telegraph*. Retrieved January 22, 2017 from http://www.telegraph.co.uk/news/2017/02/16/kim-jong-nams-facebook-fixation-may-have-aided-assailants/

Ryan, T., & Xenos, S. (2011). Who uses Facebook? An investigation into the relationship between the Big Five, shyness, narcissism, loneliness, and Facebook usage. *Computers in Human Behavior*, *27*(5), 1658–1664. doi:10.1016/j.chb.2011.02.004

Sakaluk, J. K. (2014). *Exploring Small, Confirming Big*: An Alternative System to *The New Statistics* for Advancing Cumulative and Replicable Psychological Research. *Journal of Experimental Social Psychology*, *66*, 47–54. Retrieved June 14 2017 from http://johnsakaluk.com/wp-content/uploads/2014/06/Sakaluk_2015_JESP.pdf doi:10.1016/j.jesp.2015.09.013

Salazar, L. R. (2015). The negative reciprocity process in marital relationships: A literature review. *Aggression and Violent Behavior*, *24*, 113–119. doi:10.1016/j.avb.2015.05.008

Saltz, J. (2014). Art at arm's length: A history of the selfie. Retrieved from http://www.vulture.com/2014/01/history--of--the--selfie.html

Sanghani, R. (2014). Why we really take selfies: the "terrifying" reasons explained. *Telegraph*. Retrieved March 30, 2017, from http://www.telegraph.co.uk/women/10760753/Why-we-really-take-selfies-the-terrifying-reasons-explained.html

Schlenker, B. R. (2012). Self-Presentation. In M. R. Leary & J. P. Tangney (Eds.), *Handbook of Self and Identity Self and Identity* (2nd ed., pp. 542–570). New York, NY: The Guilford Press.

Scruton, R. (1981). Photography and Representation. *Critical Inquiry*, *7*(3), 577–603. doi:10.1086/448116

Segoete, L. (2015). African female sexuality is past taboo. *This is Africa*. Retrieved June 10, 2016, from http://thisisafrica.me/sexuality-taboo/

SelfieCop. (2016). *Selfie & Sexting. The perfect storm*. London: Selfie Cop Research Review.

Senft, T. M. (2008). *Camgirls: Celebrity and Community in the Age of Social Networks*. New York, NY: Peter Lang.

Senft, T. M. (2013). Microcelebrity and the Branded Self. In J. Hartley, J. Burgess, & A. Bruns (Eds.), *A Companion to New Media Dynamics* (pp. 346–354). West Sussex, UK: Wiley-Blackwell. doi:10.1002/9781118321607.ch22

Senft, T., & Baym, N. (2015). What does the selfie say? Investigating a global phenomenon. *International Journal of Communication*, *9*, 1588–1606.

Sentana-Lledo, D., Barbu, C. M., Ngo, M. N., Wu, Y., Sethuraman, K., & Levy, M. Z. (2016). Seasons, searches, and intentions: What the Internet can tell us about the bed bug (hemipteran: Cimicidae) epidemic. *Journal of Medical Entomology*, *53*(1), 116–121. doi:10.1093/jme/tjv158 PMID:26474879

Shaffer, D. R., Ogden, J. K., & Wu, C. (1987). Effects of self-monitoring and prospect of future interaction on self-disclosure reciprocity during the acquaintance process. *Journal of Personality*, *55*(1), 75–96. doi:10.1111/j.1467-6494.1987.tb00429.x

Sheehan, T. (2011). *Doctored: The Medicine of Photography in Nineteenth-century America.* University Park, PA: The Pennsylvania State University Press.

Sheehan, T. (2014). Retouch Yourself: The Pleasures and Politics of Digital Cosmetic Surgery. In M. Sandbye & J. Larsen (Eds.), *Digital Snaps: The New Face of Photography* (pp. 179–204). London: I.B. Tauris.

Shoshitaishvili, Y., Kruegel, C., & Vigna, G. (2015). Portrait of a privacy invasion. *Proceeding on Privacy Enhancing Technology, 1*, 41–60.

SiKhonzile, N. (2016). Kim's Naked Selfie. *Black African Woman.* Retrieved June 14, 2016 from https://blackafricanwoman.org/2016/03/08/guest-post-kims-naked-selfie-by-sikhonzile-ndlovu/

Simmel, G. (2009). *Bireysellik ve kültür. Tuncay Birkan (çev.).* İstanbul: Metis Yayınları.

Şişman, B. (2012). Sayısal kültür, toplum ve medya: Msn örneği. *Gümüşhane Üniversitesi İletişim Fakültesi Elektronik Dergisi, 3*, 89–101.

Snyder, J., & Allen, N. W. (1975). Photography, Vision, and Representation. *Critical Inquiry, 2*(1), 143–169. Retrieved from http://www.jstor.org/stable/1342806 doi:10.1086/447832

Snyder, M., & Ickes, W. (1985). Personality and social behavior. In E. Aronson & G. Lindzey (Eds.), *Handbook of social psychology* (3rd ed., Vol. 2, pp. 883–947). New York: Random House.

Sorokowska, A., Oleszkiewicz, A., Frackowiak, T., Pisanski, K., Chmiel, A., & Sorokowski, P. (2016). Selfies and personality: Who posts self-portrait photographs? *Personality and Individual Differences, 90*, 119–123. doi:10.1016/j.paid.2015.10.037

Sorokowski, P., Sorokowska, A., Oleszkiewicz, A., Frackowiak, T., Huk, A., & Pisanski, K. (2015). Selfie posting behaviors are associated with narcissism among men. *Personality and Individual Differences, 85*, 123–127. doi:.2015.05.00410.1016/j.paid

Sorokowski, P., Sorokowska, A., Oleszkiewicz, A., Frackowiak, T., Huk, A., & Pisanski, K. (2015). Selfie posting behaviors are associated with narcissism among men. *Personality and Individual Differences, 85*, 123–127. doi:10.1016/j.paid.2015.05.004

South, S. C., Eaton, N. R., & Krueger, R. F. (2011). Narcissism in official psychiatric classification systems. In W. K. Campbell & J. D. Miller (Eds.), *The handbook of narcissism and narcissistic personality disorder* (pp. 22–30). Hoboken, NJ: John Wiley and Sons.

Souza, F., de Las Casas, D., Flores, V., Youn, S., Cha, M., Quercia, D., & Almeida, V. (2015, November). Dawn of the selfie era: The whos, wheres, and hows of selfies on Instagram. In *Proceedings of the 2015 ACM on conference on online social networks* (pp. 221-231). ACM. doi:10.1145/2817946.2817948

Steeves, V. (2015). "Pretty and just a little bit sexy, I guess". Publicity, privacy and the pressure to perform "appropriate" femininity on social network. In B. Jane & S. Valerie (Eds.), *eGirls, eCitizens* (pp. 153–174). Ottawa: University of Ottawa Press.

Stephens-Davidowitz, S., & Varian, H. (2014). A hands-on guide to Google data. Retrieved May 28, 2017, from http://people.ischool.berkeley.edu/~hal/Papers/2015/primer.pdf

Stephens-Davidowitz, S. (2017). *Everybody Lies: Big Data, New Data, and What the Internet Can Tell Us About Who We Really Are*. New York: Day St., HarperCollins Publishers.

Stieffer, V. J. (2016). Internalizing beauty ideals: The health risks of adult women's self-objectification. *OPUS: Applied Psychology, 12*(2), 12–34.

Stock, T., & Tupot, M. L. (2014, Jan.). Analyzing Selfies: Culture Mapping the Meaning and Evolution of Selfie Shots. SlideShare. Retrieved Apr. 29, 2017 from https://www.slideshare.net/scenariodna/analyzing-selfies

Storr, A. (1968). Human Aggression. New York, NY: Atheneum. Retrieved from https://books.google.co.id/books/about/Human_Aggression.html?id=GpZ9AAAAMAAJ&redir_esc=y

Stosny, S. (2016). *Soar Above: How to Use the Most Profound Part of Your Brain Under Any Kind of Stress*. Deerfield Beach, Florida: Health Communications, Inc.

Sunar, L., & Kaya, Y. (2014). Toplumsal yaşamda değerler: Modernleşme, muhafazakarlaşma ve kutuplaşma. In L. Sunar (Ed.), Türkiye'de Toplumsal Değişim. Ankara: Nobel Yayıncılık.

Sung, Y., Lee, J. A., Kim, E., & Choi, S. M. (2016). Why we post selfies: Understanding motivations for posting pictures of oneself. *Personality and Individual Differences, 97*, 260–265. doi:10.1016/j.paid.2016.03.032

Surma, J. (2015). Social exchange in online social networks. The reciprocity phenomenon on Facebook. *Computer Communications: 73*(2016), 342 – 346.

Svelander, A., & Wiberg, M. (2015, July – August). The practice of selfies. *Interaction*, 35–38.

Swift, T. (2014, July 7). For Taylor Swift, the future of music is a love story. *The Wall Street Journal*. Retrieved from http://www.wjs.com

Tamborski, M., & Brown, R. P. (2011). The measurement of trait narcissism in social-personality research. In W. K. Campbell & J. D. Miller (Eds.), *The handbook of narcissism and narcissistic personality disorder* (pp. 133–140). Hoboken, NJ: John Wiley and Sons. doi:10.1002/9781118093108.ch11

Test, M. A., & Bryan, J. H. (1967). Dependency, models, and reciprocity. *Research Bulletin (Sun Chiwawitthaya Thang Thale Phuket)*.

The Capital. (2016). Fad or faux pas? Nigerian celebrities strip nude to show baby bump. *The Capital*. Retrieved September 1, 2016 from http://www.thecapital.ng/?p=3184

The New York Times. 22 September 2015, Makeup for the selfie generation, Courtney Rubin. Retrieved from http://www.nytimes.com/2015/09/24/fashion/selfie-new-test-makeup.html?_r=0

The Power of the Spoken Word. (n. d.). Orality in contrast with Literacy. Retrieved from http://www.lib.uidaho.edu/digital/turning/pdf/orality.pdf

Thordsen, T., Murawski, M., & Bick, M. (2016). The role of non-social benefits related to convenience: Towards an enhanced model of user's self-disclosure in social networks. In IFIP International Federation for Information Processing (pp. 389-400).

Tice, D. M., Butler, J. L., Muraven, M. B., & Stillwell, A. M. (1995). When Modesty Prevails: Differential Favorability of Self-Presentation to Friends and Strangers. *Journal of Personality and Social Psychology, 69*(6), 1120–1138. doi:10.1037/0022-3514.69.6.1120

Tifentale, A., & Manovich, L. (2015). *Selficity: Exploring photography and self-fashioning in social media.* New York: The Selficity Project.

Tifferet, S., & Vilnai-Yavetz, I. (2014). Gender differences in facebook self-presentation: An international randomized study. *Computers in Human Behavior, 35*, 388–399. doi:10.1016/j.chb.2014.03.016

Tong, S. T., Van Der Heide, B., Langwell, L., & Walther, J. B. (2008). Too Much of a Good Thing? The Relationship Between Number of Friends and Interpersonal Impressions on Facebook. *Journal of Computer-Mediated Communication, 13*(3), 531–549. doi:10.1111/j.1083-6101.2008.00409.x

Trivers, R. (2006). *Reciprocal altruism: 30 years later. Cooperation in Primates and Humans* (pp. 67–83). Berlin: Springer. doi:10.1007/3-540-28277-7_4

Trivers, R. L. (1971, March). The evolution of reciprocal altruism. *The Quarterly Review of Biology, 46*(1), 35–57. http://www.jstor.org/stable/2822435 RetrievedJune112017 doi:10.1086/406755

Trzesniewski, K. H., Donnellan, M. B., & Robins, R. W. (2008). Is Generation Me really more narcissistic than previous generations? *Journal of Personality, 76*(4), 903–918. doi:10.1111/j.1467-6494.2008.00508.x

Türkoğlu, N. (2000). *Görü-yorum gündelik yaşamda imgelerin gücü.* İstanbul: Der Yayınları.

Twenge, J. M. (2013). Social media is a narcissism enabler. Retrieved from: http://www.nytimes.com/roomfordebate/2013/09/23/facebook-and-narcissism/social-media-is-a-narcissism-enabler

Twenge, J. M. (2011). Narcissism and culture. In W. K. Campbell & J. D. Miller (Eds.), *The handbook of narcissism and narcissistic personality disorder* (pp. 202–209). Hoboken, NJ: John Wiley and Sons.

Twenge, J. M., & Campbell, W. K. (2009). *The Narcissism Epidemic: Living in the Age of Entitlement.* New York: Free Press.

Twenge, J. M., Campbell, W. K., & Gentile, B. (2012). Generational increases in agentic self-evaluations among American college students. *Self and Identity, 11*(4), 409–427. doi:10.1080/15298868.2011.576820

Twenge, J. M., & Foster, J. D. (2010). Birth cohort increases in narcissistic personality traits among American college students, 19822009. *Social Psychological & Personality Science, 1*(1), 99–106. doi:10.1177/1948550609355719

Twenge, J. M., Konrath, S., Foster, J. D., Campbell, W. K., & Bushman, B. J. (2008). Egos inflating over time: A cross-temporal meta-analysis of the Narcissistic Personality Inventory. *Journal of Personality, 76*(4), 875–901. doi:10.1111/j.1467-6494.2008.00507.x PMID:18507710

Van Dijck, J. (2013). *The culture of connectivity: a critical history of social media.* New York: Oxford UP. doi:10.1093/acprof:oso/9780199970773.001.0001

Varnalı, K. (2013). *Dijital kabilelerin izinde, sosyal medyada netnografik araştırmalar.* İstanbul Mediacat.

Vazire, S., Naumann, L. P., Rentfrow, P. J., & Gosling, S. D. (2008). Portrait of a narcissist: Manifestations of narcissism in physical appearance. *Journal of Research in Personality, 42*(6), 1439–1447. doi:10.1016/j.jrp.2008.06.007

Walasek, L., & Brown, G. D. A. (2016). Income inequality, income, and Internet searches for status goods: A cross-national study of the association between inequality and well-being. *Social Indicators Research, 129*(3), 1001–1014. doi:10.1007/s11205-015-1158-4 PMID:27881892

Walker, M. (2013, August). The good, the bad, and the unexpected consequences of the selfie obsession. *Teen Vogue.* Retrieved from http://www.teenvogue.com/advice/201308/selfie-obsession

Wallace, H. M., & Baumeister, R. F. (2002). The performance of narcissists rises and falls with perceived opportunity for glory. *Journal of Personality and Social Psychology, 82*(5), 819–834. doi:10.1037/0022-3514.82.5.819 PMID:12003480

Walther, J. B. (1996). Computer-Mediated Communication: Impersonal, Interpersonal, and Hyperpersonal Interaction. *Communication Research, 23*(1), 3–43. doi:10.1177/009365096023001001

Walton, K. L. (1984). Transparent Pictures: On the Nature of Photographic Realism. *Critical Inquiry, 11*(2), 246–277. doi:10.1086/448287

Wambu, O. (2015). Tradition versus modernity. *New African Magazine.* Retrieved August 30, 2016 from http://newafricanmagazine.com/tradition-versus-modernity/

Wang, C. F. (2013). Psychological analysis of online selfie communication. *Editorial friends.* (8), 77-78.

Wang, X. (2016). *Social Media in Industrial China.* London: University College London Press. Retrieved December 26, 2016 from www.ucl.ac.uk/ucl-press

Wang, R., Yang, F., & Haigh, M. M. (2016). Let me take a selfie: Exploring the psychological effects of posting and viewing selfies and groupies on social media. *Telematics and Informatics, 34*(4), 274–283. doi:10.1016/j.tele.2016.07.004

Warfield, K. (2014, October 29-30). Making selfies/making self: digital subjectivites in the selfie. *Presented at the Fifth International Conference On The Image And The Image Knowledge Community,* Freie Universität, Berlin, Germany.

We Are Social. (2016). Digital in 2016. Retrieved from http://wearesocial.com/

Wei, K. Z. (2016). Sub-cultural communication displayed in the selfie phenomenon. *News world,* (7), 89-91

Weick, K. E. (1984). Small wins: Redefining the scale of social problems. *The American Psychologist, 39*(1), 40–49. Retrieved June 16 2017 from http://psycnet.apa.org/journals/amp/39/1/40/ doi:10.1037/0003-066X.39.1.40

Weiser, E. B. (2015). #Me: Narcissism and its facets as predictors of selfie-posting frequency. *Personality and Individual Differences, 86,* 477–481. doi:10.1016/j.paid.2015.07.007

Wen, J., & Ünlüer, A. (2015, November 30-December 2). Redefining the fundamentals of photography with cooperative photography. In Proceedings of the 14th International Conference on Mobile and Ubiquitous Multimedia (MUM '15), Linz, Austria (pp. 37-47). doi:10.1145/2836041.2836045

Wendt, B. (2014). *The allure of the selfie. Instagram and the new self-portrait.* Amsterdam: Institute of Network Cultures.

Weststeijn, T. (2008). *The Visible World.* Amsterdam: Amsterdam University Press.

Whitbourne, K. S. (2013). Your body on display: Social media and your self-image. *Psychology Today,* December 3, 30-31.

Wickel, T. M. (2015). Narcissism and social networking sites: The act of taking selfies. *Elon Journal of Undergraduate Education, 6.* Retrieved from http://www.inquiriesjournal.com/articles/1138/2/narcissism-and-social-networking-sites-the-act-of-taking-selfies

Wikipedia. (2016, December 21). Reciprocity (evolution). Retrieved June 16, 2017 from https://en.wikipedia.org/wiki/Reciprocity_(evolution)

Williams, A. A., & Marquez, B. A. (2015). The lonely selfie king: Selfies and the conspicuous prosumption of gender and race. *International Journal of Communication, 9,* 1775–1787.

Wong, S.-S., & Burton, R. M. (2000). Virtual teams: What are their characteristics and impact on team performance? *Computational & Mathematical Organization Theory, 6*(4), 339–360. doi:10.1023/A:1009654229352

Wortham, J. (2013, October 19). My selfie, myself. *The New York Times.* Retrieved from http://www.nytimes.com/2013/10/20/sunday-review/my-selfie-myself.html?pagewantedall&_r0

Wright, A. G. C., Lukowitsky, M. R., Pincus, A. L., & Conroy, D. E. (2010). The higher order factor structure and gender invariance of the Pathological Narcissism Inventory. *Assessment, 17*(4), 467–483. doi:10.1177/1073191110373227 PMID:20634422

Wright, E. (2015, November). Watch the birdie: The star economy, social media and the celebrity group selfie. *Networking Knowledge, 8*(6), 1–13.

Wu, J. B., Hom, P. W., Tetrick, L. E., Shore, L. M., Jia, L., Li, C., & Song, L. J. (2006). The norm of reciprocity: Scale development and validation in the Chinese context. *Management and Organization Review*, *2*(3), 377–402. doi:10.1111/j.1740-8784.2006.00047.x

Wu, P. F., & Korflatis, N. (2013). You scratch someone's back and we'll scratch yours: Collective reciprocity in social Q&A communities. *Journal of the American Society for Information Science and Technology*, *64*(10), 2069–2077. doi:10.1002/asi.22913

Xie, Q. (2015). Analyze the meaning of selfies from a cultural perspective. *Art Education Research*, (7), 55.

Xu, Q. (2014). Should I trust him? The effects of reviewer profile characteristics on eWOM credibility. *Computers in Human Behavior*, *33*, 136–144. doi:10.1016/j.chb.2014.01.027

Yang, Z. & Wang, C.L. (2010). *Guanxi* as a governance mechanism in business markets: Its characteristics, relevant theories, and future research directions. *Industrial Marketing Management*, *40*, 492-495.

Yang, S., Santillana, M., Brownstein, J. S., Gray, J., Richardson, S., & Kou, S. C. (2017). Using electronic health records and Internet search information for accurate influenza forecasting. *BMC Infectious Diseases*, *17*(332), 1–9. PMID:28482810

Yetunde, A. (2014) Mystery of the waist beads and modern sexuality. Vanguard, December 27, 23-28.

Zhang, H. (2015). Intercultural communication displayed by selfies. *Exam Weekly*, (12), 23.

Zhang, Y., Arab, A., Cowling, B. J., & Stoto, M. A. (2014). Characterizing influenza surveillance systems performance: Application of a Bayesian hierarchical statistical model to Hong Kong surveillance data. *BMC Public Health*, *14*(850), 1–18. Retrieved June 14, 2017 from http://www.biomedcentral.com/1471-2458/14/850 PMID:25127906

Zhu, Y.-X., Zhang, X.-G., Sun, G.-Q., Tang, M., Zhou, T., & Zhang, Z.-K. (2014, July). Influence of reciprocal links in social networks. *PLoS ONE*, *9*(7), 1–8. doi:10.1371/journal.pone.0103007 PMID:25072242

Zoorob, M. (2015). Soul searching? State-level search term correlates of political behavior. *Intersect*, *8*(2), 1–21.

张慧. (2015). 从自拍门 (selfie) 看跨文化交际. 考试周刊, (12), 23-23.

王传芬. (2013). 网络自拍的传播心理探究. 编辑之友, (8), 77-78.

谢钦. (2015). 从文化角度分析自拍意义. 美术教育研究, (7), 55-55.

郭肖. (2015). 女性网络自拍现象的文化意义解读. 东南传播, (6), 51-53.

魏科召. (2016). 自拍现象的亚文化传播解读. 新闻世界, (7), 89-91.

鲁肖麟. (2015). 社交网络自拍中的印象管理与自我认知. 陕西教育 (高教), (2015年02), 5-7.

About the Contributors

Shalin Hai-Jew works as an instructional designer at Kansas State University (K-State). She has taught at the university and college levels for many years (including four years in the People's Republic of China) and was tenured at Shoreline Community College but left tenure to pursue instructional design work. She has Bachelor's degrees in English and psychology, a Master's degree in Creative Writing from the University of Washington (Hugh Paradise Scholar), and an Ed.D in Educational Leadership with a focus on Public Administration from Seattle University (where she was a Morford Scholar). She is currently editing a book titled "Methods for Analyzing and Leveraging Online Learning Data" with IGI-Global. She reviews for several publishers. She has authored and edited a number of books. Hai-Jew was born in Huntsville, Alabama, in the USA.

* * *

Nicky Chang Bi is a doctoral student in the School of Media and Communication at Bowling Green State University, USA. She is also an instructor there. Her research interests are Social Media, Public Relations, Health Communication, and Strategic Communication.

Endong Floribert Patrick Calvain (PhD) is a research consultant in the humanities and social sciences. He is a reviewer and editor with many scientific journals in the social sciences. His current research interest focuses on international communication, gender studies, digital media, media laws, international relations, culture and religious communication He is author of numerous peer-reviewed articles and book chapters in the above mentioned areas of interest.

Louisa Ha is Professor in the School of Media and Communication at Bowling Green State University, USA. She is the Founder and Leader of the Emerging Media Research Cluster there. She is the editor-in-chief of Journalism and Mass Communication Quarterly. Her research interests are Audience Behavior, Media Business Models, Webcasting, Social and Mobile Media, International and Online Advertising and Research Methods.

Ikbal Maulana is a researcher in the Center for Science and Technology Development Studies, Indonesian Institute of Sciences (PAPPIPTEK – LIPI). His research interests include social media studies, sociology of knowledge and technology, knowledge management, and philosophy of technology. Currently, he focuses his research on the impact of social media on politics, social transformation, as well as individual transformation.

Ayşe Aslı Sezgin is an Assistant Professor in the Faculty of Economics and Administrative Sciences, the Department of Political Science &Public Administration at Osmaniye Korkut Ata University /Turkey where she has been a faculty member since 2013. Ayşe Aslı Sezgin completed her Bachelor, Master and Ph.D. degrees at Gazi University Faculty of Communication, Ankara/Turkey. Her research interests lie in the area of higher education, internet, new media, network society, communication technologies, social media, political communication, media literacy. Her teaching interests include sociology, communication studies and corporate communicaton. She has published articles at international and national journals and has presented papers at international and national conferences. Her recent publications include *"New media's digital bell-jar impact: A review on generation Z"* (2017), *"Instagram phenomenon in Turkey: cultural analysis of life built in social sharing network"* (2016), *"Ideological tendencies of the social media contents for children"* (2016). She is the Project Coordinator at the *"Social Media Aspects of Corporate Profiles of Universities: Separation of State and Foundation University" (2017) Project at Turkey which supported by The Scientific and Technological Research Council of Turkey (TUBITAK).*

Eric B. Weiser is Professor and Chair of the Psychology Department at Curry College in Milton, MA. Dr. Weiser has published numerous peer reviewed journal articles and chapters in textbooks, and he has been called upon by local media to comment on matters related to psychology and social media. Dr. Weiser and his wife Linda reside in Stoneham, MA.

Fiouna Ruonan Zhang is a doctoral student in the School of Media and Communication at Bowling Green State University, USA. Her research interests are media psychology in digital media era, parasocial interaction and parasocial relationship theory, audience analysis on YouTube, and the international influence of Korean popular culture.

Index

A

altruism 131, 134-135, 137, 142-145, 161, 170-171
attention-seeking 3-4, 26, 55, 60, 62-63, 65, 67, 72

B

beauty standard 28, 36, 45-46

C

Categorization and Exploration of Group Selfies Instrument (CEGSI) 173, 175-176, 187, 237, 240
cheap talk 140-141, 159, 170
conservatism 103, 105-107, 117-118, 120-121, 125
cooperative photography 180, 244
Cooperative Reputation 268
costly signaling 140, 159, 170
Cross-National 51-52, 57
culture 2, 16, 35-36, 46, 58-59, 75-92, 95, 97, 101-102, 104-107, 111, 113-117, 121-122, 143, 170, 198, 226, 228

D

Data Mining 244
Digital Album 244
digital image processing 28, 36, 39-41, 44-45, 47
Digital Society 75-76, 101

Digital Timeline 244

Digital Timeline 244
direct reciprocity 134, 137-138, 140, 147, 153-154, 161-163, 170, 268
downstream reciprocity 137, 160-161, 170, 269
dronie 175, 180, 187, 195, 197, 202, 205-206, 208, 210-214, 216-220, 223-228, 230, 239, 244
Dynamic Self-Regulatory Processing Model of Narcissism 14, 25

E

Entitlement/Exploitativeness (E 5, 25

F

Facebook 7-8, 11-12, 15, 34, 60, 66, 102-105, 111, 118, 148, 154-157, 159, 179, 240
Fairness Norms 170
femininity 107-108, 116, 125
Flickr 88, 255-257
Followback 140, 268
Followee 149, 268
Follower 149, 268

G

Google Correlate 249-251, 253-255, 257-259, 261-265, 269-270
Grandiose Exhibitionism (GE) 5, 26
grandiose narcissism 4, 8, 12-14, 26, 55
group selfie 53, 173, 175-176, 180-181,

183-187, 190, 197, 202, 204, 206-208, 214, 216-219, 221, 223-224, 226, 229-230, 244-245, 269

groupies 54, 61, 63, 68, 173-174, 178, 180-181, 187, 223, 244

H

Hyper Sociality 170

I

impression management 31, 51, 58, 64, 68-69, 72, 117, 177, 240

indirect reciprocity 131, 137-138, 140, 147, 153-154, 156, 159-161, 163-164, 171, 269

individuality 28-30, 33, 38, 42, 44-46

Instagram 2, 8, 11-12, 59-60, 75-76, 91-93, 95, 102-105, 111-112, 116, 118, 240

L

Leadership/Authority (L 5, 26

life recording 60, 68

M

male gaze 104, 109-110, 114, 126

micro-expressions 103, 112, 119, 126

mobile device 213, 226, 238, 244-245, 269

N

narcissism 1-8, 11-17, 25-26, 32, 45, 51-59, 62, 65, 67-69, 72, 88, 90-91, 97, 111, 182

Narcissistic Personality Inventory (NPI) 26

negative reciprocity 134, 138-139, 152, 171, 268

Network Motif 171

O

oral culture 75-77, 84-85, 87, 97, 102

P

Parasocial 149, 171, 210

photograph 28, 37, 39-42, 44-46, 52, 72, 88, 105, 126, 174, 180

positive reciprocity 134, 138, 152, 171, 268

profile 95, 150-151, 154, 156-157, 159, 171, 175, 177, 179, 233

R

realism 28, 37, 39-42, 45, 47

relationship management 51, 53-54, 56, 68-69

Reputation Economy 141, 171

S

self-disclosure 4, 57, 171, 178

Self-Editing 72

self-esteem 3, 6, 15-16, 29, 32-34, 42, 44-45, 51-57, 61, 68-69, 72, 114, 178

selfie 1-2, 8, 11-12, 14-17, 28-31, 33-34, 37, 42, 45, 47, 51-60, 62-63, 65, 67-69, 72-73, 75-76, 78, 88-90, 97, 102-105, 107, 110-121, 126-127, 131, 142-143, 145, 147, 161-164, 171, 173-187, 190, 197, 202, 204, 206-208, 210-212, 214, 216-219, 221, 223-226, 229-230, 239-240, 244-245, 249, 253, 255-263, 265, 269-270

Selfie Obsession 72

selfie stick 54, 104, 111, 114, 174, 177, 179-180, 211-212, 245

selfie-objectification 104-105, 117, 119, 126

selfies 1-3, 7-8, 11-16, 28-30, 34, 41, 45, 51-69, 72-73, 75-78, 82-83, 88-93, 95, 97, 103-107, 111-121, 142-143, 147-148, 153, 161, 164, 173-183, 185-187, 189-190, 194-197, 199-205, 207-208, 210-211, 213-215, 217, 220-229, 231-241, 249, 253, 255, 257, 259, 263

Self-Interest 150, 171

self-objectification 103-106, 108, 110-111,

113-114, 118, 121, 126
sentiment analysis 156, 261, 265, 269
Snapchat 2, 60-61, 63, 65-66, 68
social media 1-3, 7-8, 12-16, 28-37, 42-
 47, 51-52, 54-57, 59-60, 63-65, 67,
 72, 75-76, 78, 80, 82-83, 86-93, 95,
 102-105, 107, 112, 114, 131-132, 139,
 141, 143, 145, 147-150, 153, 156, 159,
 163, 170-171, 173-174, 177, 179, 182,
 205, 215, 231, 234, 236, 241, 244,
 253, 268-269
social media platform 91, 93, 153, 171,
 241, 269
social networking sites 8, 87, 91, 111, 115,
 126, 149, 164, 179
social performance 44, 177, 245
Social Proof 171
Social Web 173, 175, 177, 245
strong reciprocity 134-135, 138, 152, 171

T

Time-Series Data 264, 269
trust 28-30, 39, 42, 44, 47, 54, 136-137,
 141-142, 145-146, 149-152, 154, 159

U

upstream reciprocity 137, 160, 171, 269
us-ies 164, 173-174

V

virtual teaming 164
visual culture 75-78, 85-87, 90-92, 97, 102
vulnerable narcissism 4-5, 12-14, 26, 55

W

Web Browser Add-On 245
Web Browser Extension 245
web browser plug-in 245
web cam 212, 244-245
web search 249, 251-253, 255, 264, 269
Wechat 60, 64
wefies 174, 182, 245
work-based self-portrayals 131, 143, 163
written culture 75-77, 79, 85, 87-88, 97, 102

Stay Current on the Latest Emerging Research Developments

Become an IGI Global Reviewer for Authored Book Projects

The overall success of an authored book project is dependent on quality and timely reviews.

In this competitive age of scholarly publishing, constructive and timely feedback significantly decreases the turnaround time of manuscripts from submission to acceptance, allowing the publication and discovery of progressive research at a much more expeditious rate. Several IGI Global authored book projects are currently seeking highly qualified experts in the field to fill vacancies on their respective editorial review boards:

Applications may be sent to:
development@igi-global.com

Applicants must have a doctorate (or an equivalent degree) as well as publishing and reviewing experience. Reviewers are asked to write reviews in a timely, collegial, and constructive manner. All reviewers will begin their role on an ad-hoc basis for a period of one year, and upon successful completion of this term can be considered for full editorial review board status, with the potential for a subsequent promotion to Associate Editor.

If you have a colleague that may be interested in this opportunity, we encourage you to share this information with them.